Storey's Illustrated Guide to
Poultry Breeds

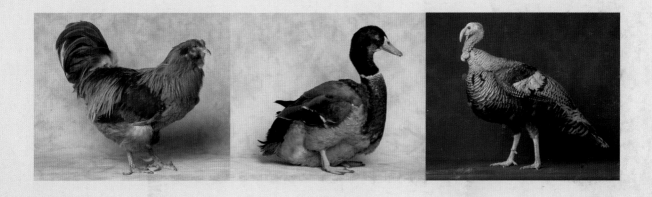

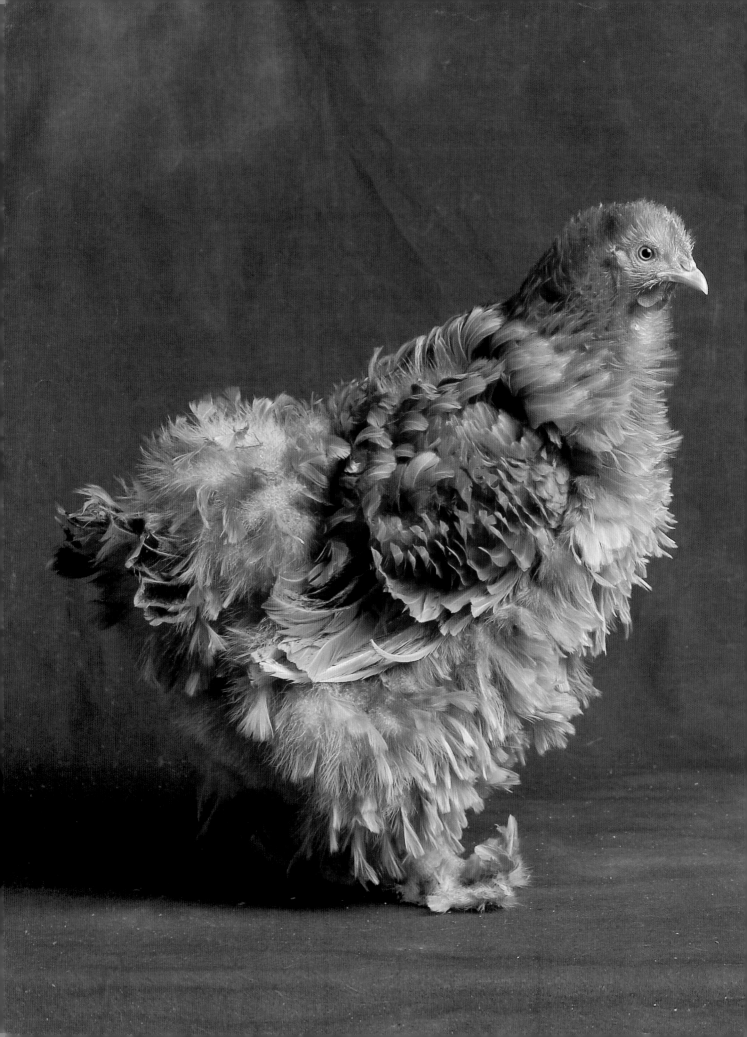

Storey's Illustrated Guide to
Poultry Breeds

CHICKENS • DUCKS • GEESE • TURKEYS • EMUS • GUINEA FOWL • OSTRICHES
PARTRIDGES • PEAFOWL • PHEASANTS • QUAILS • SWANS

Carol Ekarius

Storey Publishing

*The mission of Storey Publishing is to serve our customers by
publishing practical information that encourages
personal independence in harmony with the environment.*

Edited by Sarah Guare and Deborah Burns
Art direction and cover design by Vicky Vaughn Design
Text design and production by Monika Stout and Vicky Vaughn Design
Cover photographs by © Adam Mastoon, except for © Robert Dowling: front cover, bottom right, and iStock photo/Andris Smits: front cover, top center
Author's photograph by Ken Woodard Photography
Interior photographs by © Adam Mastoon with exceptions listed on page 273
Illustration credits listed on page 273
Image acquisition by Ilona Sherratt; Image management by Laurie Figary
Prepress by Kevin A. Metcalfe

Indexed by Barry Koffler

Text © 2007 by Carol Ekarius

Printed in China by Regent Publishing Services
10 9 8 7 6 5 4 3 2 1

LIBRARY OF CONGRESS CATALOGING-IN-PUBLICATION DATA

Ekarius, Carol.
 Storey's illustrated guide to poultry breeds : more than 128 breed profiles of
chickens-waterfowl-turkeys-ratites-game birds / Carol Ekarius.
 p. cm.
 Includes index.
 ISBN 13: 978-1-58017-667-5 (pbk. : alk. paper); ISBN 13: 978-1-58017-668-1 (hardcover
jacketed : (alk. paper)
 1. Poultry breeds. I. Title. II. Title: Illustrated guide to poultry breeds.
 SF487.E33 2007
 664'.93—dc22
 2007003170

DEDICATION

To my mom, Barbara Ekarius, for encouraging me to love words, to love books, and to pursue dreams.

CONTENTS

Acknowledgments

BOOKS ARE THE WORK OF MANY PEOPLE, and this one is no exception. In fact, by its very nature, this book has benefited more from the recommendations and expertise of others than my other books. Thanks to everyone who helped, including:

• The staff at the American Livestock Breeds Conservancy, in particular Dr. Don Bixby, Don Schrider, and Marjorie Bender, for writing about the need to protect breeds and for reviewing text.

• Glenn and Linda Drowns, who have personally worked to protect so many breeds at Sandhill Preservation, for reviewing text, and for working with us to schedule a photo shoot, so we could capture many of the rare breeds on film at one time.

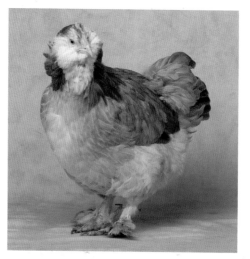

• George Allen, editor of *Game Bird Gazette*, for reviewing the Other Birds of Interest chapter.

• Matt Ranson, Barbara Green, Mary Keyes, Dr. Antonio Alcalde (Catholic University of Chile), Dr. Elizabeth Reitz (University of Georgia), Dr. Michael Romanov (San Diego Zoo), and Dr. Carl Johannessen (University of Oregon), for assisting me with information about the Araucana.

• Dr. Jerry Dodgson (Michigan State University), for answering questions about the Araucanas, genetics, and the Poultry Genome Project and for reviewing text.

• Dr. Wesley Towers (retired, Delaware State Veterinarian) for information on the Blue Hen of Delaware.

• Dr. David Mindell (University of Michigan), for helping me understand turkey evolution.

• August Vinhage, for explaining some of the differences between the APA Standard of Perfection and the ABA Bantam Standard.

• John Henderson, a reference librarian at Ithaca College and chicken fancier at Sage Hen Farm, and Margaret Shephard, technical editor at the Ecological Society of America, for providing information on beak color.

• Craig Russell, of the Society for the Preservation of Poultry Antiquities, for his research and for filling in some holes for me, as well as Christine Heinrichs, also of SPPA, for her invaluable assistance helping us locate breeders of rare breeds.

• Kent Whealy at the Seed Savers Exchange, for supplying information on the Iowa Blue.

• David Holderread for reviewing the text in the Waterfowl chapter.

• More than one hundred individual breeders affiliated with the APA, the ABA, and breed clubs, who graciously responded to questions, pointed me to another breeder/expert, or reviewed the text for the breed they work closely with.

• Adam Mastoon, for supplying the beautiful photos that help bring this book — and the birds in it — to life, and all the breeders who either shared their birds with our photographers or their photographs with us (see page 271 for a complete list of breeders and photographers).

• Monika Stout and Vicky Vaughn Shea for creating a beautiful design.

• Deborah Burns, Sarah Guare, Ilona Sherratt, and the rest of the Storey team, for helping make this project happen.

Preface

I STILL REMEMBER OUR FIRST CHICKENS. It was the early 1980s, and we had just moved to a place in the country — 40 acres outside Kremmling, Colorado. We immediately began acquiring critters. First came a couple of horses, then a calf, then some rabbits. We planned on ordering chicks as soon as the weather warmed up.

At the time I ran the waste-water treatment plant in Frisco, Colorado, and in that capacity had dealings with the local businesspeople. One day I was telling one of the businessmen about our new place. He lit up immediately.

"Carol, have I got a deal for you," he said with a big grin. He had gotten eight chicks for his children at Easter. His wife and kids had brooded them under a heat lamp in their basement, and now the chicks were getting large and feathering out. They were making a mess in the basement, and he really didn't want to build a pen in his backyard for them. "You can have them for free, with the food, the feeders, the waterer — everything. The only catch is that you have to let me bring the kids out to see them once, so they know their

chickens went to a good home. After that, they're yours . . . if you want to eat them that's okay."

Since they were layers, those chickens had a long life; they were the beginning of an almost full-time pursuit (save a short birdless period during one of our cross-country moves) that has lasted more than two decades. Our flocks have ranged in size from just a handful of birds in a backyard pen to hundreds of birds on a commercial farm. We've also had turkeys, ducks, and geese.

Those first chickens were just a commercial Leghorn strain. Since then, our birds have represented a variety of breeds, each with its own strengths and weaknesses. There is no perfect breed, but there is an amazing array of breeds that have real value for enthusiasts. We have enjoyed all of our birds. Their antics, their beauty, and the good food they provide more than compensate us for the time and expense of keeping them. I hope this book will help you, too, appreciate what the barnyard and backyard birds have to offer.

— Carol Ekarius

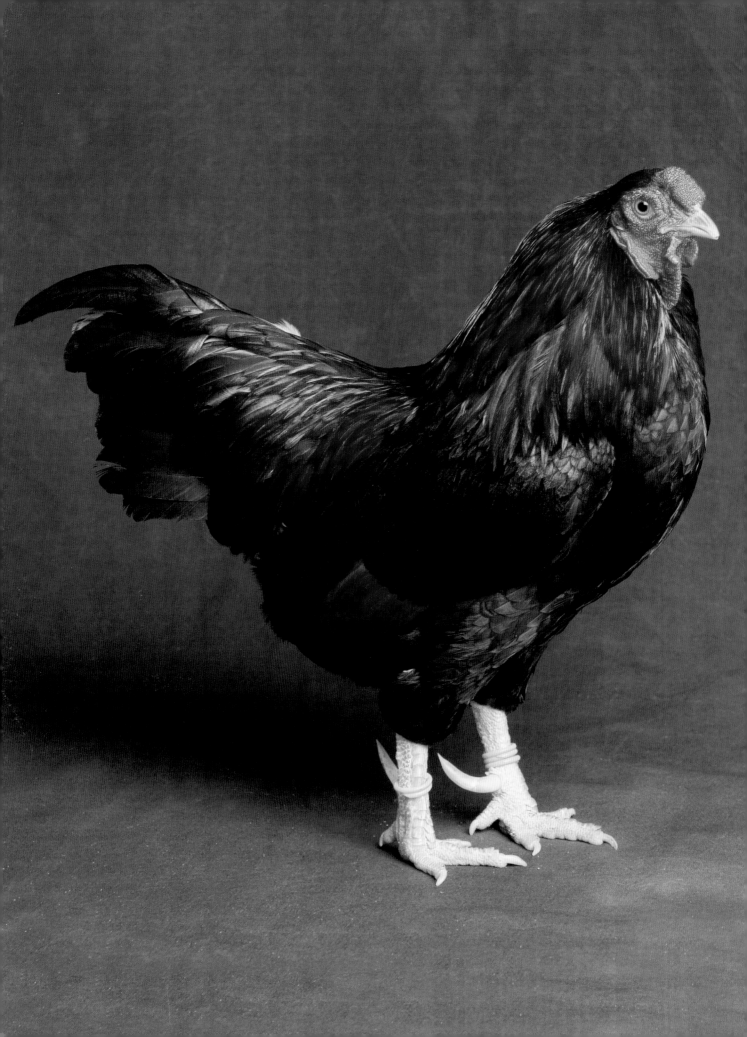

Introduction

Farmers who have had no experience with the different varieties of purebred fowls are very apt to choose a breed because they "like the looks" of the fowls, or because somebody says that particular breed "is the best," but it frequently happens that their poultry fails to pay, because the breed selected is not the one best adapted to the special purpose for which they keep fowls, and disappointment results.

— Waldo F. Brown, *The People's Farm & Stock Cyclopedia,* 1884

HUMANS HAVE DEPENDED on domesticated and captive-bred wild birds for thousands of years. These fowl have both fed us and provided us with feathers for uses ranging from strictly ornamental to highly practical (such as goose down insulation). They have played a spiritual role for many cultures and attracted us with their beauty and interesting character.

Our need (both utilitarian and aesthetic) for fowl has resulted in an amazing variety of barnyard birds. There are over a dozen species, hundreds of breeds, and thousands of varieties kept in barnyards and backyards around the country and around the world.

Let this book serve as your guide to the marvelous selection of birds that are kept by farmers and fanciers in North America. This first chapter provides some gen-

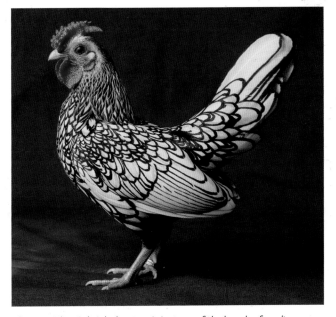

Above: A Silver Sebright bantam is just one of the breeds of poultry raised for show and pleasure. Left: Partridge Chantecler bantam.

eral background information on the birds of the barn. Next comes a chapter dedicated to chickens (by far the largest group of domesticated birds), followed by chapters on turkeys, waterfowl, and finally some of the other birds that farmers and fanciers raise (such as the upland game birds).

To make it easier to cross-reference breed information, we have highlighted in bold breed names that are discussed in the book and included the number of the page on which their write-up appears.

Welcome to the fascinating world of fowl. Enjoy your exploration of our feathered friends.

A Little Natural History

Trying to understand the natural history of domesticated birds is like doing a giant jigsaw puzzle: as each piece, or clue, falls into place, you begin to get a feel for the picture, yet as other pieces are added the picture can change before your eyes to something you hadn't quite expected. Biologists, archaeologists, historians, and bird fanciers continue to search for evidence that will help finish the picture, but in the meantime, I've gathered some of the prevailing thoughts on where, and how, our domestic birds got their start.

EARLY PREDECESSORS

Scientists are fairly certain that there is some connection between our modern birds and dinosaurs. If you see a chicken attacking a hapless mouse that has had the misfortune of finding itself in the coop, the resemblance to a killer dinosaur is very clear, and you're darn glad that bird isn't 40 feet (12 m) tall and standing above you.

In fact, most scientists think that birds evolved from the same line of dinosaurs that spawned the bad-guy dinosaur of the movie *Jurassic Park*, the Velociraptor. Some, however, speculate that birds are more like cousins of dinosaurs, having evolved concurrently from a common ancestor that gave way to dinosaurs, birds, and reptiles about 275 million years ago. Either way, modern birds and reptiles share a surprising number of traits that support the idea of an evolutionary connection, such as scales (which birds have on their legs) and the external incubation of eggs.

The earliest birds that are recognized as such, *Archaeopteryx lithographica*, were discovered in limestone deposits in Europe and appeared during the Upper Jurassic period (about 150 million years ago). The trip from *Archaeopteryx lithographica* to our modern birds (subclass Neornithes) included several now-extinct intermediary species and took millions of years. Somewhere around the end of the Cretaceous period, about 65 to 70 million years ago, the relatives of today's waterfowl showed up, making them among the earliest modern birds that scientists have documented. Then, by 35 million years ago, the ancestors of the majority of modern birds had made the scene.

BASIC CLASSIFICATIONS

There are about nine thousand known birds within the subclass Neornithes; these are separated into two major subdivisions: the Eoaves, a rather small group that includes ostriches, rheas, emus, and kiwis; and the Neoaves, which includes all other living birds, from albatrosses and avocets to woodpeckers and wrens (and, of course, chickens, turkeys, and other domesticated birds). Within the Neoaves there are many major subdivisions, but for our purposes the superorders Gallomorphae and Anserimorphae are the two important groups.

The gallinaceous birds, which are members of Gallomorphae, are

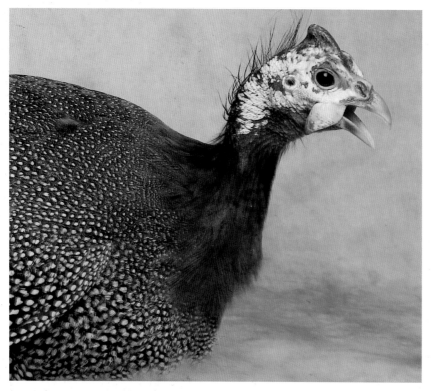

Guinea fowl, such as this helmeted guinea, are unusual-looking birds that are known for eating insects, snakes, and small rodents.

terrestrial, chickenlike birds with relatively blunt wings that aren't capable of flying very far. They have strong legs and feet for digging, fighting, and running. There are over 250 species in this group, including many barnyard birds, such as chickens, jungle fowl, turkeys, pheasants, quail, grouse, and guineas.

The Anserimorphae are waterfowl, and there are over 150 species in the group. They are strong swimmers with short, stout legs and webbed feet. They also fly very well, though many of the domestic ducks and geese have been bred to have a large breast, which reduces their flying capabilities. They have a feathered oil gland and down feathers to help maintain their temperature whether in water, on land, or in the air. They also have a thick layer of fat that acts as insulation and provides buoyancy.

One unusual characteristic of waterfowl is the way they molt (shed their plumage). Most birds undergo a gradual molt during which the feathers are shed and replaced slowly, so the birds can still fly during this time. Waterfowl, however, molt all of their flight feathers (wing and tail feathers) simultaneously, with the result that they become flightless for several weeks. You may notice that during the molt period male ducks (wild or domestic) lose their typically vibrant breeding colors and assume a drab appearance like that of the females and juvenile birds.

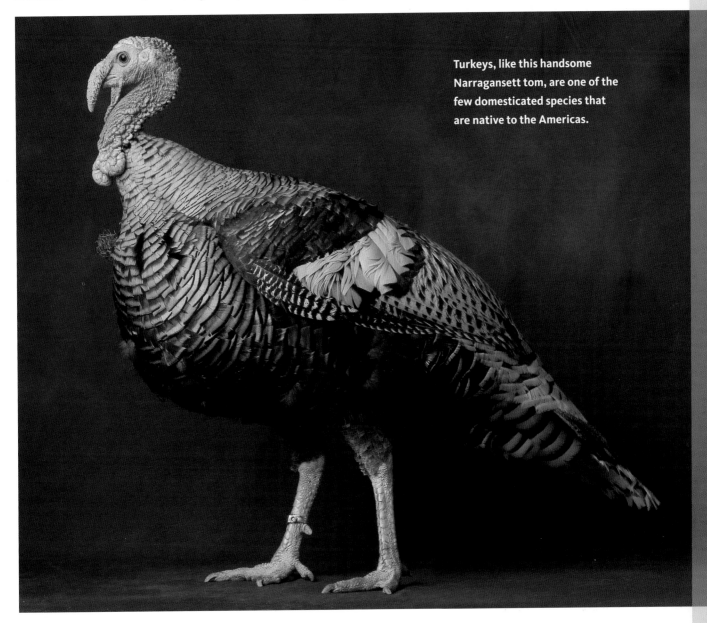

Turkeys, like this handsome Narragansett tom, are one of the few domesticated species that are native to the Americas.

The Mystery of the Araucanas

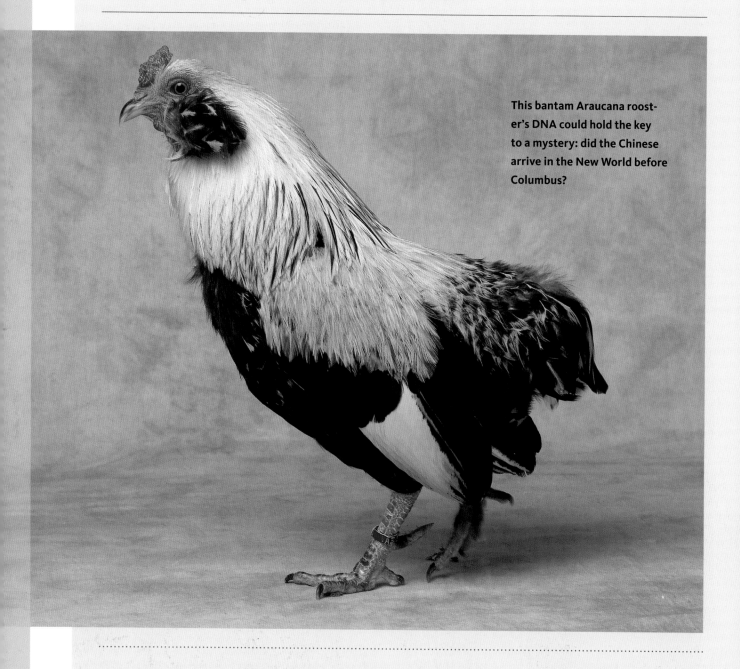

This bantam Araucana rooster's DNA could hold the key to a mystery: did the Chinese arrive in the New World before Columbus?

The Araucana chicken breed provides a great example of the way thoughts are challenged in the scientific world and of how our understanding of history can change over time.

There is a great deal of debate about the Araucana and its progenitors, the Collonca and Quetero birds, domestic races that were kept by tribal groups in different areas of Chile. The debate centers on whether these birds predated the arrival of Columbus in the New World, and if so, where they came from. Here is the short version of the story, which, as one Italian scientist wrote, has had lots of ink spilled on it, with more yet to come.

We have all been taught that Columbus discovered America. Until recently the accepted wisdom was that livestock — ranging from chickens to pigs, goats, sheep, cows, and horses — were introduced to the New World by Columbus and the Europeans that followed him. Now, however, there is a divide in

the academic community between those who agree with this view and another group that believes the Chinese arrived in South America before Columbus and introduced chickens to the New World.

"There have been repeated rumors about pre-Columbian chickens, generally focused on the Araucana, but this has never been supported by scientific evidence and is considered highly improbable, as is all evidence for any trans-Pacific human migration into South America after the early Holocene [about eleven thousand years ago]," according to Dr. Elizabeth Reitz, an anthropologist at the University of Georgia who manages the zooarchaeology lab. "Both concepts are unsupported in the professional archaeological literature at this time. Chickens are not the only European introduction that spread in advance of Europeans themselves. European-introduced diseases surely spread far in advance of Europeans, as did a number of plant species (for example, watermelon and peaches)."

But the opposite view has its own strong — and well-respected — supporters. Dr. Carl Johannessen, professor emeritus in the geography department at the University of Oregon, is a strong proponent of the view that there were transoceanic contacts between the Chinese and Amerindians before Columbus came to the New World. "Chickens are just one of about 125 species of plants and animals that appear to have moved between Asia and South America before Columbus came," he says.

Dr. Antonio Alcalde, an agronomist and lecturer on plant and animal domestication at Catholic University in Chile, also supports the pre-Columbian introduction of chickens. "My educated guess is that these chickens were here before the Europeans arrived," he says.

Both Johannessen and Alcalde point to some strong evidence that the Araucana's forebears were pre-Columbian chickens, including these five basic points:

1 The names for the hen and rooster in the local language are *achawl* and *alka*. These don't resemble the Spanish names (*gallina* and *gallo*), though words for other species that the Spanish introduced are quite similar to the Spanish words, such as for cow (*waca* versus *vaca*), horse (*kawello* versus *caballo*), and sheep (*oweja* versus *oveja*).

2 The Mapuche (a native tribe) tell very old stories that speak of a semi-domestication process they imposed on these birds, altering their evolution and having to pay for that mistake by having to care for the birds.

3 The birds have numerous traits that have more in common with Asiatic breeds than Mediterranean breeds. For example, brown eggshells, red earlobes, pea and rose combs, and slow-feather-

ing types are all associated with Asian breeds.

4 The chicken diffusion rate (the rate at which the birds spread across the landscape) in South America, if they were introduced only after European discovery, was at an order of magnitude greater than their diffusion rate in the Old World.

5 The use of chickens in religious ceremonies and for medicinal purposes in some parts of South America are far more similar to Asian uses than to European uses.

Which camp is right in this debate? Only time will tell, but scientists are now using DNA analysis to help solve the puzzle of the Araucana.

The Araucana is known for several unusual traits, such as the lack of tail and ear tufts seen on this bantam hen.

Species, Breeds, and Varieties

A SPECIES IS A GROUP of organisms that are genetically similar and have evolved from the same genetic line. Organisms within the same species readily interbreed, exchanging genes to produce viable offspring that are also capable of interbreeding. Sometimes different-yet-similar species are capable of breeding (for example, horses and donkeys), but generally these cross-species pairings result in offspring that are not viable or that are not readily capable of interbreeding (as is the case with the mule, which is sterile).

A *breed* is a group within a species that shares definable and identifiable characteristics (visual, performance, geographical, and/or cultural) which allow it to be distinguished from other groups within the same species. So, although chickens are of the same species, an Ameraucana is easily distinguished from a Yokohama, and a Dutch Bantam is readily distinguished from a Jersey Giant.

Within breeds there are additional subdivisions for variety and type. *Varieties* are often defined on the basis of the color of their plum-age, the shape of their comb, or the presence of a beard and muffs. *Types* are defined based on differences in use, such as production or utility types versus exhibition types.

Some chicken and duck breeds have corresponding miniature versions (one-fifth to one-quarter the size of the large bird). There are also some breeds that exist only in a small form. These diminutive forms are referred to as bantams.

RECOGNIZING BREEDS

Breeds have been developed over many millennia. In North America the designation of poultry and fowl into breeds is basically determined, or "recognized," by one of two groups: the American Poultry Association (APA) and the American Bantam Association (ABA). Both organizations publish a "standard" (the APA *Standard of Perfection* and the ABA *Bantam Standard*) that describes each breed in great detail. These standards are used by breeders in selecting breeding stock and by judges at poultry shows in evaluating birds.

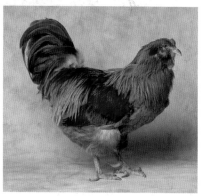

Breeds come in a wide variety of sizes, shapes, and colors. The Jersey Giant hen (top photo) represents one of the largest breeds and one of the most common colors — Black. Blue Wheaten, as seen in the Ameraucana cock (lower photo), is a somewhat uncommon color.

Within one breed there is often a large, or standard-sized variety, and a small, or bantam, variety. A standard New Hampshire rooster and a bantam New Hampshire hen are shown at right for comparison.

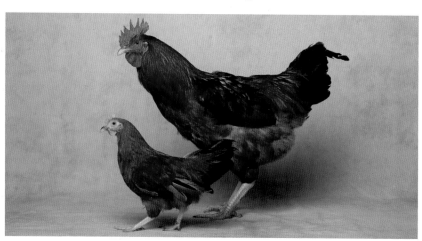

The terms purebred and registered do not mean the same thing for poultry as they do for large livestock animals. Rather, poultry that meet the breed and variety descriptions found in the APA *Standard of Perfection* or the ABA *Bantam Standard* are said to be "standard bred."

Founded in Buffalo, New York, in 1873, the APA is the oldest livestock organization in the United States. The ABA formed in 1914 with the goal of setting standards for, and promoting, the bantam breeds. There is some crossover between the two organizations: the APA recognizes many, but not all, of the bantams that the ABA recognizes, and vice versa. In other words, some bantam breeds and varieties are recognized by both groups, while other breeds and varieties are recognized only by one.

When breeds are first introduced to this country, the interested breeders arrange with the APA and/or the ABA to host a qualifying meet. If the birds at the meet show sufficient standardization of characteristics, they may be accepted for inclusion in a future standard. Anyone interested in raising or showing standard-bred poultry (chickens, turkeys, ducks, and geese) should invest in a copy of the appropriate standard.

Unfortunately, breeds come and go. New ones are developed; older ones languish when few breeders are interested in them anymore; some breeds become extinct. The American Livestock Breeds Conservancy (ALBC) and the Society for the Preservation of Poultry Antiquities (SPPA) are two of the leading organizations that work on protecting breeds from extinction.

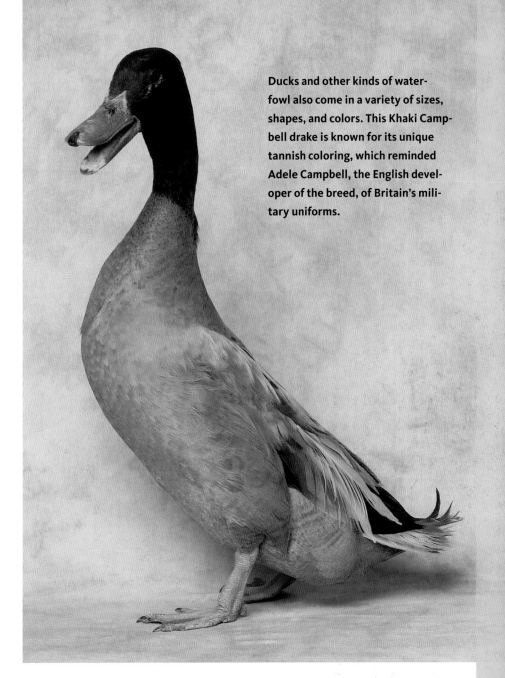

Ducks and other kinds of waterfowl also come in a variety of sizes, shapes, and colors. This Khaki Campbell drake is known for its unique tannish coloring, which reminded Adele Campbell, the English developer of the breed, of Britain's military uniforms.

Slow Food USA's Ark of Taste

The Ark of Taste is a program designed to preserve and celebrate endangered tastes. It does this by promoting economic, social, and cultural heritage foods ranging from animals raised for meat to fruits and vegetables, cheeses, cereals, pastas, and confectionaries. The following breeds were accepted by Slow Food USA (see Resources, p. 261) into the Ark of Taste as of September 2006.

Chickens: Delaware, Dominique, Black Jersey Giant, White Jersey Giant, New Hampshire, "Old Type" Rhode Island Red, Plymouth Rock, Wyandotte

Geese: American Buff, Pilgrim

Turkeys: Bourbon Red, American Bronze (Standard), Buff, Midget White, Narragansett

Rare Poultry Breeds and Healthy Biodiversity

Text courtesy of the American Livestock Breeds Conservancy.

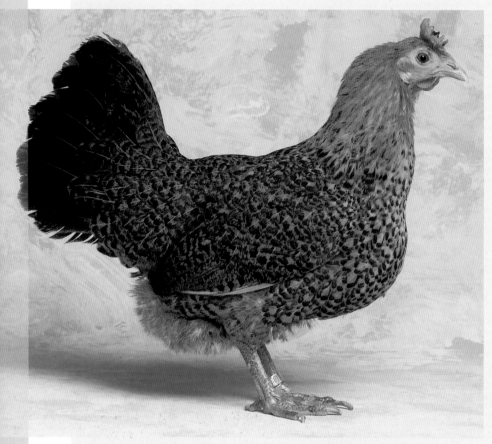

The Sicilian Buttercup, named for its unusual comb, is a beautiful but critically endangered breed of chicken.

Since the earliest days of agriculture, countless individuals have dedicated themselves to the care and breeding of poultry. These birds have filled a wide array of human needs for food, fiber, creative and spiritual expression, sport, and companionship. Both human and natural selection have worked together in the evolution of breeds, so that each breed reflects a particular set of characteristics valued in the interplay among the people who depend on them, the birds, and environment.

Breed diversity today is a legacy from our ancestors and reflects the ways that they lived.People who lived in cold climates had breeds adapted to the cold; in hot climates, breeds were adapted to the heat and to the greater number of parasites that plague steamy regions. In areas where grass was plentiful, breeds were adapted to good forage, but in areas of poor forage, the breeds were adapted to survive on lower feed quality. Taken together, the breeds within a species represent the

species' adaptability and utility, providing the genetic diversity the species needs to survive and prosper.

The importance of genetic diversity is widely recognized as it relates to the wild realm — rain forests, wetlands, tidal marshes, and prairies. Similarly, agriculture is a biological system with humans as a major source of selection pressure, and genetic diversity allows it to be both dynamic and stable.

Genetic diversity *within* a species is the presence of a large number of genetic variants for each of the species' characteristics. For example, variation in the amount of feathering in chicken populations allows for some individuals to have featherless necks (as seen in the Naked Neck breed), which is an excellent adaptation for a hot environment, and for others to have thicker and looser feathers that trap insulating air (as seen in the Buckeye and Chantecler breeds), which is the perfect adaptation for a cold climate. This variability, resulting from small genetic differences among the breeds, allows the species to adapt to changes in the environment or other selection pressures.

The opposite of genetic diversity is genetic uniformity. Populations that have been intensely bred for certain characteristics over time, such as the Broad Breasted White turkey, may be well adapted to a specialized habitat or production system. Unfortunately, such specialization leads to genetic uniformity, resulting in inbreeding and a limited reserve of genetic options. This dramatically restricts the population's ability to adapt to changing

conditions, making it vulnerable, for example, to being wiped out by a disease outbreak or by climatic change.

The industrialization of agriculture has consolidated and specialized the once decentralized and integrated production of poultry into uniform systems of specialized mass production. Climate-controlled confinement housing, sophisticated husbandry and veterinary support, chemical additives, and heavy grain feeding have allowed breeders to ignore adaptation and other survival characteristics in favor of maximized production. While highly productive in exquisitely designed and supported environments, industrial stocks are unlikely to be able to adapt to any changes in their environment, such as a sudden restriction of external energy.

Genetic conservation must include varied breeds and types, especially those that have traits no longer found in industrial stocks. Failure to be far-sighted will eventually result in an agricultural crisis. Conservation of breed diversity must be actively pursued now, while the genetic diversity within the species is still available and relatively robust.

The conservation of rare breeds of poultry protects the broad genetic base found in each of the species of chickens, turkeys, ducks, geese, and other poultry. This genetic diversity is imperative to meeting seven societal needs: food security, economic opportunity, environmental stewardship, scientific knowledge, cultural and historical preservation, ethical responsibility, and common ownership.

Food Security

Our culture is dependent on a stable food supply. Genetic diversity is the basis for responses to future environmental challenges, such as global warming, evolving pests and diseases, bioterrorism, and dwindling energy supplies. The Irish potato famine and the more recent outbreaks of foot-and-mouth disease and avian influenza are examples of the vulnerability of genetic uniformity and industrial consolidation. Diversity is essential for long-term food security. Most people recognize the wisdom of not putting all of their eggs in one basket.

Economic Opportunity

Rare breeds can offer economic opportunity by providing specialty products and services, such as free-range meat and eggs, colored eggs, and unusual feathers for fly-tying, crafts, decoration, and fashion that can be marketed into specialty niches. Specialty services might include pest control, recreational opportunities (the best fishing flies, for example, are produced with real feathers, rather than manmade materials), and product association for marketing purposes (such as Clydesdale horses with Anheuser-Busch's Budweiser beer or Highland cattle with Dewar's Scotch).

Genetic diversity can be used to develop new breeds to meet new needs. The specialization of the Leghorn for egg production and the Cornish-Rock cross for broiler production has been so successful that development of other breeds has not been considered recently. That does not mean that these specialized,

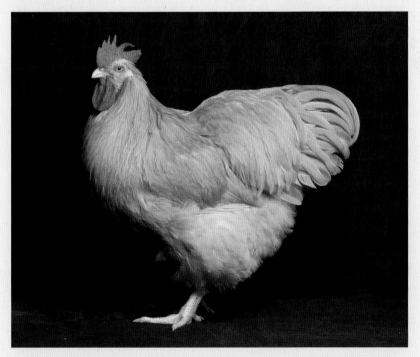

This Buff Orpington rooster is a member of a breed that is making a comeback. This resurgence is due to the efforts of conservation breeders, who recognize the many great traits of breeds that don't perform well in an industrial system but do perform well in a barnyard setting.

(continued on next page)

ubiquitous breeds will always be able to provide for our needs.

Breeds that are rare today were important contributors to human welfare in the past and may possess characteristics that will be needed again to meet new or reemerging needs. The loss of these survival traits through negligence would be a tragedy for humankind.

Environmental Stewardship

Agriculture, including animal husbandry, is the chief interaction of humans with the environment. Genetic diversity within agriculture is essential for us to be able to adapt to environmental changes. It also allows us to improve the sustainability of agriculture by selecting breeds and production methods that require less input (of chemicals, energy, and so on) than what "modern" agriculture requires.

For example, poultry breeds that are adapted to do well on free-range forage require less input than those that are bred for mass production in contained, highly specialized environments. These sustainable practices are increasingly recognized for their economic and environmental value.

Scientific Knowledge

To fully understand the animal kingdom (to which we ourselves belong) requires the conservation of genetic diversity. Many rare breeds are biologically unusual because of the selection pressures applied in their evolution. Knowing about these pressures — climatic conditions and changes, diseases and parasites, reproductive differences, feed utilizations — and the way in which populations responded to them could provide useful information for improved agricultural production and human health.

Cultural and Historical Preservation

Like artwork, architecture, language, and other complex artifacts, rare breeds inform us about the interests, skills, and values of our ancestors. Solutions to contemporary problems are often found in records of the past. Many traditional poultry husbandry techniques retain their usefulness today, but this once common wisdom is slipping away.

These living creatures also reflect our evolving relationship with the natural world. Rare breeds of domestic birds and other animals, as well as rare varieties of agricultural plants, represent the biodiversity that is closest to us and upon which we are most dependent.

Ethical Responsibility

Stewardship of the planet includes not only the many species of wild animals, plants, and habitats but also the domestic animals and plants that are part of the biological web of life. Those who appreciate the role of domesticated animals in providing services, food, and other products must believe that domestic animals have a right to continued existence, as do the wild species.

Domestic animals have been our partners for many centuries of coevolution and interdependence. They play a unique role in our culture; they are the first animals we learn about as children and are the subject of most nursery rhymes and children's stories. We have a special obligation to protect them.

Common Ownership

Rare-breed conservation keeps genetic resources in the hands of individual farmers and breeders around the world. This allows poultry to be freely owned, used, and bred by farmers and breeders without the barriers of patents and other corporate restrictions.

In contrast, consider the example of the seed industry, in which the concentration of genetic ownership and corporate patenting of hybrid and genetically modified seed varieties has resulted in a lack of public access to diverse seed supplies and the loss of many heirloom varieties. Widespread breed conservation can help prevent the same from happening to the poultry industry.

The adaptability and biological health of all domesticated species must be maintained to ensure that they continue to thrive in a wide range of environments and production systems without elaborate and expensive support systems.

The American Livestock Breeds Conservancy (ALBC) is the pioneer conservation organization for farm animals in North America. Its mission is the protection and promotion of over 150 breeds of cattle, goats, horses, asses, sheep, pigs, rabbits, chickens, ducks, geese, and turkeys. Founded in 1977, the American Livestock Breeds Conservancy is a nonprofit membership organization working to conserve genetic diversity and save heritage breeds from extinction. For information about participating in breed conservation efforts, contact the ALBC; see page 260 for contact information.

Genetics 101

Englishman Robert Bakewell took over his father's Dishley Grange farm in 1760. While still quite young, Bakewell traveled throughout Europe studying farming practices of the time. Once the family's farm became his, he began applying and documenting new ideas for irrigation, fertilization, crop rotation, and breeding.

Bakewell began his breeding program with the old native breed of sheep in his region of Leicestershire. At the time, both sexes were traditionally kept together in the fields. The first thing Bakewell did was separate the males from the flock. By controlling which rams were allowed to enter the flock for breeding, and when they were allowed to enter the flock, he found he could breed for specific traits.

The rams Bakewell selected for breeding were big, yet delicately boned, and had good quality fleece and fatty forequarters to respond to the market of the day, which favored fatty mutton. Soon Bakewell's flock showed distinctive changes, and he named his new breed of sheep New Leicesters.

Bakewell's approach to breeding was revolutionary. His efforts were based on a keen sense of observation and willingness to experiment, and his work provided the foundation upon which much of our understanding of breeding and genetics is based. Both Gregor Mendel (a monk whose 1865 paper on inheritance in peas is considered to be the first scientific research on the topic of genet-

ics) and Charles Darwin referred to Bakewell's efforts in developing their theories.

Review of the Basics

If you haven't given much thought to biology since high school, then a quick review of some of the principles may be helpful. All living things are made up of cells, and with the exception of some types of single-cell organisms (such as blue-green algae), every cell contains a nucleus. Stored within the nucleus is the genetic data that defines the creature, be it a microscopic organism or the incomprehensible teenager who works at the movie rental store. This genetic data is carried on chromosomes.

There are some important points to remember about chromosomes:

Different species have different numbers of chromosomes. Chromosomes come in pairs in all cells of the body except the egg and sperm cells. Each egg and sperm cell has only half of the pair of chromosomes; when the egg and sperm combine to create a zygote, or fertilized egg, the two halves combine to create a complete pair of chromosomes.

All but one pair of chromosomes are identical in shape and proportion, though they do vary in size; these pairs are called autosomes. The pair that is distinctly different from the rest is the pair that determines the sex of the animal.

A turkey, for example, which has a total of 40 chromosome pairs, has 39 pairs of autosomal chromosomes that are the same shape and

Nature versus Nurture

We often hear debates over the influence of genes on everything from behavior to health — the nature-versus-nurture debate. The truth is, most traits are influenced by both nature and nurture.

For instance, birth weight and growth rate are both definitely dependent on the genetic material passed down from Mom and Dad, but they are also highly influenced by environmental factors such as diet and weather. An animal can have top-of-the-line breeding and perform poorly if not given proper care, or an animal that has poorer genetic material can do really well when given excellent care (think Sea Biscuit, the knock-kneed poor-excuse-of-a-racehorse that captured the world's fancy and the Triple Crown when the right owner, trainer, and jockey gave him their best).

A small group of traits, like the color of plumage, are controlled primarily by heredity; however, even these can be affected by extremes in environmental factors. To give just one example, black-feathered animals that have inadequate amounts of the trace minerals zinc and copper in their diet may exhibit a coppery tinge.

Number of Chromosome by Species

SPECIES	NUMBER OF CHROMOSOME PAIRS	TOTAL NUMBER OF CHROMOSOMES
Human	23	46
Chicken	39	78
Turkey	40	80
Duck	40	80

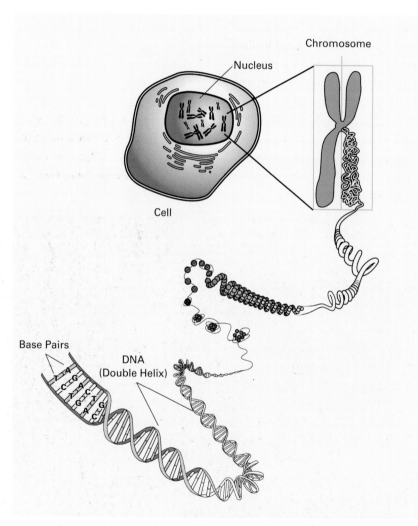

Genetic information is contained on chromosomes, which are made up of a DNA molecule and reside within the nucleus of the cell. DNA consists of thousands of genes, and each parent contributes one-half of the genetic code to its offspring.

share the same proportions within each pair. It also has one pair of chromosomes that are clearly different, and these are referred to as the sex chromosomes.

In poultry, the letters Z and W designate the sex chromosomes, with the male having two Z chromosomes (written ZZ), and the female having a Z and a W chromosome (written ZW). (In mammals the sex chromosomes are designated by the letters X or Y, with the female combination written as XX and the male as XY.)

Each chromosome is made up of a single molecule of DNA (deoxyribonucleic acid), but the DNA molecule can be parsed out into still smaller units called genes. DNA molecules typically have hundreds or even thousands of genes. Scientists estimate that most mammals and birds have a total complement of twenty thousand to thirty thousand genes, depending on the species, and this total complement is called the genome.

Scientists around the world are busy trying to map the genome for humans and other species, including poultry. This research is yielding some interesting findings. For instance, chickens and humans share over 60 percent of the same genes, yet there are significant divergences in the DNA sequences along those genes. Scientists say this information will help them better understand how the evolutionary tree of birds and mammals split over millions of years.

DNA STRUCTURE

DNA takes the form of a double helix (picture a very long, though submicroscopic, ladder that twists as it

extends upward). Four compounds, adenine (A), thymine (T), guanine (G), and cytosine (C), are the primary chemical building blocks of the DNA molecule. Each rung of the ladder is made up of two of these compounds. The A always shares a rung with the T, and the G always shares a rung with the C. The rails, or sides of the ladder, are made up of a sugar molecule (deoxyribose) and a phosphoric acid molecule. The average gene is thought to occupy an area of about 600 pairs, or rungs, of these DNA building blocks.

As a cell divides and multiplies into two cells, the DNA molecule separates down the middle of the ladder, like a zipper opening up. Each new cell receives one side of the helix. The designated pairings of A to T and G to C serve as a template for rebuilding the molecule from chemical compounds within the cell.

Traits ranging from color to size, hardiness, and personality are most often influenced by more than one gene. When multiple genes are responsible for a trait, one may be epistatic over other genes, meaning that it will suppress them and thus control how the trait manifests.

GENE STRUCTURE

Each gene is made up of a pair of "alleles," or gene forms, which are typically designated by a letter, or by letters and symbols. Every gene has at least two potential alleles, or variations, but many have multiple alleles. Some of these alleles are dominant over others, acting like an on-off button that activates certain genetic manifestations. Others act like a dimmer switch on a light, altering the intensity of a trait. In other words, how a trait actually

shows up depends on which alleles are present on the gene. By convention, capital letters are generally used to represent dominant alleles and lowercase letters to represent recessive ones.

So far, geneticists have identified over thirty different genes that can come into play in determining the color of poultry plumage, eyes, earlobes, beak, and legs and at least thirteen genes that contribute to eggshell color. It is thanks to this great variation in gene and allele combinations that we see such an extraordinary range of colors in our humble barnyard birds and their eggs.

Let's use one of these color genes, the melanocortin (MC) gene, as an example. Also known as the "extended black" gene, the MC gene has eight allele forms, which

Over thirty genes influence color in chickens, which helps to explain the extraordinary array of feather colors and patterns, such as the spangled pattern in this bantam Old English hen.

Single comb

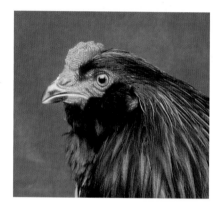

Pea comb

are designated by *E, ER, e+, eb, ewh, es, ebc,* and *ey.* These alleles control black, brown, red, and yellow pigments in the plumage, as well as speckling.

The order of dominance among the MC alleles is generally accepted as *E > ER > e+ > eb > ewh > es > ebc > ey.* For example, the E form is associated with solid black plumage, and the e+ with black-breasted red plumage (called the "wild type" because it is similar to the coloring of the Red Jungle Fowl). If the pair of genes shows up as *Ee+,* the dominant E results in solid black, but if the *e+e+* combo happens to show up, the black-breasted red feather pattern is seen.

GENETIC TRAITS

Genes are passed from one generation to the next in a fairly orderly manner. Just as DNA is supplied by both parents, so are the alleles that adjust traits. Since the comb type is primarily controlled by just two genes (the rose, or *R,* gene and the pea, or *P,* gene) and each has just two alleles (*R* and *r* for the rose and *P* and *p* for the pea), we will use it to see how traits actually pass from one generation to the next.

For the two genes, there are essentially nine combinations (*RRPP, RRPp, RRpp, Rrpp, RrPp, RrPP, rrPp, rrPP,* and *rrpp*). The majority of chickens have a single comb — the upright type of comb with spikes that most people visualize when they picture a rooster cock-a-doodle-dooing. It is the default when neither a dominant rose allele (*R*) nor a dominant pea allele (*P*) is present; in other words, when the combination of the two genes is *rrpp.*

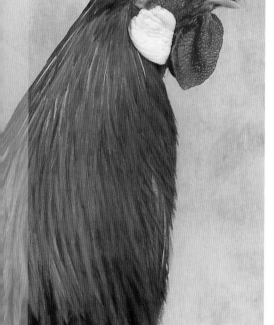

Rose comb

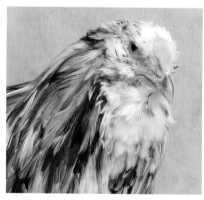

Walnut comb

Comb type is usually controlled by just two genes, the rose and the pea gene. The Hamburg rooster (at left) has at least one dominant R allele on the rose gene, and no dominant P alleles on the pea gene. The Andalusian rooster (top right) shows the most common comb, the single, which results when no dominant R or P shows up on either gene. The Ameraucana rooster (center right) has a dominant P on the pea gene. The walnut comb, as seen on the Orloff rooster (lower right) has at least one dominant allele on both the rose and pea genes.

Birds that have a rose comb have at least one dominant rose allele but they don't have a dominant pea allele (*RRpp* or *Rrpp*); birds with a pea comb have at least one dominant pea allele but they don't have a dominant rose allele (*rrPP* or *rrPp*); and birds with a walnut comb have both a dominant rose allele and a dominant pea allele (*RRPP*, *RrPp*, *RrPP*, or *RRPp*).

The chart to the right shows the likelihood of outcomes for a pea-comb hen and a single-comb rooster, depending on the allele combinations that the rooster and hen have.

Although most of the time genetic messages are passed from parents to offspring correctly, sometimes they are not. When chromosomal material is lost or rearranged during early development, the most common outcome is death of the developing embryo.

As a rule, most chromosomal problems are attributable to a problem during formation of the egg or sperm or during the combining of the sperm and egg. Some minor losses or rearrangements may not be lethal, but they often cause continuing health problems such as slow and abnormal growth or infertility.

When inherited from both parents, some alleles (referred to as "lethal alleles") result in death or serious health problems. One example of a lethal allele is associated with the ear tuft gene in Araucana chickens. Araucana chicks that are homozygous, or that have the same form on both halves of the gene for ear tufts (*EtEt*), usually die in the egg somewhere between day 17 and day 19 of incubation. Araucanas that survive have the (*Etet+*) combination.

Likelihood of Comb Outcomes

VERSION 1			Single-comb Rooster (rrpp)	
			rp	rp
Pea Comb Hen (rrPP)		rP	rrPp	rrPp
		rP	rrPp	rrPp
VERSION 2			Single-comb Rooster (rrpp)	
			rp	rp
Pea Comb Hen (rrPp)		rP	rrPp	rrPp
		rp	rrpp	rrpp

Two hens with a pea comb, when mated with a single-comb rooster, may not have chicks with the same comb types, depending on the allele combinations in the hen. In version 1, all of the chicks will be born with a pea comb, but in version 2, roughly half of the chicks will be born with a pea comb and the other half will be born with a single comb.

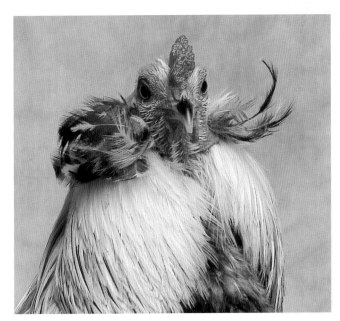

Some allele combinations, referred to as "lethals," result in death or serious health problems. The dominant Et allele of the ear tuft gene, which gives the Araucana its ear tuft feathers, is such a lethal. Birds that have the EtEt combination usually die in the egg.

Definitions

Breed. Historically, breeds were developed and recognized as predictable packages of characteristics. Juliette Clutton-Brock, a historian, biologist, and leading expert on the domestication of animals, defines the term breed as "a group of animals with a uniform appearance and behavior that distinguishes them from other groups of animals of the same species. When mated together they reproduce the same type." That is, breeds breed true.

Domesticated Species. A species that has been brought into a codependent and relatively "tame" relationship with humans that has resulted in unique biological changes within the species. Many individual wild animals can be tamed, but of the thousands of species that share the earth with us, fewer than 50 have been truly domesticated.

Genotype. The complete genetic makeup of an individual as described by the arrangement of its genes. The genotype of individuals within the same breed will be similar but unique.

Phenotype. The physical characteristics or behaviors of an animal that can be observed or tested for, such as feather color, aggressiveness, or blood type.

Variety. A subdivision within a breed that breeds true for distinct characteristics, such as color or comb type.

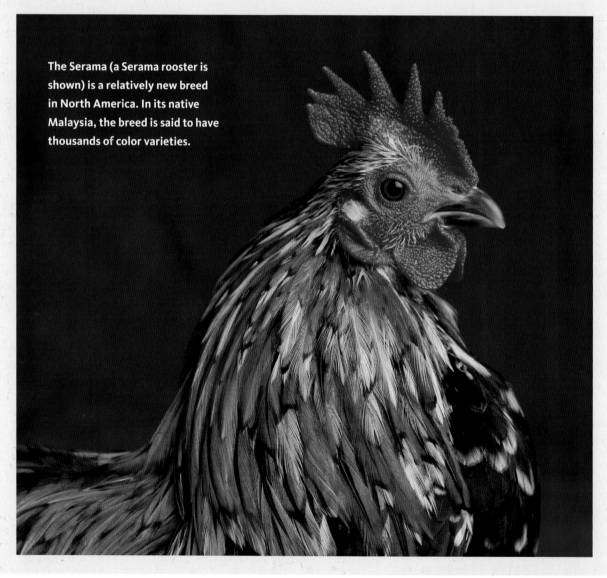

The Serama (a Serama rooster is shown) is a relatively new breed in North America. In its native Malaysia, the breed is said to have thousands of color varieties.

Breeding Approaches

THE HUSBANDRY OF POULTRY isn't particularly challenging, but selective breeding for maintaining traits is. One of the challenges that arises is caused simply by the genetic complexity that exists within the gene pool of domesticated birds. Another is caused by the social network that birds live in: Chicken, duck, and turkey flocks, for example, have a distinct hierarchy, or pecking order, and introducing new birds (or new bloodlines) to the flock usually results in fighting and a reorganization period. And geese and swans form pair bonds, taking particular mates that they keep for long periods.

Selections generally need to be made for multiple traits. Physical conformation, general health and soundness, reproductive qualities (including broodiness and mothering capabilities), color, utility qualities (such as meat or egg production), hardiness, foraging ability, adaptability to confinement, and temperament are just some of the traits that need to be considered when planning a breeding program. Successful breeders stay focused on

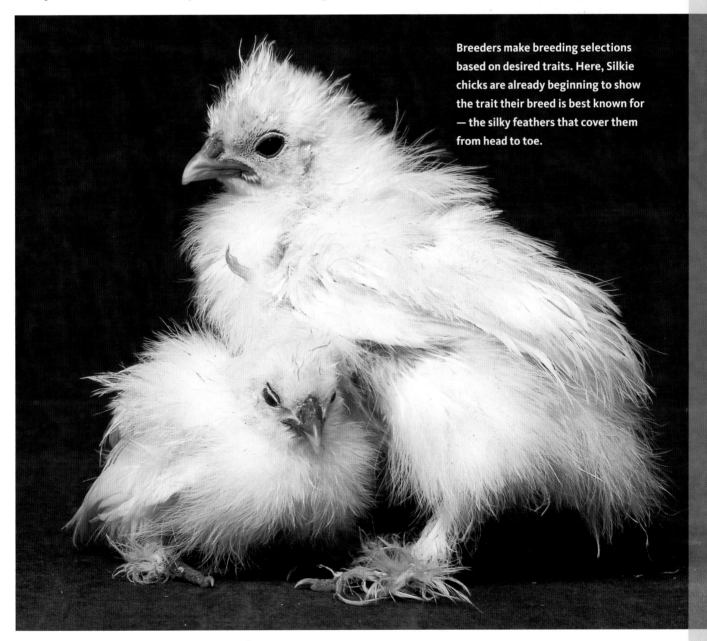

Breeders make breeding selections based on desired traits. Here, Silkie chicks are already beginning to show the trait their breed is best known for — the silky feathers that cover them from head to toe.

the traits they are trying to maintain or improve and make breeding decisions systematically.

There are several approaches to breeding. These include single mating, where one specific male is bred to one specific female in a pen separated from the rest of the flock; line mating, where closely related birds are bred, such as a rooster to his daughters; multiple-sire mating with selection, where groups of three to five males are cycled through a segregated flock of females and the best offspring from the multiple matings are selected; and distinct-line breeding, where unrelated lines are crossed in genetically limited groups of birds to improve vigor. Each option has its own benefits, depending on the goals of the breeder.

BECOMING A BREEDER

Probably the best way to learn the breeder's skills is to be mentored by a poultry breeder who has been at it for some time. Over the years I have found serious poultry keepers to be generous souls who love to share their knowledge with those that are new to the endeavor (see the resources section to find out how to meet these folks). Your mentor will reinforce these three keys to success:

Breeding to meet specific colors or physical characteristics can often be a challenge. For example, meeting the standard for the Japanese bantam's conformation is not something many neophyte breeders do well.

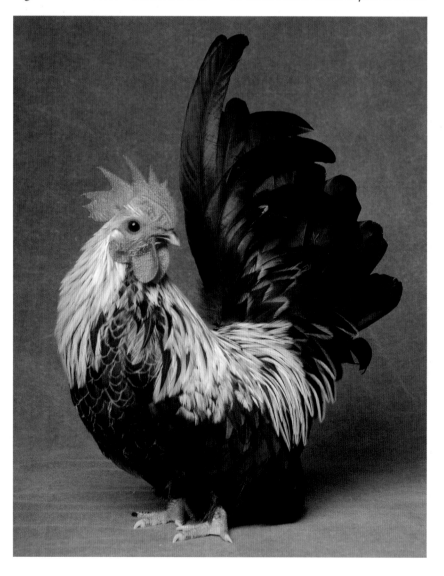

1. Begin with the best-bred birds you can obtain. It's always a whole lot easier to start with high-quality birds than to breed unwanted traits out of poor specimens. If you are interested in exhibition poultry or serious breeding for specific production traits, this probably means buying from fanciers and private breeders rather than hatcheries, whose birds may not be anywhere close to the standard or whose birds may not meet the production goals you have in mind.

2. Keep records! You need to be able to track lineage and control matings, and the only way to do that is to write down information on each bird that is part of (or may become part of) a breeding flock. Having a way to clearly identify individuals, such as through the use of leg bands, is critical to the success of a breeding program.

3. Cull, cull, and cull some more. Never keep birds that show unwanted traits — they will just drag your flock backward.

If there are no knowledgeable breeders near you, the ALBC has published two excellent books: *A Conservation Breeding Handbook*, by Dr. Phillip Sponenberg and Carolyn J. Christman, and *Managing Breeds for a Secure Future: Strategies for Breeders and Breed Associations,* by Dr. Phillip Sponenberg and Dr. Donald E. Bixby.

No matter where you live, you can probably keep poultry on a small scale. Even large cities usually allow homeowners to keep a few hens. Birds are fun, and they supply real value, from eating pesky bugs to keeping the family in eggs. Let this book be your guide to the breeds and do get started with poultry; it is a decision you won't regret.

This bantam White Leghorn hen is the result of generations of breeding for outstanding ability as a layer.

About Conservation Status

As you read the bird descriptions in later chapters, you will see for each a category labeled Conservation Status. This category uses designations established by the ALBC for its Conservation Priority List. These designations (listed below) are based on the estimated number of breeding birds and breeding flocks, as determined by a census and other research.

Critical. Fewer than 500 breeding birds in the United States, with five or fewer primary breeding flocks (50 birds or more), and globally endangered.

Threatened. Fewer than 1,000 breeding birds in the United States, with seven or fewer primary breeding flocks, and globally endangered.

Watch. Fewer than 5,000 breeding birds in the United States, with ten or fewer primary breeding flocks, and globally endangered. Also included are breeds with genetic or numerical concerns or limited geographic distribution.

Recovering. Breeds that were once more threatened and have now exceeded "Watch" category numbers but are still in need of monitoring.

Study. Breeds that are of interest but either lack definition or lack genetic or historical documentation.

Not Applicable. The ALBC has not listed this breed on its Conservation Priority List. This could be due to a number of reasons: the breed has sufficient breeding birds and flocks; it was never established with continuous breeding populations in North America; the foundation stock is no longer available; or the global population is sufficient to protect a breed that isn't traditionally important in North America.

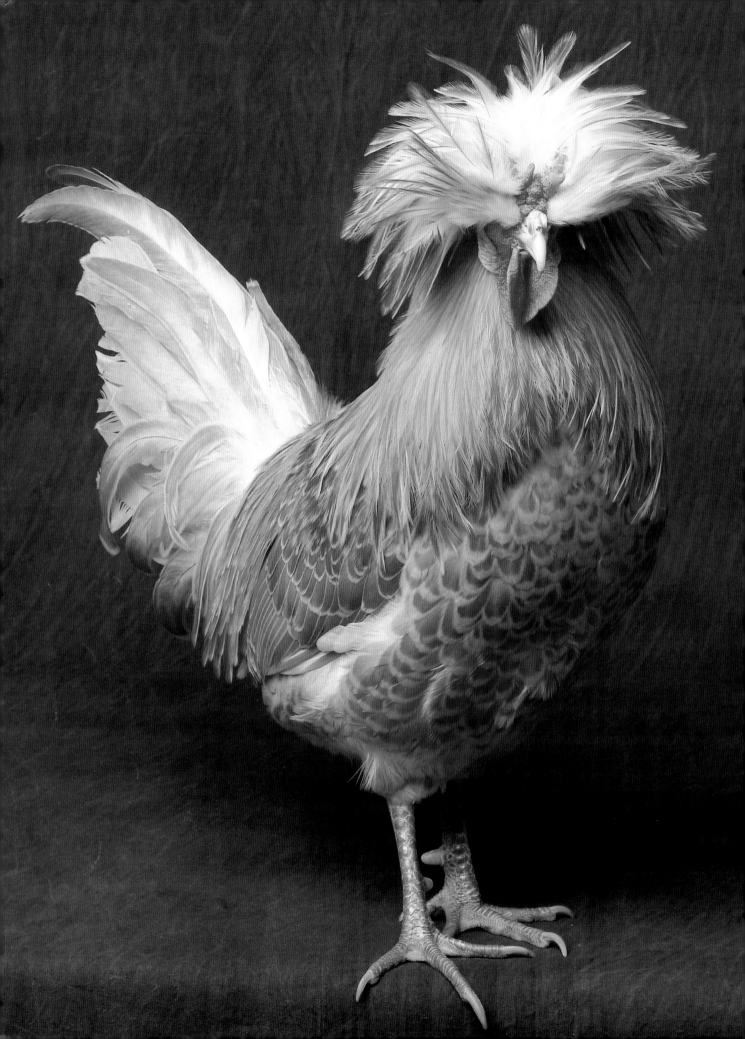

Chickens

..

Do not count your chickens before they hatch.

—Aesop, *The Milkmaid and Her Pail*

People who count their chickens before they are hatched act very wisely,

because chickens run about so absurdly that it is impossible to count them accurately.

—Oscar Wilde, letter from Paris, 1900

IN SCIENTIFIC LINGO, the chicken is known as *Gallus domesticus*. There are several other members of the *Gallus* clan, including *Gallus gallus* (Red Jungle Fowl), *Gallus lafayettei* (Sri Lankan Jungle Fowl), *Gallus sonnerati* (Gray Jungle Fowl), and *Gallus varius* (Green Jungle Fowl). Based on DNA and fossil evidence, many experts think that the Red Jungle Fowl was the exclusive parent of today's chicken, which was domesticated about ten thousand years ago.

Some scientists, such as Dr. Jerry Dodgson, who is coordinating the Poultry Genome Project at Michigan State University, disagree. Dr. Dodgson says, "At this stage, it's difficult, if not impossible, to rule out some contribution from other wild species" in the development of the modern chicken. In fact, a recent study of DNA performed by scientists in Japan seems to indicate that some crossing with the Gray and Sri Lankan Jungle Fowl occurred over the past ten thousand years.

The Red Jungle Fowl can still be found in parts of its original range, which covered large tracts of southern and southeastern Asia from

Above: Chickens, such as this bantam Old English Game hen, were domesticated from the wild jungle fowl. Left: Buff Laced Polish.

India and Pakistan to Indonesia and Thailand, but its numbers in the wild are dwindling. Many wildlife experts believe it is critically endangered, in part because it can breed back with its domestic offspring, thus yielding a hybrid that dilutes its bloodlines.

The birds are small (about 2 pounds [1 kg]) compared to their domestic relatives, but they show many of the same traits. They are social creatures that live in flocks and establish a pecking order. The roosters crow in the morning, and hens are highly protective of their chicks. They spend a great deal of the day scratching for seeds, fruits, grasses, bugs, and worms. They also eat small calcium-based stones, which help with digestion and shell formation.

In the wild, Red Jungle Fowl spend most of their time

in habitat that has dense vegetation and provides good cover. Like their modern offspring, Red Jungle Fowl are primarily grounded birds: they don't fly far, or high. But they do have strong legs and can run surprisingly fast.

Red Jungle Fowl were probably fairly easy to domesticate. Even today, birds raised from chicks come back as adults to the people they know for feed. And if the chicks are cooped in one place during rearing, as adults they will return there to roost at night.

Protecting the Red Jungle Fowl

Some fanciers and scientists are keeping Red Jungle Fowl in captivity to help preserve this important genetic resource. The urgency of the Red Jungle Fowl's situation is driven by two things: First, in the centuries since humans first domesticated chickens from the Red Jungle Fowl, wild stocks in many areas have been crossbred back to domestic chickens, yielding a hybrid jungle fowl. Second, habitat has been destroyed through large areas of their range.

The American Bantam Association recognizes Red Jungle Fowl in its standards, and there are thousands of birds that are claimed to be Red Jungle Fowl, but only a few are the pure subspecies that have not been interbred with domestics or other subspecies of jungle fowl. There is now a studbook for this species, and many breeders are having their birds' DNA tested for species purity.

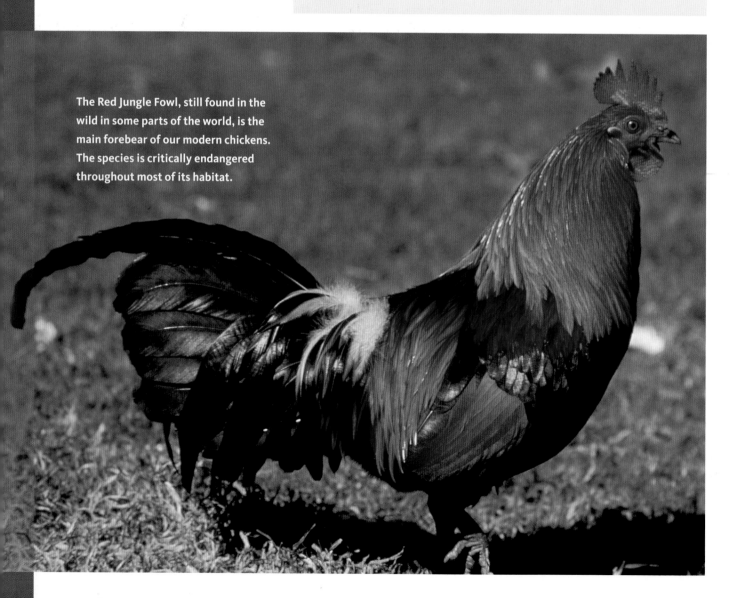

The Red Jungle Fowl, still found in the wild in some parts of the world, is the main forebear of our modern chickens. The species is critically endangered throughout most of its habitat.

Breaking Down "Chickendom"

WITH HUNDREDS of breeds of chickens around the world, fanciers and breeders have developed systems to classify birds, with designations such as class, variety, and strain. For the first major breakdown, birds are grouped according to size as either standard (large) or bantam (small). Most standard breeds have a corresponding bantam breed; however, there are some breeds that exist only in standard size and some that exist only as bantams.

CLASS

The breeds of chickens in the American Poultry Association (APA) *Standard of Perfection* are arranged first according to their class and then alphabetically by breed within each class. The class names applied to the standard-size birds are tied to the geographic regions where the breeds were first developed. These classes are American, Asiatic, Continental (for Europe, not including England), English, and Mediterranean. The lesser-known breeds, or those that don't fit neatly into one of the main classes, fall in the "All Other Standard Breeds" class.

Bantams are classified according to physical traits, not geographic point of origin. The APA *Standard of Perfection* recognizes bantams in five classes: Game; Single Comb, Clean Legged; Rose Comb, Clean Legged; All Other Combs, Clean Legged; and Feather Legged.

VARIETY

A variety is a subdivision within a breed. Varieties are differentiated based on physical characteristics such as color, comb type, leg feathering, and presence of a beard and muffs (a cluster of feathers around the sides of the eyes and covering the earlobes).

For instance, Plymouth Rocks have seven varieties recognized by the APA based on their color. The Leghorn breed has varieties based on the type of comb (single or rose) as well as on color. The Polish breed has just one style of comb — a "V" comb — but comes in numerous varieties based on color and the presence, or absence, of a beard.

As you read through the breed descriptions in the chapters that follow, you will notice a sentence that gives the date when the breed was first admitted to the APA. This is the year that the first variety was admitted. Other varieties may have been admitted at later dates.

For example, the White, the Silver-Gray, and the Colored Dorkings were admitted in 1874; the Red was admitted in 1995; and the Cuckoo Dorkings were just admitted in 2001. Breeds that don't have a note about admittance in the write-up have never been admitted to the APA or were dropped sometime in the past due to lack of interest among APA breeders.

Now, to confuse things just a little bit, there is also an organization that is associated strictly with bantams, called the American Bantam Association (ABA). The ABA usually recognizes the same bantam varieties as the APA — but not always. Often it recognizes colors that the APA hasn't recognized yet, and once in a while it

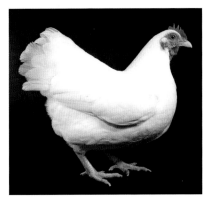

Bantam White Plymouth Rock hen

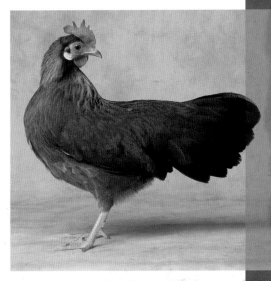

Bantam Light Brown Single Comb Leghorn hen

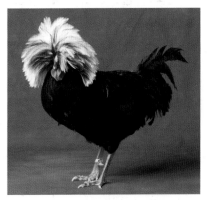

Bantam White-Crested Black Polish rooster
Some breeds are further categorized into varieties, based on things like color, comb type, and bearded/non-bearded.

doesn't recognize a color variety that the APA has recognized.

STRAIN

A strain is a breeding population that exhibits a close common trait and is usually the result of a single breeder's efforts over long periods of time. Many commercial strains are bred by major agricultural companies, with those strains of chickens being bred for specific production purposes, such as laying ability, feed conversion, or days to maturation.

HYBRIDS

Hybrids are not a specific breed but a cross of known breeds. Because of hybrid vigor (the tendency of crosses to perform better), they are usually developed and marketed by commercial companies. Some hybrids, like the Cinnamon, the Red, and the Red Star, are autosexing, meaning that male and female chicks are different colors when they "pop" from their shell.

Hybrids tend to lay more eggs or produce a larger carcass more quickly, so people who are interested in production traits usually choose them. However, the pure breeds are much more colorful and interesting. Keeping pure breeds helps maintain agricultural diversity, and many of these breeds have traits that are valuable for small-scale producers, such as good foraging ability and broodiness.

Frizzles

Frizzles are not a breed in their own right but may be shown in any breed that demonstrates the frizzle mutation. The mutation manifests as feathers that grow curling outward, instead of lying smoothly along the bird's body. Frizzling can occur in many breeds but is most common in the **Cochin** (page 113), **Plymouth Rock** (page 68), **Japanese Bantam** (page 122), and **Polish** (page 145) breeds.

The frizzle is judged for shape, stature, and color pattern based on the breed, type, and variety. For example, a Barred Plymouth Rock Frizzle must conform to the standards for Barred Plymouth Rocks as to size, shape, and color but should also have uniformly curly feathers throughout its plumage. From a judging point of view, the closer and more even the curl, the better the frizzle.

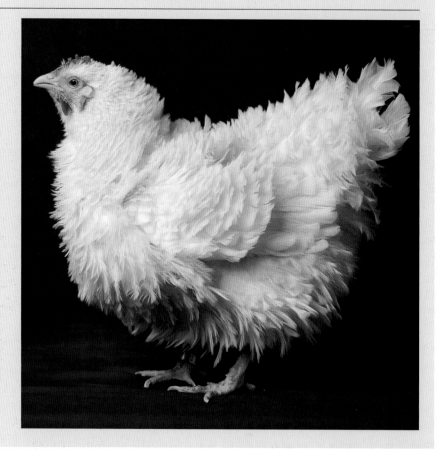

Colors and Feather Patterns

CHICKENS COME IN a fabulous array of colors and patterns. The color descriptions listed below and in the specific breed write-ups are only generalized descriptions, and these colors can manifest differently from breed to breed. For example, a Light Brown Leghorn (page 34) shows a very vivid and bright pattern and color that is well refined, whereas a Light Brown Dutch Bantam (page 119) has a much more subtle base color that gives it an almost faded appearance if seen next to a Light Brown Leghorn.

The barred breeds shown in the photographs below provide another example: the Barred Rock has large, regular, and sharply defined bars that alternate a light color (just short of pure white) with a dark color (just short of pure black). The Dominiques have irregular bars that give an almost slate-colored appearance.

Anyone considering raising a breed for show purposes should not consider the descriptions listed here as suitable for selecting ideal breeders. In that case, one should study the detailed color descriptions in the APA *Standard of Perfection* or the ABA *Bantam Standard*, or in standards set forth by a breed club.

As you read through the descriptions of each breed you may see a few color references that are unfamiliar to you. These include *horn, willow, gypsy, slaty blue,* and *undercolor.*

In many breeds, *horn* is used to refer to beaks that aren't true white, black, or yellow but are muted or semitranslucent shades of gray to grayish brown to yellowish gray. *Willow* is a yellowish green to green color and applies to shanks and toes. *Gypsy* is a grayish to almost dark plum color seen on some combs, wattles, and earlobes. For feathering, *slaty blue* is a dark grayish blue color. *Undercolor* refers to the lower portion of the feather — the fluff that is usually hidden from view. A bird's undercolor may be quite different than the color that is on the exposed portion of the feathers.

On the following pages are descriptions and photographs of some of the most common plumage colors. The birds photographed match the color descriptions, but the APA and the ABA may not accept the color variety in the breed that is shown. Other, less common colors will be described next to the appropriate breed.

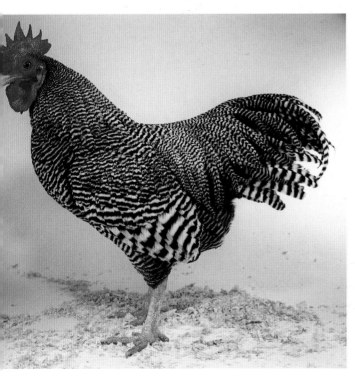

Bantam Barred Plymouth Rock rooster

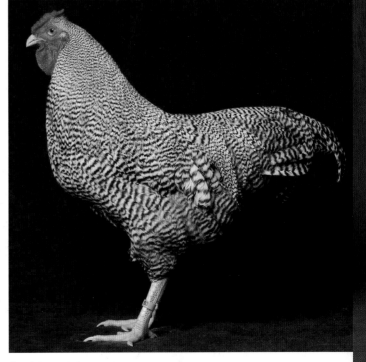

Dominique rooster

BARRED. Feathers are crossed with sharply defined bars of one color (usually black or slate) against another (usually white or cream). Bars can be irregular in size or uniform throughout the feather. A female's bars are generally narrower and darker than those of a male.

BIRCHEN. Head is white to silvery white. Neck and upper breast have white feathers with a slender black stripe down the middle transitioning to black feathers with white lacing. Lower breast, body, legs, wings, and tail are black. *Male*: Back and saddle are similar to neck. *Female*: Back is black; black may tend toward brownish black.

BLACK. Plumage is uniformly black, ranging from shiny greenish black to duller black, over entire body in both sexes.

BLACK-BREASTED RED. *Male*: Predominantly black with creamy white head and hackle and golden back; wings are black highlighted by red and green. *Female*: Plumage is reddish brown, ranging from a dark shade on head to a light shade on body, with black highlights in tail and wings.

BLACK-TAILED RED. Plumage is primarily rich, lustrous dark red. Tail is mainly black, though it may have some red near the saddle or edges. Wings are mainly red with some black highlights. Undercolor is deep red.

BLUE. Head ranges from lustrous bluish black to slaty blue. Remainder of plumage is uniform slaty blue, laced with bluish black.

BLUE RED. *Male*: Head is light orange. Hackle and saddle are golden red. Back is rich red. Front of neck, breast, body, legs, and tail are blue. Wings are blue with red and bay highlights. *Female*: Head is orangey red. Hackle is light orange with a blue stripe down the middle of each feather. Front of neck and breast are light salmon, shading to ashy gray as the breast blends with body feathers. Body, wings, legs, and tail are bluish gray stippled with brown, which gives an overall effect of drab brown.

BROWN RED. Head is bright, lustrous orange. *Male*: Plumage is predominantly black (down the front of the neck, beard and muffs, breast, body, and tail); feathers on back and sides of neck are highlighted with golden red; feathers on top of head, back, and sides of neck have dominant rich red. *Female*: Primarily brownish black plumage highlighted with reddish brown feathers on top of head and down the back and sides of neck; does not have red back and saddle.

BUFF. Plumage is an even shade of golden buff throughout.

BUFF COLUMBIAN. Plumage on body, breast, and legs is primarily buff. Black feathers with buff lacing are on the hackle (and cape and saddle on males). Tail is primarily black with buff highlighting. Wings are primarily buff with black highlighting.

COLUMBIAN. Plumage on body, breast, and legs is primarily white (more silvery white in the male). Black feathers with white lacing are on hackle (and cape and saddle of males). Tail is primarily black with white highlighting. Wings are primarily white with black highlighting.

CRELE. *Male*: Barred orange-red against pale straw on head, hackle, back, and saddle. Remainder is barred gray and white. *Female*: Head and hackle are pale gold barred with grayish brown. Front of neck and breast are salmon shading

Crele Old English cock

to ashy gray as it blends with body. Remainder is dark gray to ashy gray with some barring.

CUCKOO. Plumage is bluish white barred with irregular light and dark bars. Female is slightly darker than male.

DARK. *Male*: Plumage overall is a lustrous greenish black. Shafts and centers of hackle and back feathers are dark red. Wings have some black barring and bay. *Female*: Head is greenish black; hackle is greenish black with bay shafts. Neck, breast, and body are primarily reddish mahogany with black lacing. Tail and legs are primarily black, with some bay penciling. Fronts, bows, and coverts of wings are mahogany laced with black; primaries and secondaries of wings are black with bay penciling.

DARK BROWN. Head is red. Undercolor is dull slatelike black. *Male*: Hackle, back, and saddle are red with a greenish black stripe running through the middle of each feather; front of neck is lustrous greenish black. Breast, body, legs, and tail are black. Wings are primarily red to reddish brown with black highlights. *Female*: Hackle is red with a greenish black stripe running through the middle of each feather; front of neck, back, breast, legs, tail, and wings are black with stippling of reddish brown.

GINGER RED. *Male*: Head and back are lustrous red. Hackle and saddle are lustrous yellowy orange. Front of neck and breast are ginger-red, darkening near thighs. Body and legs are dusky red. Wings and tail are black highlighted in red and ginger. *Female*: Head, breast, and front of neck are ginger-yellow. Hackle is golden yellow striped with black. Back is ginger-yellow stippled with black. Body and legs are dull ginger. Tail is black stippled with ginger. Wings are ginger highlighted with black.

GOLDEN. *Male*: Head and hackle are creamy white. Back is gold. Front of neck, breast, body, and tail are black. Wings are golden with black and white highlights. *Female*: Primarily gray, in shades ranging from light to dark, with salmon-colored front of neck and breast. Tail is black with gray highlighting. Wings are gray with brownish black highlights.

GOLDEN DUCKWING. *Male*: Mainly black, with cream-colored head and hackle, gold-colored back, and golden highlights on wings and tail. *Female*: Primarily shades of gray, with salmon-colored front of neck and breast. Black highlights in tail; dark brown highlights in wings.

GOLDEN PENCILED. *Male*: Predominantly solid golden red (almost dark burnt orange). Tail is bright greenish black with distinct golden red border. Wings have some black bars. *Female*: Head and hackle are golden red. Rest of body, wings, and tail are penciled with narrow bars of black to greenish black set against gold.

GOLDEN SPANGLED. *Male*: Head is solid golden red. Hackle and saddle are golden red with a narrow greenish black stripe extending

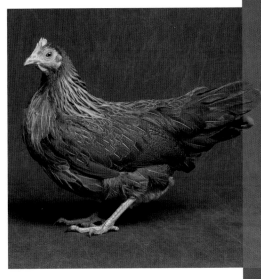

Golden Phoenix hen

down the middle to a point at feathers' tips. Front of neck, breast, back, body, wings, and legs are spangled with black or greenish black. Spangles start small and sparse at neck and become larger and more dominant toward bottom of the bird. Tail is solid, lustrous greenish black. *Female*: Golden red with large black spangles distributed evenly over most of body. Tail is primarily greenish black.

GRAY. Head is white to silvery white. *Male*: Hackle is silvery white with a black stripe through the middle of each feather. Breast and front of neck are black with silvery white lacing. Back is white with silver luster. Body and tail are black. Wings are black highlighted with silvery white. *Female*: Neck and breast are black with white lacing. Remaining plumage is black.

LEMON BLUE. Head is lustrous lemon yellow. Hackle is lemon with a slate blue stripe down the middle of each feather. Upper breast is slate blue with a narrow lacing of lemon. Lower breast and body, tail,

Lamona

Harry M. Lamon, senior poultryman of the Bureau of Animal Industry, developed the Lamona in 1912 at the U.S. Department of Agriculture Experimental Station in Beltsville, Maryland. Lamon sought to create a new farmyard dual-purpose breed that had good shape and market qualities and laid a white egg.

He crossed **White Plymouth Rock** (page 68) males with **Silver-Gray Dorking** (page 85) females and then crossed a **Single-Comb White Leghorn** (page 58) male, having a rather small, low comb, to a Silver-Gray Dorking female. From these crosses he kept back the best layers, and the sons of the best layers, and recrossed these.

The breed was known for producing layers that would still be fairly tender when processed after they'd completed their useful laying lives. This was atypical for old layers, most of which have an eating quality similar to chewing on old shoe leather. The birds also had red earlobes yet laid white eggs, which is unusual: the rule of thumb is that white-eared birds lay white eggs and red-eared birds lay brown eggs. The breed may be extinct.

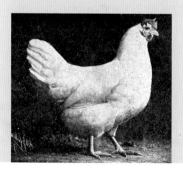

legs, shank, and outer toe are slate blue (darker in male). *Male*: Cape is lemon; saddle is lemon with slate blue stripe. Wings are slate with lemon highlights. *Female*: Back and wings are slate blue.

LIGHT BROWN. *Male*: Hackle is orange at head, changing to golden yellow at shoulder. A black stripe runs down the middle of each lower hackle feather. Front of neck is black highlighted by salmon. Back and saddle are orangey red ranging from deep to light color and showing some stippling. Breast, body, legs, and tail are black, possibly tinged with some brown on breast. Wings are orangey red and golden, highlighted by black. *Female*: Hackle is light orange with a black stripe down the middle of each feather; front of neck and breast are rich salmon. Body, back, coverts, and wings are dark brown stippled with a lighter shade of brown. Tail is primarily black with some brown stippling.

MILLE FLEUR. Plumage is primarily orange with white and greenish black accents. *Male*: Orangey red head feathers are tipped with white and black. Hackle has rich orangey red feathers accentuated by a single greenish black arrow shot into a white diamond-shaped spangle at the tip. Front of neck, breast, and body have golden feathers tipped by a white diamond set against a "V" of black. Back feathers are deep reddish gold highlighted by a greenish black stripe and a white diamond tip. Wings are the same shade of red as the back but show black and white striping. Tail is primarily black highlighted with white. *Female*: Similar to the male, but back, saddle, and wings are the same shade of gold as neck and breast.

MOTTLED. Plumage is black with white V-shaped markings on the tips of some feathers (typically one feather out of two over most of the body). In males, the black is highly lustrous; in females, it is a little duller.

PARTRIDGE. Head is red to reddish bay. *Male*: Hackle, back, and saddle are lustrous greenish black laced with red to the point that they may appear solid red from a distance. Front of neck, breast, and body are black. Stern is black tinged with red. Tail is lustrous black with narrow red lacing on coverts. Wings are black and red. *Female*: Plumage is penciled in reddish bay and black.

PORCELAIN. Plumage is primarily beige to lustrous straw, with slaty blue stripes or V-shaped spangles and white spangle highlights. Tail is primarily slaty blue with beige and white highlights. Wings are similar to body but with slaty highlights.

RED. Plumage is brilliant, even red throughout. May be slightly less glossy in female.

RED PYLE. *Male*: Head is bright orange; hackle and saddle are lighter orange. Front of neck is white, possibly tinged with bright yellow. Back is red. Breast, body, legs, and tail are white. Wings are white highlighted with black and red. Undercolor is light slate. *Female*: Head is gold. Hackle is white edged with gold. Front of neck is white tinged with salmon. Breast is salmon. Remainder is white.

Self Blue Old English Game bantam hen

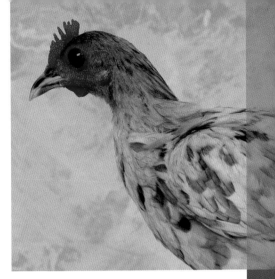

Splash Modern Game hen

SELF BLUE. Plumage is an even shade of slaty blue over entire body.

SILVER. *Male:* Shining greenish black body is highlighted by solid silvery white head, back of neck, back, and saddle, with a distinct silver bar on the bow of the wing. *Female:* Body ranges from dull black on tail to grayish brown and reddish brown over most of body; feathers over much of body show thin stripes of silver down the middle. Head is solid silver; back of neck is highlighted brightly in silver.

SILVER DUCKWING. *Male:* Head plumage is white, giving way to silvery white hackles and silvery white back. Front of neck, breast, and body are black. Tail and wings are highlighted in silvery white. *Female:* Primarily shades of silver to light gray. Front of neck and breast are pale salmon. Tail is black with gray highlights; wings are black and gray.

SILVER LACED. Plumage is composed primarily of laced feathers. On the Cochin, Cornish, and Wyandotte, feathers on upper body are primarily black laced with silvery white to silvery gray; feathers on lower body are primarily sil-

ver laced with black; tail is primarily black. Males have silvery white highlights on cape and wings. The Polish and Sebright breeds are recognized as "Silver" in the APA *Standard of Perfection*, but they actually have a silver-laced pattern with silvery white to silvery gray feathers laced with black throughout.

SILVER PENCILED. *Male:* Head, neck, breast, back, and legs are silvery white. Main tail feathers are solid black; tail sickles and coverts are black with white edging. Wings and body near wings have some black penciling. *Female:* Solid white head. Penciling begins on neck and is higher in front and lower on hackle. Rest of body is penciled with black against silvery white. Undercolor for all sections is slate.

SILVER SPANGLED. Undercolor for both sexes is slate. *Male:* Head is pure white. Spangles of black begin on neck and cover body. As spangles are just at feather tips, tail and wings tend to have more pure white exposed. *Female:* Body is fully spangled (black against silvery white). Tail has more white exposed.

SPANGLED. *Male:* Head, hackle, back, and saddle are rich red with

white spangles. Breast, body, tail, wings, and legs are black with white spangles. *Female:* Head and hackle are golden red to salmon, striped with black, ending with a white spangle. Back, tail, and wings are black stippled with brown, with some white spangling. Breast, body, and legs are salmon stippled with brown and spangled with white, offset by black bars.

SPLASH. Plumage has irregularly shaped, slaty blue blobs against a white background tinged with bluish gray.

WHEATEN. *Male:* Predominantly shiny greenish black plumage on breast, body, and tail, with bright golden red feathers on head, neck, and back and over saddle. Beard and muffs are black. Wings have a reddish brown stripe on shoulder and bow. *Female:* Plumage in shades of wheat (tans to golden yellows) over most of body, with some black in tail.

WHITE. Plumage is white throughout entire body, varying from lustrous to dull.

WHITE-LACED RED. Plumage is rich red with white lacing throughout.

COMMON COLOR PATTERNS

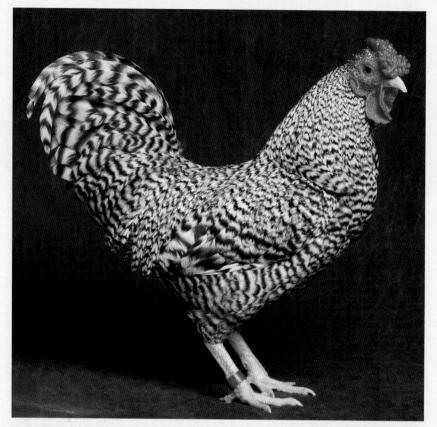

Barred, Dominique

Birchen (M), Modern Game

Birchen (F), Modern Game

Black, Sumatra

Black-Breasted Red (M), Rosecomb

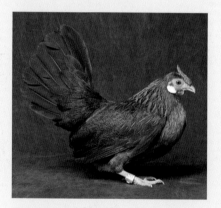

Black-Breasted Red (F), Rosecomb

Black-Tailed Red (M), Rhode Island Red

Black-Tailed Red (F), Rhode Island Red

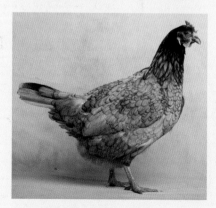

Blue, Andalusian

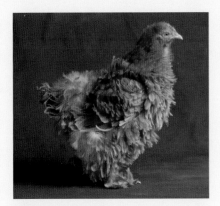

Red, *Cochin Frizzle*

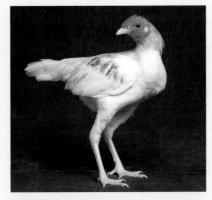

Red Pyle (M), *Modern Game*

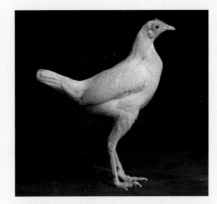

Red Pyle (F), *Modern Game*

Self Blue, *Bearded d'Uccle*

Silver (M), *Phoenix*

Silver (F), *Kraienkoppe*

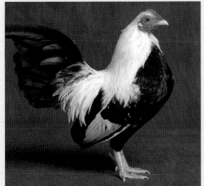

Silver Duckwing (M), *Old English Game*

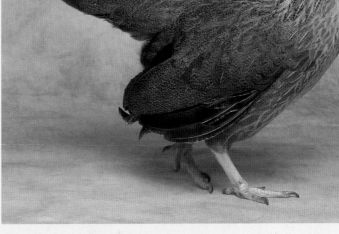

Silver Laced, *Wyandotte*

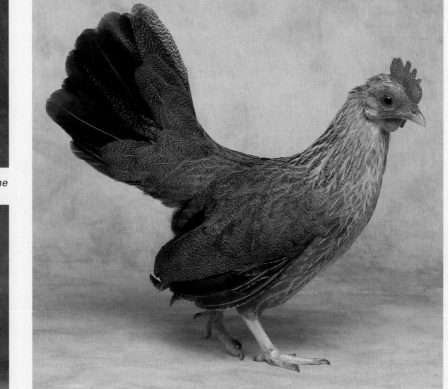

Silver Duckwing (F), *Old English Game*

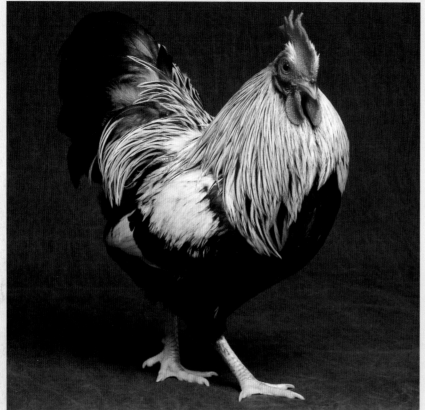

Silver Penciled (M), Plymouth Rock

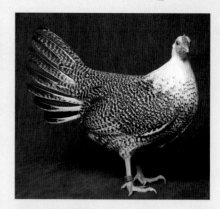

Silver Penciled (F), Hamburg

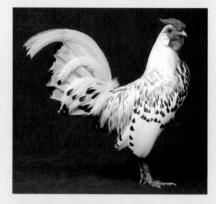

Silver Spangled (M), Hamburg

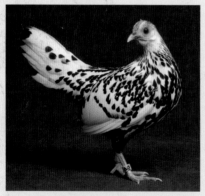

Silver Spangled (F), Hamburg

Spangled (M), Orloff

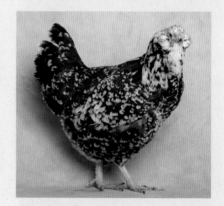

Spangled (F), Orloff

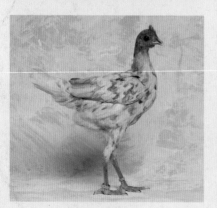

Splash, Modern Game

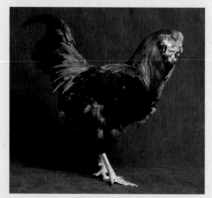

Wheaten (M), Ameraucana

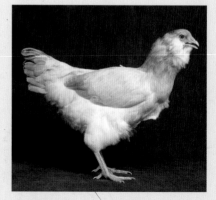

Wheaten (F), Ameraucana

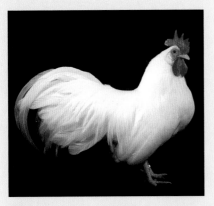

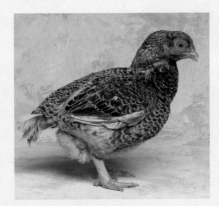

White, *Leghorn*

White-Laced Red, *Cornish*

*Though considered Dark, this color of the Brahma matches the description for standard silver penciled plumage.

FEATHER PATTERNS

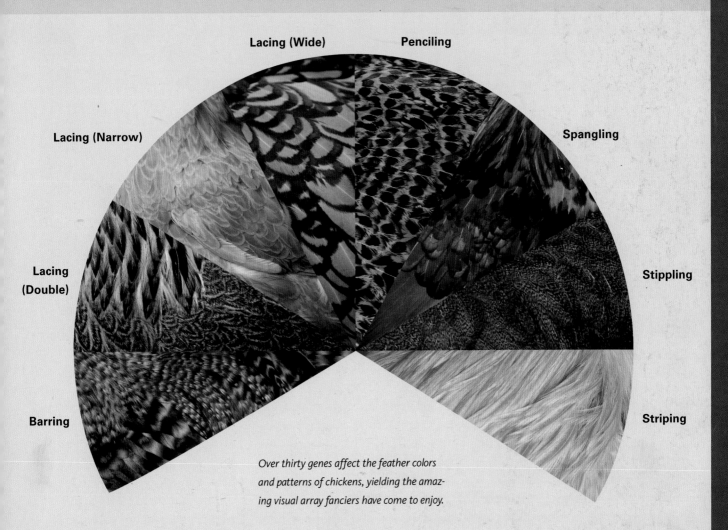

Lacing (Wide)

Penciling

Lacing (Narrow)

Spangling

Lacing (Double)

Stippling

Barring

Striping

Over thirty genes affect the feather colors and patterns of chickens, yielding the amazing visual array fanciers have come to enjoy.

Ameraucana

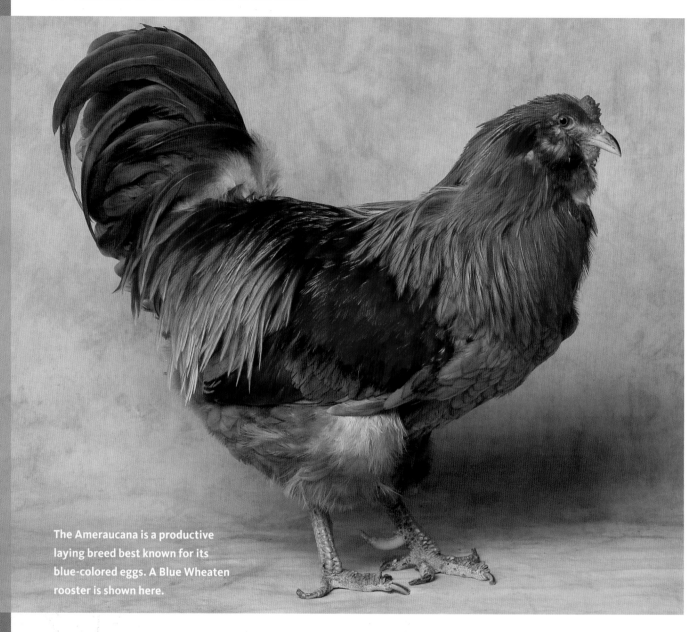

The Ameraucana is a productive laying breed best known for its blue-colored eggs. A Blue Wheaten rooster is shown here.

ALTHOUGH BREEDERS have been improving the Ameraucana breed since the 1930s, when **Araucana** (page 42) parent stock was imported to the United States from South America, the modern breed was developed in the 1970s. Breeders developed the Ameraucana to standardize a bird with the blue-egged trait of the Araucana but without its lethal allele combination.

The Ameraucana breed produces fine-looking birds that have a well-spread, medium-length tail, muffs, and a relatively small pea comb. They have a somewhat stocky build, with broad heads and large eyes.

We have some Ameraucanas in our flock, and the hens have an impressively long laying season. We don't need to use artificial light to keep the birds laying year-round; the Ameraucanas are among the last of our hens to quit laying in late November or early December, and the first to start back up in early January. The hens will go broody. Ameraucanas are quite hardy, with active but friendly personalities.

The Ameraucana was first admitted to the APA in 1984.

AMERAUCANA FACTS

CLASS **Standard** All Other Standard Breeds.
Bantam All Other Combs, Clean Legged.

SIZE **Standard Cock**: 6.5 lb. (3 kg) | **Hen**: 5.5 lb. (2.5 kg)
Bantam Cock: 30 oz. (850 g) | **Hen**: 26 oz. (740 g)

COMB, WATTLES & EARLOBES Pea comb; small or absent wattles; small, round earlobes. All are red.

COLOR Eyes are reddish brown. Beak is horn to dark horn, unless noted otherwise. Shanks are slate-colored, and bottoms of feet and toes are white, unless noted otherwise.

Black. Standard black plumage (page 26), including beard and muffs; black beak; shanks are dark slate to black, but bottoms of feet and toes are still white.

Blue. Standard blue plumage (page 26).

Blue Wheaten. *Male*: Plumage is predominantly blue — ranging from dark blue to bluish gray — highlighted with striking orange contrasts, including light orange on head and back of neck, bright reddish orange on back, golden orange on saddle, and orange stripe on bow of wings. *Female*: Plumage is highlighted by wheaten shades (tans to golden yellows) with hints of light blue on tail and wings and very light grayish blue beard and muffs.

Brown Red. Standard brown-red plumage (page 26). Beard and muffs are black.

Buff. Standard buff plumage (page 26).

Silver. Standard silver plumage (page 29). *Male*: Black beard and muffs. *Female*: Light gray beard and muffs; salmon at lower extremity of beard.

Wheaten. Standard wheaten plumage (page 29).

White. Standard white plumage (page 29). Light horn beak.

PLACE OF ORIGIN United States

CONSERVATION STATUS Not applicable

SPECIAL QUALITIES Lays blue eggs in various shades.

A Wheaten rooster.

A Black rooster.

Notice the difference between the coloring of the Wheaten cock at left above and this lovely Wheaten hen.

Ancona

ANCONAS ORIGINATED along the coast of Italy, in the town of the same name, making them members of the Mediterranean class. They were imported from Italy to Britain in the mid-nineteenth century, and from Britain to the United States soon thereafter.

Anconas are closely related to the **Leghorns** (page 58). In fact, when they first arrived in North America some people referred to the Anconas as "Mottled Leghorns" or "Black Leghorns" (though the black variety of Leghorn was already known). Today, some people still mistakenly call the Anconas "Mottled Leghorns." Like the Leghorns, they are known as excellent layers of large white eggs. The hens aren't broody by nature and generally won't sit on a clutch of eggs.

The breed is truly beautiful thanks to striking black plumage that is speckled white at the tips on about a third of the feathers. Chicks are cute, showing a combination of black and white patches.

The breed is considered to be very hardy. The birds have an active (some would say flighty, though easy to tame) disposition, and they are excellent foragers. Some breeders contend that their quick and alert temperament combined with their dark color makes them a good choice in areas where birds of prey pose a serious predation threat.

The APA first admitted the single-comb variety in 1898 and the rose-comb variety in 1914.

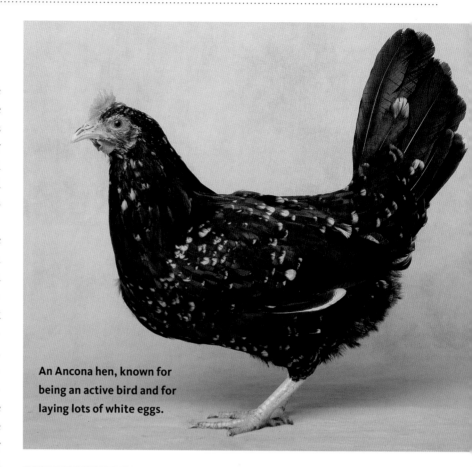

An Ancona hen, known for being an active bird and for laying lots of white eggs.

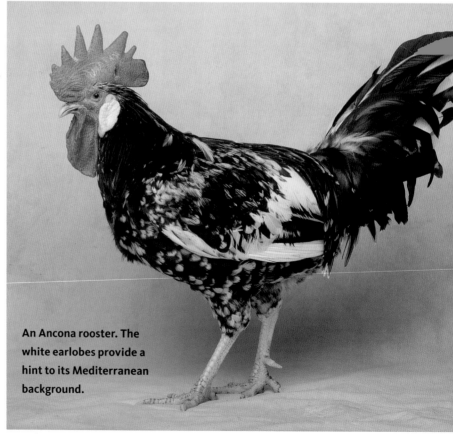

An Ancona rooster. The white earlobes provide a hint to its Mediterranean background.

ANCONA FACTS

CLASS **Standard** Mediterranean.

Bantam Single Comb, Clean Legged; Rose Comb, Clean Legged.

SIZE **Standard Cock**: 6 lb. (2.75 kg) | **Hen**: 4.5 lb. (2 kg)

Bantam Cock: 26 oz. (740 g) | **Hen**: 22 oz. (625 g)

COMB There are two varieties based on comb.

Single Comb. Bright red, medium-size red comb has five distinct points. *Male*: All five points stand upright. *Female*: First point stands upright; other four droop to one side.

Rose Comb. Bright red, medium-size red rose sits square in front, terminating in a well-developed spike.

WATTLES & EARLOBES Wattles are bright red; earlobes are white. *Male*: Long, well-rounded wattles and small almond-shaped earlobes, close to head. *Female*: Medium, well-rounded wattles and oval earlobes close to the head.

COLOR

Yellow beak, though some black or horn shading at center of upper mandible. Reddish brown eyes. Shanks and toes are yellow, though yellow mottled with black is acceptable. Plumage is shiny greenish black with white speckling on tips of feathers (known as mottling), distributed evenly and frequently across body (approximately every second to sixth feather).

PLACE OF ORIGIN Italy

CONSERVATION STATUS Threatened

SPECIAL QUALITIES Lays longer into the winter without supplemental light than most breeds.

Andalusian

THOUGH ONCE REFERRED to as the Blue Minorca, the breed is now known as the Andalusian for its namesake province, Andalusia.

The Spanish breeders that developed this old breed (reports from ancient Rome describe a very similar bird) found that crossing a black bird with one of its white sports (naturally occurring genetic mutations) would yield lovely slate blue feathers laced with darker blue. When mated together these slate blue birds show hybrid color characteristics. In other words, they produce offspring in the ratio of one black, two blues, and one splash.

The splashes and blacks are not eligible to be shown. However, they can be kept for breeding purposes and when mated together they produce 100 percent slate blue offspring. Andalusian breed numbers have fallen drastically in recent times;

The Blue Andalusian hen is an active and rugged layer.

experts speculate that one reason for this is that maintaining a high-quality blue flock is a challenge.

The modern Andalusian is a graceful bird that carries itself with an upright carriage. Hens produce

large, almost chalky white eggs and rarely go broody. The birds are larger than **Leghorns** (page 58), rather active, and talkative. They are also very rugged, robust, and healthy and not meant for confinement; they excel in free-range conditions.

The Andalusian was first admitted to the APA in 1874.

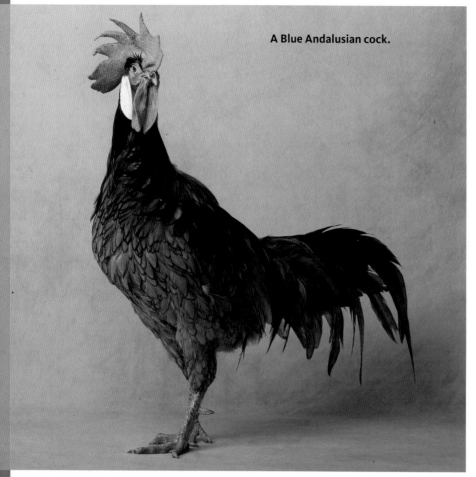

A Blue Andalusian cock.

Araucana

ARAUCANAS ARE TRULY unique birds. They were initially developed in Chile in the early 1900s by a professor of animal science. He developed them from birds kept for centuries by the Mapuche, a native Chilean tribe (read more about the Araucana on page 4).

Araucanas lack a tail and their earlobes are partially hidden by an "earring" or tuft of feathers. These traits are due to the crossing of the Collonca, a small single-combed bird that had no tail and laid intensely blue eggs, with the Quetero, which had a flowing tail, a pea comb, tufts at its ears, and laid brown eggs. The offspring lay pale blue eggs with a greenish tint.

When crossed with any other bird, Araucana offspring will produce greenish blue eggs, or occasionally eggs of another color, such as green, pink, or yellow. This is how hatcheries came up with the "Easter Egg" chickens they began advertising in the 1970s and which led to the development of the Ameraucana.

The breed also has a genetically lethal allele combination that results in the death of some chicks.

The Araucana was first admitted to the APA in 1976.

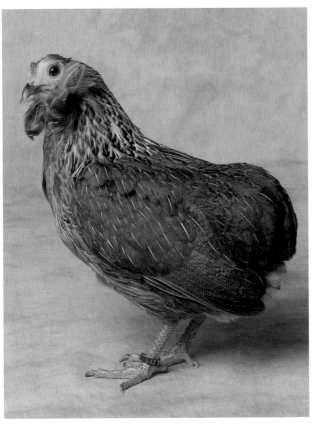

Notice the prominent ear tufts and the lack of a tail on this bantam Golden Duckwing hen that are both defining traits of the Araucana breed.

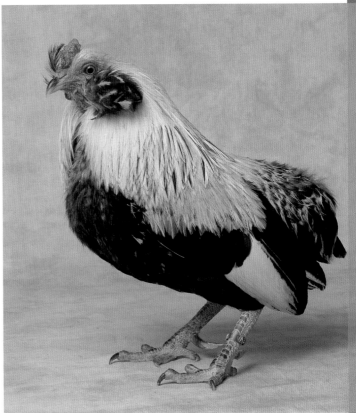

A bantam Golden Duckwing Araucana rooster.

ARAUCANA FACTS

CLASS **Standard** All Other Standard Breeds.
Bantam All Other Combs, Clean Legged.

SIZE **Standard Cock**: 5 lb. (2.25 kg) | **Hen**: 4 lb. (1.8 kg)
Bantam Cock: 26 oz. (740 g) | **Hen**: 24 oz. (680 g)

COMB, WATTLES & EARLOBES Small pea comb; wattles are very small or absent; earlobes are very small and smooth and covered by an ear tuft. All are bright red.

TAIL Entirely absent; saddle feathers flow over rump.

COLOR

Black. Black beak, shanks, and toes; brown eyes; standard black plumage (page 26).

Black-Breasted Red. Horn beak; reddish bay eyes; grayish yellow shanks and toes. *Male*: Head, hackle, and saddle are reddish chestnut changing to gold at lower extremities. Front of neck and breast are lustrous black. Tail and wings are black with reddish bay highlights. Undercolor is slate. *Female*: Head and hackle are reddish chestnut against cinnamon brown body. Tails and wings have some black. Undercolor is slate to light cinnamon.

Blue. Standard blue plumage (page 26).

Buff. Standard buff plumage (page 26).

Golden Duckwing. Horn beak; red eyes; willow shanks and toes. Standard golden duckwing plumage (page 27).

Silver. Standard silver plumage (page 29).

Silver Duckwing. Horn beak; red eyes; willow shanks and toes. Standard silver duckwing plumage (page 29).

White. Yellow beak, shanks, and toes; red eyes. Standard white plumage (page 29).

PLACE OF ORIGIN Chile

CONSERVATION STATUS Study

SPECIAL QUALITIES Lays blue to bluish green eggs. Has a lethal allele combination; some chicks die during incubation.

Australorp

BLACK ORPINGTONS (page 98), imported to Australia from England in the 1890s and early 1900s, provided the primary parent stock for the Australorp, though some **Minorca** (page 63), **White Leghorn** (page 58), **Plymouth Rock** (page 68), and **Langshan** (page 128) blood may have been used in the mix. It is Australia's "national breed."

When developing the Australorp, breeders emphasized utility, and to this day that's what the breed is known for. It is a great layer (two hundred plus eggs per year), but its meaty body and pinkish white skin make it a good choice for those looking for a dual-purpose bird. Australorps mature early and are docile and quiet birds. Australorps have loose and fluffy feathers that make them very hardy.

The Australorp was first admitted to the APA in 1929.

AUSTRALORP FACTS

CLASS **Standard** English. **Bantam** Single Comb, Clean Legged.

SIZE **Standard Cock**: 8.5 lb. (3.9 kg) | **Hen**: 6.5 lb. (3 kg) **Bantam Cock**: 30 oz. (850 g) | **Hen**: 26 oz. (740 g)

COMB, WATTLES & EARLOBES Moderately large single comb with five evenly spaced, perfectly straight points. Front point is smallest. Oblong, smooth earlobes. *Male*: Medium-size, smooth, round wattles. *Female*: Small, well-rounded wattles. All are bright red.

COLOR Black beak; dark brown eyes; shanks are black to dark slate; bottoms of feet and toes are pinkish white. Standard black plumage (page 26).

PLACE OF ORIGIN Australia

CONSERVATION STATUS Recovering

SPECIAL QUALITIES Good dual-purpose bird that has a relatively meaty body for a layer.

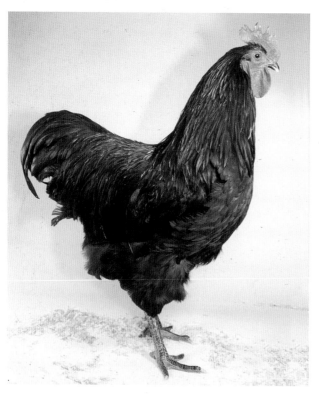

The Australorp (rooster shown here) is the national breed of Australia.

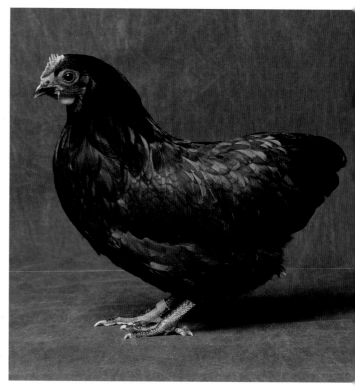

This bantam Australorp hen is an excellent utility bird for both meat and eggs, and very hardy.

Barnevelder

THE BARNEVELD REGION of the Netherlands has long been the center of poultry production for that country. Breeders developed the Barnevelder by crossing local birds from the Barneveld area with Asiatic breeds, such as **Brahma** (page 77), **Cochin** (page 113), **Langshan** (page 128), and Maleier.

The breeders were seeking to increase egg production — particularly of dark brown eggs with a coppery tinge — by selecting birds that would lay well into the long, damp winter months of northern Europe. The Barnvelders are docile yet active birds. Hens rarely go broody.

Although four color varieties are recognized in the Barnevelder's native Netherlands, only one variety has been admitted to the APA *Standard of Perfection*. The APA-accepted variety is quite showy, with plumage that has an iridescent quality. This is thanks to the lacing of bronze on shiny, greenish black feathers, or greenish black lacing on bronze-colored feathers, and a full tail that is carried high with a uniform sweep.

The Barnevelder was first admitted to the APA in 1991. There is also a bantam variety that has yet to be accepted by either the APA or the ABA.

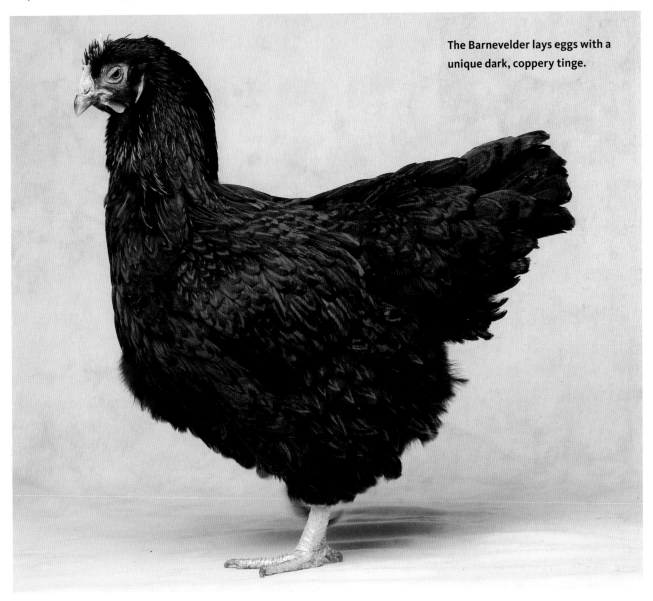

The Barnevelder lays eggs with a unique dark, coppery tinge.

BARNEVELDER FACTS

CLASS Continental

SIZE **Cock**: 7 lb. (3.2 kg) | **Hen**: 6 lb. (2.75 kg)

COMB, WATTLES & EARLOBES Single comb with straight, upright, well-defined points. Medium-size wattles and earlobes. All are bright red.

COLOR Dark horn beak; reddish bay eyes; yellow shanks and toes. *Male*: Head, neck, and back have black feathers laced with bronze; saddle and breast have bronze feathers laced with lustrous greenish black; tail is greenish black; wings are black and bronze. The overall effect is dark but glistening. *Female*: Head and hackle are greenish black; front of neck, back, breast, and wings are primarily bronze with lacing (or double lacing) of greenish black; tail is black. The female seems to shimmer in sunlight.

PLACE OF ORIGIN Holland

CONSERVATION STATUS Not applicable

SPECIAL QUALITIES Lovely iridescent color. Coppery brown eggs.

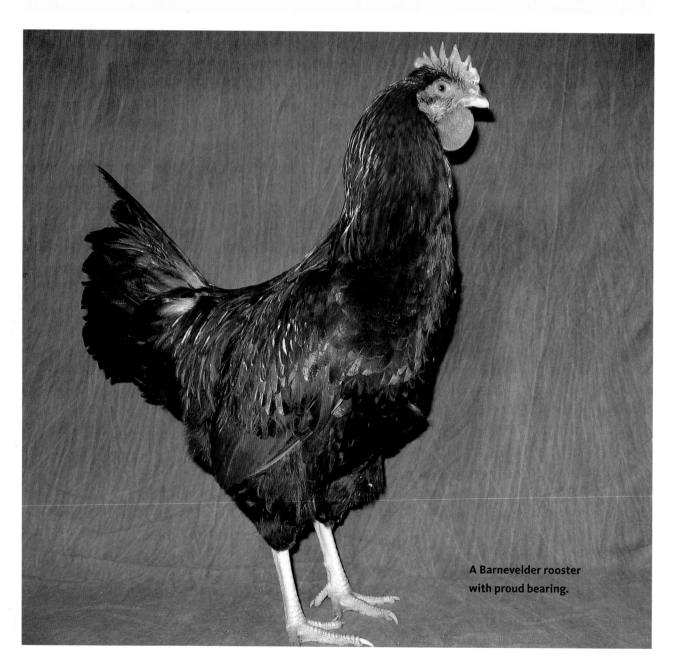

A Barnevelder rooster with proud bearing.

California Gray

THIS IS A BREED that was developed in California during the 1930s by crossing **White Leghorns** (page 58) with **Barred Plymouth Rocks** (page 68). The goal was to have a good dual-purpose bird that laid large white eggs. It was never accepted into the APA *Standard of Perfection*, so the breed never really took off.

This breed is autosexing, with distinctly different coloring in pullets and cockerels at hatching time. It was later used in the development of the California White, a commercial hybrid (for more information on hybrids, see page 24). California Grays are said to be calm, and they are excellent winter layers.

CALIFORNIA GRAY FACTS

SIZE **Cock:** 5.5 lb. (2.5 kg) | **Hen:** 4.5 lb. (2 kg)

COMB, WATTLES & EARLOBES Bright red single comb and wattles; small white earlobes close to head.

COLOR Dark horn beak; reddish bay eyes; yellow shanks and toes. *Male:* Barred in light gray and white. *Female:* Barred in dark gray (almost black) and white.

PLACE OF ORIGIN United States

CONSERVATION STATUS Not applicable

SPECIAL QUALITIES Good layer of white eggs. Autosexing. Parent stock of today's commercial California White hybrid.

The California Gray breed was never recognized by the APA so it has really languished, yet it was a foundation bird for the commercial California White hybrid.

Chicks and young birds are easily sexed by the differing colors among females and males. A hen is shown above; a rooster is shown at right.

Campine

THE CAMPINE is a Belgian breed whose origins are thought to date back to the time of Julius Caesar. Poultry historians believe it descended from the Brakel, a breed that has been documented in writing in Belgium since 1416.

The Campine differs from the Brakel noticeably: the Campine is smaller than the Brakel, and the male lacks sickle and saddle feathers. Breeders attribute its smaller size and lack of male feathers to the much poorer soil found in the area of Campine.

Both breeds, as well as Groningers and Grey Bresse of Belgium, appear to be descended from Eygptian **Fayoumis** (page 54) that were brought to northern Europe by the Romans. After World War II, the Campine's numbers plummeted and the breed was almost lost, but a handful of breeders brought it back to the point of being still rare but stable.

Though not large birds, Campines have tight, close-fitting feathers that disguise their size, making them appear smaller than they are.

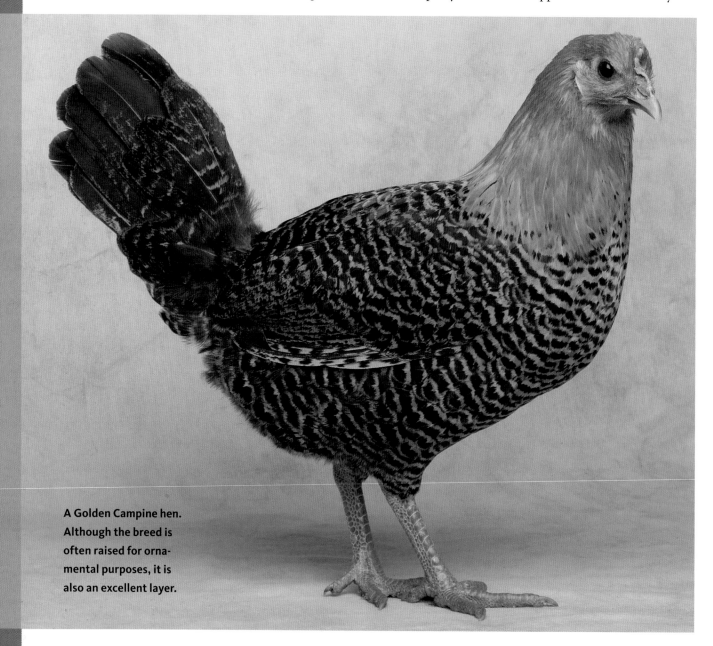

A Golden Campine hen. Although the breed is often raised for ornamental purposes, it is also an excellent layer.

The breed is known for a modified form of "hen feathering," in which the male doesn't develop the long sickle feathers in the tail or the pointed hackle and saddle feathers. A cock with very long, curved sickle feathers or long and profuse saddle feathers will be disqualified in shows.

Campines are said to be friendly, chatty birds that are good foragers and fliers. Very attractive birds, with lustrous plumage that is solid on the head and hackles and barred on the body, they are largely treated as ornamentals in North America, yet they are a good laying breed. Hens produce more than two hundred medium-size eggs per year and rarely go broody.

The Campine was first admitted to the APA in 1914.

This Silver Campine cock shows the modified hen feathering the breed is known for having.

CAMPINE FACTS

CLASS **Standard** Continental.

Bantam Single Comb, Clean Legged.

SIZE **Standard Cock**: 6 lb. (2.75 kg) | **Hen**: 4 lb. (1.8 kg)

Bantam Cock: 26 oz. (740 g) | **Hen**: 22 oz. (625 g)

COMB, WATTLES & EARLOBES Bright red wattles are medium in size and well rounded. Bright white earlobes are oval and fit closely to head. Bright red, medium-size red comb has five distinct, deeply serrated points. *Male*: All five points stand upright. *Female*: First point stands upright; other four droop to one side.

COLOR Beak is horn; eyes are dark brown; shanks and toes are leaden blue. Plumage is quite lustrous in both sexes.

Golden. Head and hackle are golden bay (some black markings are not a serious defect). Remainder is golden bay with black barring. Black bars on tail are about four times as wide as golden bay sections.

Silver. Head and hackle are white to silvery white (some black markings are not a serious defect). Remainder is white with black barring. Black bars on tail are about four times as wide as the white sections.

PLACE OF ORIGIN Belgium

CONSERVATION STATUS Critical

SPECIAL QUALITIES Prolific layer of medium-size, white eggs.

Catalana

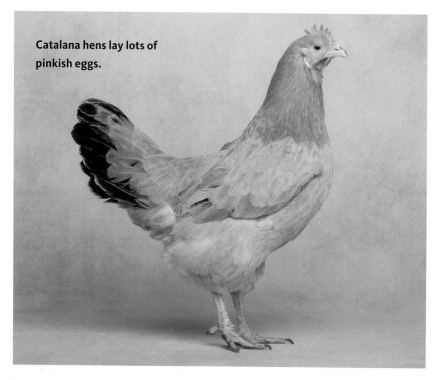

Catalana hens lay lots of pinkish eggs.

THE CATALANA IS ALSO known as the Buff Catalana or the Catalana del Prat Leonada (Prat for short) and comes from the area around Barcelona, Spain. This breed is known for hardiness, particularly its ability to handle extreme heat, and for good foraging ability. It does not do well in tight confinement.

The birds have a golden body and green tail. They are the only dual-purpose Mediterranean-class birds bred for both meat and eggs. The eggs are white or lightly tinted in a pinkish cream color. Hens don't tend to go broody.

The Catalana was first admitted to the APA in 1949.

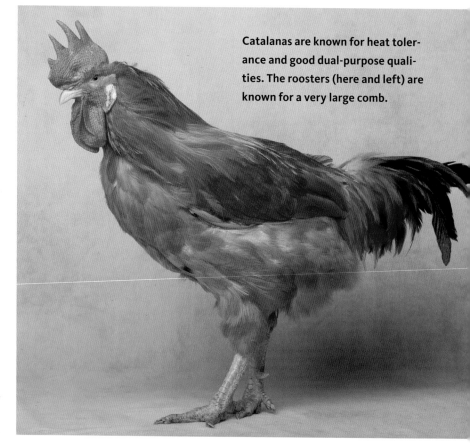

Catalanas are known for heat tolerance and good dual-purpose qualities. The roosters (here and left) are known for a very large comb.

CATALANA FACTS

CLASS **Standard** Mediterranean.
 Bantam Single Comb, Clean Legged.

SIZE **Standard Cock:** 8 lb. (3.6 kg) | **Hen:** 6 lb. (2.75 kg)
 Bantam Cock: 32 oz. (910 g) | **Hen:** 28 oz. (795 g)

COMB, WATTLES & EARLOBES Large, bright red wattles; large, bright white earlobes set close to head. Medium-size, bright red single comb has six distinct points. *Male:* All six points stand upright; those at front and rear are shorter than those in center. *Female:* First point stands upright; rest droop to one side.

COLOR Light horn beak; dark reddish brown eyes; slate blue to greenish blue shanks and toes. Primarily buff colored, in shades ranging from light tan to reddish gold, with greenish black tail.

PLACE OF ORIGIN Spain

CONSERVATION STATUS Critical

SPECIAL QUALITIES Ornamental bird with dual-purpose characteristics. Produces meat and plenty of medium to large eggs.

Chantecler

THE CANADIANS originally developed the white variety of this breed in the early 1900s by crossing **Dark Cornish** (page 81), **White Leghorn** (page 58), **Rhode Island Red** (page 70), **White Wyandotte** (page 103), and **White Plymouth Rock** (page 68) birds. In the 1930s they developed the partridge variety by crossing Partridge Wyandotte, **Partridge Cochin** (page 113), Dark Cornish, and Rose-Comb Brown Leghorn birds.

For both varieties, breeders were seeking a general-purpose fowl that would lay through much of the cold Canadian winter. They bred for small combs, wattles, and earlobes, and for plumage that lies tightly against the body but has a high percentage of fluff.

The breed is quite gentle but somewhat high-strung and a bit edgy in confinement, though it will lay fairly well when confined. Hens, particularly the two- and three-year-olds, will frequently go broody.

The Chantecler was first admitted to the APA in 1921.

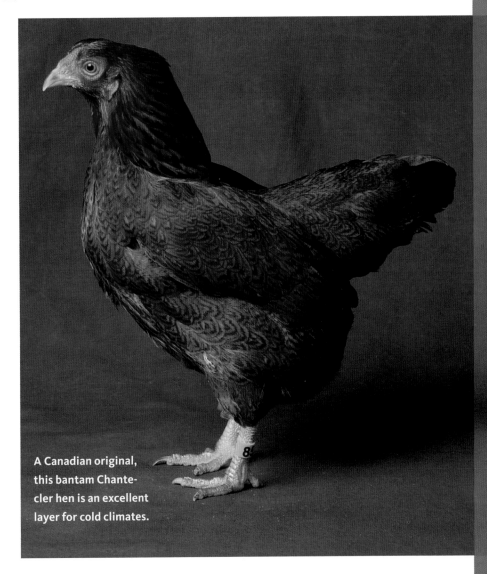

A Canadian original, this bantam Chantecler hen is an excellent layer for cold climates.

LAYING BREEDS

Roosters of the Partridge variety are known for highly lustrous plumage, as seen here.

CHANTECLER FACTS

CLASS **Standard** American. **Bantam** All Other Combs, Clean Legged.

SIZE **Standard Cock**: 8.5 lb. (3.9 kg) | **Hen**: 6.5 lb. (3 kg) **Bantam Cock**: 34 oz. (965 g) | **Hen**: 30 oz. (850 g)

COMB, WATTLES & EARLOBES Cushion-shaped comb. Comb, wattles, and earlobes are very small and bright red.

COLOR There is a buff-colored Chantecler that has been around since the 1950s, though it has never been admitted to the standards.

Partridge. Dark horn beak that may be yellow at point; reddish bay eyes; yellow shanks and toes. Standard partridge plumage (page 28).

White. Yellow beak; reddish bay eyes; yellow shanks and toes. Standard white plumage (page 29).

PLACE OF ORIGIN Canada

CONSERVATION STATUS Critical

SPECIAL QUALITIES Very hardy; retains body heat thanks to tight feathering and heavy down. Dual-purpose bird that lays light brown eggs.

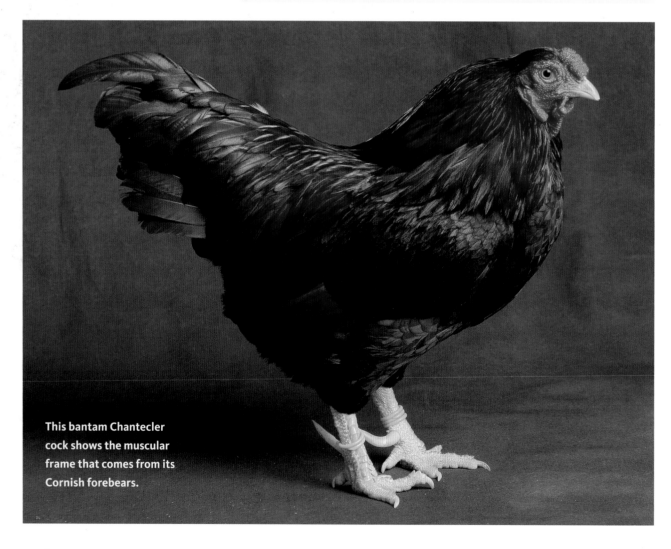

This bantam Chantecler cock shows the muscular frame that comes from its Cornish forebears.

Dominique

THE DOMINIQUE IS truly the original American bird. Well known in the United States by the mid-eighteenth century, it remained popular for almost a century, but during the mid-nineteenth century the **Barred Plymouth Rock** (page 68) replaced it as the most common barnyard bird.

By the 1950s Dominiques were thought to be extinct. A few breeders had held on to them, however, and in the 1970s they got a second chance at survival thanks to the efforts of these breeders and the ALBC. Today they are on the ALBC's "Watch" list, and breeders around the country enjoy them.

Dominiques are hardy birds that do well when allowed to range, though they tolerate confinement. They are known as extremely good foragers and have a good reputation for egg laying. Hens will go broody. Their indistinct barring pattern is commonly referred to as "hawk coloring" and offers the breed some protection from aerial predators. The birds are calm, genial, and easy to work with and show. They feather out and mature early.

The Dominique was first admitted to the APA in 1874.

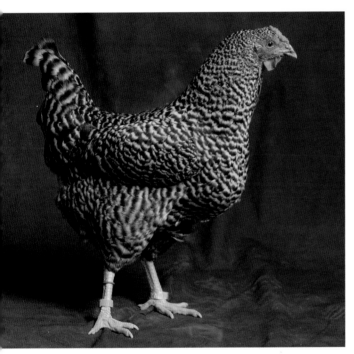

The Dominique is thought to be the oldest American breed.

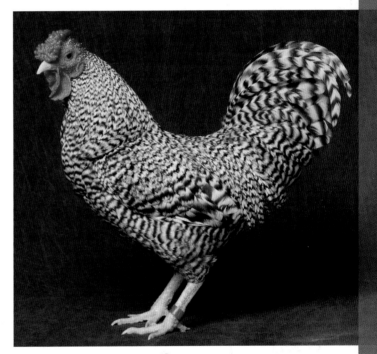

The hen (at left) will be slightly darker than the cock (above, bantam).

DOMINIQUE FACTS

CLASS **Standard** American.
 Bantam Rose Comb, Clean Legged.
SIZE **Standard Cock**: 7 lb. (3.2 kg) | **Hen**: 5 lb. (2.25 kg)
 Bantam Cock: 28 oz. (795 g) | **Hen**: 24 oz. (680 g)
COMB, WATTLES & EARLOBES Small to medium rose comb; small to medium wattles that are well rounded and smooth; medium-size, oblong earlobes. All are bright red.

COLOR Yellow beak; reddish bay eyes; yellow shanks and toes. Feathers are barred in black (varying from pure black to dark slate gray) and creamy white over whole body. Males may be a shade lighter than females.
PLACE OF ORIGIN United States
CONSERVATION STATUS Watch
SPECIAL QUALITIES The oldest U.S. breed, and still a good dual-purpose bird. Lays medium-size brown eggs.

Fayoumi

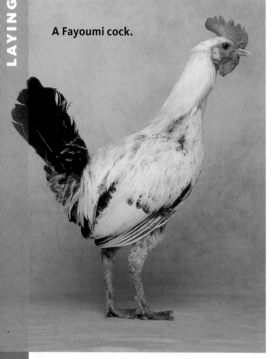

A Fayoumi cock.

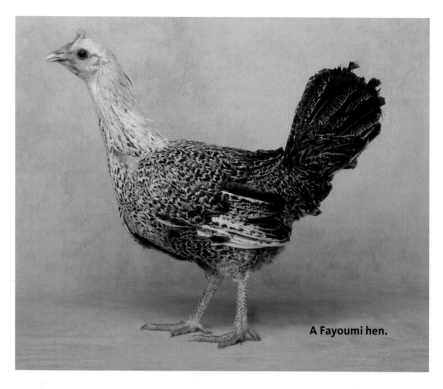

A Fayoumi hen.

A SMALL, ACTIVE BIRD, the Fayoumi (pronounced *fay-yoo-mee*) hails from Egypt. Also known as the Egyptian Fayoumi, it has been known in Egypt since the time of the pharaohs.

Fayoumis are not common among breeders. However, Iowa State University has maintained a flock since the 1940s, when Dr. R. E. Buchanan, then dean of agriculture, carried eggs of the Fayoumi home from Egypt for members of the poultry genetics program to study.

Scientists at Iowa State have found that the breed has excellent resistance to a number of viral and bacterial infections, possibly including avian influenza, for which there are anecdotal reports from Africa and the Middle East. This makes them quite interesting when considering the potential of pandemic avian flu outbreaks.

The Fayoumi has a tail that sticks up at a jaunty angle, with a forward tilt that gives the full-speed-ahead appearance of a roadrunner. Young hens are not given to broodiness, but the two- and three-year-old hens are. The hens are excellent layers of small, off-white eggs, though pink-tinted eggs are not unusual.

They are fast to mature: pullets begin to lay at four and a half months, and cockerels start to crow by five to six weeks. They are almost feral-like, being self-sufficient and rugged, foraging for all their own food if given a chance.

FAYOUMI FACTS

SIZE **Standard Cock**: 4.5 lb. (2 kg) | **Hen**: 3.5 lb. (1.6 kg)

COMB, WATTLES & EARLOBES Moderately large single comb with six upright points; medium-size wattles and earlobes. All are bright red, though earlobes have a white spot.

COLOR Dark horn to slate blue beak; dark brown eyes; slate shanks and toes. *Male*: Head, neck, back, and saddle silvery white. Breast, body, and legs barred in black and silvery white. Tail and wings black with white highlights. *Female*: Head and neck silvery white. Rest of plumage barred in black and silvery white.

PLACE OF ORIGIN Egypt

CONSERVATION STATUS Study

SPECIAL QUALITIES Good disease resistance and egg production.

Hamburg

ALTHOUGH MOST SOURCES say the Hamburg breed originated in Holland, Craig Russell, a renowned poultry historian who is active with the Society for the Preservation of Poultry Antiquities, believes that the Hamburg is actually a very old breed that got its start in Turkey or another area of the eastern Mediterranean. Russell believes that breeders transported birds of the breed to Holland and Britain possibly as early as the fourteenth century.

Wherever the breed's origin, Dutch and British breeders definitely had a great deal of influence on the varieties of the modern Hamburg. Thanks to its long-standing history in Europe, the APA classified it as a Continental breed.

Hamburgs are stylish and graceful birds. They are small yet active, and they are particularly good fliers. Thanks to their excellent foraging ability, they do very well in backyard and barnyard settings, but they perform poorly in close confinement. The breed is known for cold-hardiness. Hens are early to mature and prolific layers of relatively small eggs. They don't tend to go broody.

The Hamburg was first admitted to the APA in 1874.

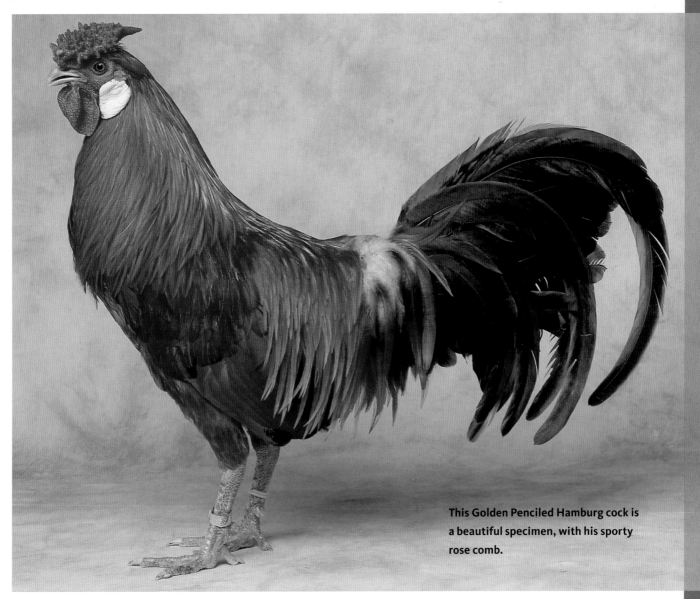

This Golden Penciled Hamburg cock is a beautiful specimen, with his sporty rose comb.

Hamburg *continued*

A bantam Golden Spangled hen.

A bantam Silver Spangled hen.

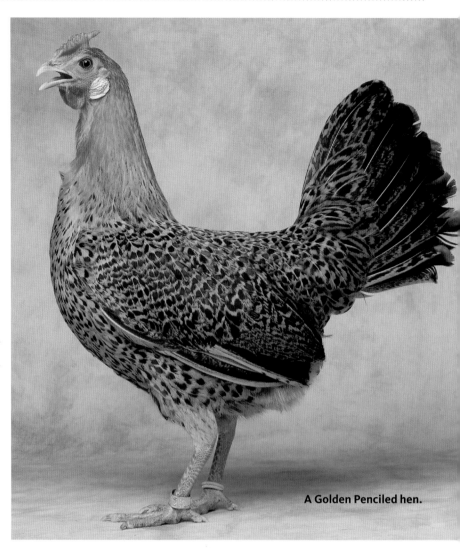

A Golden Penciled hen.

HAMBURG FACTS

CLASS **Standard** Continental.

Bantam Rose Comb, Clean Legged.

SIZE **Standard Cock**: 5 lb. (2.25 kg) | **Hen**: 4 lb. (1.8 kg)

Bantam Cock: 26 oz. (740 g) | **Hen**: 22 oz. (625 g)
(Black and spangled varieties may be larger.)

COMB, WATTLES & EARLOBES Red rose comb covered with small points; moderately large, white earlobes close to head. Red, well-rounded wattles are medium size in males and small in females.

COLOR Dark horn beak, grayish blue shanks (unless otherwise noted), and pinkish white bottoms of feet. All have reddish bay eyes. Blue Hamburgs aren't recognized by the APA, though they are sold by several hatcheries in North America.

Black. Standard black plumage (page 26). Black beak and black shanks.

Golden Penciled. Standard golden penciled plumage (page 27).

Golden Spangled. Standard golden spangled plumage (page 27).

Silver Penciled. Standard silver penciled plumage (page 29).

Silver Spangled. Standard silver spangled plumage (page 29).

White. Standard white plumage (page 29).

PLACE OF ORIGIN Turkey

CONSERVATION STATUS Watch

SPECIAL QUALITIES Excellent forager; prolific layer of relatively small white eggs.

Lakenvelder

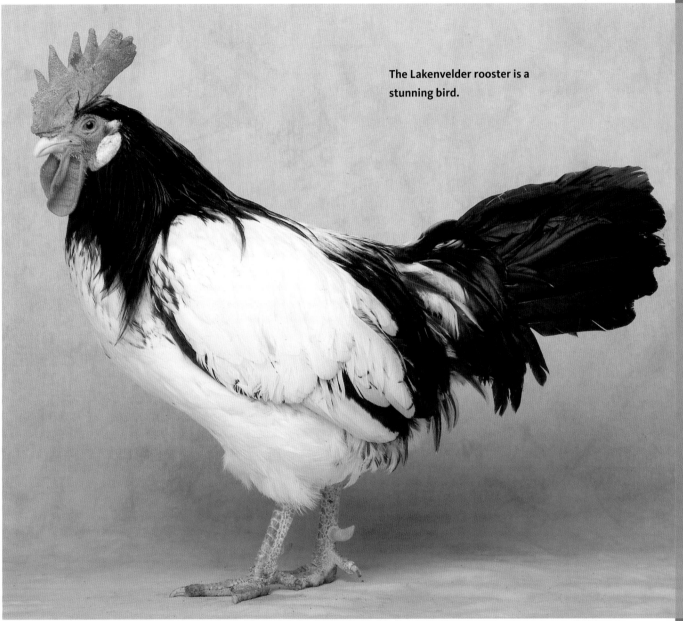

The Lakenvelder rooster is a stunning bird.

I HONESTLY THINK that the Lakenvelder is one of the most stunning chicken breeds. With its rich black head, neck, and tail, offset by a bright white body, it is a real showstopper. The breed was developed in the early nineteenth century near the border of Germany and Holland.

In North America, the only recognized Lakenvelder is the black-and-white variety, but some hatcheries sell a bird that they call a "Golden Lakenvelder." Outside of North America, this large-bodied bird is considered to be a separate breed, the Vorwerk. There is also a blue variety that is recognized as a Lakenvelder in Europe, but it has not made its way here yet.

The Lakenvelders are quite active and if allowed to forage will move around in a fairly large area. They tend to be a little flighty. Hens lay plenty of small white eggs and don't go broody.

The Lakenvelder was first admitted to the APA in 1939.

Lakenvelder *continued*

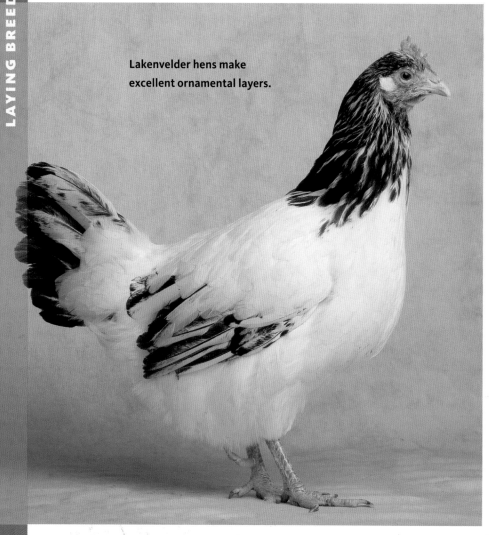

Lakenvelder hens make excellent ornamental layers.

LAKENVELDER FACTS

CLASS **Standard** Continental. **Bantam** Single Comb, Clean Legged.

SIZE **Standard Cock:** 5 lb. (2.25 kg) | **Hen:** 4 lb. (1.8 kg) **Bantam Cock:** 24 oz. (680 g) | **Hen:** 20 oz. (570 g)

COMB, WATTLES & EARLOBES Single comb with five distinct points held upright. Medium-length, well-rounded wattles. Small, oblong earlobes. Comb and wattles are bright red; earlobes are white.

COLOR Beak is dark horn; eyes are dark red; shanks and toes are slate. *Male:* Rich black plumage on head, neck, saddle, and tail stands out against a bright white body. *Female:* Black on head, neck, and tail; white body.

PLACE OF ORIGIN Germany

CONSERVATION STATUS Threatened

SPECIAL QUALITIES Ornamental layer — very handsome. Early to mature; good layer of small eggs.

Leghorn

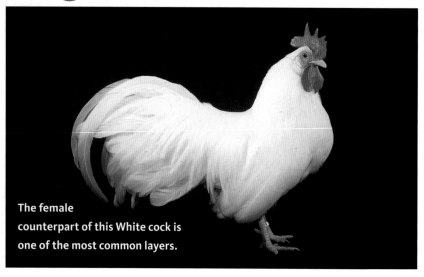

The female counterpart of this White cock is one of the most common layers.

INTERESTINGLY, LEGHORNS, which originated in Italy, made their way first to North America around 1835 and then back across the Atlantic to Britain in the 1870s. Birds of that first importation are thought to have died out in North America; the Leghorns that are here now are from importations made in the 1950s.

The breed has long been one of the most popular in the world, thanks to the birds' exceptional laying ability, adaptability (they do well

whether in confinement or free-ranging), and hardiness. The APA recognizes a whopping 16 varieties of large birds and 17 varieties of bantams. The ABA recognizes 24 varieties. All varieties have large, prominent eyes and fairly long, full tails.

Leghorns are early to mature and lay lots of large white eggs, with about the best feed-to-egg conversion ratio of any pure breed. Hens rarely go broody.

The Leghorn was first admitted to the APA in 1874.

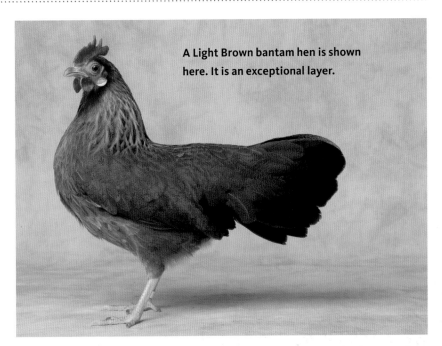

A Light Brown bantam hen is shown here. It is an exceptional layer.

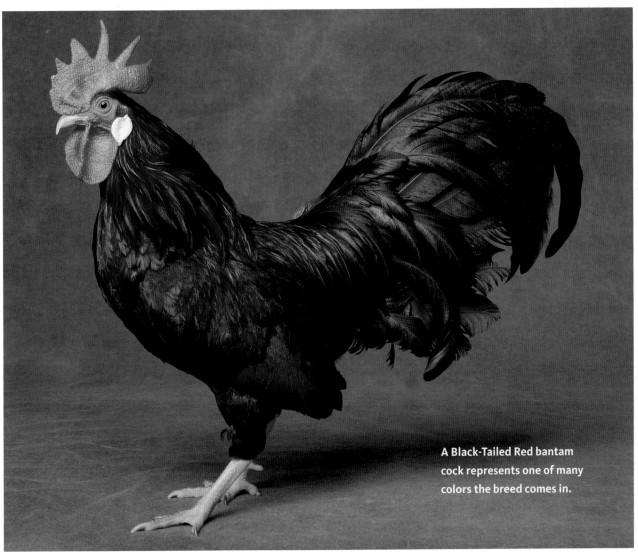

A Black-Tailed Red bantam cock represents one of many colors the breed comes in.

LEGHORN FACTS

CLASS **Standard** Mediterranean. **Bantam** Single Comb, Clean Legged; Rose Comb, Clean Legged.

SIZE **Standard Cock**: 6 lb. (2.75 kg) | **Hen**: 4.5 lb. (2 kg) **Bantam Cock**: 26 oz. (740 g) | **Hen**: 22 oz. (625 g)

COMB There are two varieties based on comb.

Single Comb. Bright red, medium-size comb has five distinct points. *Male*: All five points stand upright. *Female*: First point upright; other four droop to side.

Rose Comb. Bright red, medium-size rose comb; square in front, terminating in a well-developed spike.

WATTLES & EARLOBES Red wattles and white earlobes, unless otherwise noted. *Male*: Medium-length, well-rounded wattles; broad, oval earlobes close to head. *Female*: Medium-size wattles; oval earlobes close to head.

COLOR Additional varieties, such as cuckoo and mottled, are recognized outside the United States but not by the APA or ABA at this time. Beak, shanks, and toes are yellow, unless otherwise noted. Eyes are red.

Barred. Both single- and rose-comb varieties. Standard barred plumage (page 26).

Black. Both single- and rose-comb varieties. Standard black plumage (page 26).

Black-Tailed Red. Single-comb variety. Beak is yellow but may be tinged in reddish horn. Standard black-tailed red plumage (page 26).

Blue. Single-comb variety. Standard blue plumage (page 26).

Buff. Both single- and rose-comb varieties. Standard buff plumage (page 26).

Buff Columbian. Both single- and rose-comb varieties. Standard buff Columbian plumage (page 26).

Columbian. Both single- and rose-comb varieties. Standard Columbian plumage (page 26).

Dark Brown. Both single- and rose-comb varieties. Standard dark brown plumage (page 27).

Dominique. Rose comb only. Feathers are barred in black (varying from pure black to dark slate gray) and creamy white over whole body. Males may be a shade lighter than females. Undercolor is slate.

Exchequer. Both single- and rose-comb varieties. White and black, fairly evenly distributed over body.

Golden. Single comb only. Standard golden plumage (page 27).

Light Brown. Both single- and rose-comb varieties. Beak is horn colored. Standard light brown plumage (page 28).

Mille Fleur. Single comb only. Standard mille fleur plumage (page 28).

Red. Single comb only. Standard red plumage (page 28).

Silver. Both single- and rose-comb varieties. Standard silver plumage (page 29).

White. Both single- and rose-comb varieties. Standard white plumage (page 29).

PLACE OF ORIGIN Italy

CONSERVATION STATUS Recovering

SPECIAL QUALITIES Early to mature; excellent layer of large eggs.

A Dark Brown bantam hen.

A Light Brown bantam rooster.

Maran

IN THE LATE 1800s a farmer of Maran, a town on the Atlantic coast of France, began introducing **Langshans** (page 128), an Asiatic breed, into the bloodlines of the game-type birds that were dominant in the area at the time. The resulting breed was named after the town where it was developed.

The Maran shows the tight, "hard" feathers (meaning narrow and short, with a heavy, tough shaft and an absence of fluff) that are commonly associated with game birds, along with a solid body, a strong-looking beak, and a relatively short tail. The French strain has the feathered legs that are common with Asiatic breeds; the English strain, which was developed during the 1920s and '30s and is more common on this side of the Atlantic, has non-feathered legs.

Marans are well-known for their large eggs, which are the darkest brown of any chicken egg, bordering on a dark chocolate to coppery color. The color results from a recessive gene, so if you cross a Maran with another breed, the dark eggs will become lighter. Hens occasionally go broody. They are active birds but adapt well to confinement.

Although the breed is not yet recognized by the APA or the ABA, there is growing interest in the breed in North America. A new breed club formed in 2005 with the hope of promoting the breed and encouraging other breeders to start raising Marans.

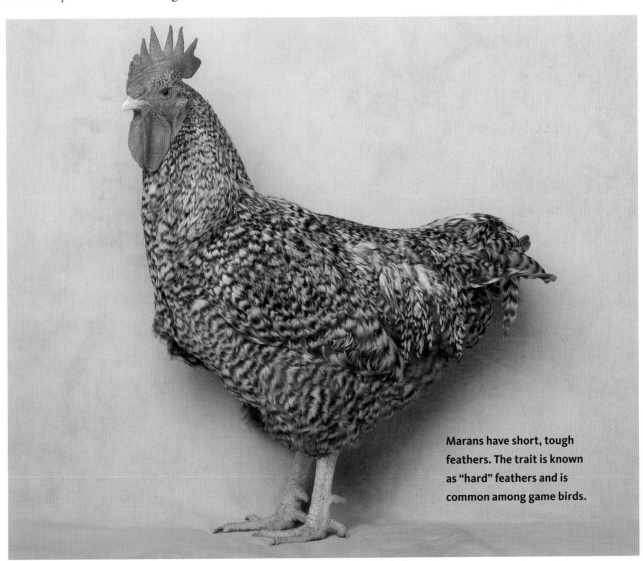

Marans have short, tough feathers. The trait is known as "hard" feathers and is common among game birds.

Maran *continued*

MARAN FACTS

SIZE **Standard Cock:** 8.5 lb. (3.9 kg) | **Hen:** 7 lb. (3.2 kg)
Bantam Cock: 38 oz. (1.1 kg) | **Hen:** 32 oz. (910 g)

COMB, WATTLES & EARLOBES Rough-textured, single comb with five or more points held upright. Fairly long wattles and earlobes. All are bright red.

COLOR Beak is horn; eyes are dark red; shanks and toes are slate, unless otherwise noted.

Birchen. Standard birchen plumage (page 26).

Black. Black beak, shanks, and toes. Standard black plumage (page 26).

Black-Tailed Buff. All plumage except tail is uniform buff, ranging from a light shade to a deep reddish shade. Tail is primarily black, but feathers may have brown edging.

Brown Red. Standard brown-red plumage (page 26).

Columbian. Standard Columbian plumage (page 26).

Golden Cuckoo. Feathers on head, hackle, and back have golden bars set against white. Breast, body, legs, tail, and wing feathers have a pattern of dark slate bars set against white, always ending in a dark bar.

Silver Cuckoo. Feathers have a pattern of dark slate bars (almost black in females and sometimes lighter in males) set against white, always ending in a dark bar.

Wheaten. Standard wheaten plumage (page 29).

White. White shanks and toes. Standard white plumage (page 29).

PLACE OF ORIGIN France

CONSERVATION STATUS Not applicable

SPECIAL QUALITIES Good layer of large, dark brown eggs. Dual-purpose bird, yielding both meat and eggs.

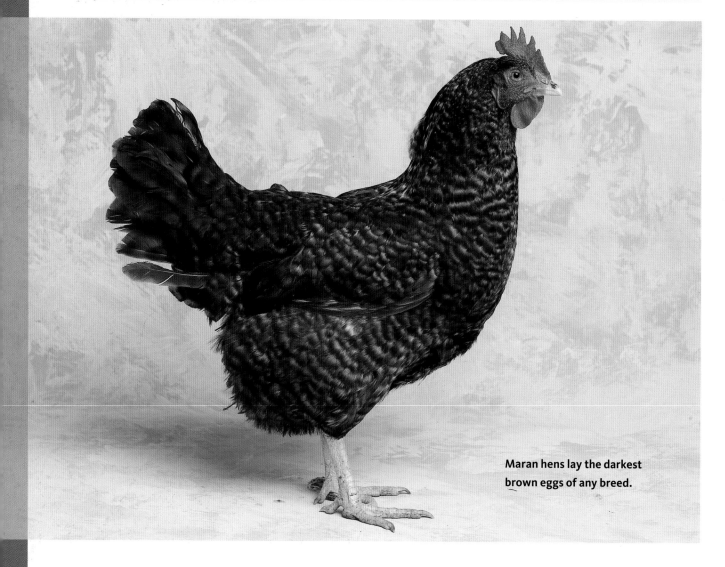

Maran hens lay the darkest brown eggs of any breed.

Minorca

THE MINORCA BREED is quite old, known even in the time of the ancient Romans. It was developed in Spain, though British breeders of the eighteenth and nineteenth centuries had great influence on the development of the modern breed.

It is the largest of the Mediterranean breeds. It really gives the impression of size and strength, thanks to its large comb, wattles, and earlobes; its large, full tail that's held up at a jaunty angle; and its muscular legs set squarely under its body.

Minorca hens are early to mature, lay lots of extra-large chalky white eggs, and seldom go broody. The breed is quite active and tends to avoid humans, though it does all right in confinement. In free-range operations, the birds will range boldly out into open areas, much like a turkey. Aerial predators generally leave them alone due to their size. The breed's large comb, wattles, and earlobes prove a distinct disadvantage in cold climates, as they are more susceptible to frostbite than other breeds, but the Minorca does quite well in hot climates.

The Minorca was first admitted to the APA in 1888.

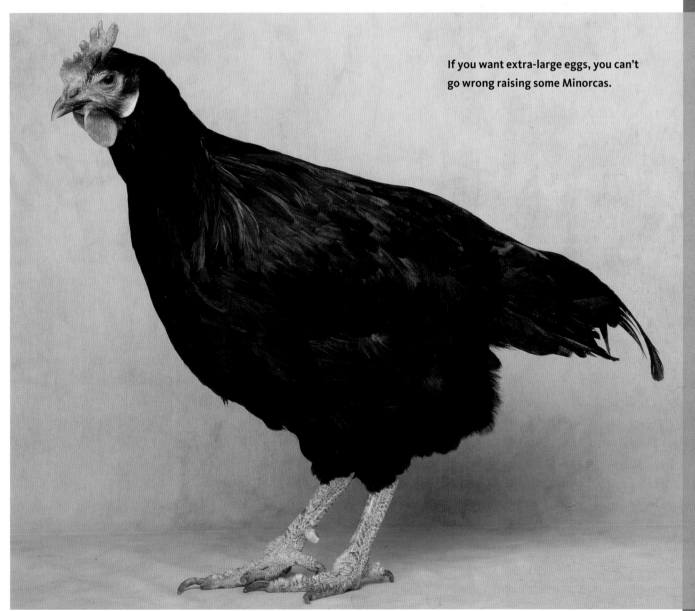

If you want extra-large eggs, you can't go wrong raising some Minorcas.

MINORCA FACTS

CLASS **Standard** Mediterranean. **Bantam** Single Comb, Clean Legged; Rose Comb, Clean Legged.

SIZE **Standard Cock**: 9 lb. (4.1 kg) | **Hen**: 7.5 lb. (3.4 kg)
Bantam, Single Comb Cock: 32 oz. (910 g)
Hen: 26 oz. (740 g) | **Bantam, Rose Comb Cock**:
26 oz. (740 g) | **Hen**: 24 oz. (680 g)

COMB, WATTLES & EARLOBES Large wattles and large, almond-shaped earlobes set close to head. Combs and wattles are bright red; earlobes are bright white.

Single Comb. *Male*: Large comb has six evenly serrated points that stand upright. Middle points are longest. *Female*: Large comb with six distinct points. First point loops over beak; rest droop to opposite side of head.

Rose Comb. Moderately large comb, square in front, tapering evenly from front to back, covered with small, rounded points.

COLOR

Black. Black beak, dark brown eyes, dark slate shanks and toes. Standard black plumage (page 26).

Buff. Pinkish white beak, shanks, and toes. Reddish bay eyes. Standard buff plumage (page 26).

Self Blue. Horn beak, brown eyes, slaty blue shanks and toes. Plumage is evenly colored light slaty blue. Head, neck, wings, and tail are highly glossy on males; head and neck are slightly glossy on females.

White. Pinkish white beak, shanks, and toes. Reddish bay eyes. Standard white plumage (page 29).

PLACE OF ORIGIN Spain

CONSERVATION STATUS Watch

SPECIAL QUALITIES Ornamental layer of large eggs. Stands up to hot weather but doesn't do well in extreme cold. Early to mature.

The Minorca cock is known for having a large comb, wattles, and earlobes, which can be a disadvantage in very cold climates.

Norwegian Jaerhon

THE JAERHON IS the only breed credited to Norway. It was developed in the 1920s from native stock around the town of Stavanger on the southern Atlantic coast of Norway. The breed was first imported to North America at the beginning of the twenty-first century.

Jaerhons are small, hardy, and active birds that can fly well. The hens don't tend to go broody, and they can wear themselves out by laying lots of large white eggs.

NORWEGIAN JAERHON FACTS

SIZE **Standard Cock**: 5 lb. (2.25 kg) | **Hen**: 3.5 lb. (1.6 kg)

COMB, WATTLES & EARLOBES
Small single comb, wattles, and earlobes. Comb and wattles red; earlobes white.

COLOR Beak horn, eyes brown, shanks and toes yellow.
Dark Brown. Primarily brown (varying from light on head to dark on body) plumage with uneven barring.

Light Yellow. Cream and yellow plumage with dark, uneven barring.

PLACE OF ORIGIN Norway
CONSERVATION STATUS
Not applicable
SPECIAL QUALITIES Exceptional layers of large white eggs from hens that are barely bigger than banties.

Jaerhon hens are prolific layers of large white eggs.

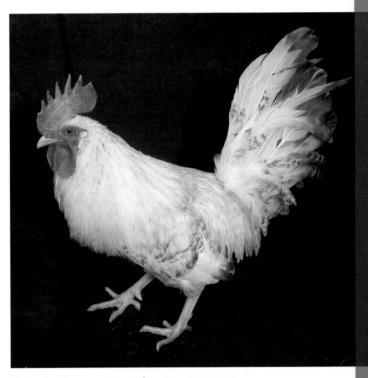
The Jaerhon is a recent import from its native Norway.

Penedesenca

The Penedesenca has an unusual comb.

THE PENEDESENCA was developed during the first half of the twentieth century in the Catalonian province of Spain. Native barnyard chickens, known for producing remarkably dark brown eggs, were the parent stock. The breed was first standardized and recognized in Spain in a black variety in 1946.

The breed almost died out, but in the 1980s a biologist with the Spanish government began efforts to save it. Since then it has made a real comeback, thanks in part to breeders around the world who are interested in chickens that produce dark eggs.

The eggs are among the darkest of any chicken. In their first year, pullets lay eggs that are so dark that they are nearly black; after the first year, hens lay eggs with a reddish brown cast.

Penedesencas are good free-range birds that can find most of their own fare during the spring, summer, and fall. Hens will go broody. They produce high-quality meat for a layer breed.

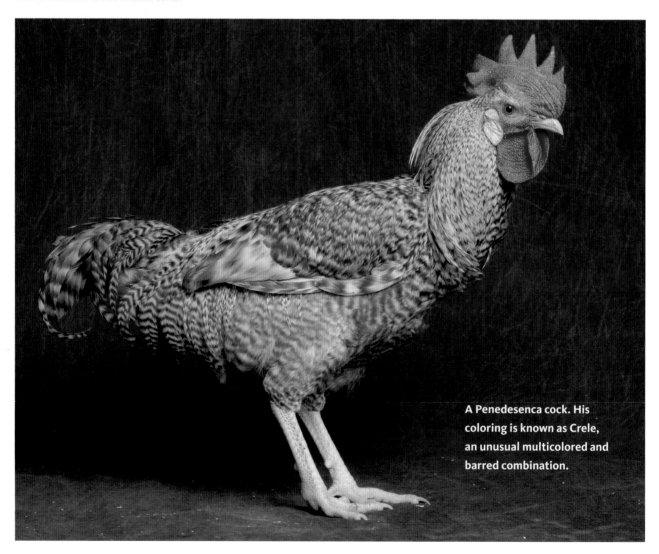

A Penedesenca cock. His coloring is known as Crele, an unusual multicolored and barred combination.

PENEDESENCA FACTS

SIZE **Standard Cock**: 5.5 lb. (2.5 kg) | **Hen**: 4.5 lb. (2 kg) (The black variety is much heavier than this.)

COMB, WATTLES & EARLOBES Unusual comb that begins like a large single but has multiple lobes at the rear; referred to in Spain as the "king's comb" or "carnation comb." Comb stands upright in males; droops to the side in females. Medium-size wattles are moderately long in the male and well rounded in the female. Earlobes are of medium size. Comb and wattles are bright red; earlobes are red with a white center.

COLOR Eyes are black around the edges with a honey-colored iris. **Black.** Dark horn beak; dark slate shanks and toes. Standard black plumage (page 26). **Crele.** Beak, shanks, and toes are almost white. Standard crele plumage (page 26). **Partridge.** Dark horn beak; bluish slate shanks and toes. Standard partridge plumage (page 28). **Wheaten.** Dark horn beak in male, light reddish horn in female; light slate shanks and toes. Standard wheaten plumage (page 29).

PLACE OF ORIGIN Spain

CONSERVATION STATUS Not applicable

SPECIAL QUALITIES Good layers, under free-range conditions, of very dark eggs.

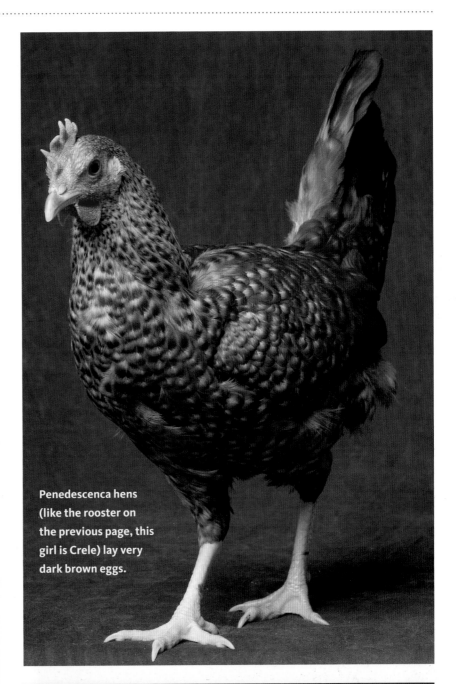

Penedescenca hens (like the rooster on the previous page, this girl is Crele) lay very dark brown eggs.

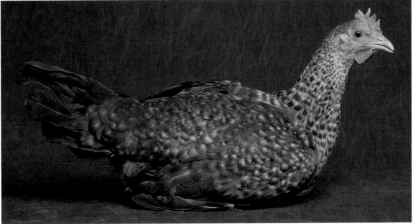

Plymouth Rock

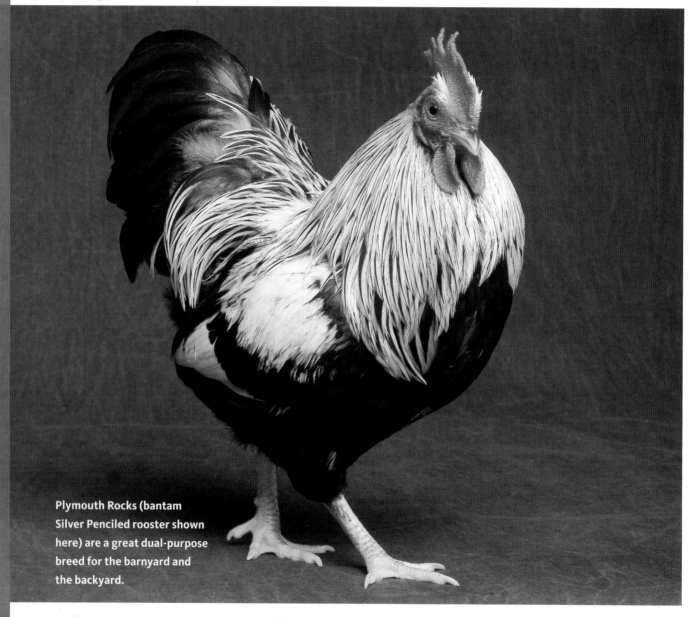

Plymouth Rocks (bantam Silver Penciled rooster shown here) are a great dual-purpose breed for the barnyard and the backyard.

THE PLYMOUTH ROCK is a truly all-American breed that got its start in the 1860s when D. A. Upham of Worcester, Massachusetts, crossed **Black Java** (page 92) pullets with a common single-comb barred cock. He kept only the offspring that had clean yellow legs and barred feathers as breeding stock.

Upham showed his birds at a poultry exhibition in 1869. Thanks to good functional traits like high egg production and a meaty body, excellent hardiness, a docile disposition, and hens that go broody and make good mothers, the breed was an immediate hit. Before long, Plymouth Rocks were the most common birds in America.

In the 1950s commercial poultry production transformed from a small-farm endeavor to an industrial undertaking. Though the white variety of Plymouth Rock was used extensively in producing commercial broiler crosses, the breed (like most pure breeds) suffered a fall from favor and a significant threat to its existence. Today, homesteaders have rediscovered its virtues, and the breed is doing better.

The Plymouth Rock was first admitted to the APA in 1874.

PLYMOUTH ROCK FACTS

CLASS **Standard** American.

Bantam Single Comb, Clean Legged.

SIZE **Standard Cock**: 9.5 lb. (4.3 kg) | **Hen**: 7.5 lb. (3.4 kg)

Bantam Cock: 36 oz. (1 kg) | **Hen**: 32 oz. (910 g)

COMB, WATTLES & EARLOBES Medium-size single comb with five evenly serrated points that are longer in the middle than the ends. Comb stands upright. Wattles are moderately long and well rounded. Earlobes are elongated ovals of medium size. All are bright red.

COLOR Beak, shanks, and toes are yellow, unless otherwise noted. Eyes are dark reddish bay.

Barred. Standard barred plumage (page 26).

Black. Horn beak with shading of yellow at the point. Standard black plumage (page 26).

Blue. Horn beak with shading of yellow at the point. Standard blue plumage (page 26).

Buff. Standard buff plumage (page 26).

Columbian. Standard Columbian plumage (page 26).

Partridge. Dark horn beak with shading of yellow at the point. Standard partridge plumage (page 28).

Silver Penciled. Standard silver penciled plumage (page 29).

White. Standard white plumage (page 29).

PLACE OF ORIGIN United States

CONSERVATION STATUS Recovering

SPECIAL QUALITIES Great dual-purpose bird for barnyard or backyard. Cold-hardy, friendly, and adaptable to either confinement or free range.

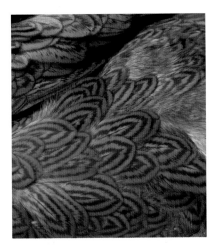

A close-up of the penciling of a Partridge hen.

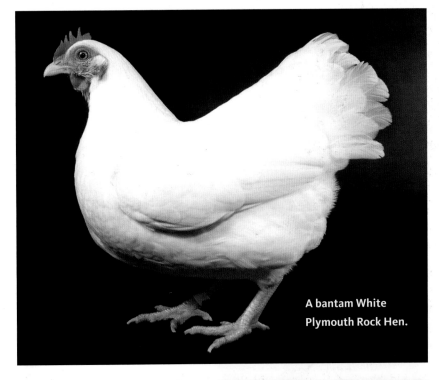

A bantam White Plymouth Rock Hen.

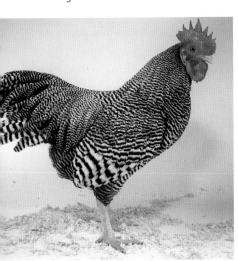

The Barred coloring (as seen on this bantam rooster) is one of the most popular and common colors for the Plymouth Rock breed.

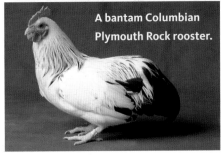

A bantam Columbian Plymouth Rock rooster.

Rhode Island Red

This Rhode Island Red hen is a true production layer with good dual-purpose characteristics.

NOT ONLY WAS the Rhode Island Red named for the state in which it was developed in the late 1800s, but it also garnered unusual recognition when the Rhode Island legislature designated it the state bird of Rhode Island in 1954. This made it the only breed recognized in the APA *Standard of Perfection* to receive such honors (though read about Delaware's state bird, the **Blue Hen of Delaware**, on page 75).

Unlike a lot of breeds, the Rhode Island Red was not developed for show purposes by fanciers. Instead, Rhode Island poultry farmers developed the bird in the 1830s to produce a good utility bird that had excellent egg-laying ability married to a meaty frame. They succeeded by crossing native birds of mixed blood with **Brown Leghorns** (page 58), **Cochins** (page 113), and **Brahmas** (page 77), as well as **Red Malays** (page 96), which are credited with contributing the color.

The Rhode Island Red is one of the best dual-purpose breeds and a super choice for backyard flocks. The birds are hardy and do well on a free-range operation, though they will tolerate confinement. Hens are prolific layers of large brown eggs. They rarely go broody, but those that do are usually great moms. They are generally docile, though cocks are sometimes aggressive.

The Rhode Island Red was first admitted to the APA in 1904.

This Rhode Island Red rooster is a specimen to represent Rhode Island's state bird.

RHODE ISLAND RED FACTS

CLASS **Standard** American.

 Bantam Single Comb, Clean Legged.

SIZE **Standard Cock:** 8.5 lb. (3.9 kg) | **Hen:** 6.5 lb. (3 kg)

 Bantam Cock: 34 oz. (965 g) | **Hen:** 30 oz. (850 g)

COMB, WATTLES & EARLOBES Recognized in both single- and rose-comb varieties. Medium-size wattles and earlobes. All are bright red.

 Single Comb. Medium to moderately large single comb, with five evenly serrated points that are longer in the middle than the ends. Comb stands upright.

 Rose Comb. Moderately large in the male; smaller in the female.

COLOR Reddish horn beak; reddish bay eyes; rich yellow shanks and toes tinged with reddish horn. A line of red pigment running down sides of shanks and extending to tips of toes is desirable. Plumage is primarily rich, lustrous dark red. Tail is mainly black, though it may have some red near saddle or edges. Wings are mainly red with some black highlights.

PLACE OF ORIGIN United States

CONSERVATION STATUS Recovering

SPECIAL QUALITIES Excellent layer of large brown eggs, but also a fine eating bird. Hardy, early to mature, and usually calm.

Rhode Island White

THE RHODE ISLAND WHITE is a separate breed from the Rhode Island Red. The White was developed by John Alonzo Jocoy, a poultry farmer of some renown, in Peacedale, Rhode Island, in 1888. Jocoy crossed **Partridge Cochins** (page 113), **White Wyandottes** (page 103), and **Rose-Comb White Leghorns** (page 58) to get a dual-purpose bird. The White has never been as popular as the Red, though it is also a good barnyard bird.

Rhode Island White hens don't tend to go broody. Whites have a mellow disposition and mature early. Like the Reds, they are fairly hardy and do well in either confinement or free-range operations.

Rhode Island Whites are used in a cross with Rhode Island Reds to produce "Red Sexlinks," which is used as a commercial brown-egg layer. Females are red with white undercolor; males are white.

The Rhode Island White was first admitted to the APA in 1922.

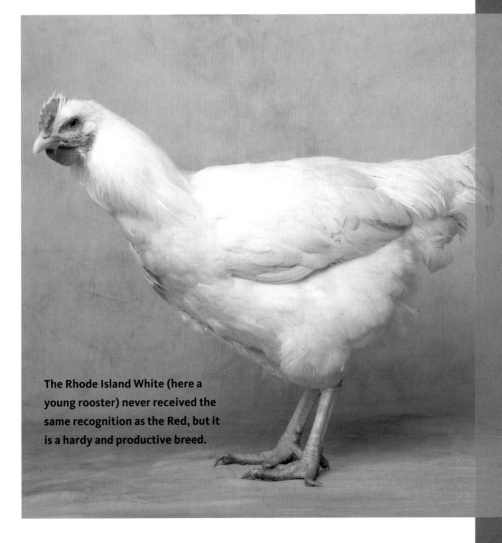

The Rhode Island White (here a young rooster) never received the same recognition as the Red, but it is a hardy and productive breed.

RHODE ISLAND WHITE FACTS

CLASS **Standard** American. **Bantam** Single Comb, Clean Legged.

SIZE **Standard Cock**: 8.5 lb. (3.9 kg) | **Hen**: 6.5 lb. (3 kg) **Bantam Cock**: 34 oz. (965 g) | **Hen**: 30 oz. (850 g)

COMB, WATTLES & EARLOBES Medium-size rose comb; medium-size wattles; medium-size, oblong earlobes. All are bright red.

COLOR Yellow beak; reddish bay eyes; yellow shanks and toes. Standard white plumage (page 29).

PLACE OF ORIGIN United States

CONSERVATION STATUS Watch

SPECIAL QUALITIES Great dual-purpose bird for barnyard or backyard. Cold-hardy, friendly, and adaptable.

A Rhode Island White hen.

Welsummer

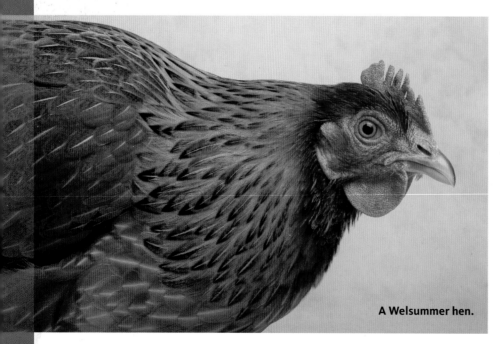

A Welsummer hen.

THE WELSUMMER is a relatively new breed to North America, though it was developed in its native Holland in the early twentieth century. The breed takes its name from the village of Welsum, where a farmer began crossing **Barnevelders** (page 45) with the native birds until he obtained a stable cross.

Welsummers are purported to be one of the top free-range foragers of all the layers. They lay a moderate number of large terra-cotta eggs. Hens mature early and sometimes go broody.

The Welsummer was first admitted to the APA in 1991.

WELSUMMER FACTS

CLASS **Standard** American.
Bantam Single Comb, Clean Legged.

SIZE **Standard Cock:** 7 lb. (3.2 kg) | **Hen:** 6 lb. (2.75 kg)
Bantam Cock: 34 oz. (965 g) | **Hen:** 30 oz. (850 g)

COMB, WATTLES & EARLOBES Medium-size single comb with five evenly serrated points, longer in the middle than the ends. Comb stands upright. Wattles are moderately long and well rounded. Earlobes are elongated ovals of medium size. All are bright red.

COLOR Breeders are producing several color varieties, but as of this writing only one is recognized in the APA *Standard of Perfection*: Beak is dark horn; eyes are reddish bay; shanks and toes are yellow. *Male*: Rich golden brown to reddish brown head, hackle, back, and saddle; breast and body are black with some red mottling; tail is black with some brown edging on coverts; wings are reddish brown with black highlighting. *Female*: Primarily reddish brown with a stippling of black or gray on some feathers.

PLACE OF ORIGIN Holland

CONSERVATION STATUS Not applicable

SPECIAL QUALITIES Lays beautiful eggs of a dark and deep reddish brown. Excellent forager.

The Welsummer (cock here) is a new breed to North America.

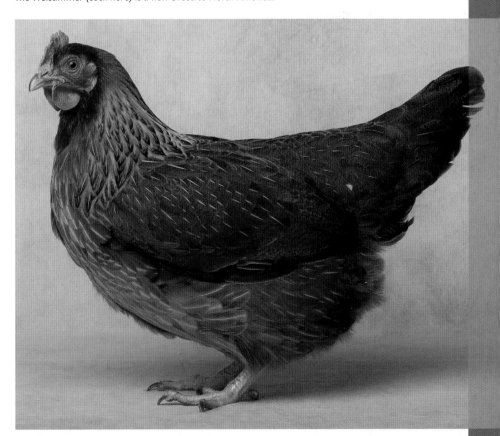

This Welsummer hen will lay attractive, terra-cotta–colored eggs.

Aseel

GAME BIRDS WERE DEVELOPED for fighting, and the Aseel (spelled Asil in some texts) may be the gamiest of them all. It is definitely one of the oldest game breeds, having been bred in India and surrounding countries for over two thousand years.

The Aseel was bred to fight with only its own natural spurs and strength. In fact, its name translates to "of long pedigree" in Arabic. The breed's fighting trait is so strong that chicks will fight almost immediately upon hatching. Cocks will fight to the death and must be kept physically isolated from other males.

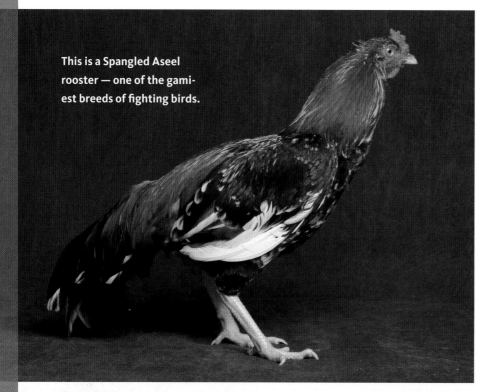

This is a Spangled Aseel rooster — one of the gamiest breeds of fighting birds.

Hens are also quite aggressive with other game hens, though they are purportedly mellower when kept with hens of less aggressive breeds. They are excellent mothers, and some breeders who keep them for preservation purposes will use them as brood hens for other breeds. However, all this adds up to a breed that's not well suited to inexperienced poultry keepers or a mixed-flock situation. In spite of that, there is a real need for enthusiasts who will help keep the breed from extinction in North America.

Aseels stand very upright and have high shoulders, and their tail is carried below the horizontal, all of which gives them a tall demeanor. They are remarkably athletic and have a well-defined, broad breast and heavy-boned legs that are set wide apart. Their feathers are short, hard, and held tight against the body; they may be missing on the keel (center line of the breast) or shoulders.

The Aseel was first admitted to the APA in 1981.

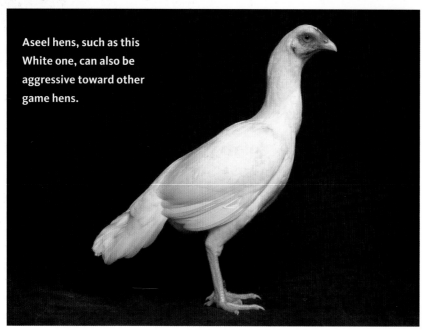

Aseel hens, such as this White one, can also be aggressive toward other game hens.

ASEEL FACTS

CLASS All Other Standard Breeds.

SIZE Cock: 5.5 lb. (2.5 kg) | **Hen:** 4 lb. (1.8 kg)

COMB, WATTLES & EARLOBES Small, bright red pea comb and earlobes; no wattles.

COLOR Beak is yellow to horn; eyes are pearl; shanks and toes are yellow.

Black-Breasted Red. Standard black-breasted red plumage (page 26).

Dark. Standard dark plumage (page 27).

Spangled. Standard spangled plumage (page 29).

Wheaten. Standard wheaten plumage (page 29).

White. Standard white plumage (page 29).

PLACE OF ORIGIN India

CONSERVATION STATUS Critical

SPECIAL QUALITIES
Prehistoric-looking bird, and parent to the Cornish. Highly aggressive.

Blue Hen of Delaware

THE BLUE HEN OF DELAWARE has not really been raised for production or show in recent times, yet it is the state's bird and the mascot of the University of Delaware, and it has an interesting story.

Cockfighting was a regular pastime in Colonial America; in fact, several presidents of that era, including Washington and Jefferson, kept fighting birds. Captain John Caldwell of the Kent company, part of "the Delaware regiment," was a devoted gamecock owner. He and his troops, who had been called up at the start of the American Revolution, were still fighting during the final months of the conflict. They gained a reputation for bravery and competence in battles with the British at Trenton, Princeton, White Plains, and Long Island.

During down times the company often staged cockfights with a blue-feathered breed dubbed the Kent County Blue Hen. Word spread that these "Blue Hens' Chickens" were the birds to beat. In time the regiment became known by the nickname "Blue Hens' Chickens,"

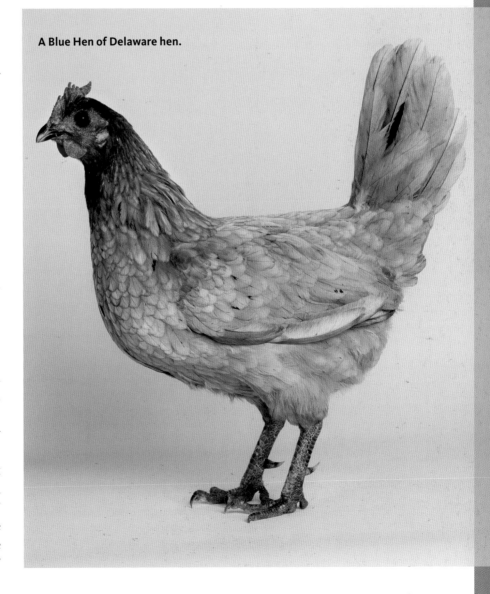

A Blue Hen of Delaware hen.

in respect for the fighting abilities of both its soldiers and its chickens. And in 1939 the Delaware General Assembly designated the Blue Hen chicken as the official state bird.

The Blue Hen breed is essentially a unique strain developed from **Old English Games** (page 137). Over the years individual fanciers continued to keep these birds, including Hallock DuPont. Since the Blue Hens were the mascot of the University of Delaware, DuPont donated six pairs of adult birds to the school in the 1960s, so that they could have a live mascot. A poultry professor at the university decided to breed for a bluer bird that would have less of the gold coloring on the hackle and cape, crossing the university's flock with Blue Andalusians.

Today the university has the largest flock (about 40 birds) of Blue Hens, though its birds now manifest a number of traits that come from the infusion of Andalusian blood, including white earlobes, a larger comb, and a slightly larger and different body shape than the original Blue Hens. There are also still some Delaware fanciers who continue to keep the traditional bloodlines of the Blue Hen chicken.

As is the case for Andalusians, breeding of Blue Hens yields three colors: a steely blue (50 percent of the brood), a black (25 percent), and a splash (25 percent). Crossbreeding of the splash and black results in 100 percent blue offspring.

Blue Hen of Delaware roosters were respected fighting birds during the American Revolution. This rooster and the hen on the previous page show the traditional coloring and characteristics for the breed.

BLUE HEN OF DELAWARE FACTS

SIZE **Cock:** 5 lb. (2.25 kg) | **Hen:** 4 lb. (1.8 kg)

COMB, WATTLES & EARLOBES Small single comb has five points that stand upright. Small, thin, smooth wattles and earlobes. All are bright red. Comb, wattles, and earlobes are dubbed (removed) in cocks for show.

COLOR Yellow beak; reddish bay eyes; willow shanks and toes. Head, hackle, cape, and saddle can be in shades of yellow and orange; front of neck, lower body, and tail are steely blue.

PLACE OF ORIGIN Delaware

CONSERVATION STATUS Not applicable

SPECIAL QUALITIES State bird

Brahma

LITTLE IS KNOWN ABOUT the exact origins of the Brahma breed, other than that it is named for the Brahmaputra River in India. Some poultry historians speculate that Brahmas are the same birds as the Chittagongs of India. Others suspect that the breed as we know it today may have been developed by immigrants crossing Chinese Shanghai (see **Cochin**, page 113) chickens with Chittagongs in the great American melting pot of 1840s California.

Early Brahmas grew quickly, but today they mature more slowly. They also are one of the largest breeds. They have a level back line, but their long, feathered legs, arched neck, and short tail give the birds an upright posture. These physical traits, combined with their lovely color patterns, make for a really magnificent-looking bird.

Although they don't lay a lot of eggs, Brahmas are known for good winter production of brown eggs. The hens go broody quite easily, but they occasionally break eggs in the nest due to their weight. Brahmas do all right in confinement if given sufficient space but do better when given access to the outdoors. They are mellow and quite hardy, standing up well to both heat and cold.

The Brahma was first admitted to the APA in 1874.

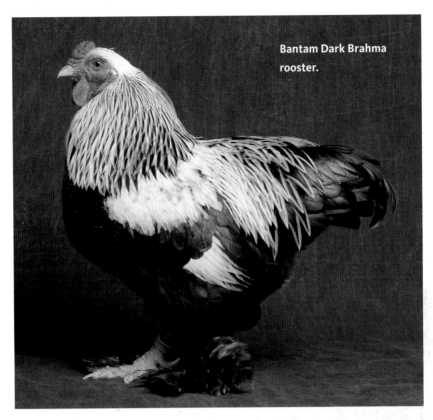

Bantam Dark Brahma rooster.

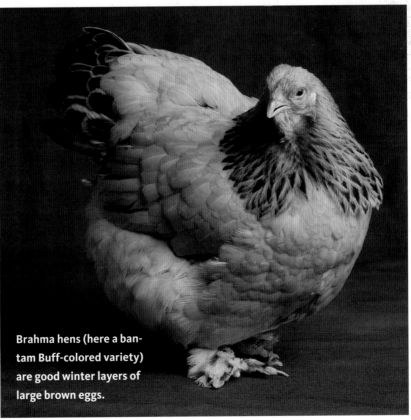

Brahma hens (here a bantam Buff-colored variety) are good winter layers of large brown eggs.

Brahma *continued*

Dark penciling up close.

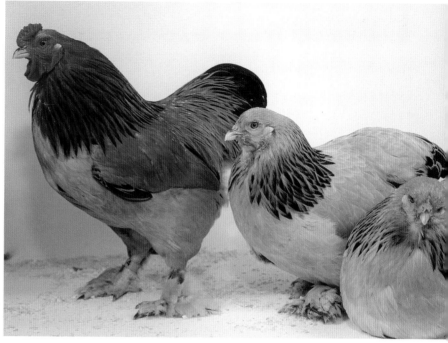

A lovely trio of bantam Buff Brahmas. The feathering on shanks and toes is a common trait in a number of oriental breeds.

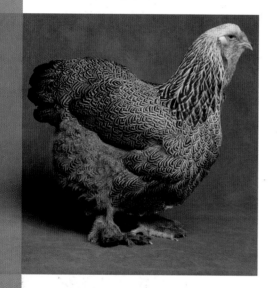

A Dark Brahma hen.

BRAHMA FACTS

CLASS **Standard** Asiatic. **Bantam** Feather Legged.

SIZE **Standard Cock**: 12 lb. (5.5 kg) | **Hen**: 9.5 lb. (4.3 kg)

 Bantam Cock: 38 oz. (1.1 kg) | **Hen**: 34 oz. (965 g)

COMB, WATTLES & EARLOBES Pea comb; medium-size, well-rounded wattles; large, and long earlobes. All red.

COLOR Breeders are developing new color varieties that have not yet been accepted into the *APA Standard of Perfection*, including blue, partridge, and red. Yellow beak, though it may have a dark stripe down the upper mandible; reddish brown eyes; yellow shanks and toes.

Black. Standard black plumage (page 26). Shank and outer toe feathers are black.

Buff. Although this variety is referred to as "Buff," it fits the description for standard buff Columbian plumage (page 26). *Male*: Shank feathers and outer toe feathers are buff and black. *Female*: Shank feathers are buff; outer toe feathers are buff and black.

Dark. Although this variety is referred to as "Dark," it fits the description for standard silver penciled plumage (page 29). *Male*: Shank and outer toe feathers are black. *Female*: Shank feathers are penciled with steel gray.

Light. Although this variety is referred to as "Light," it fits the description for standard Columbian plumage (page 26). *Male*: Shank feathers and outer toe feathers are white and black. *Female*: Shank feathers are white; outer toe feathers are white and black.

White. Standard white plumage (page 29). Shank and outer toe feathers are white.

PLACE OF ORIGIN United States

CONSERVATION STATUS Watch

SPECIAL QUALITIES One of the largest breeds; good winter layer.

Buckeye

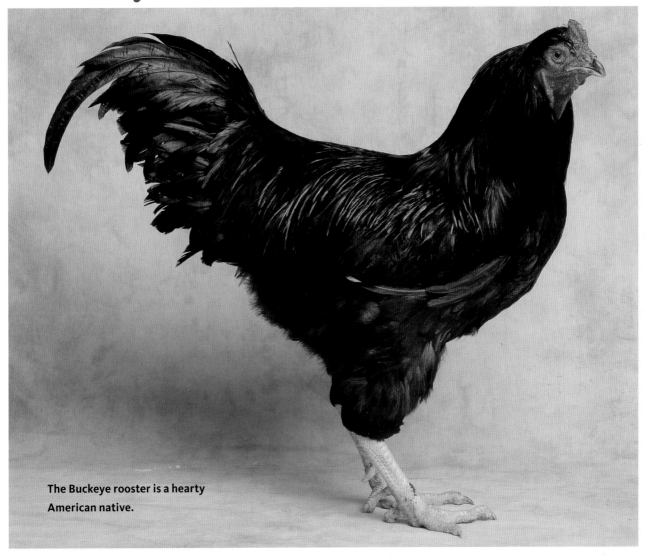

The Buckeye rooster is a hearty American native.

An American native, the Buckeye was developed in the 1890s by Nettie Metcalf, a farmwife from Warren, Ohio. It is the only American breed to sport a pea comb — and the only one developed solely by a woman, though women of the period were the primary keepers of farm chickens in the United States.

Metcalf crossed **Barred Plymouth Rock** (page 68) hens to a **Buff Cochin** (page 113) rooster, then added some black-breasted game fowl to get a functional, dual-purpose bird that would perform well on the farm.

Though not the most unusual-looking birds, Buckeyes are a good choice for a barnyard setting. They are known for their meaty thighs, wings, and breast and have very dark "dark meat." They are calm, sociable birds that acclimate to being around humans to the point of being quite friendly, though the occasional rooster may get aggressive.

Good foragers, they perform well when allowed to roam but

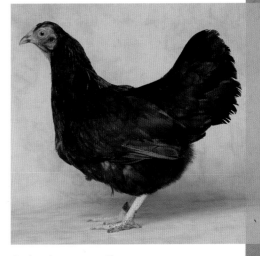

Buckeye hens are good layers.

Buckeye *continued*

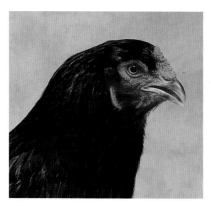

A hen's pea comb.

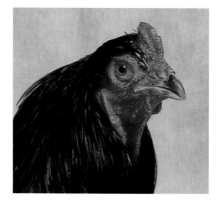

A rooster's pea comb.

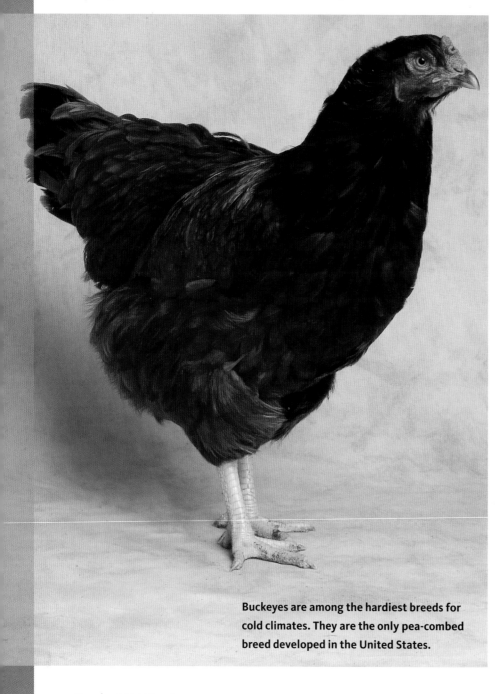

Buckeyes are among the hardiest breeds for cold climates. They are the only pea-combed breed developed in the United States.

will adapt to close confinement, though they will grow more slowly when crowded. One good point for Buckeyes kept in confinement: they don't get into feather picking, even when crowded.

They are very hardy, venturing out on the coldest days of winter. According to Don Schrider of the ALBC, "they are one of the two best American breeds for cold weather — the other being the Chantecler — both being far superior to Rhode Island Reds, Rhode Island Whites, or Plymouth Rocks." Hens readily become broody.

The Buckeye was first admitted to the APA in 1904.

BUCKEYE FACTS

CLASS **Standard** American. **Bantam** All Other Combs, Clean Legged.

SIZE **Standard Cock**: 9 lb. (4.1 kg) | **Hen**: 6.5 lb. (3 kg) **Bantam Cock**: 34 oz. (965 g) | **Hen**: 28 oz. (795 g)

COMB, WATTLES & EARLOBES Small to medium-size pea comb, well-rounded wattles, and ears. All are bright red.

COLOR Beak is yellow shaded with reddish horn; eyes are reddish bay; shanks and toes are yellow. Plumage is a rich and lustrous reddish brown, or mahogany, though tail contains some black. Most of undercolor is bright red, but with a slate-colored bar on down of back.

PLACE OF ORIGIN United States

CONSERVATION STATUS Critical

SPECIAL QUALITIES Calm demeanor. Good dual-purpose bird and very cold-hardy.

Cornish

THE CORNISH BREED is the foundation of our modern broiler industry. It is the bruiser of the chicken world. A muscular, pugnacious-looking bird, it was developed in Cornwall, England, and has a strong game bird heritage, which accounts for its alias, the Indian Game.

The **Aseel** (page 74), which was imported to England during the mid-eighteenth century, provided the foundation bloodlines for the breed, but other game breeds also made contributions, such as **Old English Games** (page 137) and **Malays** (page 96).

One defining and unusual characteristic of the breed is that males and females have almost the same conformation, which includes a wide and deep breast, large and wide-set legs, and a medium-length, slightly downsloping back. When viewed from above, a Cornish's back has a heart-shaped appearance. Like the game breeds, Cornishes have hard feathers, which are narrow and short with a heavy, tough shaft and an absence of fluff.

Cornishes don't do well in a free-range situation without supplemental feed, and they are very heavy feeders. They are considered quite hardy and fairly docile for birds with game bloodlines, though some individuals may be quite aggressive. Hens can go broody and are protective mothers, but many Cornish roosters are no longer capable of natural breeding due to the size of their breast and the proportional shortness of their legs.

The Cornish was first admitted to the APA in 1893.

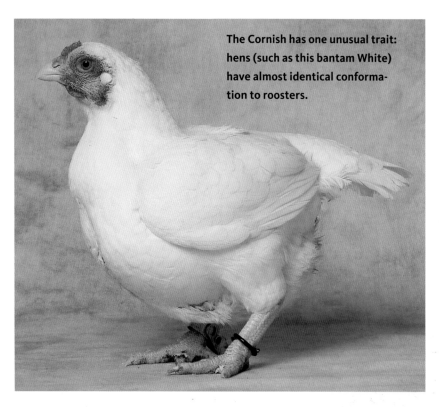

The Cornish has one unusual trait: hens (such as this bantam White) have almost identical conformation to roosters.

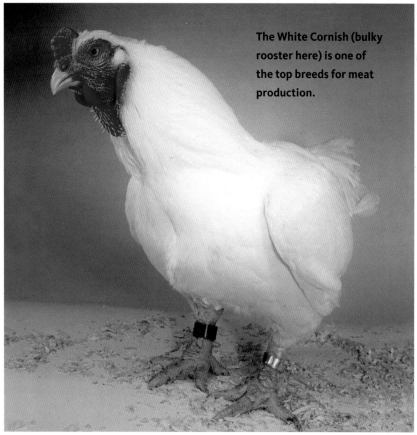

The White Cornish (bulky rooster here) is one of the top breeds for meat production.

CORNISH FACTS

CLASS **Standard** English.

Bantam All Other Combs, Clean Legged.

SIZE **Standard Cock:** 10.5 lb. (4.75 kg) | **Hen:** 8 lb. (3.6 kg)

Bantam Cock: 44 oz. (1.25 kg) | **Hen:** 36 oz. (1 kg)

COMB, WATTLES & EARLOBES Small pea comb, wattles, and ears. All are bright red.

COLOR Beak is yellow; eyes are pearl; shanks and toes are yellow.

Black. Standard black plumage (page 26).

Blue. Standard blue plumage (page 26).

Blue-Laced Red. Most feathers are red, either tipped or laced in blue. *Male*: Tail feathers are blue with red shafts and center.

Buff. Standard buff plumage (page 26).

Columbian. Standard Columbian plumage (page 26).

Dark. Standard dark plumage (page 27).

Jubilee. *Male*: Head, neck, saddle, breast, body, legs, and tail are white. Back and wings are white highlighted with rich red. *Female*: Head and neck are white. Rest of body is red with white lacing or double lacing.

Mottled. Standard mottled plumage (page 28).

Silver Laced. Standard silver laced plumage (page 29).

Spangled. Standard spangled plumage (page 29).

White. Standard white plumage (page 29).

White-Laced Red. *Male*: Primarily rich red feathering laced in white; main tail feathers are white. *Female*: Primarily rich red feathering laced in white.

PLACE OF ORIGIN England

CONSERVATION STATUS Watch

SPECIAL QUALITIES Produces great broilers; the White Cornish (crossed with the White Plymouth Rock) is the principal bird used for developing commercial broiler strains. Requires heavy feeding regimen.

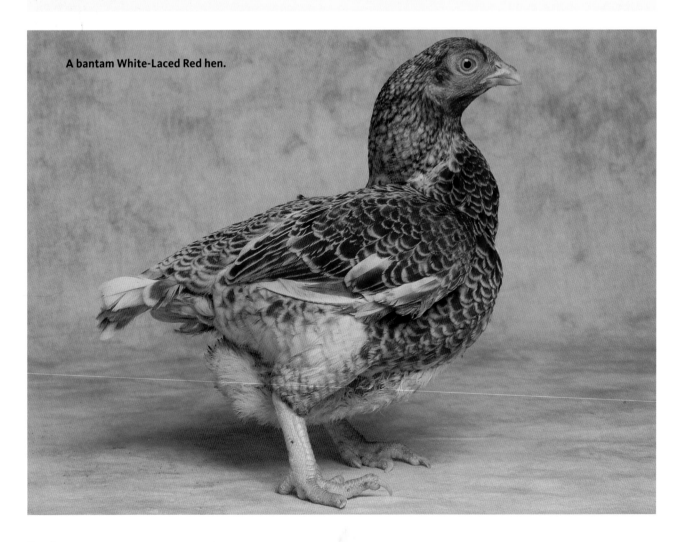

A bantam White-Laced Red hen.

Delaware

In 1940 George Ellis, a poultryman from Delaware, was using a common cross of the time, **Barred Plymouth Rock** (page 68) roosters with **New Hampshire** (page 97) hens, for broiler production. Through the breeding of one special sport of this cross with New Hampshire hens, Ellis developed the Delaware breed.

Normally the Barred Plymouth Rock–New Hampshire cross resulted in barred females and either black or red males, but sometimes it happened to produce some sports, or birds with a distinctive and different color than is normal. Ellis's cross produced a bird that was mostly white, with black barring on the hackle, tail, and wings.

This type of sport had excellent qualities for broiler production, yielding a meaty carcass that, thanks to the white feathering, did not have dark coloring under the skin at butchering. But the production of such sports was inconsistent. However, one of Ellis's sports, a rooster he named Superman, was an exceptional specimen, and when

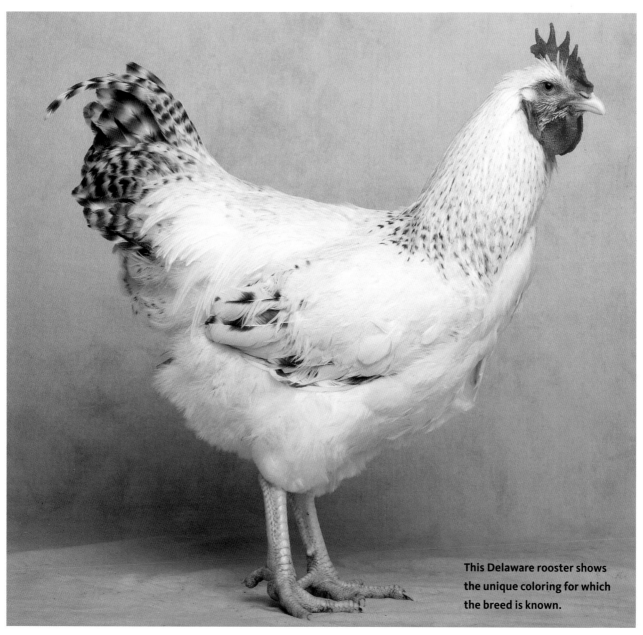

This Delaware rooster shows the unique coloring for which the breed is known.

Delaware *continued*

A closeup of a hen's comb.

Ellis began breeding Superman to New Hampshire hens the cross stabilized with the sport's coloring, and the foundation of the Delaware breed was established.

The Delaware quickly ascended to dominance in the broiler industry of Delaware's Delmarva Peninsula, which at the time provided chicken for the entire East Coast. Though the Delaware's dominance was short-lived, giving way in just twenty years to the Cornish-Rock cross, it still makes an excellent dual-purpose barnyard breed. Unfortunately, it is now quite rare.

Delawares can adapt to either confinement or free-range operations. They are hardy and early to mature and have a calm disposition. Hens lay large, rich brown eggs and will go broody, and they make fairly good mothers.

The Delaware was first admitted to the APA in 1952.

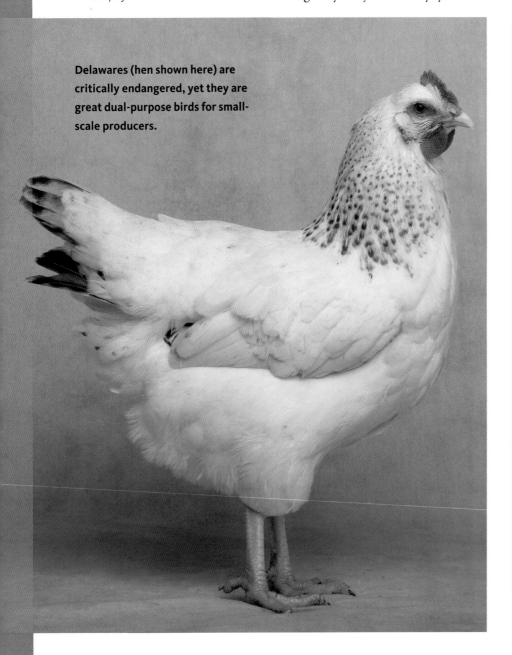

Delawares (hen shown here) are critically endangered, yet they are great dual-purpose birds for small-scale producers.

DELAWARE FACTS

CLASS **Standard** American. **Bantam** All Other Combs, Clean Legged.

SIZE **Standard Cock**: 8.5 lb. (3.9 kg) | **Hen**: 6.5 lb. (3 kg) **Bantam Cock**: 34 oz. (965 g) | **Hen**: 30 oz. (850 g)

COMB, WATTLES & EARLOBES Moderately large single comb with five well-defined points. Medium to moderately large wattles and elongated, oval earlobes. All are bright red.

COLOR Beak is reddish horn; eyes are reddish bay; shanks and toes are yellow. Body and breast are white to silvery white; hackle, tail, and wings are white with some black barring; all feathers have white shaft and quill.

PLACE OF ORIGIN United States

CONSERVATION STATUS Critical

SPECIAL QUALITIES Excellent broilers for small-scale meat production.

Dorking

NAMED FOR the southern English town of Dorking, the modern Dorking breed is considered English. However, based on the writings of Columella, a Roman farmer and writer (AD 4 to 70) who chronicled agriculture of the time, we know that the possible progenitor of the Dorking was actually found in ancient Italy. The square-framed, five-toed, short-legged bird was brought to England in 54 BC by the legions of Julius Caesar.

The English bred the Dorking as a table bird, renowned for its fine-textured and very white meat. Some of the earliest English settlers to North America, in places like Williamsburg, Jamestown, and Plymouth, probably brought them to the United States. By the mid-nineteenth century they were common on North American farms, particularly in New York State.

The breed is known to be calm, docile, and quite adaptable to a variety of settings. Dorkings are good foragers but don't tend to scratch much, making them an ideal choice in a backyard setting. Hens readily go broody (often all at the same time if given the chance) and are excellent mothers. They lay a fair amount of large, creamy white eggs.

The males are susceptible to having their large combs freeze in extreme winter weather, though the hens are quite hardy and will continue to lay well throughout the winter.

The Dorking was first admitted to the APA in 1874.

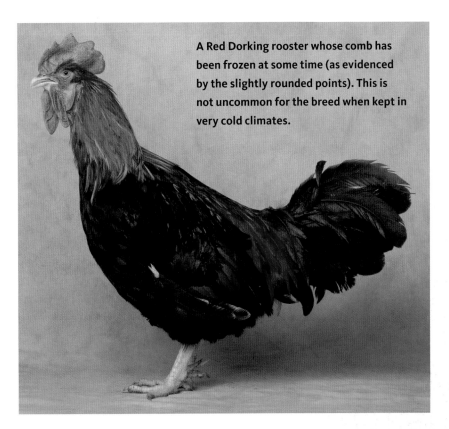

A Red Dorking rooster whose comb has been frozen at some time (as evidenced by the slightly rounded points). This is not uncommon for the breed when kept in very cold climates.

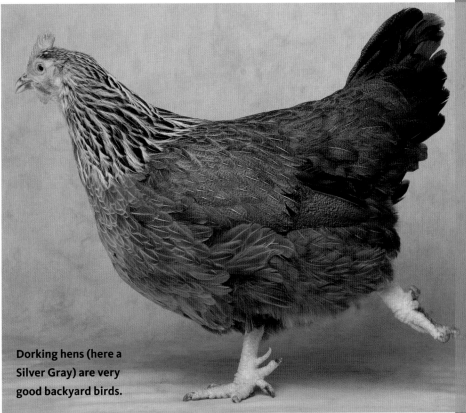

Dorking hens (here a Silver Gray) are very good backyard birds.

Dorking *continued*

DORKING FACTS

CLASS **Standard** English. **Bantam** Single Comb, Clean Legged; Rose Comb, Clean Legged.

SIZE **Standard Cock**: 9 lb. (4.1 kg) | **Hen**: 7 lb. (3.2 kg)
Bantam Cock: 36 oz. (1 kg) | **Hen**: 32 oz. (910 g)

COMB, WATTLES & EARLOBES Large wattles; medium-size earlobes. All, including comb, are bright red.
Single Comb. *Male*: Large comb has six evenly serrated points that stand upright. The middle two points are longest. *Female*: Medium-size comb with six distinct points falling to side of head.
Rose Comb. Large, square in front, terminating in well-defined spike, covered with small rounded points.

COLOR Some varieties, including black, crele, light gray, and speckled, are available but not yet recognized by the APA or ABA. Eyes are reddish bay; shanks and toes are pinkish white.
Colored. Single and rose comb. Beak is dark horn. *Male*: Hackle and saddle have straw-colored feathers with a black stripe; front of neck, cape, breast, body, and tail are lustrous black. Back and wings are black with straw lacing. *Female*: Hackle is black with straw lacing and shaft. Front of neck and breast are salmon with some black edging on lower areas. Remainder of feathers are brown to brownish black, mixed with gray.

Cuckoo. Single and rose comb. Beak is pinkish white streaked with horn. Standard cuckoo plumage (page 27).

Red. Single and rose comb. Beak is pinkish white streaked with horn. Although this variety is referred to as red, it meets the description of black-breasted red plumage (page 26).

Silver Gray. Single comb. Beak is pinkish white streaked with horn. *Male*: Head, neck, back, and saddle are white to silvery white. Cape, breast, body, and legs are black to greenish black. Tail is primarily greenish black, though small coverts near saddle are laced in white. Wings are black with white highlighting. Undercolor is slate. *Female*: Head is silvery white. Hackle is silvery white with a narrow black stripe and some gray stippling. Front of neck and breast are salmon shading to gray at sides. Back, body, legs, and wings are ashy gray with some white stippling. Tail is dull black stippled with gray.

White. Single and rose comb. Beak is pinkish white. Standard white plumage (page 29).

PLACE OF ORIGIN Britain

CONSERVATION STATUS Threatened

SPECIAL QUALITIES Good dual-purpose breed with fine-textured meat. Great choice for backyard birds.

Faverolle

NAMED FOR A VILLAGE in France, the Faverolle was developed in the mid-nineteenth century as a good dual-purpose breed known for fine table quality and strong production of brown eggs in winter. No good records were kept on the breed's development, so there is some uncertainty as to its bloodlines.

Some poultry historians speculate that it is a cross of **Dorkings** (page 85), **Houdans** (page 121), and an Asiatic breed; **Brahmas** (page 77), **Langshans** (page 128), and **Cochins** (page 113) are all mentioned as possible suspects. Others lean toward crosses between a five-toed fowl similar to the Dorking and found in the French countryside and an old Belgian breed, the Maline, that showed gamebird influence, with perhaps some Brahma mixed in. Regardless of the breeds involved, the resulting birds show some distinctive physical features: five toes, lightly feathered legs, a beard and muffs, and a broad breast carried well forward.

Faverolles are very gentle and make good backyard birds, particularly for people with kids; they become almost affectionate with their handlers. However, they tend to be more aggressive toward other breeds. Hens lay plenty of medium-size, light brown eggs and have good winter production. They may go broody and are good mothers to their clutch.

The Faverolle was first admitted to the APA in 1914.

FAVEROLLE FACTS

CLASS **Standard** Continental.

Bantam All Other Combs, Clean Legged.

SIZE **Standard Cock:** 8 lb. (3.6 kg) | **Hen:** 6.5 lb. (3 kg)

Bantam Cock: 30 oz. (850 g) | **Hen:** 26 oz. (740 g)

COMB, WATTLES & EARLOBES Medium-size single comb stands upright. Wattles are small and well rounded; earlobes are oblong but hidden by the muff. All are bright red.

COLOR In addition to those listed below, breeders in Britain have developed a cuckoo variety and an ermine variety that soon may be in North America.

Black. Beak is black; eyes are dark brown; shanks and toes are black. Standard black plumage (page 26), including beard and muffs.

Blue. Beak is black streaked with gray; eyes are dark brown; shanks and toes are bluish black. Standard blue plumage (page 26), including beard and muffs.

Buff. Beak is pinkish white; eyes are reddish bay; shanks and toes are pinkish white. Standard buff plumage (page 26), including beard and muffs.

Salmon. Beak is pinkish horn; eyes are reddish bay; shanks and toes are pinkish white. *Male:* Head and hackle are straw. Beard, muffs, front of neck, breast, body, tail, and legs are black. Back is reddish brown laced with light brown changing to straw at saddle. Wings are black highlighted with straw and white. *Female:* Beard and muffs are creamy white. Head, hackle, back, wings, and tail are salmon-brown. Breast, body, and legs are creamy white.

White. Beak is pinkish horn; eyes are reddish bay; shanks and toes are pinkish white. Standard white plumage (page 29), including beard and muffs.

PLACE OF ORIGIN France

CONSERVATION STATUS Critical

SPECIAL QUALITIES Excellent dual-purpose backyard bird, particularly for kids (though occasionally a rooster can become extremely aggressive toward people).

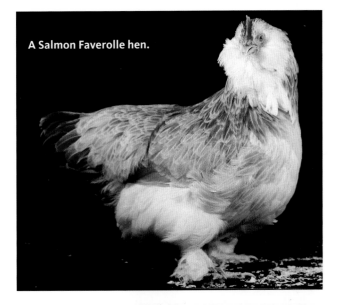

A Salmon Faverolle hen.

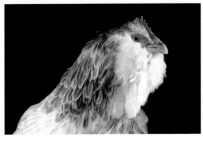

A close-up showing the beard and muffs.

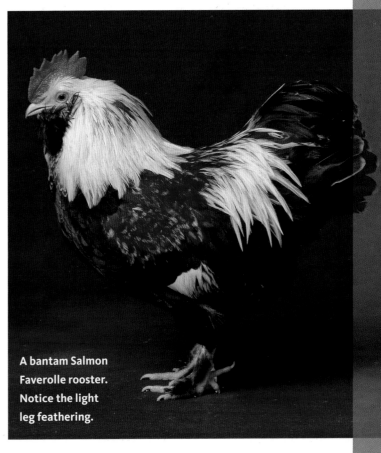

A bantam Salmon Faverolle rooster. Notice the light leg feathering.

Holland

YOU MIGHT GUESS THAT the Holland breed was developed in Holland, right? It wasn't! The breed was developed by scientists at Rutgers University in New Jersey in 1934.

In 1934, most eggs produced for market came from small farms that maintained dual-purpose flocks, and most of those dual-purpose birds laid brown eggs. Consumers were willing to pay a premium for white eggs, so the Rutgers breeders set out to produce a dual-purpose bird that laid white eggs.

The scientists created the White Holland by crossing stock imported from Holland with **White Leghorns** (page 58), **Rhode Island Reds** (page 70), **New Hampshires** (page 97), and **Lamonas** (page 28). They used White Leghorns, **Barred Plymouth Rocks** (page 68), **Australorps** (page 44), and Brown Leghorns to produce the barred variety.

Hollands are well suited to barnyard and backyard conditions. They tend to grow slowly, but they are good foragers, so they can take care of a good bit of their own food needs. They also have calm temperaments and are fairly hardy, though in extremely cold climates the males may suffer some frostbite to the comb. The hens produce lots of medium to large white eggs, will go broody, and are good moms. The breed is recognized by the APA in both standard and bantam classes, but the bantam is not recognized by the ABA.

The Holland was first admitted to the APA in 1949.

A hen from Holland? Nope; a hen from New Jersey!

HOLLAND FACTS

CLASS **Standard** American.

Bantam Single Comb, Clean Legged.

SIZE **Standard Cock**: 8.5 lb. (3.9 kg) | **Hen**: 6.5 lb. (3 kg)

Bantam Cock: 34 oz. (965 g) | **Hen**: 30 oz. (850 g)

COMB, WATTLES & EARLOBES Single comb with six well-defined points that stand upright on males and lean over at the rear on females. Medium to moderately large wattles and earlobes. Comb and wattles are bright red. Bright red was also set in the APA *Standard of Perfection* for earlobe color. Breeders have never been able to fix this trait tightly, however, so earlobes are usually red with a white center, though they vary between pure red and almost pure white.

COLOR

Barred. Standard barred plumage (page 26).

White. Standard white plumage (page 29).

PLACE OF ORIGIN United States

CONSERVATION STATUS Critical

SPECIAL QUALITIES Nice backyard or barnyard dual-purpose layer of white eggs.

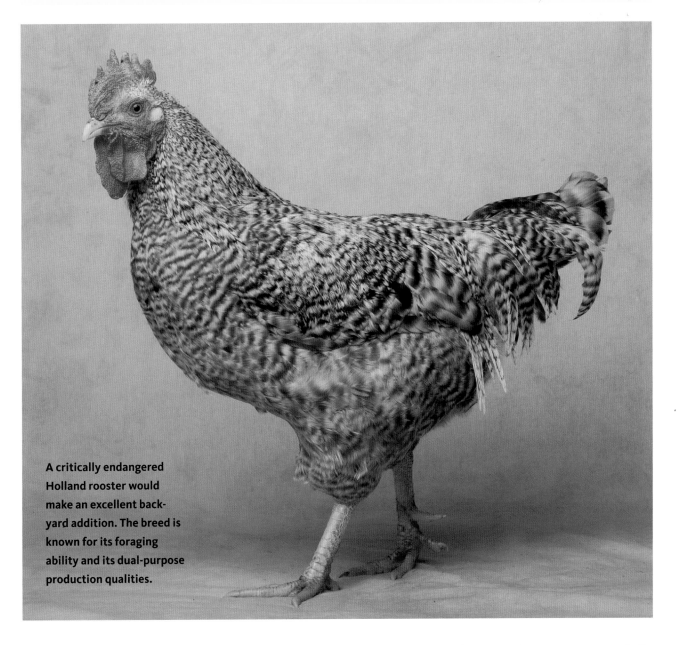

A critically endangered Holland rooster would make an excellent backyard addition. The breed is known for its foraging ability and its dual-purpose production qualities.

Iowa Blue

DEVELOPED AROUND Decorah, Iowa, in the first half of the twentieth century, the Iowa Blue is a very rare bird that has never been recognized by the APA or ABA. Little is known about its origins, but it has an interesting, folksy story.

The story goes that a **White Leghorn** (page 58) hen went broody under a building and when she emerged with a clutch of chicks, they were like none anyone had seen before. Some of the chicks were colored solid chestnut, but others looked like pheasant chicks, with light yellow, horizontal stripes on their cheeks, a triangle of yellow under their chins, and black stripes down their backs. Old-timers familiar with the breed would tell the tale that the birds were sired by a pheasant.

In the 1960s, several small hatcheries around Iowa carried the birds, but after those hatcheries went out of business the breed almost died out. Ken Whealy of the Decorah-based nonprofit Seed Savers Exchange (an organization dedicated to the preservation of heirloom plants) found a few straggling flocks. He has been helping to preserve the breed and disperse it to other interested breeders since the late 1980s.

The Iowa Blue is a dual-purpose bird that is known as a good forager; it does really well in a free-range operation. Hens lay brown eggs and will go broody, exhibiting great maternal characteristics. When Iowa Blue roosters are used in crosses they produce sex-linked chicks — such as grayish cockerels and black pullets when crossed with a **White Plymouth Rock** (page 68) hen, or reddish gray cockerels and blackish gray pullets when crossed with a **New Hampshire** (page 97) hen.

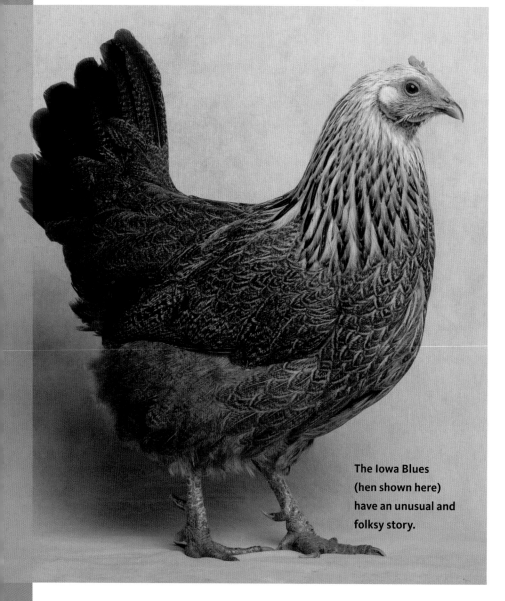

The Iowa Blues (hen shown here) have an unusual and folksy story.

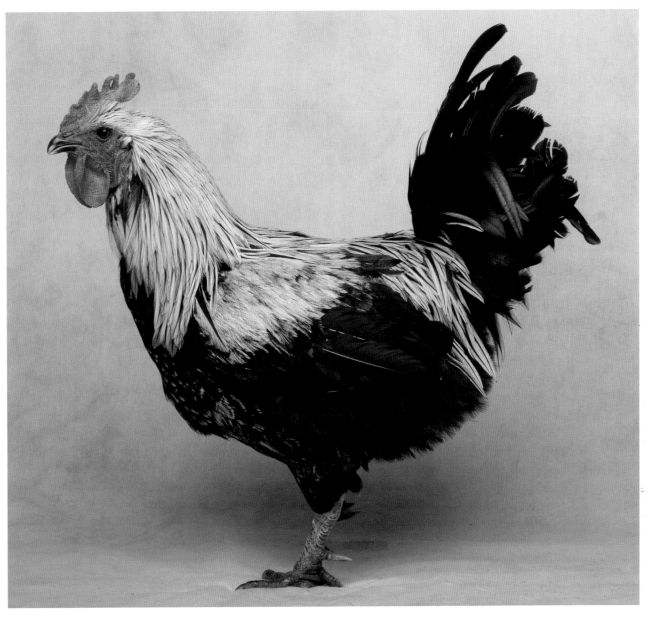

An Iowa Blue rooster.

IOWA BLUE FACTS

SIZE **Cock:** 7 lb. (3.2 kg) | **Hen:** 6 lb. (2.75 kg)

COMB, WATTLES & EARLOBES Medium to moderately large single comb with six well-defined points that stand upright. Medium to moderately large wattles and earlobes. All are bright red.

COLOR Beak is horn; eyes are dark brown; shanks and toes are slate. In spite of the name, this isn't a true blue bird. Head is white to silvery white. Neck and upper breast have white feathers with a slender black stripe down the middle transitioning to black feathers with white lacing. Lower breast, body, legs, wings, and tail are bluish black to gray with penciling. *Male:* Back and saddle are similar to neck. *Female:* Back is bluish to gray with penciling.

PLACE OF ORIGIN United States

CONSERVATION STATUS Study

SPECIAL QUALITIES Nice backyard or barnyard dual-purpose layer of lightly tinted brown eggs. Produces sex-linked offspring when used in cross-breeding programs.

Java

THE **DOMINIQUE** (page 53) was the first American breed, and the Java was the second. It was developed from birds imported from Asia and was described in literature by 1835, but the breed was probably developed well before then. Though the specifics of its parentage aren't well-known, the importance of the breed in the development of other American breeds is unquestioned: Java bloodlines played a role in the development of the **Jersey Giant** (page 94), the **Rhode Island Red** (page 70), and the **Plymouth Rock** (page 68).

Javas have a rectangular build, similar to that of the Rhode Island Red, but with a long, broad, sloping back (the longest in the American class) and a full, deep breast. Their single comb is somewhat unique in that the first point is fairly far back on the head, above the eye and not the nostril, which tends to indicate that the breed was produced from pea-combed ancestors.

Javas are well suited for backyard and barnyard production. They do well in a free-range operation but will tolerate confinement. They are calm, fairly cold-hardy, and very good foragers. The hens are excellent brooders and mothers and lay a fair number of medium-size brown eggs.

Javas are recognized by the APA in both standard and bantam classes. The bantam is recognized by the ABA but not included in its *Bantam Standard*.

At one time the APA recognized a white variety, but in 1910 the association removed it from its

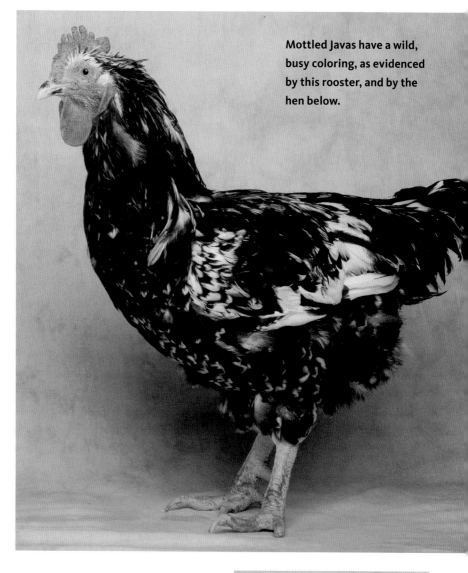

Mottled Javas have a wild, busy coloring, as evidenced by this rooster, and by the hen below.

standard because it was thought to be too similar to the White Plymouth Rock. The white results from a recessive gene; once it was removed from the APA *Standard of Perfection* the variety disappeared. In recent years, however, some white chicks showed up, and breeders began working to bring back a white strain.

The Java was first admitted to the APA in 1883.

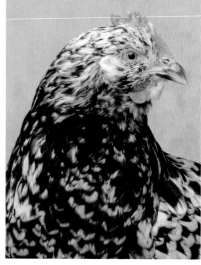

JAVA FACTS

CLASS **Standard** American.

Bantam Single Comb, Clean Legged.

SIZE **Standard Cock**: 9.5 lb. (4.3 kg) | **Hen**: 7.5 lb. (3.4 kg)

Bantam Cock: 36 oz. (1 kg) | **Hen**: 32 oz. (910 g)

COMB, WATTLES & EARLOBES Single comb, with first of five points starting well back on head. Upright in both sexes. Medium-size, well-rounded wattles; small earlobes. All are bright red.

COLOR

Black. Beak is black; eyes are dark brown; shanks and toes are black to dark willow, though bottoms of feet are yellow. Standard black plumage (page 26).

Mottled. Beak is horn; eyes are reddish bay; shanks and toes are yellow with leaden blue mottles, with yellow on bottom of feet. Standard mottled plumage (page 28).

White. Beak is horn; eyes are reddish bay; shanks and toes are light willow with yellow on bottom of feet. Standard white plumage (page 29).

PLACE OF ORIGIN United States

CONSERVATION STATUS Critical

SPECIAL QUALITIES Practical dual-purpose bird. Hardy, and a good forager.

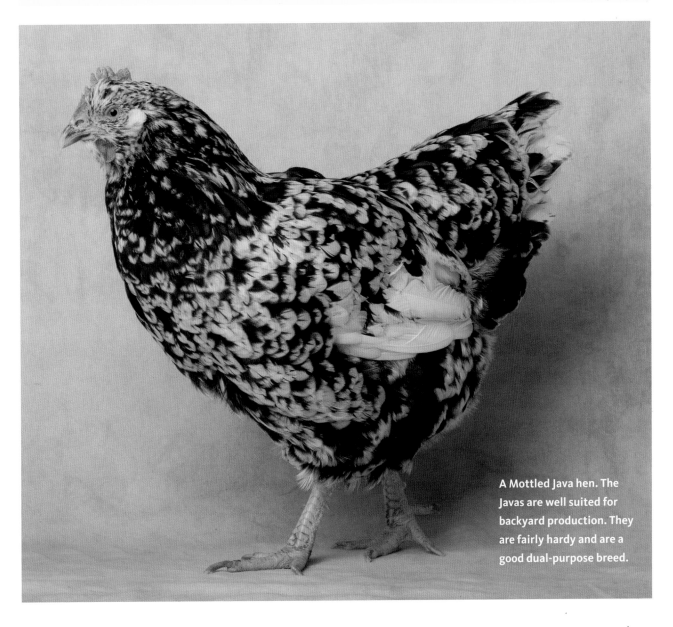

A Mottled Java hen. The Javas are well suited for backyard production. They are fairly hardy and are a good dual-purpose breed.

Jersey Giant

HAVING BEEN BORN a Jersey girl, I've always had a soft spot in my heart for Black Jersey Giants. The black variety originated in New Jersey in the 1880s when the Black brothers, John and Thomas, crossed **Black Javas** (page 92), **Dark Brahmas** (page 77), **Dark Cornishes** (page 81), and **Black Langshans** (page 128).

The white variety was developed from white sports of the black variety. Interestingly, the white chicks start out a smoky gray color. A blue variety, perfected over sixty years through the dedicated efforts of a famous Jersey Giant breeder, Mrs. Golda Miller of Bern, Kansas, and a splash variety have also been developed from sports. In addition, I have seen unconfirmed reports of a barred variety and a silver variety. The APA has not recognized any of these varieties.

As the name implies, Jersey Giants are very large birds. In fact, they are the largest chicken breed. At one time the roosters were often caponized, or castrated, which allowed them to grow to an amazing 20 pounds (9.1 kg).

They are fairly good layers of moderately large to extra-large brown eggs, with a long laying season. They are slow to mature and have a poor feed-to-meat conversion, which explains why they aren't popular as a commercial broiler, though they were popular in the late 1800s, when they took over the capon niche previously filled by their ancestor the Java. In spite of their low conversion rates, they are fairly cold-hardy and have a wonderful, calm disposition. Hens will go broody and make very good mothers.

Jersey Giants are recognized by the APA in both standard and bantam classes. The bantam is recognized by the ABA but not included in its *Bantam Standard*.

The Jersey Giant was first admitted to the APA in 1922.

One of my personal favorites: a Black Jersey Giant hen.

JERSEY GIANT FACTS

CLASS Standard American.
Bantam Single Comb, Clean
Legged.

SIZE Standard Cock: 13 lb. (5.9 kg)
| **Hen**: 10 lb. (4.5 kg)
Bantam Cock: 38 oz. (1.1 kg) |
Hen: 34 oz. (965 g)

COMB, WATTLES & EARLOBES
Large single comb with six
upright points that conforms to
the curve of the head. Medium-
size, well-rounded wattles;
medium-size earlobes. All are
bright red.

COLOR Blue and splash varieties
are available but not recognized
in the APA *Standard of
Perfection*.
Black. Beak is black shading to
yellow at tip; eyes are dark
brown; shanks and toes are
black or dark willow with yellow
on bottom of feet. Standard
black plumage (page 26), though
particularly lustrous with a bee-
tle green sheen.
White. Beak is yellow to horn;
eyes are dark brown; shanks and
toes are dark willow with yellow
underneath. Standard white
plumage (page 29).

PLACE OF ORIGIN United States
CONSERVATION STATUS Watch
SPECIAL QUALITIES The "Big
Bird" of the chicken yard. Good
disposition for backyard flocks.

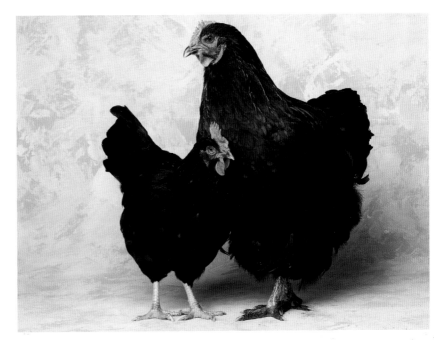

*How large is a Jersey Giant? Big, big, big! This Jersey Giant hen
is standing next to a Rhode Island Red hen.*

*A Black Jersey Giant cock, such as this one
here, can weigh 13 pounds (5.9 kg).*

Malay

THE MALAY, A VERY OLD BREED that originated in Southeast Asia, is the tallest of the chicken breeds, towering over 3 feet (91 cm) in height with a very long neck and giant legs. Although its posture is upright and quite straight, when viewed in profile the Malay shows three distinctive, downward curves at the top line of the neck, the back, and the tail (which is carried below the horizontal).

The breed is also known for its "beetle brow," a projection of the skull over the eyes that gives it an ornery appearance. There are normally few or no feathers on the face, throat, and breast; the skin here is rough. Other feathers are hard and short, lying close to the body.

In spite of its angry facade, the Malay tends to be mellower than other games. Slow to mature, the breed is active and doesn't do well in close confinement. Although hens can go broody and are good mothers, they lay eggs infrequently.

The Malay was first admitted to the APA in 1883.

The Malay is the tallest breed of chickens, with roosters standing over 3 feet (91 cm) tall! Notice the strawberry comb. At left, a Black-Breasted Red rooster; below, a Mottled hen.

MALAY FACTS

CLASS **Standard** All Other Standard Breeds.
 Bantam All Other Combs, Clean Legged.

SIZE **Standard Cock:** 9 lb. (4.1 kg) | **Hen:** 7 lb. (3.2 kg)
 Bantam Cock: 44 oz. (1.25 kg) | **Hen:** 36 oz. (1 kg)

COMB, WATTLES & EARLOBES Small to medium-size
 strawberry comb set well forward on the brow. Very
 small wattles and earlobes. All are red.

COLOR Unless otherwise noted, beak is yellow; eyes
 are pearl; shanks and toes are yellow.
 Black. Beak is dark horn; shanks and toes are dark
 horn to dusky yellow. Standard black plumage
 (page 26).

Black-Breasted Red. Standard black-breasted red
 plumage (page 26).

Mottled. Standard mottled plumage (page 28).

Red Pyle. Standard red pyle plumage (page 28).

Spangled. Standard spangled plumage (page 29).

Wheaten. Standard wheaten plumage (page 29).

White. Standard white plumage (page 29).

PLACE OF ORIGIN Southeast Asia

CONSERVATION STATUS Critical

SPECIAL QUALITIES Tallest of all chickens. Rare, but
 popular with show crowds.

New Hampshire

THE NEW HAMPSHIRE BREED was developed by researchers at the New Hampshire Agricultural Experiment Station and by New Hampshire farmers in the early years of the twentieth century. They selected **Rhode Island Reds** (page 70) for faster growth and feathering, not color, resulting in a lighter color than seen in Rhode Island Reds. They also selected parents more for meat production than for egg production, ultimately yielding a dual-purpose chicken that dresses out as a nice, plump broiler or a roaster.

New Hampshires are adaptable to either confinement or free range. They are usually calm, though some are aggressive. They mature early and are fairly cold-hardy, though their combs are susceptible to frostbite in extremely cold climates. Hens lay a fair number of large brown eggs and are good brooders and excellent mothers.

The New Hampshire was first admitted to the APA in 1935.

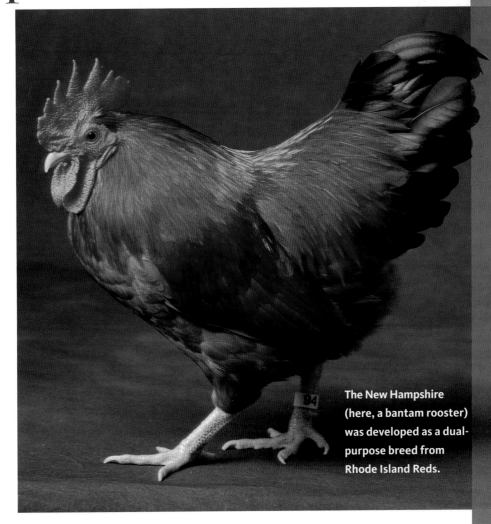

The New Hampshire (here, a bantam rooster) was developed as a dual-purpose breed from Rhode Island Reds.

New Hampshire *continued*

NEW HAMPSHIRE FACTS

CLASS **Standard** American. **Bantam** Single Comb, Clean Legged.

SIZE **Standard Cock**: 8.5 lb. (3.9 kg) | **Hen**: 6.5 lb. (3 kg) **Bantam Cock**: 34 oz. (965 g) | **Hen**: 30 oz. (850 g)

COMB, WATTLES & EARLOBES Medium-size single comb with five points that are upright in males and droop to side at rear on females. Medium to moderately large wattles and elongated earlobes. All are bright red.

COLOR Beak is reddish horn; eyes are reddish bay; shanks and toes are rich yellow tinged with reddish horn. Plumage in both sexes is primarily a lustrous golden bay to chestnut red with some black in tail. *Female*: Lower neck feathers have distinct black tips.

PLACE OF ORIGIN United States

CONSERVATION STATUS Watch

SPECIAL QUALITIES Excellent dual-purpose bird where meat production is a primary consideration.

A bantam New Hampshire hen.

Orpington

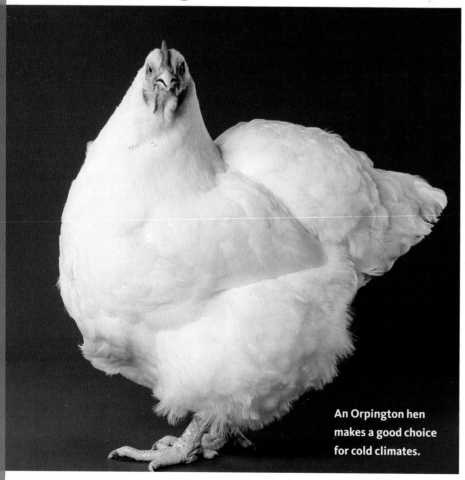

An Orpington hen makes a good choice for cold climates.

IN THE 1880S WILLIAM COOK was a successful poultryman in the village of Orpington, in county Kent, England. He published a periodical, *The Poultry Journal*; authored a book on poultry keeping titled *The Poultry Keeper's Account Book*; and sold poultry supplies. In 1886 he introduced the Black Orpington, a new breed he had developed, at the Chrystal Palace Poultry Show. His pullet won the grand prize cup.

Cook developed the bird by breeding **Black Minorcas** (page 63) with **Black Plymouth Rocks** (page 68) and crossing the resulting birds with clean-legged **Langshans** (page 128). The first Orpingtons were truly excellent production birds with good carcasses and strong winter production of brown eggs. Breeders quickly selected for looks over production, and by the turn of the century they were lethargic and often infertile birds.

Cook, and his children after him, stayed active breeding Orpingtons and came up with other colors, including blue, buff, cuckoo, ermine, jubilee, partridge, red, and white (only black, blue, buff, and white are currently recognized by the APA). The buff, which was bred from **Golden Spangled Hamburg** (page 55), **Buff Cochin** (page 113), and **Dark Dorking** (page 85), became a favorite bird for show and production and is still the most common color of the Orpingtons.

Orpingtons are still raised as a general-purpose fowl, producing a heavy carcass and plenty of brown eggs. Their feathers are quite broad and full yet lie smooth against their deep bodies, giving them a substantial appearance. They do fine in either confinement or free range. They are quite docile and even somewhat affectionate toward handlers. They are very cold-hardy and mature quickly, and the hens are good brooders and mothers.

The Orpington was first admitted to the APA in 1902.

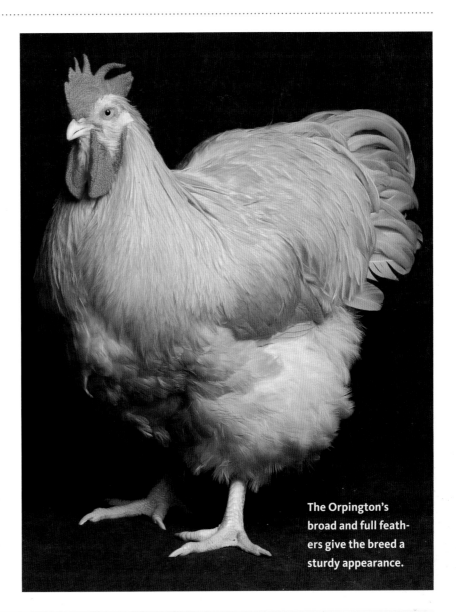

The Orpington's broad and full feathers give the breed a sturdy appearance.

ORPINGTON FACTS

CLASS **Standard** English.

 Bantam Single Comb, Clean Legged.

SIZE **Standard Cock**: 10 lb. (4.5 kg) | **Hen**: 8 lb. (3.6 kg)

 Bantam Cock: 38 oz. (1.1 kg) | **Hen**: 34 oz. (965 g)

COMB, WATTLES & EARLOBES Medium-size, bright red single comb with five well-defined points that stand upright. Medium-size, bright red wattles and earlobes.

COLOR

 Black. Beak is black; eyes are dark brown; shanks and toes are black in young and shading to dark slate in adults, with pinkish white bottoms of feet. Standard black plumage (page 26).

 Blue. Beak is horn; eyes are dark brown; shanks and toes are leaden blue, with pinkish white bottoms of feet. Standard blue plumage (page 26).

 Buff. Beak is pinkish white; eyes are reddish bay; shanks and toes are pinkish white. Standard buff plumage (page 26).

 White. Beak is pinkish white; eyes are reddish bay; shanks and toes are pinkish white. Standard white plumage (page 29).

PLACE OF ORIGIN United States

CONSERVATION STATUS Recovering

SPECIAL QUALITIES A good dual-purpose bird with a nice disposition for backyard and barnyard flocks.

Shamo

MEASURING ABOUT 30 inches (76 cm) tall, the Shamo is the second tallest chicken breed. It is an ancient Japanese breed, from which a number of other domesticated chickens in Japan were developed, including the **Yokohama** (page 166) and the **Phoenix** (page 143). The Shamo was first imported to the United States for cockfighting in 1874. It is a protected species in Japan.

Shamos have very short, hard feathers that may not fully cover the body. Like the **Malays** (page 96), with whom they share common ancestry, they have a beetle brow (a prominent and bony forehead), no feathers on their face and throat, and roughly textured facial skin. However, their body doesn't show the three distinctive curves of the Malay.

Shamos are very aggressive fighters. Chicks will begin fighting almost immediately after birth, and cocks must be kept separated, but Shamos like humans and will tame down nicely. Hens are excellent mothers and lay more eggs than the other Asiatic games.

The Shamo was first admitted to the APA in 1981.

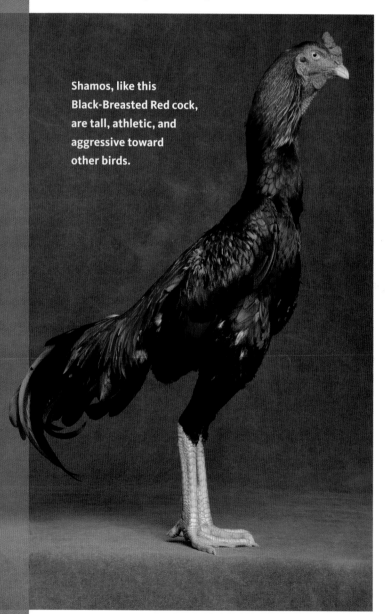

Shamos, like this Black-Breasted Red cock, are tall, athletic, and aggressive toward other birds.

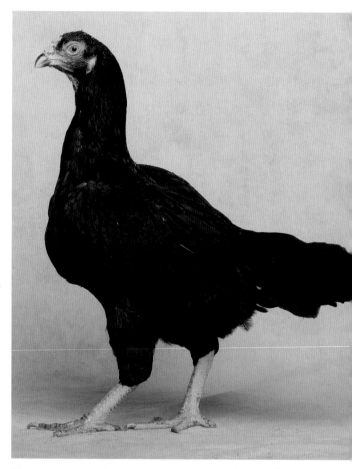

Shamo hens are excellent mothers.

SHAMO FACTS

CLASS **Standard** All Other Standard Breeds.
Bantam All Other Combs, Clean Legged.

SIZE **Standard Cock**: 11 lb. (5 kg) | **Hen**: 7 lb. (3.2 kg)
Bantam Cock: 44 oz. (1.25 kg) | **Hen**: 35 oz. (990 g)

COMB, WATTLES & EARLOBES Small pea comb and
earlobes; wattles are very small or missing entirely.
All are bright red.

COLOR Beak is yellow; eyes are pearl; shanks and toes
are yellow.
Black. Standard black plumage (page 26).
Black-Breasted Red. Standard black-breasted red
plumage (page 26).

Brown Red. Standard brown-red plumage (page 26).
Buff Columbian. Standard buff Columbian plumage
(page 26).
Dark. Standard dark plumage (page 27).
Spangled. Standard spangled plumage (page 29).
Wheaten. Standard wheaten plumage (page 29).
White. Standard white plumage (page 29).

PLACE OF ORIGIN Japan

CONSERVATION STATUS Study

SPECIAL QUALITIES Upright birds that are making a
name with show enthusiasts.

Sussex

Probably the most common utility breed for almost a century in England, the Sussex provided meat and eggs for the London market from the mid-nineteenth century through the mid-twentieth century. It never enjoyed quite as dedicated a following in North America, perhaps due to its bright pinkish white skin, which North Americans favor less than a more yellow skin.

The early history and breeding of the Sussex is unclear, but it was definitely an established breed in England by 1845, and some believe that the Romans had brought the breed to England two thousand years ago. It is also thought that this breed and **Dorkings** (page 85) were of the same breed at one time, with the five-toed offspring being Dorkings and the four-toed being Sussex.

For over half a century there was no breed club for the Sussex. This changed in 1903 when a renowned English poultryman, Edward Brown, berated the

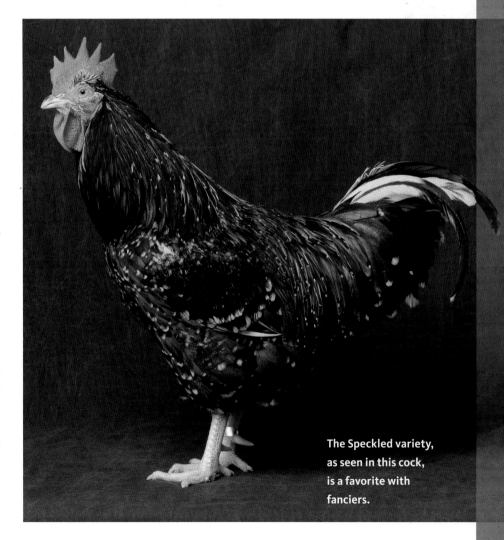

The Speckled variety, as seen in this cock, is a favorite with fanciers.

MEAT BREEDS

poultrymen of Sussex for having produced the finest poultry in England but allowing the fowl to come to the point of dying out. Mr. E. J. Wadman accepted this challenge and formed a club, which helped protect the Sussex in its native land.

The Sussex is a graceful bird, with a long and broad back giving way to a tail that sits at a 45-degree angle from the body. It is adaptable to either confinement or free range and, as a calm and curious bird, does well in backyards and barnyards. Hens lay a fair number of medium-size eggs and are good mothers.

The Sussex was first admitted to the APA in 1914.

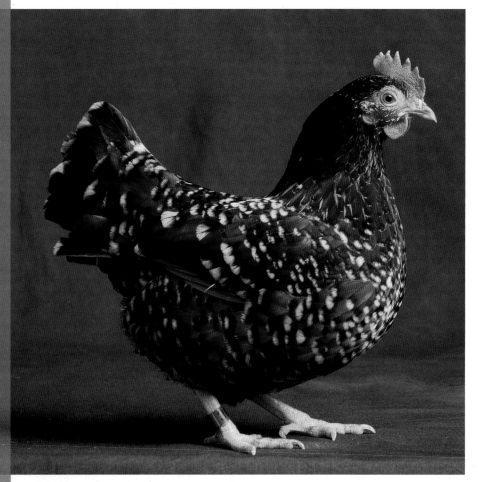

Sussex hens, such as this bantam, are calm, curious, and gracefully proportioned. The breed is a good backyard utility breed.

SUSSEX FACTS

CLASS **Standard** English. **Bantam** Single Comb, Clean Legged.

SIZE **Standard Cock**: 9 lb. (4.1 kg) | **Hen**: 7 lb. (3.2 kg) **Bantam Cock**: 36 oz. (1 kg) | **Hen**: 32 oz. (910 g)

COMB, WATTLES & EARLOBES Medium-size, single comb has five upright, well-defined points. Medium-size earlobes. Wattles are small to medium in size and well rounded. All are bright red.

COLOR Eyes are reddish bay and shanks and toes are white in all varieties.

Birchen. Beak is swarthy horn. Standard birchen plumage (page 26).

Buff. Beak is horn. Standard buff plumage (page 26).

Dark Brown. Beak is horn. Standard dark brown plumage (page 27).

Light. Beak is horn. Referred to as "Light," but meets the description for standard Columbian plumage (page 26).

Red. Beak is horn. Referred to as "Red," but meets the description for standard black-tailed red plumage (page 26).

Speckled. Beak is pinkish horn. In both sexes, overall plumage is lustrous mahogany. Feathers are tipped in a white spangle that is separated from the mahogany by a band of black.

White. Beak is white. Standard white plumage (page 29).

PLACE OF ORIGIN England

CONSERVATION STATUS Threatened

SPECIAL QUALITIES Great dual-purpose bird.

Wyandotte

THIS BREED IS NAMED after a Native American tribe (the Wendat, whose name French and English settlers corrupted to Wyandotte or Wyandot) indigenous to parts of upstate New York and Ontario, Canada. Four breeders from New York, Michigan, and Massachusetts developed the breed in the 1870s. The breeders first named their creation the American Sebright, but when the breed was accepted into the APA *Standard of Perfection* in 1883, the name was changed to conform to the tradition of giving American breeds a name associated with the place in which they were developed.

The Silver Laced Wyandotte was the first variety, and though it is a relatively recent addition to chickendom, its roots are uncertain, as the breeders did not keep any known written records. Fanciers tend to agree, however, that both Asiatic and Continental bloodlines, such as **Dark Brahma** (page 77) and **Spangled Hamburg** (page 55), were included in the mix.

Wyandottes have a well-rounded body supported on stout legs that are set well apart when viewed from the front. The tail is short and held at a 40-degree angle from the body. They have somewhat loose, fluffy feathers that add to their curvy appearance. Their body is longer than it appears. Combined with the wide range of fancy colors, these characteristics make for a showy bird that has a loyal following of fanciers. But Wyandottes are also known as superb dual-purpose birds that mature fairly quickly and have good egg production.

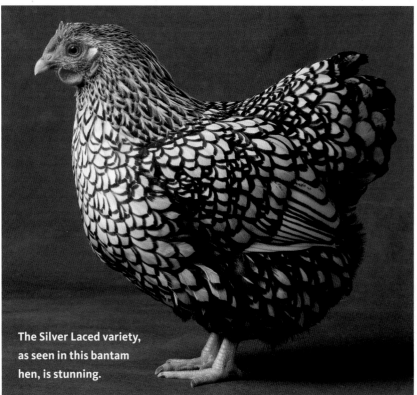

The Silver Laced variety, as seen in this bantam hen, is stunning.

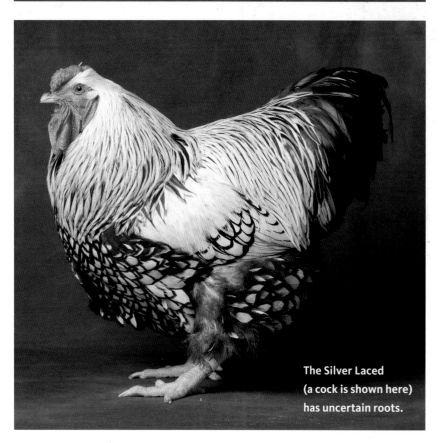

The Silver Laced (a cock is shown here) has uncertain roots.

Wyandotte *continued*

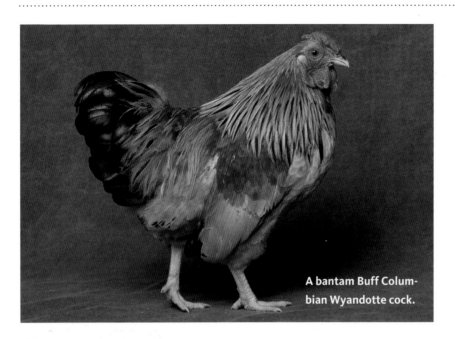

A bantam Buff Columbian Wyandotte cock.

Because of its relatively short back, a dressed Wyandotte is likely to appeal to today's consumer because it is nearly proportional to a Cornish-Rock bird found at the store. Hens will occasionally go broody and make good mothers. Adaptable to either confinement or free range, Wyandottes are generally docile, though some individuals may be aggressive, and thanks to their rose comb, they are very cold-hardy.

The Wyandotte was first admitted to the APA in 1883.

WYANDOTTE FACTS

CLASS **Standard** American.

Bantam Rose Comb, Clean Legged.

SIZE **Standard Cock**: 8.5 lb. (3.9 kg) | **Hen**: 6.5 lb. (3 kg)

Bantam Cock: 30 oz. (850 g) | **Hen**: 26 oz. (740 g)

COMB, WATTLES & EARLOBES Rose comb, low and firm on head. Well-rounded, moderately long wattles; oblong earlobes. All are bright red.

COLOR Beak is always in shades of yellow and may have some dark striping on upper mandible; eyes are reddish bay; shanks and toes are yellow.

Barred. Standard barred plumage (page 26).

Birchen. Head is white to silvery white. Standard birchen plumage (page 26).

Black. Standard black plumage (page 26).

Black-Breasted Red. Standard black-breasted red plumage (page 26).

Blue. Standard blue plumage (page 26).

Blue Red. Standard blue-red plumage (page 26).

Brown Red. Standard brown-red plumage (page 26).

Buff. Standard buff plumage (page 26).

Buff Columbian. Standard buff Columbian plumage (page 26).

Columbian. Standard Columbian plumage (page 26).

Golden Laced. *Male*: Head, hackle, and saddle are golden bay with a black stripe down the middle. Front of neck, breast, and body are reddish bay with narrow black lacing. Back is rich golden bay. Tail and wings are primarily black with some golden bay highlights. *Female*: Golden bay head. Hackle is black with golden bay lacing and shaft. Remainder of body is golden bay with black lacing. Tail is black.

Lemon Blue. Standard lemon blue plumage (page 27).

Partridge. Standard partridge plumage (page 28).

Silver Laced. *Male*: Head, neck, and saddle are silvery white with a black stripe down the middle. Cape is silvery white. Breast, body, wings, legs, shanks, and outer toe feathers are silvery white with lacing of black. Tail is primarily black. *Female*: Head is silvery white. Hackle is silvery white with a black stripe. Rest of body is silvery white with black lacing. Main tail feathers are black.

Silver Penciled. Standard silver penciled plumage (page 29).

Splash. Standard splash plumage (page 29).

White. Standard white plumage (page 29).

White-Laced Red. *Male*: Primarily rich red laced in white, except main tail feathers are white. *Female*: Primarily rich red laced in white.

PLACE OF ORIGIN United States

CONSERVATION STATUS Recovering

SPECIAL QUALITIES A workhorse of a dual-purpose breed that is extremely cold-hardy and also is a crowd-pleaser on the show circuit.

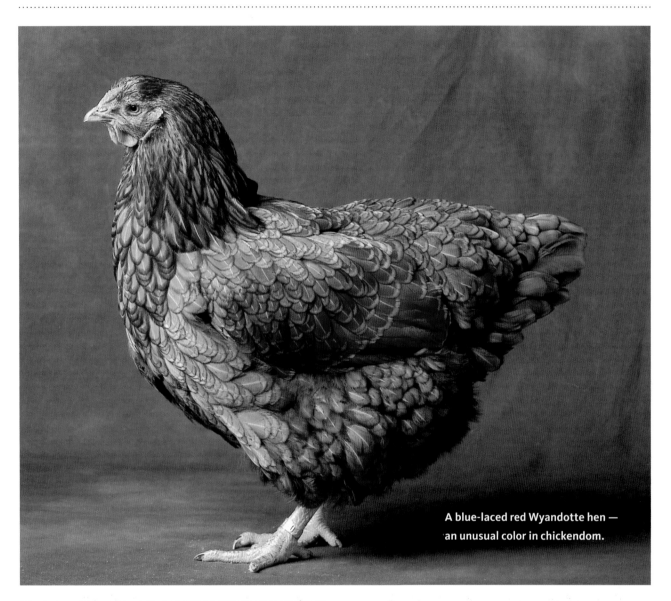

A blue-laced red Wyandotte hen —
an unusual color in chickendom.

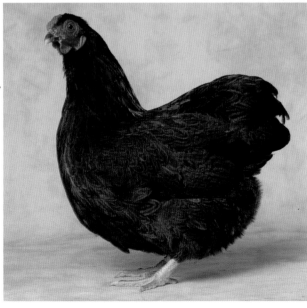

A bantam Partridge Wyandotte hen.

American Game Bantam

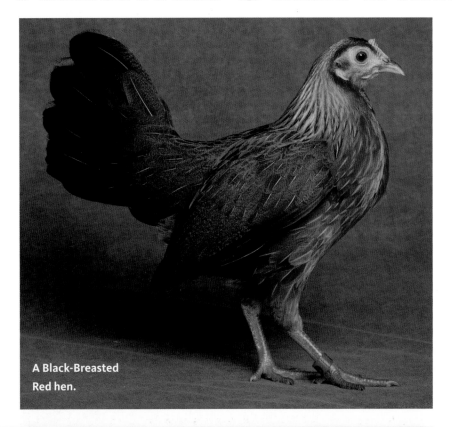

A Black-Breasted Red hen.

FRANK GARY, a New Jersey fancier, developed the American Game Bantam in the 1940s by crossing a common "pit game" bantam (a small fighting bird) with the Red Jungle Fowl. Although fanciers at the time were showing pit game bantams, they were not recognized by any breed organization.

Gary's goal was to develop a recognized breed, and to do that he had to standardize traits such as the color of the legs and earlobes. He also wanted to get some extra length in the plumage of the hackle, saddle, and sickles so the bird would have a showier quality. Although the breed Gary developed is not yet recognized by the APA, it is recognized by the ABA.

The American Games are hardy, vigorous, and easy for beginners to raise. The females are good layers that go broody easily and are superb mothers. They tolerate confinement better than many game breeds, but males should not be confined together.

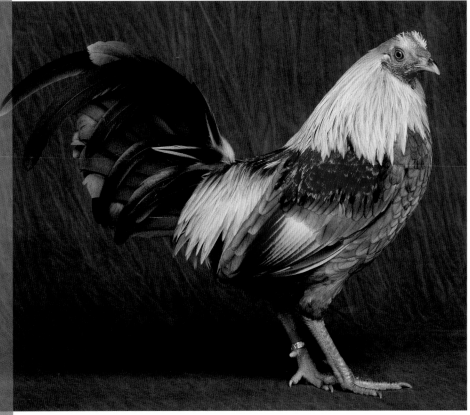

The American Game Bantam is a recent breed, only developed in the 1940s. It is a good beginner's show bird. At left is a Blue Golden Duckwing cock.

AMERICAN GAME BANTAM FACTS

SIZE **Cock:** 30 oz. (850 g) | **Hen:** 27 oz. (765 g)

COMB, WATTLES & EARLOBES Small single comb has five points that stand upright. Small, thin, smooth wattles and earlobes. All are bright red, unless otherwise noted. Comb, wattles, and earlobes are dubbed (trimmed or removed) in cocks for show.

COLOR

Birchen. Comb, wattles, and earlobes are mulberry; beak is black; eyes are dark brown; shanks and toes are black. Standard birchen plumage (page 26).

Black. Comb, wattles, and earlobes are mulberry; beak is black; eyes are dark brown; shanks and toes are black. Standard black plumage (page 26).

Black-Breasted Red. Beak is dark horn streaked with black; eyes are red; shanks and toes are bluish slate. Standard black-breasted red plumage (page 26).

Blue. Beak is dark horn streaked with black; eyes are red; shanks and toes are bluish slate. Standard blue plumage (page 26).

Blue Red. Beak is dark horn streaked with black; eyes are red; shanks and toes are bluish slate. Standard blue red plumage (page 26).

Brassy Back. Beak is dark horn streaked with black; eyes are red; shanks and toes are bluish slate. *Male:* Head, hackle, and saddle are brassy (kind of a lustrous yellow) with a black stripe down the center of each feather. Back is lustrous brass. Front of neck, breast, body, wings, tail, and legs are black to lustrous black. *Female:* Primarily chocolate to chocolaty black, with some brassiness on hackle and back.

Brown Red. Beak is black; eyes are dark brown; shanks and toes are black. Standard brown-red plumage (page 26).

Golden Duckwing. Beak is dusky horn; eyes are red; shanks and toes are bluish slate. Standard golden duckwing plumage (page 27).

Red Pyle. Beak is horn; eyes are red; shanks and toes are pinkish slate. Standard red pyle plumage (page 28).

Silver Duckwing. Beak is dusky horn; eyes are red; shanks and toes are bluish slate. Standard silver duckwing plumage (page 29).

Wheaten. Beak is dusky horn; eyes are red; shanks and toes are bluish slate. Standard wheaten plumage (page 29).

White. Beak is horn; eyes are red; shanks and toes are pinkish slate. Standard white plumage (page 29).

PLACE OF ORIGIN New Jersey

CONSERVATION STATUS Not applicable

SPECIAL QUALITIES A sprightly bird that is easy for beginners who would like to show game bantams.

Appenzeller

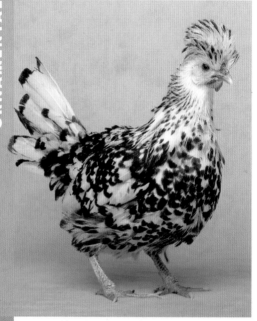

A Silver Spangled Appenzeller hen.

THERE ARE TWO TYPES of Appenzeller: the Spitzhauben ("pointed hood"), which are kind of crazy looking in a Cruella De Vil sort of way, and the Barthuhner ("bearded hen"). Neither is recognized by the APA or the ABA. In North America the Spitzhauben is available from some breeders, but the Barthuhner seems to be unknown.

Appenzellers are very active birds that fly fairly well and don't take to close confinement. They will forage for most of their own food if given the chance, are quite cold-hardy, and will remain roosting in a tree (their roost of choice) during snowstorms, apparently none the worse for wear. Birds that are allowed to roost in trees when they are young may develop bent breastbones, which is a disqualification for show birds. Hens lay a good quantity of medium-size white eggs and will occasionally go broody.

APPENZELLER FACTS

SIZE **Standard Cock:** 4.5 lb. (2 kg) | **Hen:** 3.5 lb. (1.6 kg) **Bantam Cock:** 24 oz. (680 g) | **Hen:** 20 oz. (570 g)

COMB, WATTLES & EARLOBES Red V-shaped comb; moderately large, oblong red wattles; moderately large white earlobes.

COLOR Beak dark horn; eyes dark brown; shanks and toes blue.

Black. Standard black plumage (page 26).

Golden Spangled. Standard golden spangled plumage (page 27).

Silver Spangled. Standard silver spangled plumage (page 29).

PLACE OF ORIGIN Switzerland

CONSERVATION STATUS Not applicable

SPECIAL QUALITIES Ornamental layer

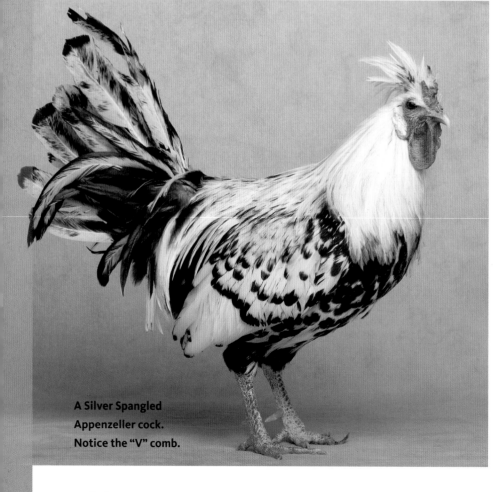

A Silver Spangled Appenzeller cock. Notice the "V" comb.

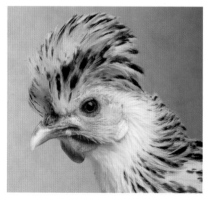

A pouf of head feathers and a white earlobe.

Bearded d'Anvers Bantam

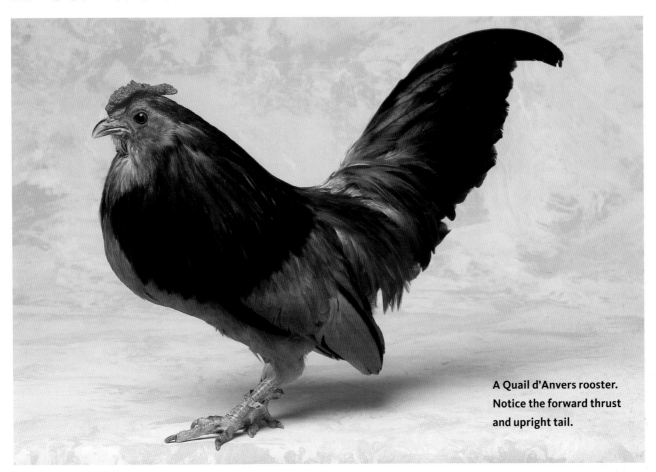

A Quail d'Anvers rooster. Notice the forward thrust and upright tail.

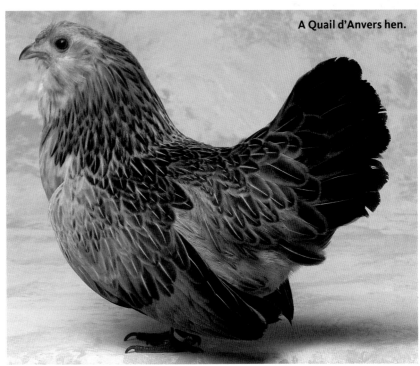

A Quail d'Anvers hen.

FORMERLY KNOWN AS the Antwerp Belgian, the d'Anvers is a true bantam; there are no large birds in the breed. No one is sure when the breed was first developed, but evidence indicates that its predecessors existed in the Netherlands and Belgium since the middle of the seventeenth century.

By the mid-nineteenth century, selection was well under way for several of the varieties that are still popular today. The number of d'Anvers increased dramatically in Europe during the early years of the twentieth century as fanciers took to the breed, though World War I resulted in a drastic drop in bird numbers. The breed was first imported to the

Bearded d'Anvers Bantam *continued*

United States in the first half of the twentieth century.

As its full name implies, the d'Anver is bearded, with thick muffs that cover the earlobes. It does well in small areas and is an active breed, though it tames nicely. The hen lays a small white egg and will go broody if you allow her. The bird's appearance is unique and striking thanks to its asymmetric body — it stands tall and carries its weight forward, with a well-spread tail that's carried at a steep angle.

The Bearded d'Anvers was first admitted to the APA in 1949.

A Porcelain d'Anvers hen.

BEARDED D'ANVERS BANTAM FACTS

CLASS Rose Comb, Clean Legged.

SIZE **Cock:** 26 oz. (740 g) | **Hen:** 22 oz. (625 g)

COMB, WATTLES & EARLOBES Rose comb is small and covered with rounded points. Breeders prefer birds with small or absent wattles. Earlobes are flat and almond-shaped but generally hidden by muffs. All are bright red.

COLOR Beak is various shades of horn. Eyes are reddish bay, unless otherwise noted. Beards and muffs are same color as plumage, unless otherwise noted.

Black. Eyes are black; shanks and toes are bluish black to slate. Standard black plumage (page 26).

Black-Breasted Red. Beards and muffs are black. Shanks and toes are light slaty blue. Standard black-breasted red plumage (page 26).

Blue. Eyes are dark brown; shanks and toes are bluish black to slate. Standard blue plumage (page 26).

Blue Quail. Eyes are dark brown; beard and muffs are brownish yellow; shanks and toes are slaty blue. *Male*: Head, hackle, back, and saddle are brilliant bluish black laced with golden bay. Breast, body, and leg feathers are brownish yellow laced with a more intense shade of brownish yellow and a straw shaft. Tail and wings are blue to black with some lacing. *Female*: Head is bluish black tinged with yellow. Hackle and back are blue to bluish black laced with golden bay. Breast, body, and leg feathers are brownish yellow laced with a lighter shade of brownish yellow and a straw shaft. Tail and wings are blue to black with some lacing.

Buff. Shanks and toes are slaty white. Standard buff plumage (page 26).

Buff Columbian. Shanks and toes are slaty blue. Standard buff Columbian plumage (page 26).

Columbian. Beard and muffs are buff; shanks and toes are slaty blue. Standard Columbian plumage (page 26).

Cuckoo. Bright red eyes; bluish white shanks and toes. Standard cuckoo plumage (page 27).

Mille Fleur. Shanks and toes are slaty blue. Standard mille fleur plumage (page 28).

Mottled. Shanks and toes are slate. Standard mottled plumage (page 28).

Porcelain. Shanks and toes are light slaty blue. Standard porcelain plumage (page 28).

Quail. Dark brown eyes; slate blue shanks and toes. Beard and muffs are brownish yellow. *Male*: Head, hackle, back, saddle, and wings are brilliant black laced with golden bay. Front of neck, breast, body, and legs are brownish yellow. Tail is black. *Female*: Head is chocolaty black tinged with yellow. Neck is lustrous chocolaty black laced with golden bay. Front of neck, breast, and body are brownish yellow laced with lighter shade of same color. Tail and wings are chocolaty black laced with light brownish yellow.

Self Blue. Eyes are brown; shanks and toes are slate. Standard self blue plumage (page 29).

White. Shanks and toes are slaty blue to pinkish gray. Standard white plumage (page 29).

PLACE OF ORIGIN Belgium

CONSERVATION STATUS Not applicable

SPECIAL QUALITIES Available only as a bantam. Good layer of small eggs.

Booted Bantam & Bearded d'Uccle

Two types of mille fleur colored bantams were imported to North America from Germany early in the twentieth century. Only one had a beard, but both had feathered legs and "vulture hocks," which are created by the growth of a group of stiff, long feathers protruding from the back of the lower thigh.

The two types had been developed around the turn of the century in Belgium by Michel van Gelder, a fancier who lived in the small town of Uccle. Van Gelder crossed **Bearded d'Anvers** (page 109) with feather-legged bantams in an attempt to get a booted bird with low posture, a compact and asymmetrical body, a full beard, and a single comb.

Today the APA and ABA recognize the two as separate but closely related breeds. They have the same description in all ways except that the d'Uccle has a full beard and muffs and the Booted doesn't. They are true bantams, with no large varieties in the breeds. Thanks to the colors in which they were first imported, both are sometimes called by the nickname "Millies," though a number of other colors now exist.

The Booted Bantam and the Bearded d'Uccle bantams are known to have particularly good dispositions, being both friendly and calm.

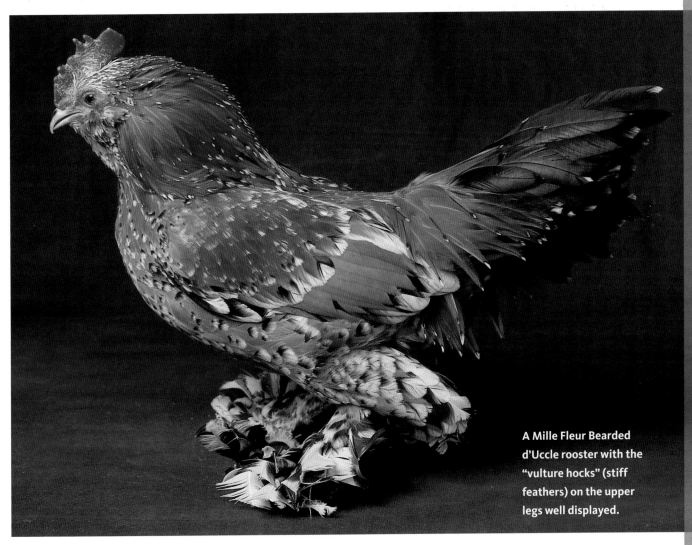

A Mille Fleur Bearded d'Uccle rooster with the "vulture hocks" (stiff feathers) on the upper legs well displayed.

Booted Bantam & Bearded d'Uccle *continued*

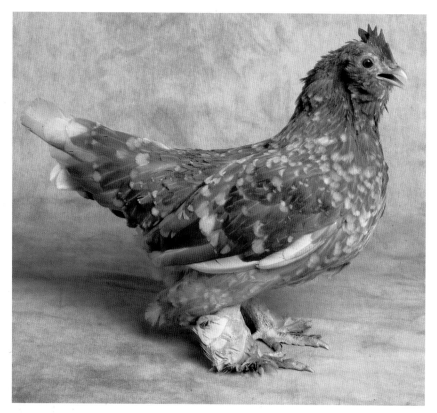

Caramel coloring, as seen in this hen, is a new color not yet recognized in the APA Standard of Perfection.

They are good foragers and fliers, so they will do well in a free-range situation, but they may need tall fencing to be kept in a backyard. The hens go broody readily and are excellent mothers, but they only produce a few chicks per clutch. Their eggs are very small and white.

The Booted Bantam and the Bearded d'Uccle were first admitted to the APA in 1914.

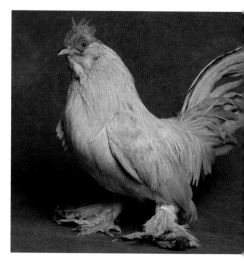

A Self Blue cock.

BOOTED BANTAM & BEARDED D'UCCLE FACTS

CLASS Feather Legged

SIZE **Cock:** 26 oz. (740 g) | **Hen:** 22 oz. (625 g)

COMB, WATTLES & EARLOBES Bright red single comb has five well-defined points and stands upright; bright red wattles and earlobes are medium size in males and small in females.

COLOR Unless otherwise noted, beak is in shades of horn; eyes are reddish bay; shanks and toes are in shades of slate.

Black. Eyes are black. Standard black plumage (page 26).

Blue. Eyes are dark brown. Standard blue plumage (page 26).

Buff. Shanks and toes are slaty white. Standard buff plumage (page 26).

Golden Neck. Beak is light horn with a reddish tinge. Plumage is primarily golden bay tipped with a creamy white spangle. Wings are golden bay highlighted in creamy white. Main tail feathers are creamy white; coverts are the same color as the back. Undercolor is creamy white. *Male:* Back is rich, lustrous red.

Gray. Standard gray plumage (page 27).

Mille Fleur. Standard mille fleur plumage (page 28).

Mottled. Eyes are dark brown. Standard mottled plumage (page 28).

Porcelain. Shanks and toes are pinkish slate in females. Standard porcelain plumage (page 28).

Self Blue. Eyes are dark brown. Standard self blue plumage (page 29).

White. Shanks and toes are white tinged with slate. Standard white plumage (page 29).

PLACE OF ORIGIN United States

CONSERVATION STATUS Recovering

SPECIAL QUALITIES A nice disposition for showy backyard and barnyard flocks. Good layers for bantams.

Cochin

When initially introduced to North America around 1845, the Cochin's progenitors were called Chinese Shanghai Fowl. Today's Cochins differ from the first Shanghai imports in that they have extremely fluffy feathering and fully feathered legs. The Shanghais that were imported had tighter feathering, resembling that of a modern **New Hampshire** (page 97), and either clean or just lightly feathered legs.

Fanciers took the fluffiest and most feathered-legged Shanghais and bred for those characteristics, quickly developing a showy breed that became a sensation, attracting attention around the world. This initiated the "Hen Craze" — a period from the 1880s through the early 1900s when fanciers ranging from Queen Victoria to backyard operators began breeding birds for aesthetic traits and show qualities, instead of for production traits.

Modern Cochins are still quite showy. They are large birds, but thanks to their dense, long, and soft plumage, they look even more massive than they really are. The birds hold their heads high and have a unique cushion of feathers on their backs and saddles that gives them a distinctive curve from their necks and shoulders to their relatively short, poufed tails.

Cochins are slow to mature, so most broiler operations aren't interested in keeping them, but they are respectable meat birds for smaller barnyard and backyard operations. They are friendly, docile birds that adapt to either confinement or free-

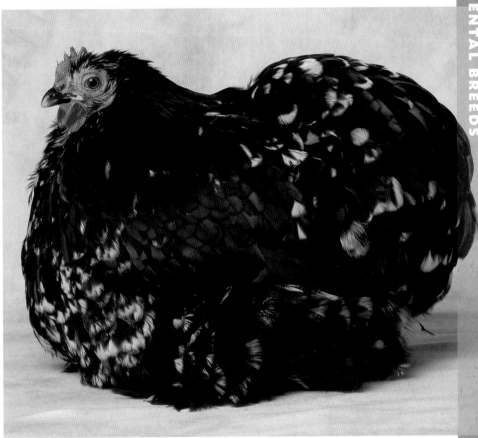

This bantam Mottled Cochin hen will lay well into the winter.

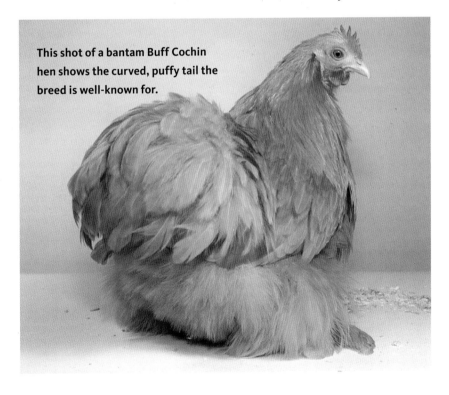

This shot of a bantam Buff Cochin hen shows the curved, puffy tail the breed is well-known for.

Cochin *continued*

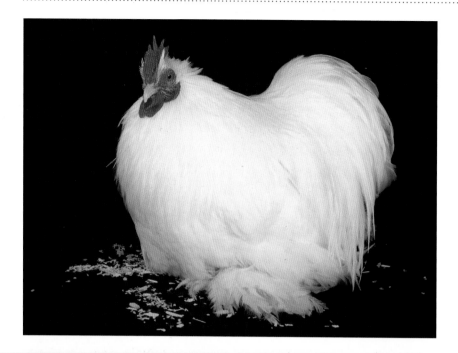

range operations. They are quite hardy in cold climates. Hens lay most of the winter, brood readily, and are excellent mothers. They can be used as foster mothers for other breeds.

The Cochin was first admitted to the APA in 1874.

Notice the leg feathers on this bantam White rooster.

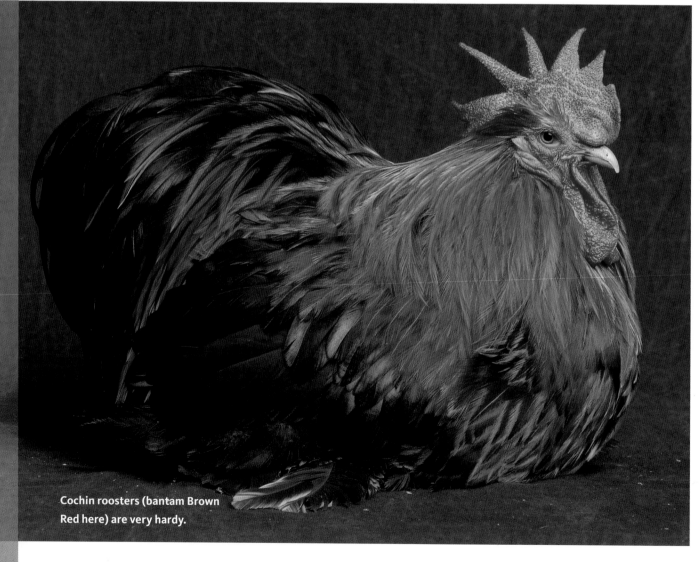

Cochin roosters (bantam Brown Red here) are very hardy.

COCHIN FACTS

CLASS **Standard** Asiatic. **Bantam** Feather Legged.

SIZE **Standard Cock**: 11 lb. (5 kg) | **Hen**: 8.5 lb. (3.9 kg)
Bantam Cock: 32 oz. (910 g) | **Hen**: 28 oz. (795 g)

COMB, WATTLES & EARLOBES All are bright red. *Male*: Medium-size single comb with five regularly spaced points that stand straight up, the middle of which is longest. Well-rounded, long wattles and earlobes. *Female*: Single comb is quite small and rounded so as to conform to curve of head. Well-rounded, small wattles. Oblong earlobes.

COLOR Beak is yellow shaded with black, unless otherwise noted; eyes are reddish bay; shanks and toes are yellow.

Barred. Standard barred plumage (page 26). Barred shank and outer toe feathers.

Birchen. Head is white to silvery white. Standard birchen plumage (page 26).

Black. Standard black plumage (page 26). Shank and outer toe feathers are black.

Black-Tailed Red. Beak is reddish horn. Standard black-tailed red plumage (page 26). Shank and outer toe feathers are deep, lustrous red.

Blue. Standard blue plumage (page 26). Shank and outer toes are blue.

Brown. Beak is horn. Head is dark orangey red. *Male*: Hackle and saddle are same color as head, or slightly more golden, but each feather has a black to greenish black stripe tapering to a point at end of feather. Front of neck, breast, body, legs, shanks and outer toes, wings, and tail are primarily black to greenish black but may be highlighted with golden bay. *Female*: Hackle is golden orange with black stripe in middle. Body is brown ranging from light to dark; feathers are stippled with black. Tail is black.

Brown Red. Standard brown-red plumage (page 26). Shank and outer toe feathers are same as legs.

Buff. Standard buff plumage (page 26). Shank and outer toe feathers are light buff.

Buff Columbian. Standard buff Columbian plumage (page 26). Shank and outer toe feathers are buff with black.

Columbian. Standard Columbian plumage (page 26). Shank and outer toe feathers are white with black.

Golden Laced. Beak is dark horn in color, shading to yellow at tip. *Male*: Head, neck, and saddle are golden bay with a black stripe down the middle. Cape is golden bay. Breast, body, wings, legs, shanks, and outer toe feathers are golden bay with lacing of black. Tail is primarily black. *Female*: Head is golden bay. Hackle is black with golden bay lacing and shaft. Rest of body is golden bay with black lacing. Main tail feathers are black.

Lemon Blue. Standard lemon blue plumage (page 27). Shanks and outer toes are grayish blue.

Mottled. Standard mottled plumage (page 28). Half of feathers on shanks and outer toes are tipped with white.

Partridge. Beak is dark horn in color, shading to yellow at tip. Standard partridge plumage (page 28). Shank and outer toe feathers in males are black and in females are deep reddish bay penciled with black.

Red. Beak is reddish horn in color. Standard red plumage (page 28).

Silver Laced. Beak is dark horn in color, shading to yellow at tip. Standard silver laced plumage (page 29).

Silver Penciled. Standard silver penciled plumage (page 29). Shanks and outer toe feathers are black in the male and penciled with steel gray in the female.

White. Standard white plumage (page 29), including shanks and outer toe feathers.

PLACE OF ORIGIN China

CONSERVATION STATUS Watch

SPECIAL QUALITIES A large, attractive bird that is popular for showing. Good winter layer with good mothering abilities.

Crevecoeur

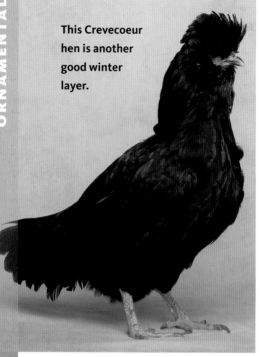

This Crevecoeur hen is another good winter layer.

ONE OF THE OLDEST BREEDS in France, the Crevecoeur is named for a town in the province of Normandy; it has been documented there since the 1700s, though poultry historians think that its history goes back to antiquity. In fact, it's thought to be one of the progenitors to the **La Fleche** (page 126), which has been documented at least since the sixteenth century. No one is quite sure how the breed developed, but historians speculate that French breeders bred crested birds from Poland with the common fowl of the French countryside at the time.

Crevecoeurs were originally raised in France as showy dual-purpose birds. The hens lay plenty of chalky white, medium-size eggs, rarely go broody, and were considered a fine table bird in France. The English and American markets prefer light-legged birds (Crevecoeurs have a dark leaden blue leg) and white feathering, so in both North America and England they were raised primarily for show. The ultimate result is that Crevecoeurs today often weigh less than the standard weight.

The breed is fairly hardy, though crest feathers can be subject to freezing in cold, wet weather. The birds tolerate confinement well, but they are somewhat standoffish.

The Crevecoeur was first admitted to the APA in 1874.

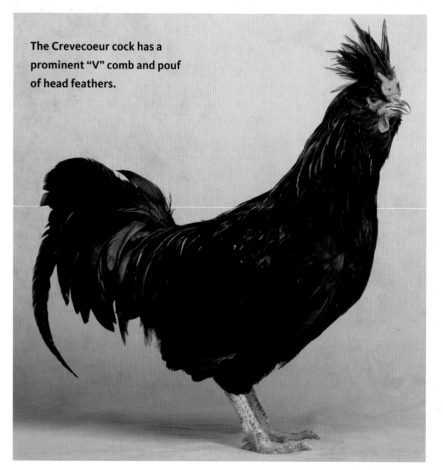

The Crevecoeur cock has a prominent "V" comb and pouf of head feathers.

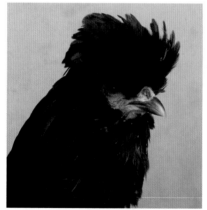

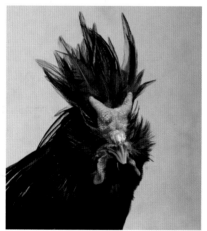

CREVECOEUR FACTS

CLASS **Standard** Continental.

Bantam All Other Combs, Clean Legged.

SIZE **Standard Cock**: 8 lb. (3.6 kg) | **Hen**: 6.5 lb. (3 kg)

Bantam Cock: 30 oz. (850 g) | **Hen**: 26 oz. (740 g)

COMB, WATTLES & EARLOBES Small wattles; small earlobes may be concealed by crest. V-shaped comb. *Male*: Medium-size comb rests against crest feathers. *Female*: Comb is very small and possibly concealed by crest feathers. All are bright red.

COLOR Beak is black shading to horn at tip; eyes are reddish bay; shanks and toes are dark leaden blue. Plumage is standard black (page 26).

PLACE OF ORIGIN France

CONSERVATION STATUS Critical

SPECIAL QUALITIES An ornamental that was traditionally used as a dual-purpose bird in France. Now very rare worldwide.

Cubalaya

CUBALAYAS HAVE BEEN BRED from Asiatic and European fighting stock in Cuba as triple-purpose birds used for egg production, game, and meat.

As game birds go they are mildmannered — they are less likely to fight in a flock situation than most game birds and are easily tamed.

They are also quite striking: They have the upright character common among the fighting breeds, but they look showy. Their long saddle feathers flow in a continuous line from the base of the neck to the tip of the tail, creating a sweeping train of feathers that trails behind them magisterially. Their tail is called, somewhat comically, a "lobster tail."

These are active birds that forage well but do not tolerate confinement. They can also be noisy, and though less aggressive than some of their counterparts, they are more aggressive than most non-game birds. Coming from steamy Cuba, they are tolerant of high heat and humidity.

In Cuba today, both the Black and White varieties are still used commercially for the production of meat and eggs, though in the United States hens may not be as prolific at laying as their island counterparts. The hens are good mothers and go broody easily.

The Cubalaya was first admitted to the APA in 1939.

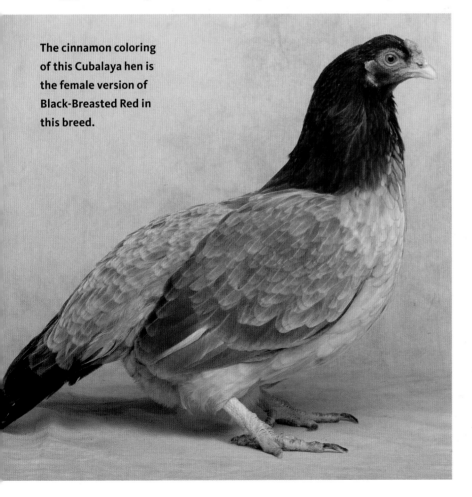

The cinnamon coloring of this Cubalaya hen is the female version of Black-Breasted Red in this breed.

CUBALAYA FACTS

CLASS **Standard** All Other Standard Breeds.
Bantam All Other Combs, Clean Legged.

SIZE **Standard Cock**: 6 lb. (2.75 kg) | **Hen**: 4 lb. (1.8 kg)
Bantam Cock: 26 oz. (740 g) | **Hen**: 22 oz. (625 g)

COMB, WATTLES & EARLOBES Small, bright-red pea comb, wattles, and earlobes.

COLOR Beak white or light horn; eyes reddish bay; shanks and toes pinkish white, unless otherwise noted.
Black. Shanks and toes are slate. Standard black plumage (page 26).
Black-Breasted Red. *Male*: Standard black-breasted red plumage (page 26). *Female*: Cinnamon-shaded, wheaten-type coloring. Dark cinnamon-red on head and neck, lighter cinnamon-wheaten on body, and dark coloring in tail.
Red Pyle. A variety not yet recognized by the APA. Standard red pyle plumage (page 28).
White. Standard white plumage (page 29).

PLACE OF ORIGIN Cuba

CONSERVATION STATUS Threatened

SPECIAL QUALITIES A simply beautiful bird. Mild-mannered, as game birds go.

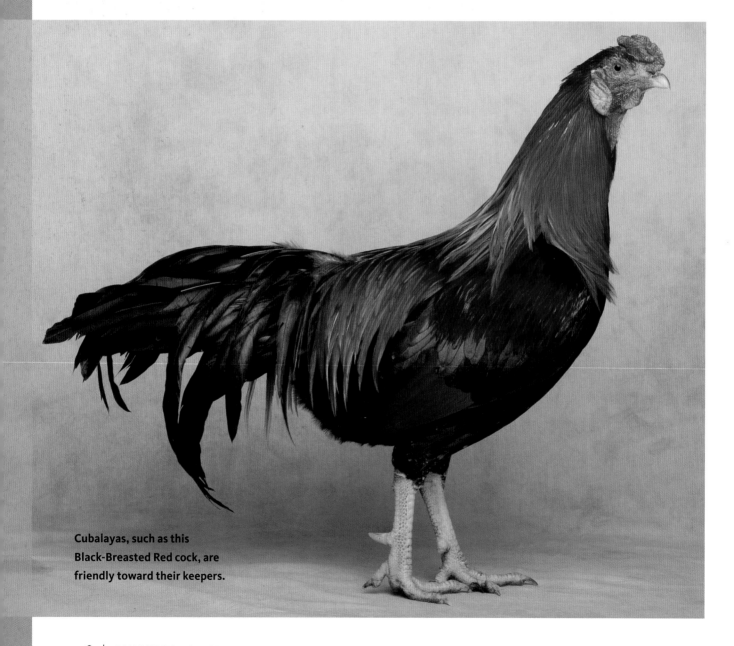

Cubalayas, such as this Black-Breasted Red cock, are friendly toward their keepers.

Dutch Bantam

THE DUTCH BANTAM was developed in the seventeenth century in Holland. Its forebears were birds that Dutch seamen acquired on Bantam Island in the Dutch East Indies (today part of Indonesia) to supply meat and eggs during voyages. These predecessors of the Dutch are thought to have been one of the earliest domesticated chickens developed from the jungle fowl in Indonesia.

The story of their development in Holland is interesting: Peasants were allowed to keep the eggs their hens laid only if they were small; the large eggs had to go to the lord of the manor. The bantams tended to lay small eggs, and so the peasants favored breeding them.

The Dutch Bantam is a true bantam, having no large varieties in the breed, and is the smallest bantam recognized by the APA and ABA. It was first imported to North America following World War II and was first shown in the United States in the early 1950s, but initially it didn't strike the fancy of breeders and seemed to have died out. It was imported again in 1969 and 1970, with several subsequent importations, and today it is quite popular with fanciers.

Dutch Bantams are jaunty little birds with an upright carriage and an attractive long tail. They are usually gentle and friendly, though some roosters can have an ornery streak. Not particularly hardy, they require tight shelter during the winter. They also need good fencing, as they are impressive fliers for their size. The Dutch are good

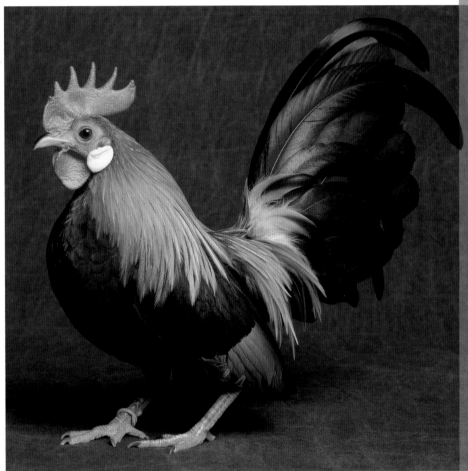

This is a Light Brown Dutch Bantam rooster. The breed is quite old and very gentle.

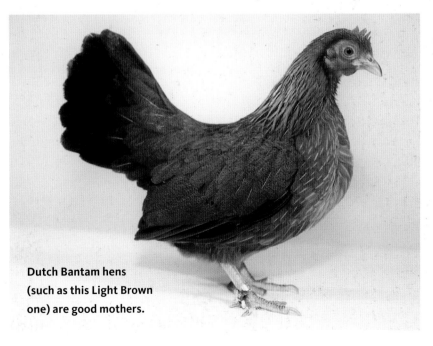

Dutch Bantam hens (such as this Light Brown one) are good mothers.

Dutch Bantam *continued*

layers during the spring, summer, and fall, but don't expect winter production. Hens go broody readily and are good mothers, though they can cover only a small clutch of eggs.

The Dutch was first admitted to the APA in 1992.

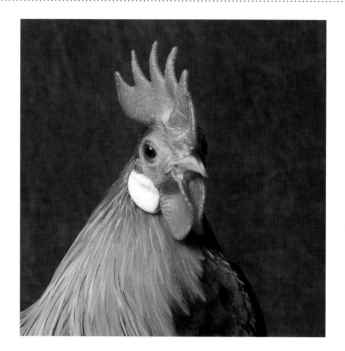

A close-up of a Light Brown Dutch Bantam rooster's comb.

DUTCH BANTAM FACTS

CLASS Single Comb, Clean Legged.

SIZE **Cock:** 21 oz. (595 g) | **Hen:** 20 oz. (570 g)

COMB, WATTLES & EARLOBES Small, bright red single comb with five well-defined, upright points; broad red wattles; medium-size, oval, pure white earlobes.

COLOR Beak is bluish horn, unless otherwise noted; eyes are reddish bay, unless otherwise noted; shanks and toes are slaty blue, unless otherwise noted.

Black. Eyes are brown. Standard black plumage (page 26).

Blue. Eyes are reddish brown. Standard blue plumage (page 26).

Blue Light Brown. *Male:* Head and back are brilliant reddish orange. Hackle and saddle are golden red with a flash of gold at the ends and a dull blue stripe down the middle. Front of the neck is blue-tinged salmon with darker blue lacing. Breast, body, and legs are slaty blue with a darker blue lacing or tinge. Tail is slaty blue. Wings are slaty blue laced in darker blue or bay, with lustrous orange highlights. *Female:* Head is orange to golden yellow, tinged with brown. Hackle is orange to golden yellow with dull blue stripe down the middle. Back, body, and wings are golden brown stippled with blue. Breast is salmon shading to ashy gray in the legs. Tail is slaty blue.

Cuckoo. Shanks and toes are slaty white. Standard cuckoo plumage (page 27).

Golden. Standard golden plumage (page 27).

Light Brown. Beak is light horn to white. Standard light brown plumage (page 28).

Self Blue. Eyes are reddish brown. Standard self blue plumage (page 29).

Silver. Standard silver plumage (page 29).

Wheaten. Standard wheaten plumage (page 29).

White. Standard white plumage (page 29).

PLACE OF ORIGIN Holland

CONSERVATION STATUS Not applicable

SPECIAL QUALITIES A fine bantam that gives a good supply of small eggs and is now a favorite for exhibition.

Houdan

NO ONE KNOWS FOR SURE when the Houdan was developed, but it is a very old French breed. It is named for the town of Houdan, which lies about 100 miles west of Paris and has a long poultry-market tradition, supplying the city with both eggs and meat. The dual-purpose Houdan was ideal for that market and was developed from crosses of the **Crevecoeur** (page 116), the **Polish** (page 145),

and native five-toed fowl. Houdans were imported to England around 1850 and came to North America from England in 1865.

While good dual-purpose birds for backyard and barnyard, with their V-shaped comb and crest of head feathers Houdans are also quite stylish. Known to be quick to mature, they have excellent eating qualities. They tolerate confinement but do very well in a free-range situa-

tion, obtaining a substantial amount of their own feed when allowed to roam. The hens lay a reasonable number of small to medium-size white eggs and lay well into the winter. The hens like to go broody but often break eggs in the nest if they are allowed to gather much of a clutch.

The Houdan was first admitted to the APA in 1874.

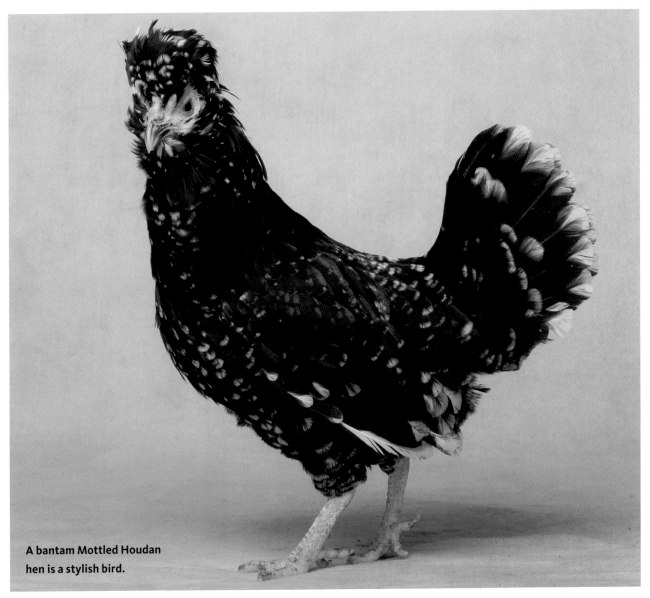

A bantam Mottled Houdan hen is a stylish bird.

Houdan *continued*

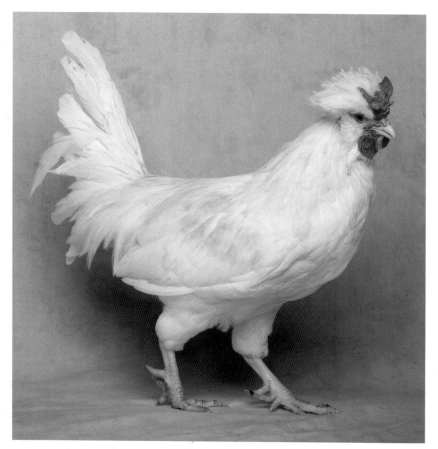

The Houdan cock has a very prominent "V" comb. Note the "fifth toe"
(spur) on the midsection of the shank.

HOUDAN FACTS

CLASS **Standard** Continental.
Bantam All Other Combs,
Clean Legged.

SIZE **Standard Cock:** 8 lb. (3.6 kg)
| **Hen**: 6.5 lb. (3 kg)
Bantam Cock: 34 oz. (965 g) |
Hen: 30 oz. (850 g)

COMB, WATTLES & EARLOBES
Small V-shaped comb resting
against crest; small, well-
rounded wattles; small ear-
lobes hidden by crest and
beard. Comb and wattles are
red; earlobes are white.

COLOR Eyes are reddish bay.
Mottled. Beak is dark horn;
shanks and toes are pinkish
white mottled with black.
Standard mottled plumage
(page 28).
White. Beak, shanks, and toes
pinkish white. Standard white
plumage (page 29).

PLACE OF ORIGIN France

CONSERVATION STATUS Critical

SPECIAL QUALITIES Exception-
ally gentle disposition.

Japanese Bantam

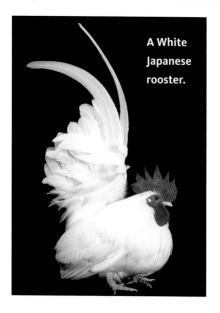

A White Japanese rooster.

THE JAPANESE IS ANOTHER TRUE bantam breed, and one of the showiest of all birds. It has a relatively large comb and a very large tail that stands up straight and forward on the body, giving this tiny bird the overall appearance of a "V." It also has very short legs and large, long wings held at an angle below the horizontal, so they touch the ground.

These birds are credited with being developed in Japan, where they are known as Chabo, which means "dwarf" or "bantam" and is also applied to some bonsai species. They are seen in Japanese art from around 1635, and in Dutch art from not much later. Believed to have arrived in Japan from China very early in the 1600s, they were bred from Malaysian stock as an ornamental garden bird by the aristocratic class of Japanese society.

These photos show a pair of Gray Japanese Bantams (hen on left). Notice that the Japanese breed has prominent eyes, a jaunty tail, and very short legs.

The Japanese, with its unique conformation (as seen in this rooster) is not a good breed for a novice breeder.

Japanese are a popular breed (in fact, the ABA considers them one of the ten most popular breeds), but they have certain challenges that should give pause to those new to poultry: Breeding these birds for good form (the short legs and tail at the proper angle) is very hard, and commericially available birds often don't show the form that the standard calls for. To keep the plumage in good shape, the birds must be kept on clean, dry bedding and allowed outdoors only in dry weather. Any accumulation of dirt or manure will stain or shred the ends of the feathers.

They are not hardy in cold weather and must be kept in a tight building during winter, possibly with supplemental heat. They also suffer from a lethal allele combination that kills off up to 25 percent of chicks just days before they would hatch.

The bantams are otherwise gentle and tame easily. During good weather, they are active foragers and happy fliers. Hens lay a fair number of very small brown eggs, brood readily, and are excellent mothers.

The Japanese was first admitted to the APA in 1914.

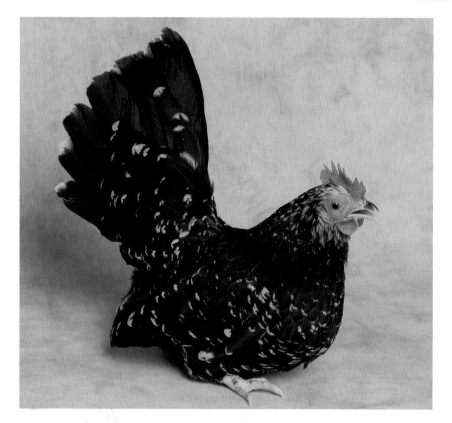

A Mottled Japanese hen. The photo above shows a close-up of the regularly recurring spots that give the mottled color its effect.

JAPANESE BANTAM FACTS

CLASS Single Comb, Clean Legged.

SIZE **Cock:** 26 oz. (740 g) | **Hen:** 22 oz. (625 g)

COMB, WATTLES & EARLOBES Comb, wattles, and earlobes are generally large in males and medium size in females. Comb is single with five well-defined, upright points. The white bearded variety has very small wattles. All are bright red.

COLOR Beak is in shades of yellow; eyes are dark brown or reddish bay; shanks and toes are in shades of yellow.

Barred. Standard barred plumage (page 26).

Black. Standard black plumage (page 26).

Black-Breasted Red. Standard black-breasted red plumage (page 26).

Black-Tailed Buff. Plumage is primarily buff. Tail is black with some buff lacing. Wings are mainly buff with some black.

Black-Tailed Red. Standard black-tailed red plumage (page 26).

Black-Tailed White. Plumage is primarily white to silvery white. Tail is black with some white lacing. Wings are mainly white with some black.

Blue. Standard blue plumage (page 26).

Brown Red. Standard brown-red plumage (page 26).

Buff. Standard buff plumage (page 26).

Gray. Standard gray plumage (page 27).

Mottled. Standard mottled plumage (page 28).

Self Blue. Standard self blue plumage (page 29).

Silver Duckwing. Standard silver duckwing plumage (page 29).

Silver Laced. Standard silver laced plumage (page 29).

Wheaten. Standard wheaten plumage (page 29).

White. Standard white plumage (page 29).

White Bearded. Beard is composed of feathers directed downward from under the beak, and muffs consist of feathers turned horizontally backward from both sides of beak. Standard white plumage (page 29).

PLACE OF ORIGIN Japan

CONSERVATION STATUS Not applicable

SPECIAL QUALITIES Strictly an ornamental bantam, but a uniquely showy one for fanciers.

Kraienkoppe

THE KRAIENKOPPE BREED was developed along the border of Germany and the Netherlands in the 1920s by crossing **Malay** (page 96) game birds with **Leghorns** (page 58) — either Brown or Silver Duckwing. Kraienkoppe is its name in Germany; Twentse is the name used on the Dutch side of the border.

The Kraienkoppe is best known as an ornamental laying breed. Hens produce a fair number of medium, off-white (ranging from cream to lightly yellowish white) eggs and lay well in cold weather. The hens will go broody. They are active birds and excellent foragers with very high feed efficiency, but they will tolerate confinement.

The breed is a fairly recent arrival on this side of the Atlantic and hasn't been recognized by the APA. In Europe there is also a bantam type, but they don't seem to have made their way across the ocean yet.

A Black-Breasted Red Kraienkoppe hen.

KRAIENKOPPE FACTS

SIZE **Standard Cock**: 6 lb. (2.75 kg) | **Hen**: 4 lb. (1.8 kg)

COMB, WATTLES & EARLOBES Small walnut comb, wattles, and earlobes. All are bright red.

COLOR Horn beak; reddish bay eyes; yellow shanks and toes.
Black-Breasted Red. Standard black-breasted red plumage (page 26).
Silver. Standard silver plumage (page 29).

PLACE OF ORIGIN Germany

CONSERVATION STATUS Not applicable

SPECIAL QUALITIES A sporty-looking ornamental layer.

A Black-Breasted Red Kraienkoppe rooster.

La Fleche

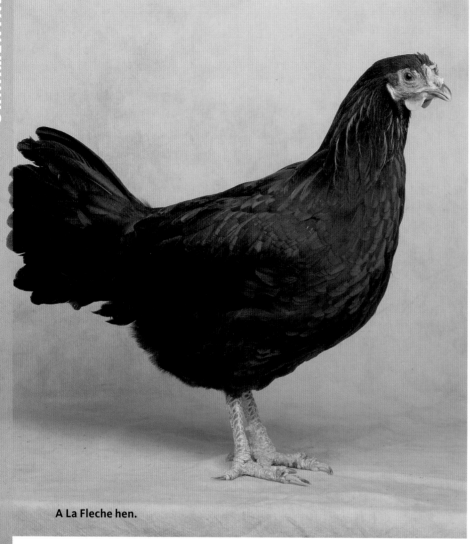

A La Fleche hen.

A close-up of a male's large "V" comb.

A hen's "V" comb is much smaller.

THE LA FLECHE IS sometimes called the devil bird because of its shiny black plumage and large, upright, V-shaped comb that takes the appearance of horns. It is thought to have been developed by crosses of the **Crevecoeur** (page 116) with a Mediterranean breed, such as the **White-Faced Black Spanish** (page 164) or the **Minorca** (page 63).

Named after the village of La Fleche in northern France (not far from the famous car-racing city of Le Mans), this ancient breed was first written about in 1580 by Prudens Choiselat, an economist of the period who wrote "a discourse on husbandry, no less profitable than delectable." In this discourse he described how French farmwives of the period could raise hens and "gain in the year four thousand and five hundred francs of honest profit after all costs and charges [were] deducted."

La Fleches are known as good foragers that do well in free range but will adapt to confinement. The breed has a reputation for producing large breast meat portions and is famous in France for this. These birds are active, slow to mature, and standoffish. They are also good fliers, so fencing needs to be high to contain them (they'll roost in trees if given a chance). Hens lay a respectable number of very large white eggs, lay well in the winter months, and rarely go broody.

The La Fleche was first admitted to the APA in 1874.

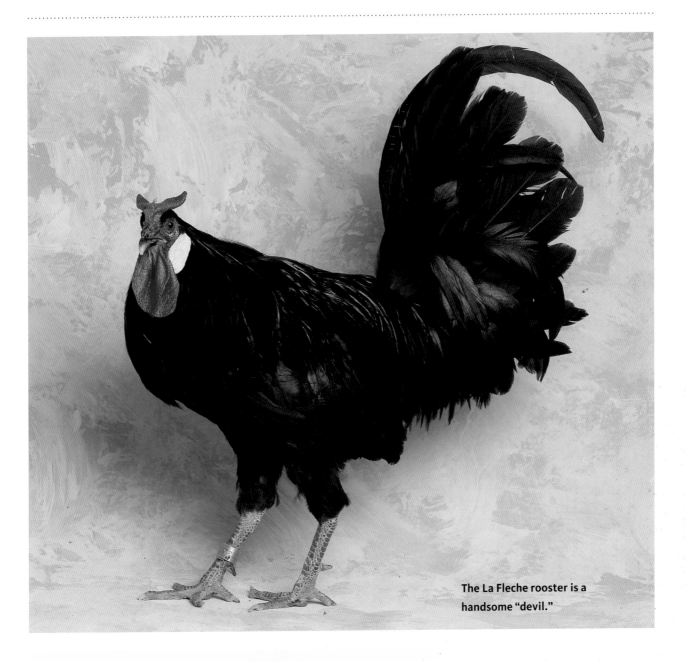

The La Fleche rooster is a handsome "devil."

LA FLECHE FACTS

CLASS **Standard** Continental.
Bantam All Other Combs, Clean
Legged.

SIZE **Standard Cock**: 8 lb. (3.6 kg) |
Hen: 6.5 lb. (3 kg) **Bantam Cock**:
30 oz. (850 g) | **Hen**: 26 oz. (740 g)

COMB, WATTLES & EARLOBES
Large V-shaped comb likened to
horns; long, well-rounded wat-
tles may be pendulous; earlobes
are large. Comb and wattles are

bright red; earlobes are white.

COLOR Beak is black shading to
horn at tip; eyes are reddish
bay; shanks and toes are dark
leaden blue. Plumage is stan-
dard black (page 26).

PLACE OF ORIGIN France

CONSERVATION STATUS Critical

SPECIAL QUALITIES Good dual-
purpose breed.

Langshan

THIS OLD BREED FROM CHINA is named for the Langshan District, north of the Chang (Yangtze) River. Not much is known of its early history in China, but the first Black Langshans arrived in England in 1872 and from there made it to North America in 1876.

Initially breeders thought the breed was just a variety of **Cochin** (page 113), though the Cochin came from a different area of China and the Langshans had some distinctly different features. For example, Langshans have black legs with pink skin on the bottoms of their feet, compared to yellow skin and yellow feet in the Cochins. And although they weigh less than Cochins, Langshans stand decidedly taller; in fact, they are the tallest of the non-game breeds.

Although Langshans make an excellent dual-purpose breed for

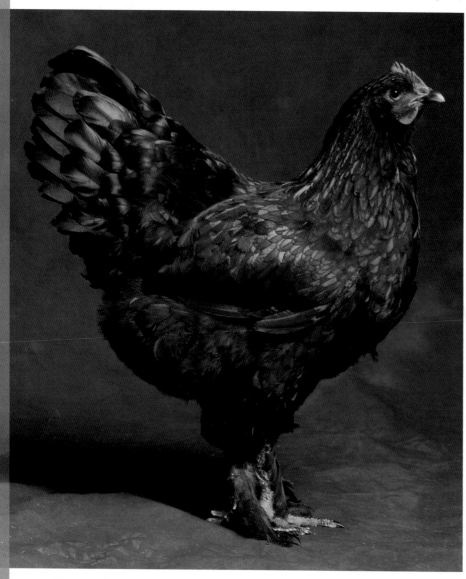

A Langshan hen.

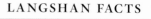

LANGSHAN FACTS

CLASS **Standard** Asiatic.
Bantam Feather Legged.

SIZE **Standard Cock:** 9.5. lb. (4.3 kg) | **Hen:** 7.5 lb. (3.4 kg)
Bantam Cock: 36 oz. (1 kg) | **Hen:** 32 oz. (910 g)

COMB, WATTLES & EARLOBES
Single comb with five well-defined, upright points is medium size in males and small in females; wattles are well rounded and medium in size; earlobes are moderately large. All are bright red.

COLOR Eyes are dark brown.
Black. Beak is dark horn shading to pinkish horn at tip; shanks and toes are bluish black with pinkish tinge between scales and pinkish white bottoms of feet. Standard black plumage (page 26).
Blue. Beak is dark horn shading to pinkish white at tip; shanks and toes are bluish slate with pinkish tinge between scales and pinkish white bottoms of feet. Standard blue plumage (page 26).
White. Beak is slaty blue shading to pinkish white; shanks and toes are bluish slate with pinkish tinge between scales and pinkish white bottoms of feet. Standard white plumage (page 29).

PLACE OF ORIGIN China

CONSERVATION STATUS Threatened

SPECIAL QUALITIES A good dual-purpose layer of brown eggs that's graceful and attractive.

meat and eggs, they are also quite ornamental thanks to their height, feathered legs, lustrous plumage, and very long, full tails that are carried well above the horizontal. They are adaptable to either confinement or free range, slow to mature, cold-hardy, and active yet docile. Hens will go broody, are good mothers, and lay a fair number of very dark brown eggs.

The Langshan was first admitted to the APA in 1883.

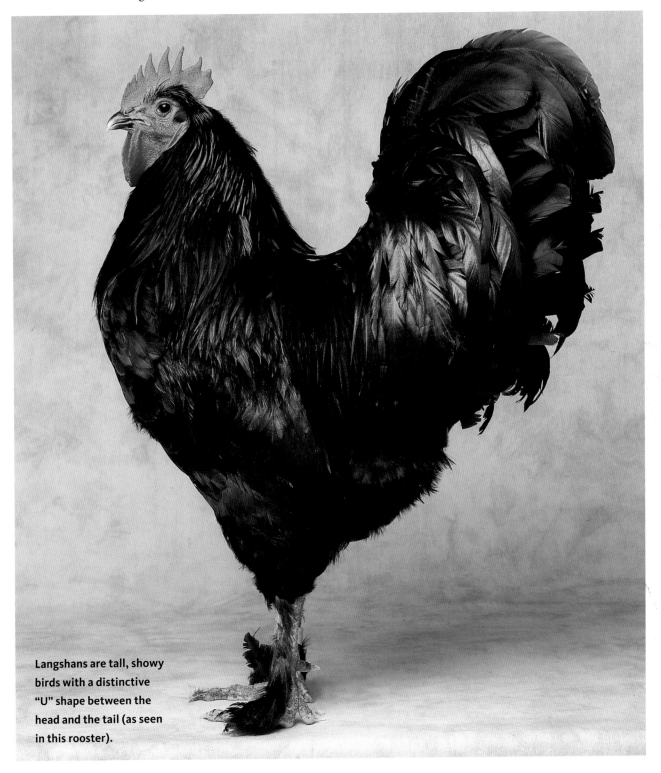

Langshans are tall, showy birds with a distinctive "U" shape between the head and the tail (as seen in this rooster).

Manx Rumpy

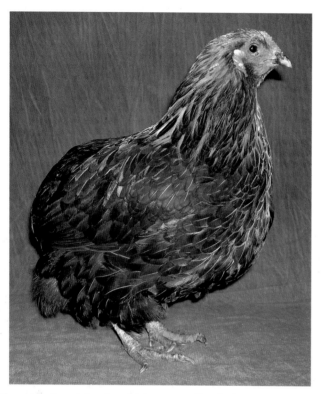

Manx Rumpies, such as this hen, are "tailless" birds.

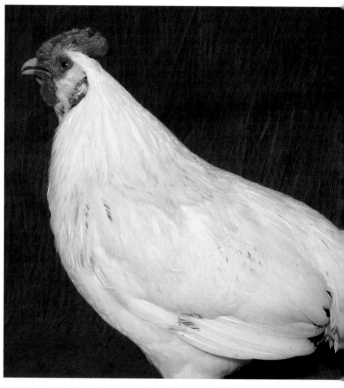

The Rumpy breed can have several comb types, including a small single, as seen on this rooster.

THE MANX RUMPY is an ancient breed from the Persian Gulf region. It is rare in North America, though a handful of breeders have kept it alive here (possibly for centuries), and it seems to be re-igniting interest among backyard poultry enthusiasts.

The breed is like the **Araucana** (page 4) in that it doesn't grow a conventional tail because it is missing the last vertebrae that would hold the tail feathers up. Historically, these birds were called Persian Rumpless, but sometime in the twentieth century an old-time breeder dubbed them Manx Rumpies thanks to their passing resemblance to the Manx cat.

Manx Rumpies are excellent for free-range operations, taking care of most of their own feed needs. They are good layers of medium-size brown eggs, though some hens will lay other colored eggs, including white, blue, and green. Hens will go broody, but fertility in this breed tends to be low.

MANX RUMPY FACTS

SIZE **Standard Cock**: 5.5 lb. (2.5 kg) | **Hen**: 4.5 lb. (2 kg)

COMB, WATTLES & EARLOBES Various combs show up regularly, but small single combs are most common. Wattles and earlobes are small to medium; all are bright red, though earlobes may have a white center.

COLOR Comes in various colors.

PLACE OF ORIGIN Persia (Iraq and Iran).

CONSERVATION STATUS Not applicable

SPECIAL QUALITIES An exceptional free-range bird that requires virtually no supplemental feed.

Modern Game

IN 1849 ENGLAND made cockfighting illegal. At about the same time interest in poultry shows exploded, so breeders began manipulating their **Old English Games** (page 137) and **Malays** (page 96) in search of a bird that would do well in exhibition. Though developed from fighting birds, the Modern Game is strictly a fancier's bird that was never actively used in a fighting pit. It has a long, thin neck and legs and an upright stature with a prominent breast and broad but short back.

The breed is slow to mature and not very winter hardy, generally requiring an insulated building in northern areas. Modern Games are active and noisy, don't tolerate close confinement, and can be aggressive at times. But breeders say they are also generally personable, curious, and a lot of fun to have around. Hens are good mothers, will go broody, and lay a fair number of eggs considering their game background.

The Modern Game was first admitted to the APA in 1874.

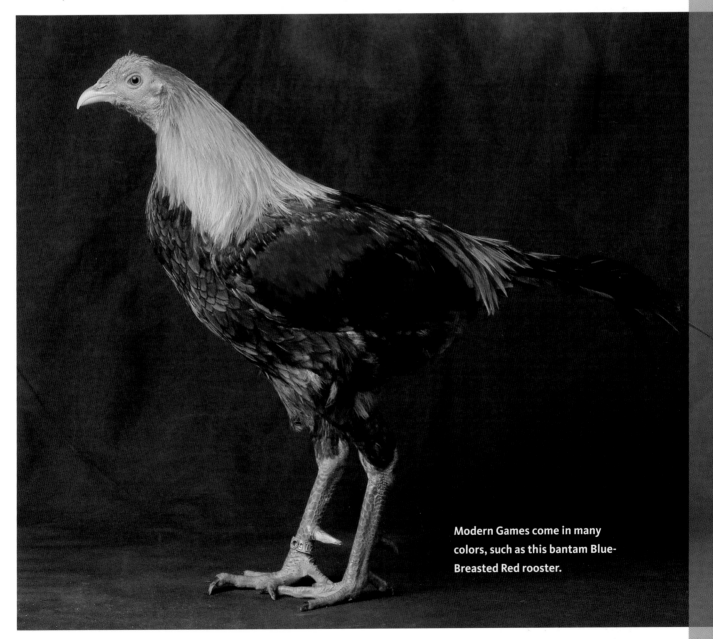

Modern Games come in many colors, such as this bantam Blue-Breasted Red rooster.

Modern Game *continued*

A bantam Birchen rooster stretches his wings.

A bantam Brown Red Modern Game hen.

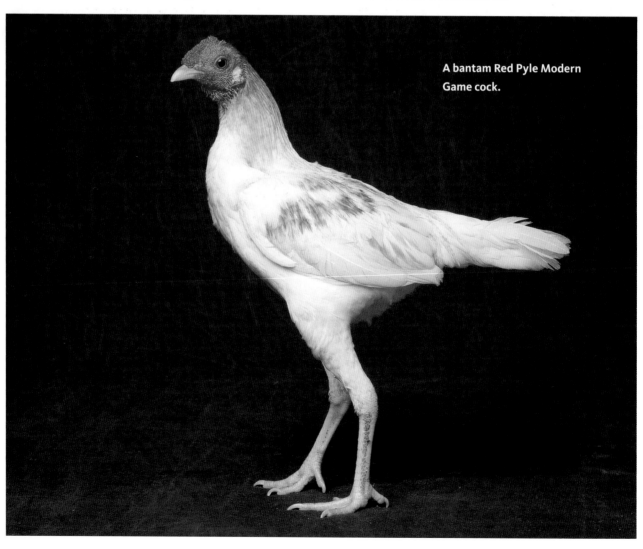

A bantam Red Pyle Modern Game cock.

Modern Game *continued*

MODERN GAME FACTS

CLASS **Standard** All Other Standard Breeds.
Bantam Game.

SIZE **Standard Cock**: 6 lb. (2.75 kg) | **Hen**: 4.5 lb. (2 kg)
Bantam Cock: 22 oz. (625 g) | **Hen**: 20 oz. (570 g)

COMB, WATTLES & EARLOBES Small single comb with five points that stand upright. Small, thin, smooth wattles and earlobes. All are bright red, unless otherwise noted. Comb, wattles, and earlobes are dubbed (removed) in cocks for show.

COLOR

Barred. Beak is horn; eyes are red; shanks and toes are yellow. Standard barred plumage (page 26).

Birchen. Comb, wattles, and earlobes are mulberry. Beak, eyes, shanks, and toes are all black. Standard birchen plumage (page 26).

Black. Beak is black; eyes are dark brown; shanks and toes are black. Standard black plumage (page 26).

Black-Breasted Red. Beak is dark horn; eyes are red; shanks and toes are willow. Standard black-breasted red plumage (page 26).

Blue. Comb, wattles, and earlobes are mulberry. Beak, eyes, shanks, and toes are black to leaden black. Standard blue plumage (page 26).

Blue-Breasted Red. Beak is horn; eyes are red; shanks and toes are willow. *Male*: Head is light orange. Hackle and saddle are golden red. Back is rich red. Front of neck, breast, body, legs, and tail are blue. Wings are blue with red and bay highlights. *Female*: Head is orangey red. Hackle is light orange with a blue stripe down the middle of each feather. Front of neck and breast are light salmon shading to ashy gray as it blends with body feathers. Body, wings, legs, and tail are bluish gray stippled with brown, which gives an overall effect of drab brown.

Brown Red. Comb, wattles, and earlobes are mulberry. Beak, eyes, shanks, and toes are all black. Standard brown-red plumage (page 26).

Crele. Beak is horn; eyes are red; shanks and toes are yellow. *Male*: Barred orange-red against pale straw on head, hackle, back, and saddle. Remainder is barred gray and white. *Female*: Head and hackle are pale gold barred with grayish brown. Front of neck and breast are salmon shading to ashy gray as it blends with body. Remainder is dark to ashy gray with some barring.

Cuckoo. Beak is horn; eyes are red; shanks and toes are yellow. Standard cuckoo plumage (page 27).

Ginger Red. Beak is horn; eyes are red; shanks and toes are willow. Standard ginger-red plumage (page 27).

Golden Duckwing. Beak is horn; eyes are red; shanks and toes are willow. Standard golden duckwing plumage (page 27).

Lemon Blue. Comb, wattles, and earlobes are mulberry. Beak, eyes, shanks, and toes are all black. Standard lemon blue plumage (page 27).

Red Pyle. Beak is yellow; eyes are red; shanks and toes are yellow. Standard red pyle plumage (page 28).

Self Blue. Beak is black; eyes are dark brown; shanks and toes are black. Standard self blue plumage (page 29).

Silver Blue. Comb, wattles, and earlobes are mulberry. Beak, eyes, shanks, and toes are all black. Head is silvery white. Hackle is lustrous blue laced with silvery white. Front of neck and breast are slaty blue laced with silvery white. *Male*: Back is lustrous silvery white. Saddle and upper breast are blue laced with silvery white. Lower breast, body, and legs are dark slaty blue. Wing coverts are dark blue, forming a distinct bar across wing; primaries, secondaries, shoulders, and fronts are dark blue laced with darker blue; bows are dark blue laced with white. Tail is dark blue.

Silver Duckwing. Beak is horn; eyes are red; shanks and toes are willow. Standard silver duckwing plumage (page 29).

Wheaten. Beak is horn; eyes are red; shanks and toes are yellow to light willow. Standard wheaten plumage (page 29).

White. Beak is yellow; eyes are red; shanks and toes are yellow. Standard white plumage (page 29).

PLACE OF ORIGIN England

CONSERVATION STATUS Study

SPECIAL QUALITIES Tall bird with distinctive appearance and showy qualities.

Naked Neck

SOMETIMES REFERRED TO as Turkens, because people think they look like a cross between a turkey and a chicken, Naked Necks are some of the oddest-looking members of the chicken clan. These birds have a naked neck and vent (the front of the breast below the neck) and a significantly reduced number of feathers over the rest of their body. This last trait is the result of a gene that reduces the general size and density of feathers. In fact, they have only 40 to 50 percent of the total number of feathers that other chickens of comparable size have.

Birds that exhibit the naked-neck trait can be found in pockets all over the world. Archaeologists think that the gene first showed up in Malaysia in antiquity, but that birds with the gene (which is dominant) dispersed over the globe early. The breed that is recognized for its naked neck in North America was developed in eastern Europe (areas around Hungary and Romania) and perfected in Germany in the nineteenth century.

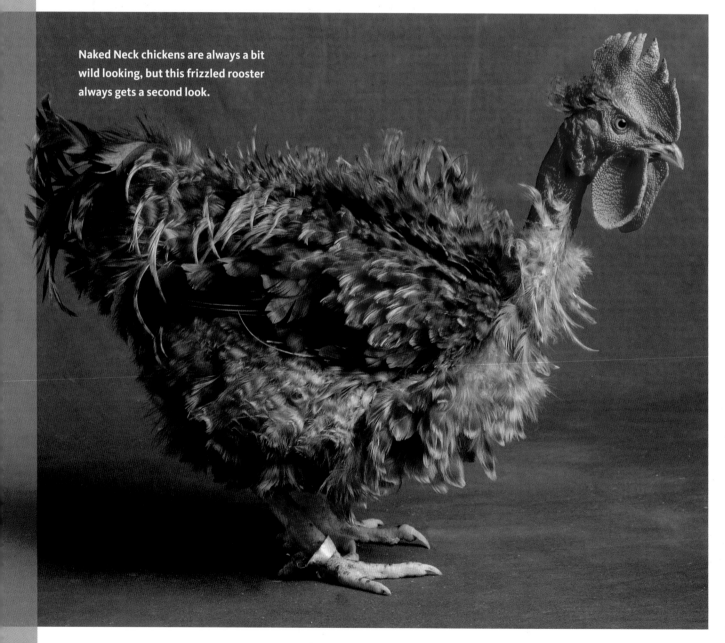

Naked Neck chickens are always a bit wild looking, but this frizzled rooster always gets a second look.

The reduced number of feathers is an attribute that many people simply hate, thinking the Naked Necks ugly. But the trait has its fans, and with good reason: Naked Necks are very well adapted to hot climates but tolerate cooler temperatures fairly well. Feathers are made up mainly of protein, so the Naked Necks, because they have fewer of them, have a reduced need for protein in their diet. The protein they do consume is used more efficiently toward the production of eggs and meat, so their feed efficiency is very high. They do great in a free-range operation but will tolerate confinement as long as they aren't packed in tightly.

They are extremely tough — and field trials at American Agricultural Experiment Stations from 1900 through the 1930s showed that the breed was highly immune to most diseases of the time. The hens lay a good number of medium to large brown eggs and are excellent mothers. And as broilers they dress very nicely: the carcass is easily and quickly plucked thanks to the bare areas and doesn't have as many feather follicles under the skin.

The Naked Neck was first admitted to the APA in 1965.

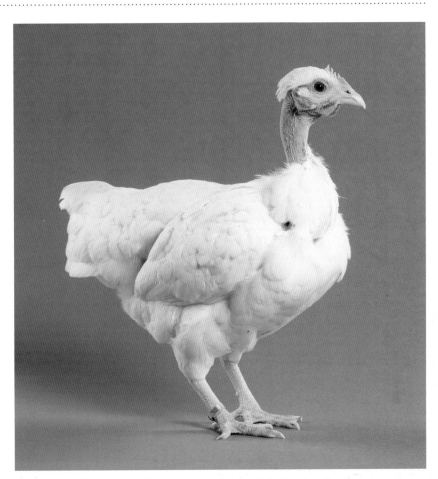

Naked Necks, like this bantam hen, are a particularly good choice in hot climates.

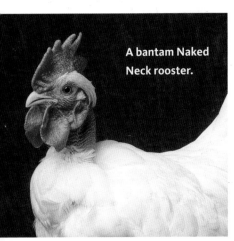

A bantam Naked Neck rooster.

NAKED NECK FACTS

CLASS **Standard** All Other Standard Breeds. **Bantam** Single Comb, Clean Legged.

SIZE **Standard Cock**: 8.5 lb. (3.9 kg) | **Hen**: 6.5 lb. (3 kg) **Bantam Cock**: 34 oz. (965 g) | **Hen**: 30 oz. (850 g)

COMB, WATTLES & EARLOBES Medium-size single comb with five well-defined upright points; medium-size wattles; medium-size, oblong earlobes. All are bright red.

COLOR Beak, shanks, and toes are yellow, unless otherwise noted; eyes are reddish bay.
Black. Beak dark slate to black; shanks and toes black. Standard black plumage (page 26).

Blue. Standard blue plumage (page 26).
Buff. Standard buff plumage (page 26).
Cuckoo. Standard cuckoo plumage (page 27).
Red. Standard red plumage (page 28).
White. Standard white plumage (page 29).

PLACE OF ORIGIN Eastern Europe (Hungary, Romania).

CONSERVATION STATUS Study

SPECIAL QUALITIES An odd-looking bird, but a good layer, with a carcass that is easy to pluck.

Nankin

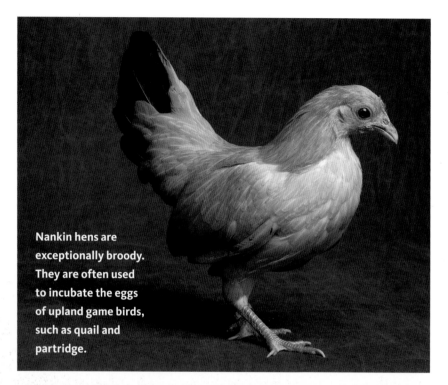

Nankin hens are exceptionally broody. They are often used to incubate the eggs of upland game birds, such as quail and partridge.

THE NANKIN IS A bantam-only breed, and according to American Livestock Breeds Conservancy's Don Schrider, it is considered to be one of the most ancient bantam breeds. These birds were first imported to the United States and Britain in the eighteenth century. During their early history in Britain they were quite popular and were used in the development of **Sebright** (page 152) bantams, but now they are rare on both sides of the Atlantic.

Nankins are slow to mature, friendly, active, and talkative birds. Although they are fliers, Nankins do well in confinement, and when given access to the outdoors, they tend to stay relatively close to their coop. Nankins are not very cold-hardy, and if kept in northern climates will need a tight, insulated structure.

Hens lay small, creamy white eggs and make excellent brooders and protective mothers. In fact, the hens are such incredible setters that they were used historically to sit on eggs for game birds such as pheasant, quail, and partridge — a fact that has helped keep them from extinction.

They are recognized by the ABA but not by the APA.

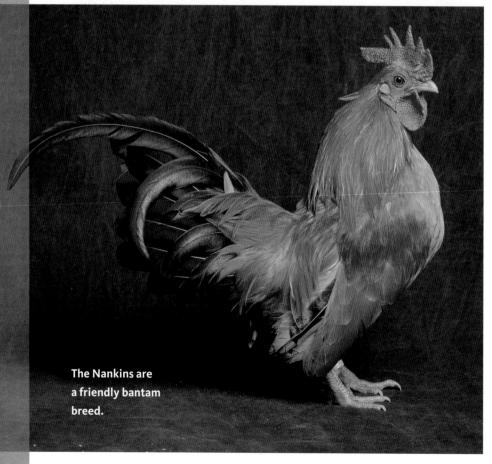

The Nankins are a friendly bantam breed.

NANKIN FACTS

SIZE **Cock:** 24 oz. (680 g) | **Hen:** 22 oz. (625 g)

COMB, WATTLES & EARLOBES There are two varieties based on comb.

Single Comb. Bright red, medium to moderately large red comb has five distinct points, all upright.

Rose Comb. Bright red rose comb is medium size in males and small in females, sits square in front, and terminates in a well-developed spike.

COLOR Beak is horn, with dark shading on upper mandible; eyes are reddish bay; shanks and toes are bluish slate, possibly with a pink stripe on the outside of shank. Plumage is primarily shades of orangey red to chestnut to golden buff and is darker, deeper, and more lustrous in males than females. Tail is black.

PLACE OF ORIGIN Southeast Asia

CONSERVATION STATUS Critical

SPECIAL QUALITIES An extremely rare, pretty, and personable true bantam. Very good brooder.

Old English Game

THE OLD ENGLISH GAME is an ornamental bird that evolved directly from English fighting birds after cockfighting was outlawed in England in 1849. The Old English Game was probably the first breed developed in Britain, and its forebears predate Julius Caesar's conquest of the British Isles around 55 BC.

Although it has been over a century since the breed was used for fighting, the birds still have a feisty character that reflects their fighting heritage. The chicks, which mature slowly, sometimes start fighting at a young age. Mature cocks should be kept apart to prevent a possible fight to the death.

Old English Games are relatively small birds with tightly feathered plumage. They are hardy, vigorous, active, and very noisy. They make good foragers, don't really tolerate confinement, and fly well, roosting in trees if given a chance. They are purported to have fine table quality, yielding a respectable carcass for a small game breed. The hens lay well for a game breed and make

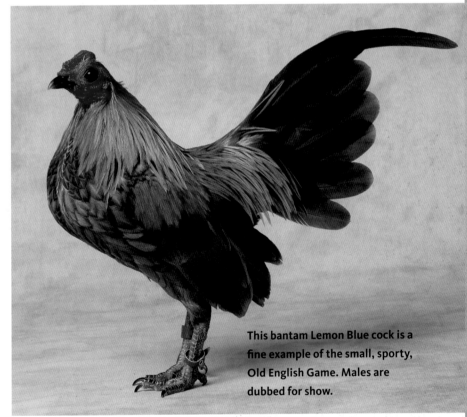

This bantam Lemon Blue cock is a fine example of the small, sporty, Old English Game. Males are dubbed for show.

excellent mothers (breeders sometimes use them as foster mothers for other breeds).

The Old English Game was first admitted to the APA in 1938.

This cock has not been dubbed.

Old English Game *continued*

The Old English Game breed is recognized in more color varieties than any other breed, and breeders continue to develop new ones.

On this page (all are bantam):
Top left, a Spangled hen; top right, a Red Pyle cock, undubbed; lower left, a close-up of Crele barring; lower right, a Lemon Blue hen.

Next page:
Top, a Silver Duckwing hen; bottom, a Blue Brassy Back cock with dubbed comb.

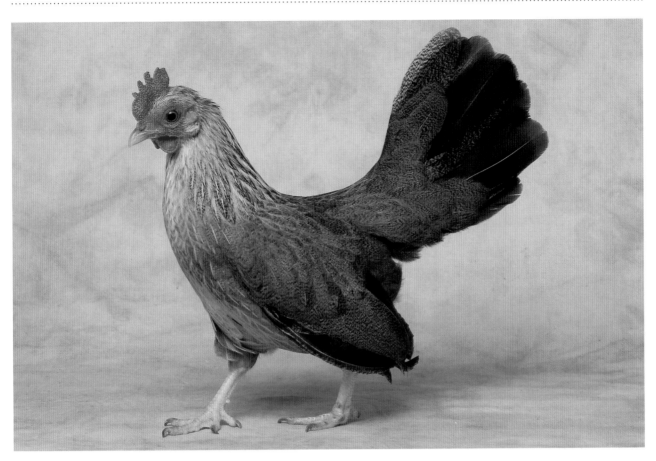

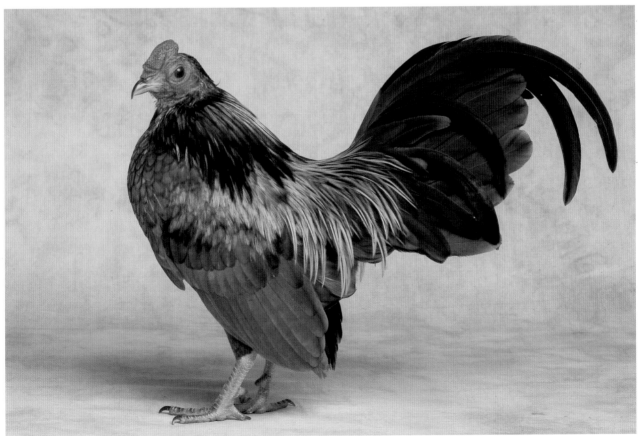

OLD ENGLISH GAME FACTS

CLASS **Standard** All Other Standard Breeds.
Bantam Game.

SIZE **Standard Cock**: 5 lb. (2.25 kg) | **Hen**: 4 lb. (1.8 kg)
Bantam Cock: 24 oz. (680 g) | **Hen**: 22 oz. (625 g)

COMB, WATTLES & EARLOBES Small single comb with
five points that stand upright. Small, thin, smooth
wattles and earlobes. All are bright red, unless noted
otherwise. Comb, wattles, and earlobes are dubbed
(removed) in cocks for show.

COLOR

Barred. Beak is horn streaked with slate; eyes are red-
dish bay; shanks and toes are white tinged with slate.
Standard barred plumage (page 26).

Birchen. Comb, wattles, and earlobes are mulberry.
Beak, eyes, shanks, and toes are all black. Standard
birchen plumage (page 26).

Black. Comb, wattles, and earlobes are red to mul-
berry. Beak is black; eyes are dark brown; shanks and
toes are black. Standard black plumage (page 26).

Black-Breasted Red. Beak is light horn; eyes are red;
shanks and toes are white tinged with pink. Standard
black-breasted red plumage (page 26).

Black-Tailed Buff. Beak is light horn; eyes are red;
shanks and toes are leaden blue. Plumage is primarily
buff. Tail is black with some buff lacing. Wings are
mainly buff with some black.

Black-Tailed Red. Beak is light horn; eyes are red;
shanks and toes are leaden blue. Plumage is primarily
red. Tail is lustrous black (may have some red fringe
in females). Wings are mainly red with some black.

Black-Tailed White. Beak is light horn; eyes are red;
shanks and toes are white. Plumage is primarily white
to silvery white. Tail is black with some white lacing.
Wings are mainly white with some black.

Blue. Beak is dark horn to black; eyes are dark brown;
shanks and toes are leaden black. Standard blue
plumage (page 26).

Blue Brassy Back. Beak is black; eyes are brown;
shanks and toes are slaty blue. *Male:* Head, hackle, and
saddle are golden brass with a blue stripe down the cen-
ter of each feather. Back is medium-golden brass. Tail is
medium blue. Wings are in shades of blue highlighted
with golden brass. Front of neck, breast, body, wings,
tail, and legs are blue with dark blue lacing. *Female:*

Head and front of neck are blue tinged with brass.
Hackle is dark blue. Breast is golden buff. Body and legs
are slaty blue with some buff. Tail and wings are
medium blue with some darker blue lacing.

Blue-Breasted Red. Beak is horn; eyes are red;
shanks and toes are pinkish white. *Male:* Head is light
orange. Hackle and saddle are golden red. Back is rich
red. Front of neck, breast, body, legs, and tail are
blue. Wings are blue with red and bay highlights.
Female: Head is orangey red. Hackle is light orange
with a blue stripe down the middle of each feather.
Front of neck and breast are light salmon shading to
ashy gray as it blends with body feathers. Body,
wings, legs, and tail are bluish gray stippled with
brown, which gives an overall effect of drab brown.

Blue Golden Duckwing. Beak is light horn; eyes are
red; shanks and toes are white. *Male:* Mainly blue, with
cream-colored head and hackle, gold back, and golden
highlights on wings and tail. *Female:* Primarily shades
of gray, with salmon front of neck and breast; black
highlights in tail; and dark brown highlights in wings.

Blue Silver Duckwing. Beak is horn streaked with
slate; eyes are red; shanks and toes are white tinged
with pink. *Male:* Head is white, giving way to silvery
white hackles and back. Front of neck, breast, and
body are blue. Tail and wings are highlighted in sil-
very white. *Female:* Primarily shades of silver to light
gray. Pale salmon front of neck and breast. Blue tail
with gray highlights; blue and gray wings.

Blue Wheaten. Beak is horn; eyes are red; shanks and
toes are white tinged with pink. *Male:* Head is light
orange. Hackle and saddle are golden red. Back is rich
red. Front of neck, breast, body, legs, and tail are blue.
Wings are blue with red and bay highlights. *Female:* Pri-
marily shades of light creamy wheaten. Tail and wings
are light wheaten with blue highlighting.

Brassy Back. Beak is black; eyes are brown; shanks
and toes are leaden blue to black. *Male:* Head and sad-
dle are brassy with a black stripe down the center of
each feather. Hackle is black edged with brass and end-
ing in a black spangle, transitioning to black around
lower hackle. Back is lustrous brass. Front of neck,
breast, body, wings, tail, and legs are black to lustrous
black. *Female:* Head and neck are all black to black

tinged with brass. Breast is light brassy salmon. Stern is brassy. Remainder is chocolate to chocolaty black.

Brown Red. Comb, wattles, and earlobes are mulberry. Beak is black; eyes are dark brown; shanks and toes are all black. Standard brown-red plumage (page 26).

Buff. Beak is horn; eyes are red; shanks and toes are white tinged with pink. Standard buff plumage (page 26).

Columbian. Beak is light horn; eyes are red; shanks and toes are white. Standard Columbian plumage (page 26).

Crele. Beak is light horn; eyes are red; shanks and toes are white tinged with pink. Standard crele plumage (page 26).

Cuckoo. Beak is horn; eyes are red; shanks and toes are white tinged with pink. Standard cuckoo plumage (page 27).

Fawn Silver Duckwing. Beak is light horn; eyes are red; shanks and toes are white tinged with pink. *Male*: Head is white, giving way to silvery white hackles and back. Front of neck, breast, and body are fawn. Tail and wings are highlighted in silvery white. *Female*: Primarily shades of silvery fawn with some gray stippling. Pale salmon front of neck and breast. Fawn tail with gray highlights; blue and gray wings.

Ginger Red. Beak is horn; eyes are red; shanks and toes are slate. Standard ginger-red plumage (page 27).

Golden Duckwing. Beak is horn; eyes are red; shanks and toes are white tinged with pink. Standard golden duckwing plumage (page 27).

Lemon Blue. Comb, wattles, and earlobes are mulberry. Beak, eyes, shanks, and toes are all black. Standard lemon-blue plumage (page 27).

Mille Fleur. Beak is horn; eyes are reddish bay; shanks and toes are slate. Standard mille fleur plumage (page 28).

Mottled. Beak is horn streaked with slate; eyes are red; shanks and toes are white mottled with black in young birds and leaden blue in older birds. Standard mottled plumage (page 28).

Quail. Beak is horn shaded with gray; eyes are brown; shanks and toes blue. Head, hackle, back, saddle, and wings are brilliant black laced with golden bay. Front of neck, breast, body, and legs are brownish yellow. Tail is black. *Female*: Head is chocolaty black tinged with yellow. Neck is lustrous chocolaty black laced with golden bay. Front of neck, breast, and body are brownish yellow laced with lighter shade of same color. Tail and wings are chocolaty black laced with light brownish yellow.

Red Pyle. Beak is horn; eyes are red; shanks and toes are white tinged with pink. Standard red pyle plumage (page 28).

Self Blue. Beak is dark horn, approaching black; eyes are dark brown; shanks and toes are bluish black. Standard self blue plumage (page 29).

Silver Blue. Comb, wattles, and earlobes are mulberry. Beak is black; eyes are dark brown; shanks and toes are all black. Head is silvery white. Hackle is lustrous blue laced with silvery white. Front of neck and breast are slaty blue laced with silvery white. *Male*: Back is lustrous silvery white. Saddle and upper breast are blue laced with silvery white. Lower breast, body, and legs are dark slaty blue. Wing coverts are dark blue, forming a distinct bar across wing; primaries, secondaries, shoulders, and fronts are dark blue laced with darker blue; bows are dark blue laced with white. Tail is dark blue.

Silver Duckwing. Beak is horn; eyes are red; shanks and toes are white tinged with pink. Standard silver duckwing plumage (page 29).

Spangled. Standard spangled plumage (page 29).

Splash. Beak varies from dark horn to black; eyes are reddish bay; shanks and toes are pinkish white. Standard splash plumage (page 29).

Wheaten. Beak is light horn; eyes are red; shanks and toes are white tinged with pink. Standard wheaten plumage (page 29).

White. Beak is light horn; eyes are red; shanks and toes are white tinged with pink. Standard white plumage (page 29).

PLACE OF ORIGIN Britain

CONSERVATION STATUS Study

SPECIAL QUALITIES Exceptionally hardy and vigorous; known for great longevity. Will easily revert to feral living.

Orloff

THE ORLOFF IS an ancient breed that developed in the Persian Gulf region, probably around Iran and Iraq, and was widely dispersed by the sixteenth century. It is named for Count Orloff-Techesmensky, a Russian livestock enthusiast and breeder who was a great promoter of the breed in the nineteenth century.

Orloffs are fairly tall birds that have a somewhat gamey appearance, with a large brow and a beard and muffs, though they tend toward a calm temperament. They are exceedingly hardy and well suited to cold climates. Though slow to mature, Orloffs are usually raised as meat birds. Hens lay light-brown eggs; they are very productive layers in their pullet year, but then their production tapers off. They are not given to broodiness.

Although the breed was once recognized in the APA *Standard of Perfection*, it was dropped due to lack of interest, though the Orloff bantams are still recognized by the ABA. Some individual breeders and a few hatcheries do offer the large Orloffs.

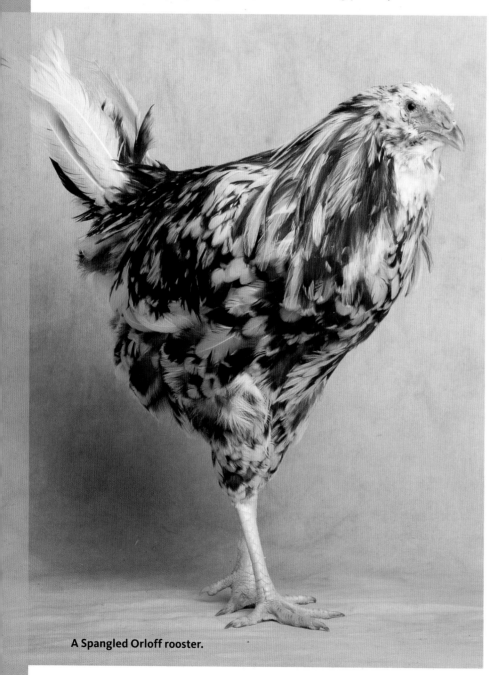

A Spangled Orloff rooster.

ORLOFF FACTS

SIZE **Standard Cock**: 8 lb. (3.6 kg) | **Hen**: 6.5 lb. (3 kg) **Bantam Cock**: 33 oz. (935 g) | **Hen**: 30 oz. (850 g)

COMB, WATTLES & EARLOBES Small walnut comb set well forward on head; very small wattles and earlobes. All are bright red.

COLOR Beak is yellow; shanks and toes are yellow; eyes are reddish bay.

Black-Tailed Red. Standard black-tailed red plumage (page 26).

Spangled. Standard spangled plumage (page 29).

White. Standard white plumage (page 29).

PLACE OF ORIGIN Persia

CONSERVATION STATUS Critical

SPECIAL QUALITIES Attractive birds for broiler production with very good eating quality, but slow growing.

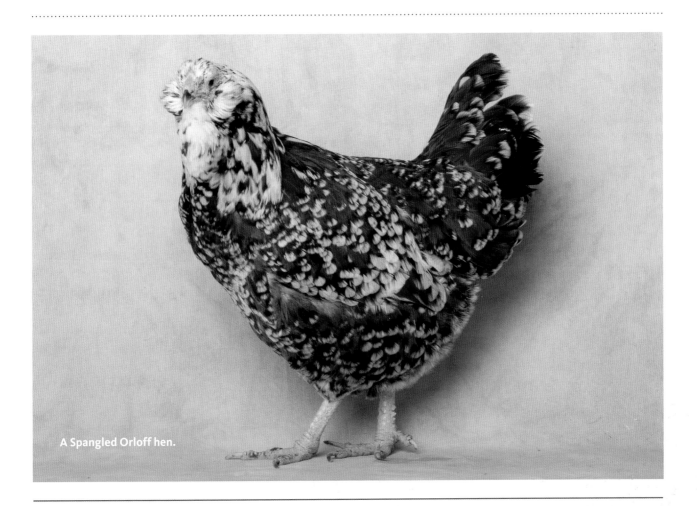

A Spangled Orloff hen.

Phoenix

FOR NEARLY A THOUSAND YEARS, breeders in Japan have bred ornamental "garden" chickens with exquisitely long tails. The tail feathers of these birds could exceed 30 feet (9.1 m)! The Phoenix was developed in the late 1800s in Germany by crossing these Japanese long-tailed birds, called Onagadori, with game birds.

The original German stock of Onagadori came from imported eggs. The German breeders quickly discovered that the birds were somewhat fragile and prone to health problems, so their goal in developing the cross was to maintain the Onagadori's beautiful traits while increasing its stamina and durability. In the early 1900s a similar program began in the United States, with breeders importing Onagadori eggs and crossing the resulting birds with game breeds and **Leghorns** (page 58).

The Onagadori has an unusual group of genes that allows for such extraordinary tail growth, including a recessive gene that keeps it from molting its feathers each year. The recessive nonmolting gene was lost in the development of the Phoenix, so its tail feathers do shed and therefore never reach the tremendous lengths of its ancestors' plumage. Nevertheless, the Phoenix's

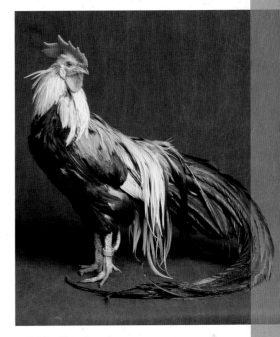

A Golden Phoenix cock.

PHOENIX FACTS

CLASS **Standard** English. **Bantam** Single Comb, Clean Legged.

SIZE **Standard Cock**: 5.5 lb. (2.5 kg) | **Hen**: 4 lb. (1.8 kg) **Bantam Cock**: 26 oz. (740 g) | **Hen**: 24 oz. (680 g)

COMB, WATTLES & EARLOBES Single comb with five well-defined, upright points is medium size in males and small in females. Wattles are medium size in males and small in females. Earlobes are medium size and oval in both sexes. Comb and wattles are bright red; earlobes are pure white.

COLOR Beak shades of horn; eyes reddish bay; shanks and toes light to dark leaden blue.
Black. Standard black plumage (page 26).

Golden. Standard golden plumage (page 27).
Golden Duckwing. Standard golden duckwing plumage (page 27).
Light Brown. Standard light brown plumage (page 28).
Silver. Standard silver plumage (page 29).
Silver Duckwing. Standard silver duckwing plumage (page 29).
White. Standard white plumage (page 29).

PLACE OF ORIGIN Germany
CONSERVATION STATUS Study
SPECIAL QUALITIES Small, highly ornamental bird with an extraordinarily long tail.

tail is really quite long and showy, reaching several feet (91 cm) in length in mature roosters. (Note: Some breeders refer to their birds as Onagadori, but unless the birds have tails that have not molted out in three years and exceed 6 feet [1.8 m] in length, the reference is probably incorrect.)

Phoenixes are small and generally docile, but unless they are hand-reared, they don't tend to be particularly friendly. They must have good accommodations that provide high perches and tight, dry, well-bedded quarters to maintain feather quality. Hens do not lay many eggs, but they can go broody and are good mothers.

The Phoenix was first admitted to the APA in 1965.

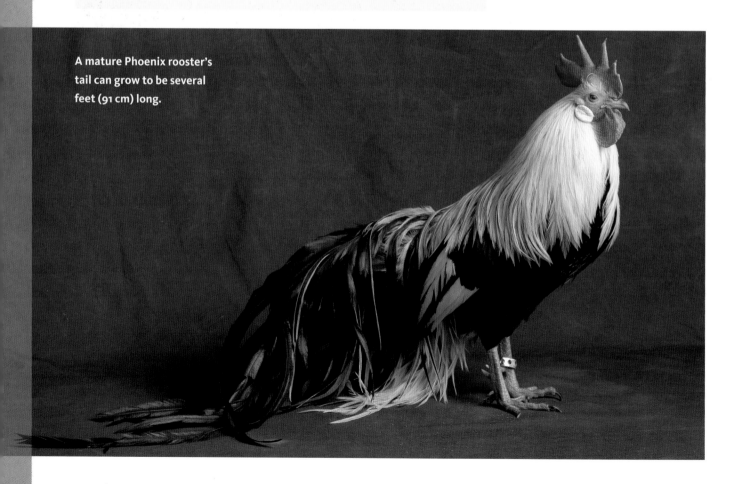

A mature Phoenix rooster's tail can grow to be several feet (91 cm) long.

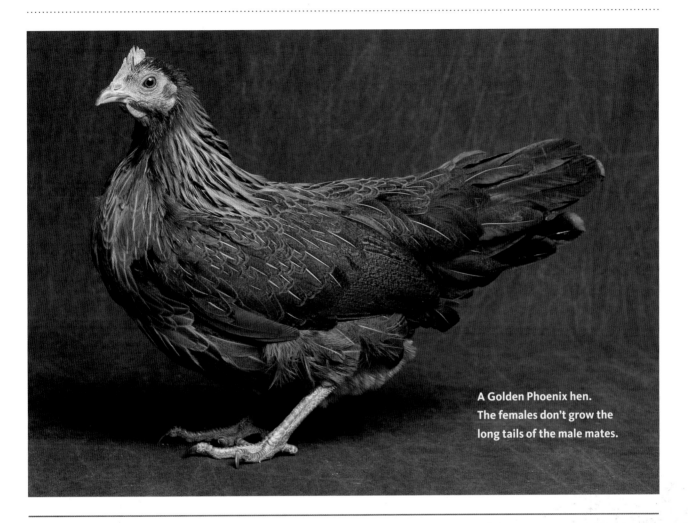

A Golden Phoenix hen. The females don't grow the long tails of the male mates.

Polish

THE VERY FIRST CRESTED chickens I ever saw were Polish, bought by some friends of mine, and I laughed until I cried: Phyllis Diller-like, with their wild crest feathers and sprightly behavior, they were immediate comic entertainers. The Diller look may be topped off with beards and muffs, depending on the variety.

In spite of the name, the Polish breed isn't from Poland. The breed as we know it today comes from Holland (where Polish birds show up in paintings dating back to the fifteenth century), but its beginnings are unclear. Some poultry historians speculate that the Polish indeed came from eastern Europe, while others think it made its way to Holland from birds originally found in Italy or Spain.

Polish chickens are usually fairly calm and friendly, but their crest and beard/muff feathers can interfere with their vision, so they are often spooked when they suddenly realize something is near. Hens don't go broody. Polish hens were originally developed as a layer breed, and many strains and varieties are still excellent layers.

The Polish was first admitted to the APA in 1874.

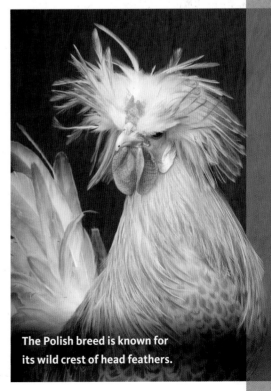

The Polish breed is known for its wild crest of head feathers.

POLISH FACTS

CLASS **Standard** Continental.

Bantam All Other Combs, Clean Legged.

SIZE **Standard Cock**: 6 lb. (2.75 kg) | **Hen**: 4.5 lb. (2 kg)

Bantam Cock: 30 oz. (850 g) | **Hen**: 26 oz. (740 g)

COMB, WATTLES & EARLOBES Small V-shaped comb. Wattles and earlobes are small and may be completely hidden in bearded/muffed varieties. Comb and wattles are bright red; earlobes are white.

COLOR A number of colors are not recognized by the APA or ABA at this time but are being worked with by members of the Polish Breeders Club, such as black-crested blue, black-crested buff, black-tailed red, crele, harlequin, self black, self chocolate, splash, white-crested blue splash, white-crested buff, white-crested dun, white-crested khaki, and white-laced red. For more information on these color varieties, contact the club (see page 260). Eyes are reddish bay.

Black-Crested White. Beak is horn; shanks and toes are slaty blue. Plumage is white, except for crest, which is lustrous black.

Blue. Beak is horn; eyes are dark brown; shanks and toes are leaden blue, with pinkish white bottoms of feet. Standard blue plumage (page 26).

Buff Laced. Beak, shanks, and toes are slaty blue. Plumage is golden buff laced in creamy white.

Golden. Beak is swarthy horn; shanks and toes are slaty blue. Standard golden plumage (page 27).

Silver Laced. Beak is swarthy horn; shanks and toes are slaty blue. Standard silver laced plumage (page 29).

White. Beak is dusky horn; shanks and toes are light slaty blue. Standard white plumage (page 29).

White-Crested Black. Beak is bluish black; shanks and toes are dark slate. Plumage is lustrous black, except for crest, which is white (a small cluster of black feathers in front is acceptable).

White-Crested Blue. Beak is bluish black; shanks and toes are dark slate. Plumage is blue, except for crest, which is white (a small cluster of blue feathers in front is acceptable).

White-Crested Chocolate. Beak is horn; shanks and toes are slate. Plumage is dark to milk chocolate with a neutral sheen, except for crest, which is white (a small cluster of chocolate feathers in front is acceptable).

White-Crested Cuckoo. Beak is horn; shanks and toes are slaty white. Plumage is barred in blue and white, except for crest, which is white (a small cluster of blue and white barred feathers in front is acceptable).

PLACE OF ORIGIN Holland

CONSERVATION STATUS Watch

SPECIAL QUALITIES Known for its wild topknot of feathers. A favorite with keepers of pet chickens.

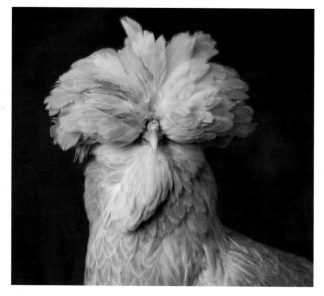

The Polish can have a beard and muff, as seen on this hen.

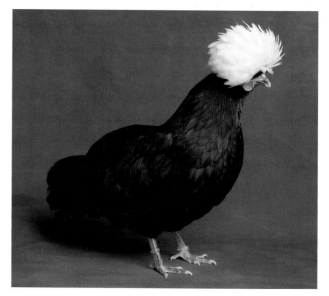

The Polish can also be beard-and-muff-free.

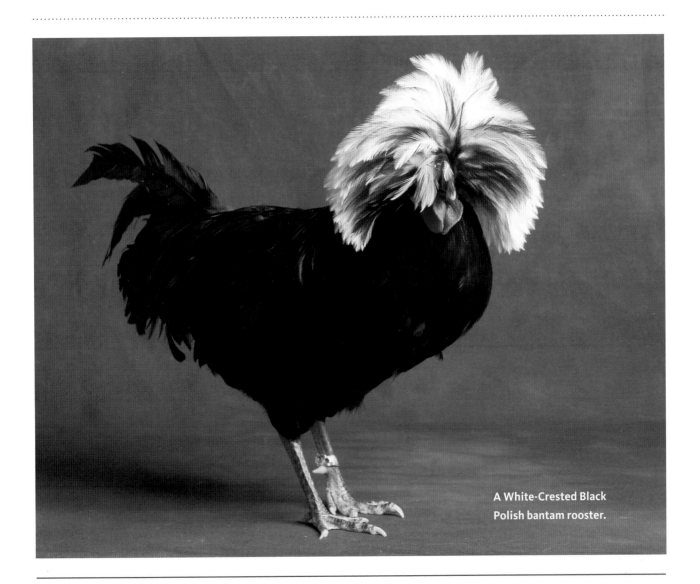

A White-Crested Black Polish bantam rooster.

Redcap

REDCAPS ARE A "TERRIFIC" old English breed, according to Glenn Drowns, owner of Sand Hill Preservation Center (a heritage seed and poultry operation in Calamus, Iowa). They were kept for generations in the area around Derbyshire and Yorkshire as a barnyard layer that could also produce a respectable carcass for Sunday dinner. No one is sure of the breed's heritage, but Redcaps have been documented in written records since at least the early nineteenth century and were probably bred up from common five-toed fowl.

Redcaps are hardy, long-lived birds that are quite active, alert, and well able to look after themselves in a free-range operation, foraging for a significant portion of their food if allowed, but they also adapt well to confinement. They are good fliers, so in a backyard environment they may need high fencing to keep them contained.

The Redcap has red ears with a white center, but the hens lay lots

The Redcap is named for its unusually large rose comb.

Redcap *continued*

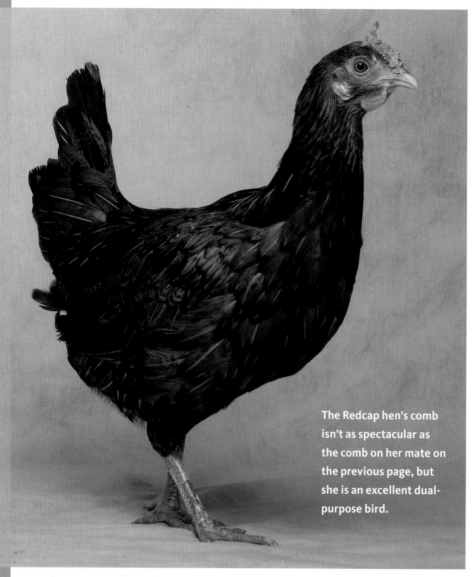

The Redcap hen's comb isn't as spectacular as the comb on her mate on the previous page, but she is an excellent dual-purpose bird.

of white eggs and don't usually go broody. The breed is known for the size and prominence of its large, pebbled rose comb, which is much bigger than other rose-comb breeds, such as the **Hamburg** (page 55).

The Redcap was first admitted to the APA in 1888.

REDCAP FACTS

CLASS **Standard** English.

Bantam Rose Comb, Clean Legged.

SIZE **Standard Cock**: 7.5 lb. (3.4 kg) | **Hen**: 6 lb. (2.75 kg)

Bantam Cock: 30 oz. (850 g) | **Hen**: 26 oz. (740 g)

COMB, WATTLES & EARLOBES Bright red rose comb covered with large, rounded points, set firm and square on head, and ending in well-developed, straight spike; it is large in females and even larger in males. Wattles and earlobes are medium in size and bright red.

COLOR Beak is horn; eyes are reddish bay; shanks and toes are dark leaden blue. *Male*: Head is rich, dark red. Hackle is bluish black edged with red, shading to black at base. Front of neck, breast, body, tail, and legs are black ranging from lustrous to dull. Back and wings are rich brown to red and black. *Female*: Head is brown. Hackle is black laced with golden bay. Front of neck, back, breast, and body are brown, ranging from rich to dull, with each feather spangled with a bluish black half-moon at the end. Legs are light brown. Tail is primarily black, though coverts are similar to back. Wings are brown highlighted with black.

PLACE OF ORIGIN England

CONSERVATION STATUS Critical

SPECIAL QUALITIES Truly an excellent layer for free range, with a stunning rose comb.

Rosecomb

THE ROSECOMB is a true bantam breed of ancient origins. As with so many of the very old breeds, its heritage is not well understood, but its development is credited to the breeders of Britain. Its popularity there soared in the fifteenth century when King Richard III began to raise Rosecombs — helping to stimulate some of the earliest European fanciers. No one knows precisely when Rosecombs crossed the Atlantic, but they were exhibited in the first poultry show in Boston in 1849.

The Rosecombs are, of course, named for their rose comb, which is large and moderately long for the birds' body size. Another distinction of the breed is the birds' prominent white earlobes. They have a cobby, or stocky, build, with a large, full tail that is well expanded and carried at a steep angle from the back, giving them a dashing appearance.

Breeders who keep Rosecombs are totally enamored with the breed, and they do well on the show circuit, but they are challenging to raise. Some breeders report that their Rosecombs suffer from poor fertility and hatchability, probably due to a genetic "flaw" that can pop up among any breeds that have a rose comb, such as **Dominiques** (page 53). This flaw can result in problems after multiple generations of close breeding for a strain that is pure for rose-shaped combs. Don Schrider of the American Livestock Breeds Conservancy (ALBC) says that an easy way to reduce this fertility problem is to save the occasional single-comb

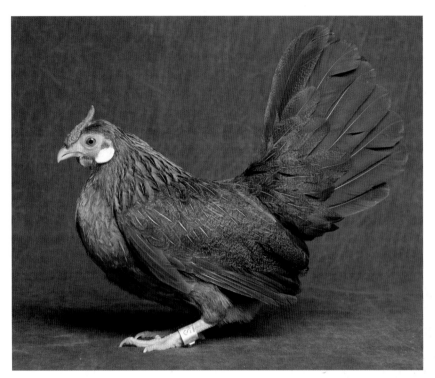

The Rosecombs are a bit challenging to raise, but breeders who keep them are completely smitten. Shown here is a Black-Breasted Red hen.

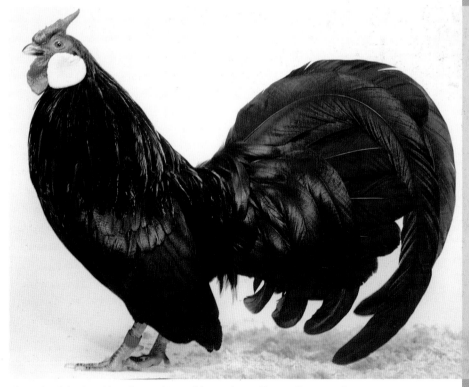

The cocks of this breed have large white earlobes and magnificent tails, as seen here.

Rosecomb *continued*

sports that are born and use them as breeding stock.

Chicks that do hatch are slow to mature and require a little more attention than chicks of many other breeds. Hens don't tend to go broody and lay only a small number of tiny, creamy white eggs. In spite of the challenge in brooding and raising chicks, the mature birds are active, good fliers, and fairly hardy in both heat and cold. Most are friendly, though some cocks can be rather aggressive.

The Rosecomb was first admitted to the APA in 1874.

A male Rosecomb has a large comb (though the curved spike shown here is not preferred) and large white earlobes.

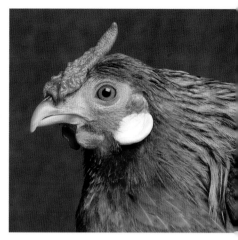

The hen's comb and earlobes are smaller and much more feminine.

ROSECOMB FACTS

CLASS Rose Comb, Clean Legged.

SIZE **Cock:** 26 oz. (740 g) | **Hen:** 22 oz. (625 g)

COMB, WATTLES & EARLOBES Large rose comb; medium to large wattles; well-rounded, fairly prominent earlobes. Comb and wattles are bright red, unless otherwise noted; earlobes are white.

COLOR

Barred. Beak is light horn; eyes are reddish bay; shanks and toes are dusky white. Standard barred plumage (page 26).

Birchen. Comb and wattles are mulberry; beak, shanks, and toes are black; eyes are brown. Standard birchen plumage (page 26).

Black. Beak is black; eyes are brown; shanks and toes are black. Standard black plumage (page 26).

Black-Breasted Red. Beak is horn shaded with black; eyes are reddish bay; shanks and toes are bluish slate. Standard black-breasted red plumage (page 26).

Black-Tailed Red. Beak is horn; eyes are reddish bay; shanks and toes are pinkish white. Plumage is primarily red. Tail is lustrous black and may have some red fringe in females. Wings are mainly red with some black.

Blue. Beak is dark horn to black; eyes are brown; shanks and toes are bluish slate. Standard blue plumage (page 26).

Brown Red. Comb and wattles are mulberry; beak is black; eyes are brown; shanks and toes are all black. Standard brown-red plumage (page 26).

Buff. Beak is pinkish white; eyes are reddish bay; shanks and toes are pinkish white. Standard buff plumage (page 26).

Buff Columbian. Beak is light horn; eyes are reddish bay; shanks and toes are bluish slate. Standard buff Columbian plumage (page 26).

Columbian. Beak is light horn; eyes are reddish bay; shanks and toes are pinkish white. Standard Columbian plumage (page 26).

Crele. Beak is light horn; eyes are reddish bay; shanks and toes are pinkish white. Standard crele plumage (page 26).

Exchequer. Beak is light horn; eyes are reddish bay; shanks and toes are bluish slate. Plumage is black and white, fairly evenly distributed over body.

Ginger Red. Beak is horn shaded with black; eyes are reddish bay; shanks and toes are bluish slate. Standard ginger-red plumage (page 27).

Golden Duckwing. Beak is dusky horn; eyes are

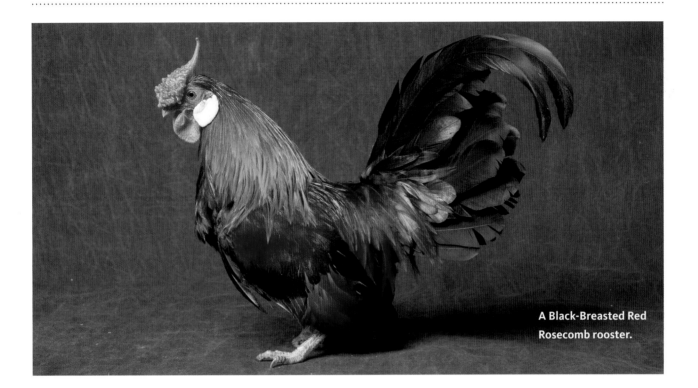

A Black-Breasted Red
Rosecomb rooster.

reddish bay; shanks and toes are light slate. Standard golden duckwing plumage (page 27).

Lemon Blue. Comb and wattles are mulberry; beak is black; eyes are brown; shanks and toes are black. Standard lemon blue plumage (page 27).

Mille Fleur. Beak is dusky horn; eyes are reddish bay; shanks and toes are bluish slate. Standard mille fleur plumage (page 28).

Mottled. Beak is dusky horn; eyes are brown; shanks and toes are pinkish white mottled with black. Standard mottled plumage (page 28).

Porcelain. Beak is dusky horn; eyes are reddish bay; shanks and toes are bluish slate. Standard porcelain plumage (page 28).

Quail. Beak is horn shaded with gray; eyes are brown; shanks and toes are slaty blue. *Male*: Head, hackle, back, saddle, and wings are brilliant black laced with golden bay. Front of neck, breast, body, and legs are brownish yellow. Tail is black. Head is chocolaty black tinged with yellow. Neck is lustrous chocolaty black laced with golden bay. Front of neck, breast, and body are brownish yellow laced with lighter shade of same color. Tail and wings are chocolaty black laced with light brownish yellow.

Red. Beak is horn; eyes are reddish bay; shanks and toes are white tinged with pink. Standard red plumage (page 28).

Red Pyle. Beak is horn; eyes are reddish bay; shanks and toes are pinkish white. Standard red pyle plumage (page 28).

Silver Duckwing. Beak is dusky horn; eyes are reddish bay; shanks and toes are white tinged with pink. Standard silver duckwing plumage (page 29).

Splash. Beak varies from light horn to black; eyes are reddish bay; shanks and toes are bluish slate. Standard splash plumage (page 29).

Wheaten. Beak is horn; eyes are reddish bay; shanks and toes are white tinged with pink. Standard wheaten plumage (page 29).

White. Beak is light horn; eyes are reddish bay; shanks and toes are white tinged with pink. Standard white plumage (page 29).

PLACE OF ORIGIN Britain

CONSERVATION STATUS Not applicable

SPECIAL QUALITIES Particularly decorative bantam for the serious fancier.

Sebright

Sir John Sebright was an influential member of England's landed gentry and Parliament and a committed agriculturalist and writer who worked on breeding programs with various animals, including chickens, in the nineteenth century. Not only did Sebright develop the breed of true bantams named for him, but his pamphlet, *The Art of Improving Breeds of Domestic Animals* (1809), drew the attention of Charles Darwin, who was struck by his statement that the weak do not survive long enough to pass on their traits. Sebright went on to correspond with Darwin and other influential thinkers of the time who were helping to increase our understanding of evolution and animal genetics.

Sebright had several goals when he began developing his namesake, hoping to perfect a very small bantam with plumage similar to that of the laced **Polish** (page 145) varieties. He crossed different native bantams, including the ancient **Nankins** (page 136), with Polish birds and continued crossing until he obtained the true-breeding bird he was looking for. The resulting birds also had unusual coloring on their comb, face, and earlobes and hen feathering in the males. Sebright's contribution to the field of genetics continues today: because of the unique traits his breed displays, molecular biologists are studying Sebrights to better understand the genome of chickens and how traits are passed on.

Like **Rosecombs** (page 149), Sebrights aren't the best bird for neophytes to start raising. They are difficult to rear due to poor hatchability and lack of vigor in the chicks. But adults are fairly hardy, active birds that fly well. Hens are not broody and lay a limited number of tiny white eggs.

The Sebright was first admitted to the APA in 1874.

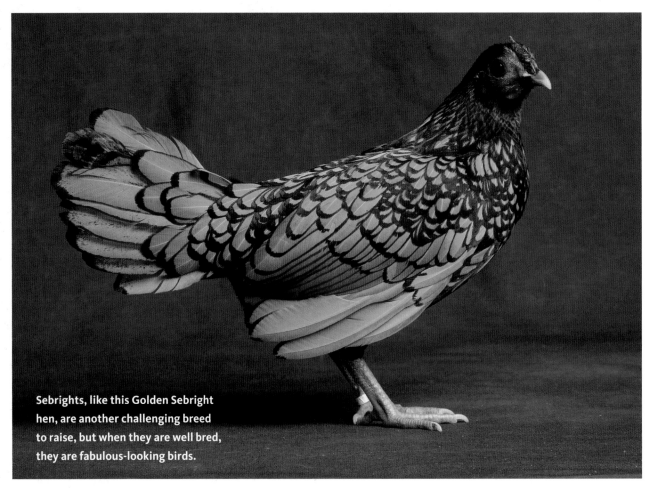

Sebrights, like this Golden Sebright hen, are another challenging breed to raise, but when they are well bred, they are fabulous-looking birds.

SEBRIGHT FACTS

CLASS Single Comb, Clean Legged.

SIZE **Cock**: 22 oz. (625 g) | **Hen**: 20 oz. (570 g)

COMB, WATTLES & EARLOBES Medium-size rose comb as well as face are purplish red in males and gypsy in females. Bright red, well-rounded wattles are broad in males and small in females. Flat, smooth earlobes are either purplish red or turquoise in both sexes and are broad in males and small in females.

COLOR Beak is dark horn; eyes are brown; shanks and toes are slaty blue.

Golden. Plumage is golden bay with narrow lacing of lustrous black.

Silver. Although the variety is called silver, it meets the description of standard silver laced plumage (page 29).

PLACE OF ORIGIN Britain

CONSERVATION STATUS Study

SPECIAL QUALITIES A unique-looking true bantam that the ABA says is one of the ten most popular bantam breeds, but it is hard to raise.

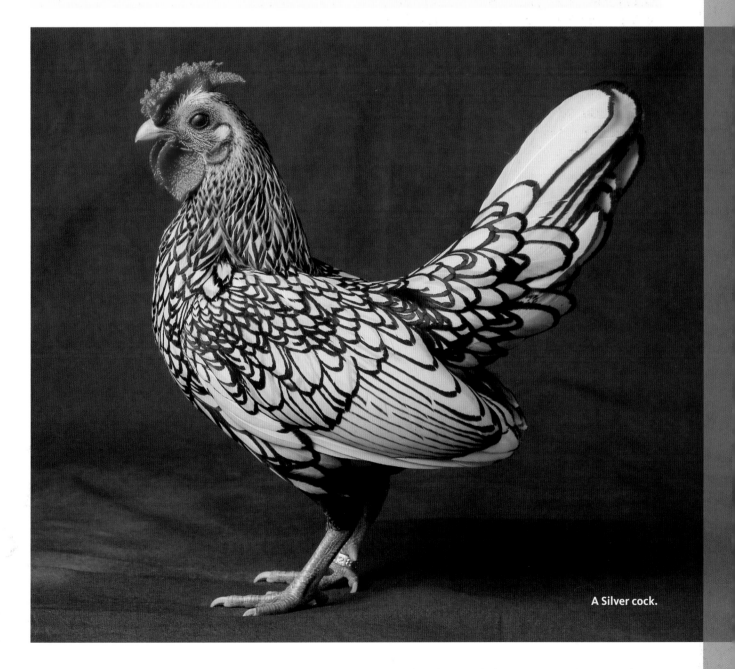

A Silver cock.

Serama

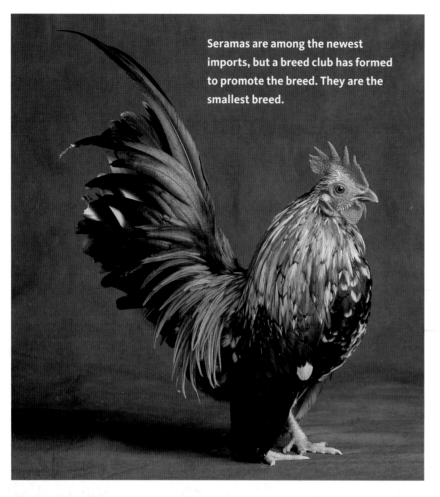

Seramas are among the newest imports, but a breed club has formed to promote the breed. They are the smallest breed.

SERAMAS WERE DEVELOPED in Malaysia from **Japanese Bantams** (page 122), possibly **Silkies** (page 158), native bantams, and jungle fowl. They are the smallest breed in the world, with mature cocks weighing as little as 12 ounces (340 g) and standing a mere 6 to 10 inches (15–25 cm) off the floor. Breeders divide them into three size classes: Class A, Class B, and Class C (see sizes below). They were recently imported to the United States (circa 2000).

Seramas are often kept as pets in apartments in their native Malaysia. They have an upright posture, with a broad, chesty build for their stature. Their tails are full, long, and held at 90 degrees to their back, and their wings are quite long and held down toward the ground, giving them a stately appearance. Several breed clubs have formed to promote Seramas, with the hope of obtaining APA and ABA recognition.

Due to their somewhat limited numbers, Seramas are not readily available and are somewhat expensive. Also, like some of the other small bantams, they are challenging to rear. Hens don't lay many eggs and don't tend to go broody. Many poultry enthusiasts are trying to obtain Seramas by purchasing hatching eggs; several breeders say they have had the best luck with hatching eggs when they have had them brooded naturally by other breeds, such as Silkies. All breeders who have gotten into the breed indicate that Seramas are tame and very friendly and seem quite enchanted with them once their flock is established.

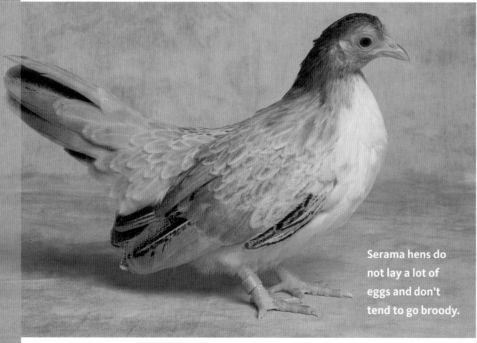

Serama hens do not lay a lot of eggs and don't tend to go broody.

SERAMA FACTS

SIZE **Class A Cock**: 12 oz. (340 g) | **Hen**: 11 oz. (310 g)
Class B Cock: 17 oz. (480 g) | **Hen**: 15 oz. (425 g)
Class C Cock: 20 oz. (570 g) | **Hen**: 17 oz. (480 g)

COMB, WATTLES & EARLOBES Small to medium-size, bright red single comb with five well-defined, upright points; small, well-rounded wattles; small, elongated earlobes.

COLOR Seramas can appear in almost any color (in fact, in Malaysia they are purported to show thousands of different colors), and there are no standards for color among the several breed clubs currently promoting them.

PLACE OF ORIGIN Malaysia

CONSERVATION STATUS Not applicable

SPECIAL QUALITIES Considered the smallest breed of chickens in the world.

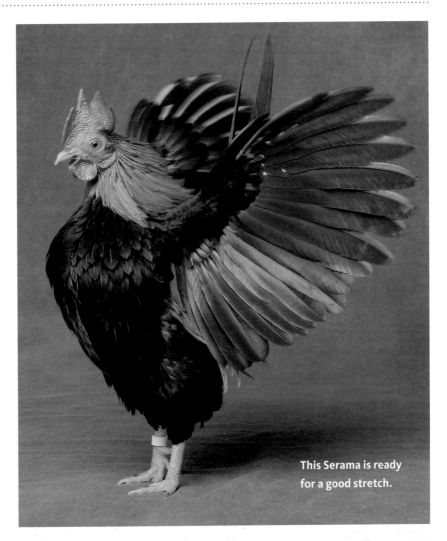

This Serama is ready for a good stretch.

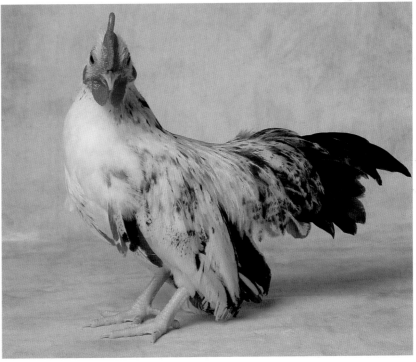

Currently, Seramas can come in many colors. They are not recognized by the APA or the ABA at this time.

Sicilian Buttercup

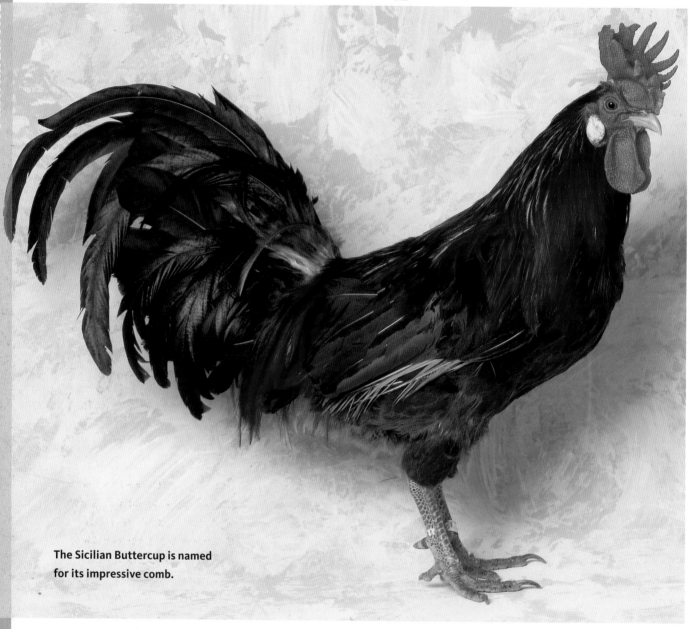

The Sicilian Buttercup is named for its impressive comb.

THE SICILIAN BUTTERCUP'S origins are unclear. The breed is known to have been found on the island of Sicily in the early nineteenth century and was first imported to the United States in 1835, but some poultry historians think the bird has very old roots dating to biblical times.

In chickens, as in many species of birds, the girls are often dull and drab compared to the guys, but I think the Buttercups are an exception to that rule of thumb. The males are handsome, black-tailed red birds, but they look like many other red roosters. The hens, on the other hand, are simply superb with their lovely, lustrous golden head and neck, golden buff body regularly marked by sharp black spangling, and sharp black tail.

The breed is named for its cup-shaped comb, which looks like a crown with medium-size regular points, and the hen's buttery golden base color. The comb is an interesting genetic variation that was produced from two side-by-side single combs that eventually merged at front and rear.

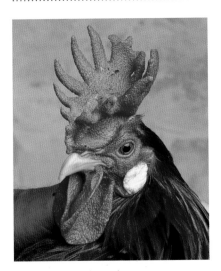

The rooster's comb, up close.

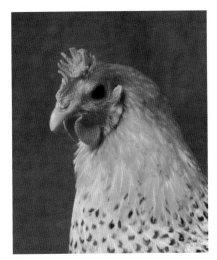

A hen's more delicate comb.

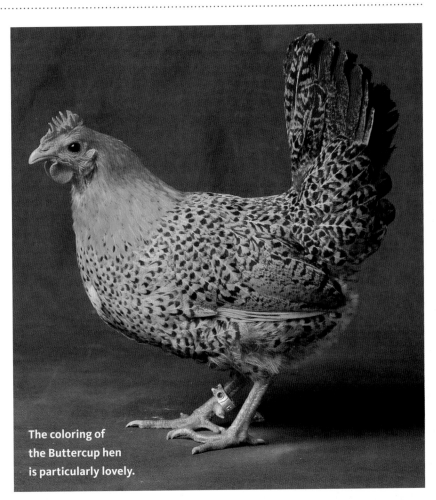

The coloring of the Buttercup hen is particularly lovely.

Buttercups are known to be active birds that mature early (though full development of the comb is slow) and don't do well in close confinement. Some Buttercup keepers report that they are flighty and don't like humans, yet others say they calm down well and become friendly in a small-flock situation. They are not cold-hardy, as their comb is susceptible to frostbite. The hens don't tend to go broody and aren't prolific layers, though they produce a respectable number of small to medium-size white eggs.

The Sicilian Buttercup was first admitted to the APA in 1918.

SICILIAN BUTTERCUP FACTS

CLASS **Standard** Mediterranean. **Bantam** All Other Combs, Clean Legged.

SIZE **Standard Cock**: 6.5 lb. (3 kg) | **Hen**: 5 lb. (2.5 kg) **Bantam Cock**: 26 oz. (740 g) | **Hen**: 22 oz. (625 g)

COMB, WATTLES & EARLOBES Cup-shaped red comb; small to medium-size red wattles; almond-shaped white earlobes.

COLOR Beak is horn; eyes are reddish bay; shanks and toes are willow, with yellow on bottoms of feet. *Male*: Plumage is primarily shades of lustrous reddish orange to reddish bay. Cape has some distinct black spangles, possibly covered by hackle. Tail and wings are black with some reddish bay and reddish orange highlights. Undercolor is slaty blue to light gray. *Female*: Head and neck are lustrous golden buff. Remainder is golden buff, ranging from lustrous to pale, marked with black spangles that extend across the feather diagonally, creating a barlike pattern, though it is different than the bars found in other breeds. The feathers are edged and tipped with golden buff.

PLACE OF ORIGIN Italy

CONSERVATION STATUS Critical

SPECIAL QUALITIES Beautiful and a decent layer.

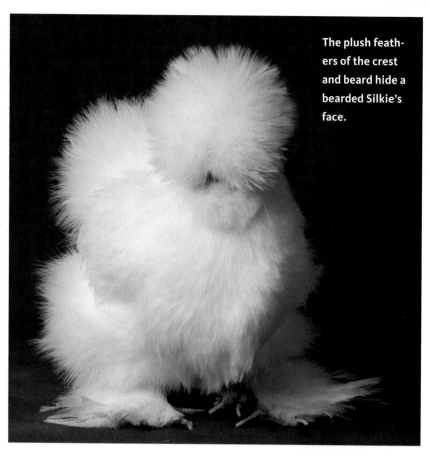

The plush feathers of the crest and beard hide a bearded Silkie's face.

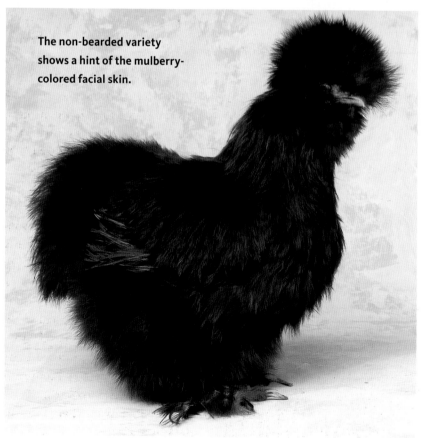

The non-bearded variety shows a hint of the mulberry-colored facial skin.

Silkie

THE SILKIE IS AN ANCIENT breed of Asian derivation (probably from China, though India and Java are also in the running for the point of origin). Europeans first heard stories of these marvelous creatures when Marco Polo returned from his travels through Asia in the thirteenth century.

Silkies are truly a one-of-a-kind breed: they have a melanotic gene that results in bluish black skin, bones, *and meat* (traits attributed with potent powers in Chinese folk medicine); mulberry bordering on bluish black combs, wattles, and faces; turquoise earlobes; bluish beaks; and silky-soft feathers that have a texture similar to that of fur. All Silkies have a crest, and there are bearded and non-bearded varieties.

The Silkies adapt well to confinement and are exceedingly docile and friendly, but they don't do well in out-of-door situations in extreme climates (cold or hot). Their feathers don't hold heat in, keep heat out, or shed water. Their looks and personality, however, have made them a favored pet chicken throughout the world.

The hens lay small, lightly tinted eggs. They aren't prolific layers, but they are one of the broodiest breeds of chickens and are often used as foster moms for other breeds' eggs. They are also excellent moms, and they happily raise the kids no matter what they look like, from other breeds of chickens to quail, pheasants, ducks, or geese.

The Silkie was first admitted to the APA in 1874.

SILKIE FACTS

CLASS Feather Legged

SIZE **Cock**: 36 oz. (1 kg) | **Hen**: 32 oz. (910 g)

COMB, WATTLES & EARLOBES
Walnut comb and wattles are small to medium; earlobes are very small. Comb and wattles are deep mulberry to black; earlobes are turquoise blue.

COLOR Beak is leaden blue; eyes are black; shanks and toes are bluish black.

Black. Standard black plumage (page 26).

Blue. Standard blue plumage (page 26).

Buff. Standard buff plumage (page 26).

Gray. Gray plumage over entire body, ranging from dark to light.

Partridge. Standard partridge plumage (page 28).

Splash. Standard splash plumage (page 29).

White. Standard white plumage (page 29).

PLACE OF ORIGIN Asia

CONSERVATION STATUS Not applicable

SPECIAL QUALITIES Unique-looking; ideal as pet chicken; excellent broody hen.

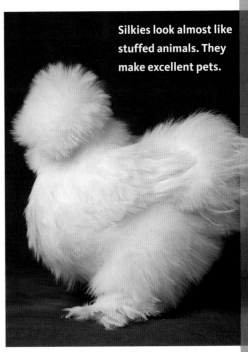

Silkies look almost like stuffed animals. They make excellent pets.

Sultan

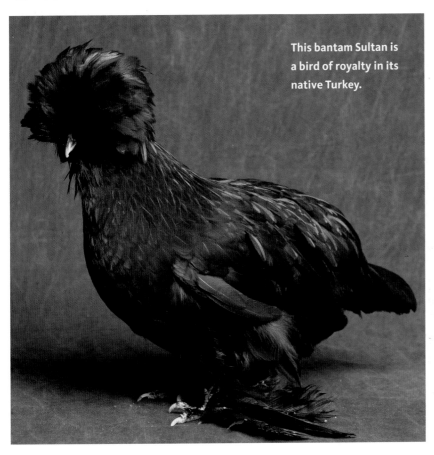

This bantam Sultan is a bird of royalty in its native Turkey.

CALLED SERAI-TAVUK ("fowls of the sultan") in their native Turkey, the Sultan is an old, ornamental breed that was indeed kept by Turkish royalty for centuries as a pet and as a living garden ornament. It was first imported to England from Constantinople in 1854 and made its way to the United States in 1867.

Sultans are relatively small birds that combine a crest, a beard and muffs, and well-feathered legs with vulture hocks. They are calm, easy to handle, and very well suited for close confinement, making them a good backyard bird, but they don't do well in a free-range situation. To keep their feathers in good form, they must have a tight, dry coop. The hens lay small white eggs but are not prolific and don't go broody.

The Sultan was first admitted to the APA in 1874.

Sultan *continued*

SULTAN FACTS

CLASS **Standard** All Other Standard Breeds.
Bantam Feather Legged.

SIZE **Standard Cock:** 6 lb. (2.75 kg) | **Hen:** 4 lb. (1.8 kg)
Bantam Cock: 26 oz. (740 g) | **Hen:** 22 oz. (625 g)

COMB, WATTLES & EARLOBES V-shaped comb, wattles, and earlobes are all very small and bright red.

COLOR

Black. Beak is black; eyes are brown; shanks and toes are black. Standard black plumage (page 26).

Blue. Beak is swarthy horn; eyes are brown; shanks and toes are bluish slate. Standard blue plumage (page 26).

White. Beak is light horn; eyes are reddish bay; shanks and toes are bluish slate. Standard white plumage (page 29).

PLACE OF ORIGIN Turkey

CONSERVATION STATUS Study

SPECIAL QUALITIES A small, regal bird that makes a good pet.

Sumatra

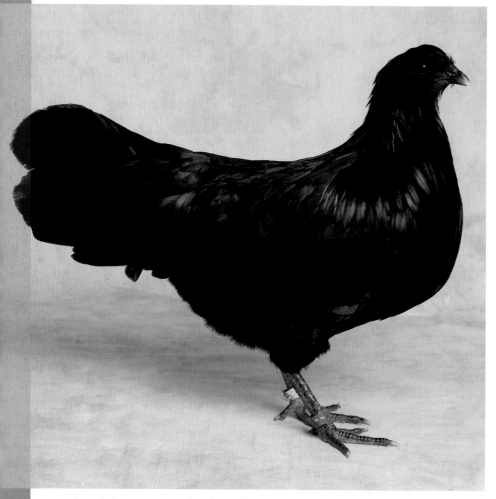

Sumatra hens are very good mothers and go broody readily.

THE SUMATRA is an ancient and primitive breed reputed to be one of the best fliers in chickendom, having flown over 5 miles (8 km) on prevailing winds from the Indonesian island of Sumatra to the island of Java. The breed was first imported to the United States in 1847 from Sumatra for cockfighting.

Fanciers and poultry preservationists who are trying to keep the breed from extinction in North America note that their flying — and jumping — ability can make keeping them where you want them a challenge. Because of this, they generally recommend using covered pens. In fact, Sumatras can reportedly jump a good six feet (1.8 m), even with their wing feathers clipped.

The Sumatras are extraordinarily stylish, with some of the most lustrous plumage of any breed (the black variety shows shades of brilliant green in the sun), a graceful pheasantlike carriage, and a long tail that flows horizontally behind them as they move. They are known for a spry strut and swagger that makes

me think of a young Mick Jagger. Their face is gypsy — an almost dark plum to almost black shade of purple — and their legs are glossy black. The cocks frequently have a cluster of several spurs on each leg, which is unique to the breed.

Though the roosters will fight with other Sumatra roosters, breeders report that they aren't particularly aggressive with roosters of other breeds. The hens are especially broody and good mothers, but they tend to begin laying later in the season than most breeds.

The Sumatra was first admitted to the APA in 1883.

SUMATRA FACTS

CLASS **Standard** All Other Standard Breeds. **Bantam** All Other Combs, Clean Legged.

SIZE **Standard Cock:** 5 lb. (2.25 kg) | **Hen:** 4 lb. (1.8 kg) **Bantam Cock:** 24 oz. (680 g) | **Hen:** 22 oz. (625 g)

COMB, WATTLES & EARLOBES Small pea comb, very small to nonexistent wattles, and very small earlobes. All are gypsy.

COLOR

Black. Standard black plumage (page 26).

Blue. Standard blue plumage (page 26).

White. Standard white plumage (page 29).

PLACE OF ORIGIN Sumatra

CONSERVATION STATUS Critical

SPECIAL QUALITIES A gorgeous bird with lustrous plumage.

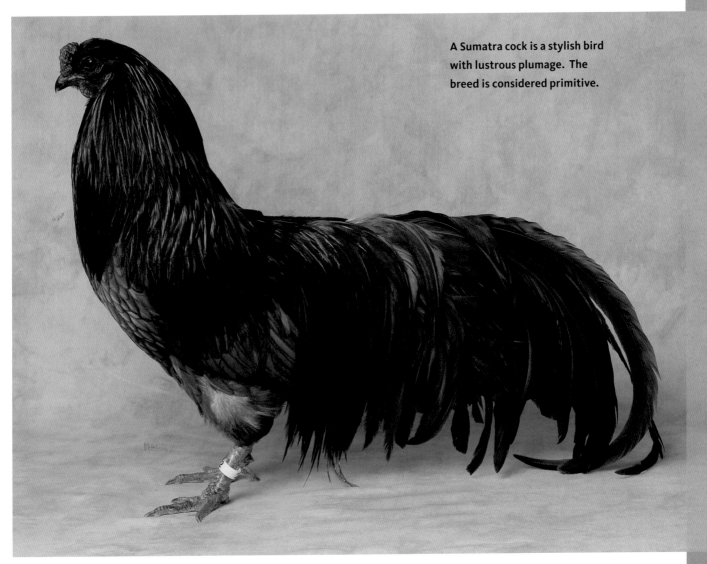

A Sumatra cock is a stylish bird with lustrous plumage. The breed is considered primitive.

Vorwerk Bantam

IN THE EARLY 1900S German breeder Oscar Vorwerk developed the first Vorwerk chickens. He crossed **Lakenvelder** (page 57), **Buff Sussex** (page 101), **Buff Orpington** (page 98), and **Blue Andalusian** (page 41) birds, with the aim of creating a large-bodied, dual-purpose bird with the Lakenvelder pattern but a buff base color. In 1966 Wilmar Vorwerk, a poultry fancier from Minnesota, read an article about the Vorwerk chickens in a German poultry paper and decided he had to have some.

After unsuccessfully scouring the United States poultry community for many years in search of his family's namesake birds, Wilmar Vorwerk decided to breed his own — in a bantam size. He combined Lakenvelder bantams, **Buff Wyandotte** (page 103) bantams, **Black-Tailed Buff Rosecomb** (page 149) bantams, Blue Wyandotte bantams, and Buff Columbian Rosecomb bantams. Ultimately, he came up with a bantam that was quite similar in appearance and character to the large Vorwerk. The breed was accepted into the ABA *Bantam Standard* in 1985.

Vorwerk Bantams are active, alert birds with an upright carriage and full tail that give them a sprightly air.

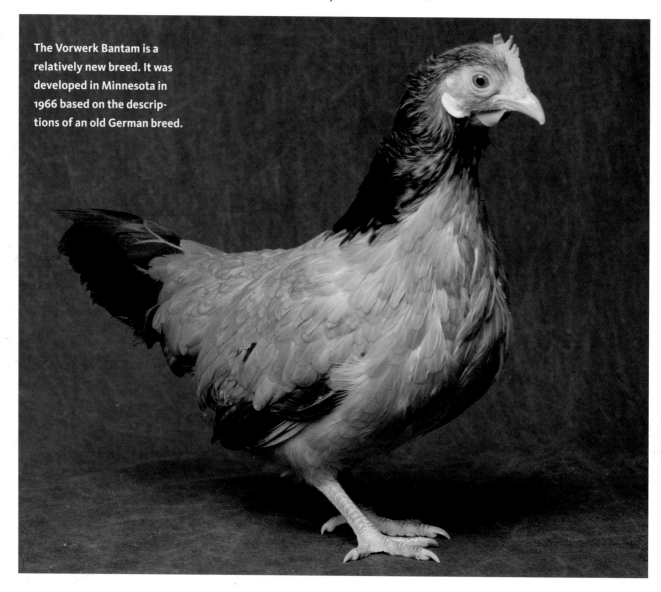

The Vorwerk Bantam is a relatively new breed. It was developed in Minnesota in 1966 based on the descriptions of an old German breed.

VORWERK BANTAM FACTS

SIZE **Cock:** 27 oz. (765 g) | **Hen:** 23 oz. (650 g)

COMB, WATTLES & EARLOBES Medium-size, bright red single comb with five well-defined upright points; rear points may droop in females. Bright red wattles are moderately long and broad in males and small in females. Medium-size, almond-shaped, white earlobes.

COLOR Beak is bluish gray to horn; eyes are orangey red with yellow iris; shanks and toes are slate. Head and hackle are rich, lustrous black. Front of neck and body are in shades of buff from deep and dark to golden. Tail is velvety black. Wings are buff highlighted with black.

PLACE OF ORIGIN United States

CONSERVATION STATUS Not applicable

SPECIAL QUALITIES A good dual-purpose bantam with a nice disposition for backyard and barnyard flocks.

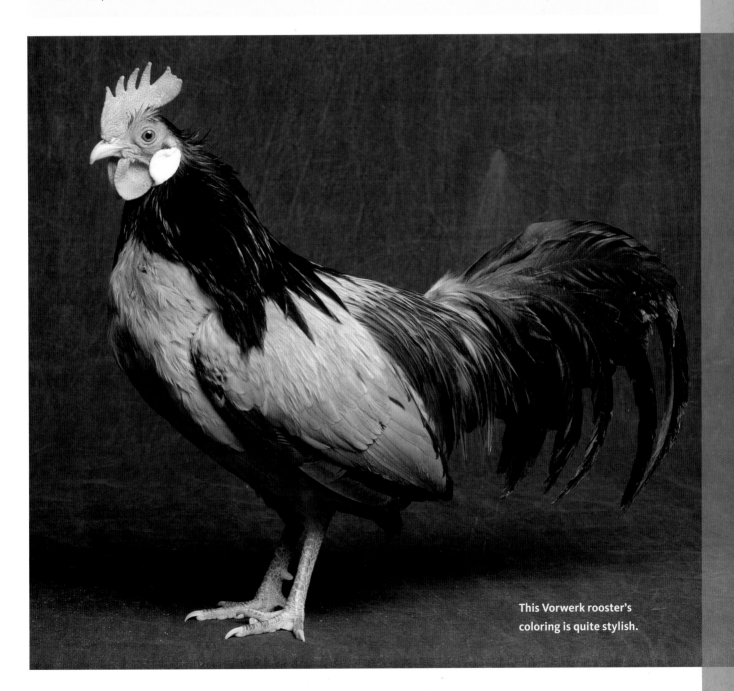

This Vorwerk rooster's coloring is quite stylish.

White-Faced Spanish

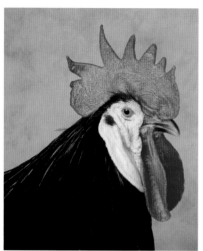

THE WHITE-FACED SPANISH is considered one of the oldest of the Mediterranean breeds, though its heritage is unclear. Spaniards brought it to the Caribbean region during the early colonization of the New World, making it one of the oldest breeds in the United States. The breed was historically black feathered, but today there are also blue bantams recognized by the ABA.

White-Faced Spanish birds are slow to mature; the development of the white face takes more than a year. They are also active and noisy, with personalities ranging from not particularly friendly and kind of standoffish to downright charming and highly people-oriented. They do really well in free-range operations but will tolerate confinement. Hens are very good layers of large, chalk-white eggs and don't tend to go broody.

The White-Faced Black Spanish was first admitted to the APA in 1874.

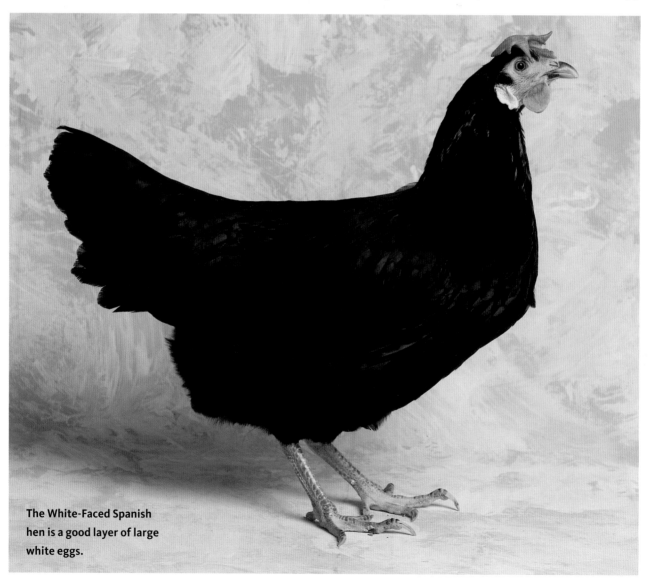

The White-Faced Spanish hen is a good layer of large white eggs.

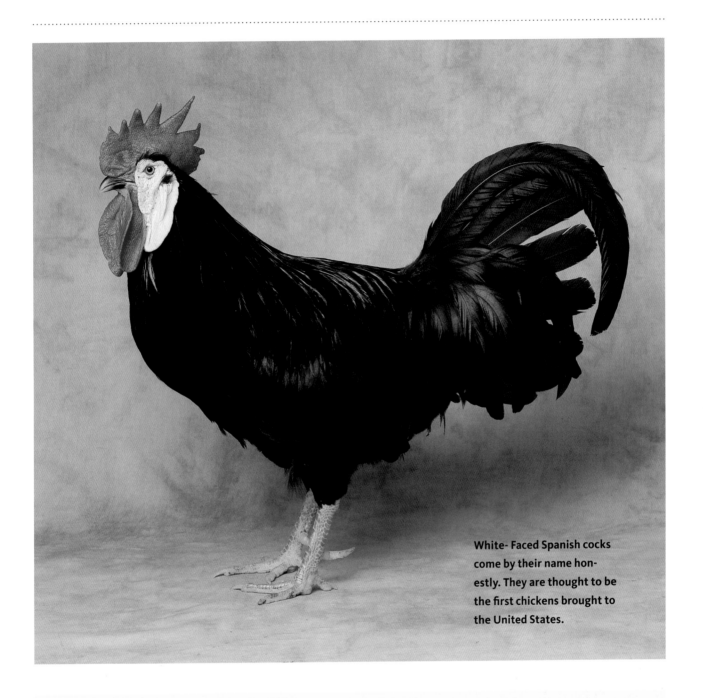

White- Faced Spanish cocks come by their name honestly. They are thought to be the first chickens brought to the United States.

WHITE-FACED SPANISH FACTS

CLASS Standard Mediterranean.
Bantam Single Comb, Clean Legged.
SIZE Standard Cock: 8 lb. (3.6 kg) | **Hen:** 6.5 lb. (3 kg)
 Bantam Cock: 30 oz. (850 g) | **Hen:** 26 oz. (740 g)
COMB, WATTLES & EARLOBES Medium-size, bright red single comb with five well-defined points that are upright in males and droop to the side in females. Long, thin, bright red wattles, with white on upper inside in males. Large, enamel white earlobes.

COLOR Beak is black; eyes are dark brown; shanks and toes are dark slate. There is a blue variety and a white variety, though these are not recognized by the APA.
 Black. Standard black plumage (page 26).
PLACE OF ORIGIN Spain
CONSERVATION STATUS Critical
SPECIAL QUALITIES First chicken brought to the United States; a good laying breed; unusual coloring.

Yokohama

THE YOKOHAMA is a relatively small bird out of the Japanese long-tail clan. Its forebear is known in Japan as the Minohiki and was bred from two game breeds: the **Shamo** (page 100) and the Shokoku (a breed of Chinese derivation that dates to the eighth century). Although it was developed from game lines, the Minohiki was kept primarily for ornamental purposes. When Minohikis made it to Europe in the 1800s, they were named Yokohama for the port from which they were shipped.

Yokohamas are generally easygoing and docile, though cocks can sometimes be aggressive around other cocks. To maintain the quality of their fancy feathering, which includes not only the long tail but also very long and profuse saddle feathers on the males, the birds need dry, well-bedded housing and high perches. The breed is slow to mature. Hens will go broody and are very good mothers, though they lay only a limited number of small, lightly tinted eggs.

The Yokohama was first admitted to the APA in 1981.

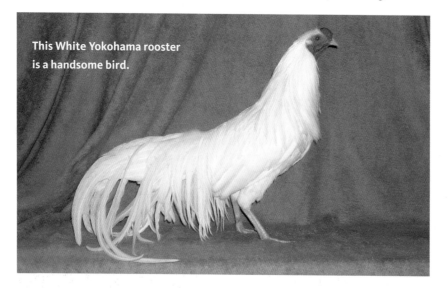

This White Yokohama rooster is a handsome bird.

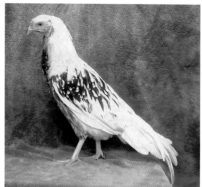

Yokohama hens are good mothers, but they don't lay many eggs.

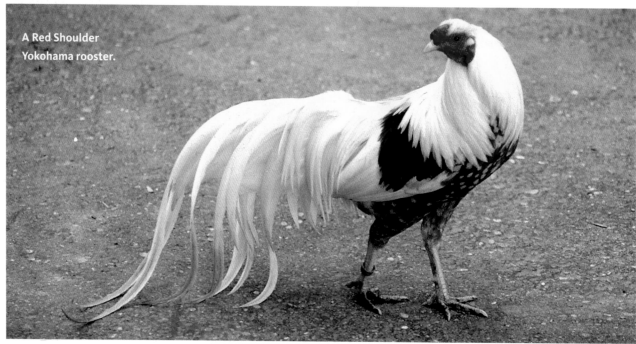

A Red Shoulder Yokohama rooster.

YOKOHAMA FACTS

CLASS **Standard** All Other Standard Breeds.
Bantam All Other Combs, Clean Legged.

SIZE **Standard Cock**: 4.5 lb. (2 kg) | **Hen**: 3.5 lb. (1.6 kg)
Bantam Cock: 26 oz. (740 g) | **Hen**: 22 oz. (625 g)

COMB, WATTLES & EARLOBES Walnut comb, wattles, and earlobes are all very to moderately small; wattles may be missing entirely. All are bright red.

COLOR Beak is yellow; eyes are reddish bay to orangey red; shanks and toes are yellow.

Dark Brown. Standard dark brown plumage (page 27).

Light Brown. Standard light brown plumage (page 28).

Red Shoulder. Color is primarily white, with substantial reddish brown highlights on shoulders, wings, and breast.

Silver. Standard silver plumage (page 29).

White. Standard white plumage (page 29).

PLACE OF ORIGIN Japan

CONSERVATION STATUS Study

SPECIAL QUALITIES An extremely attractive show bird with long tail and saddle feathers.

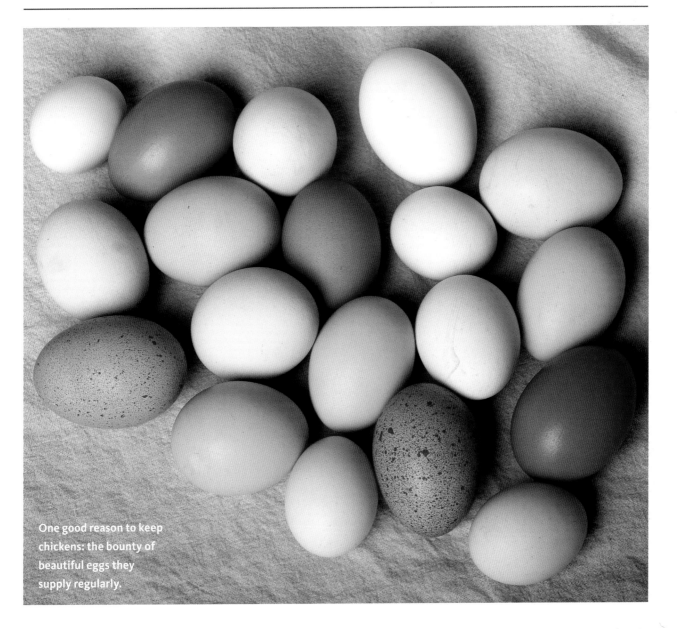

One good reason to keep chickens: the bounty of beautiful eggs they supply regularly.

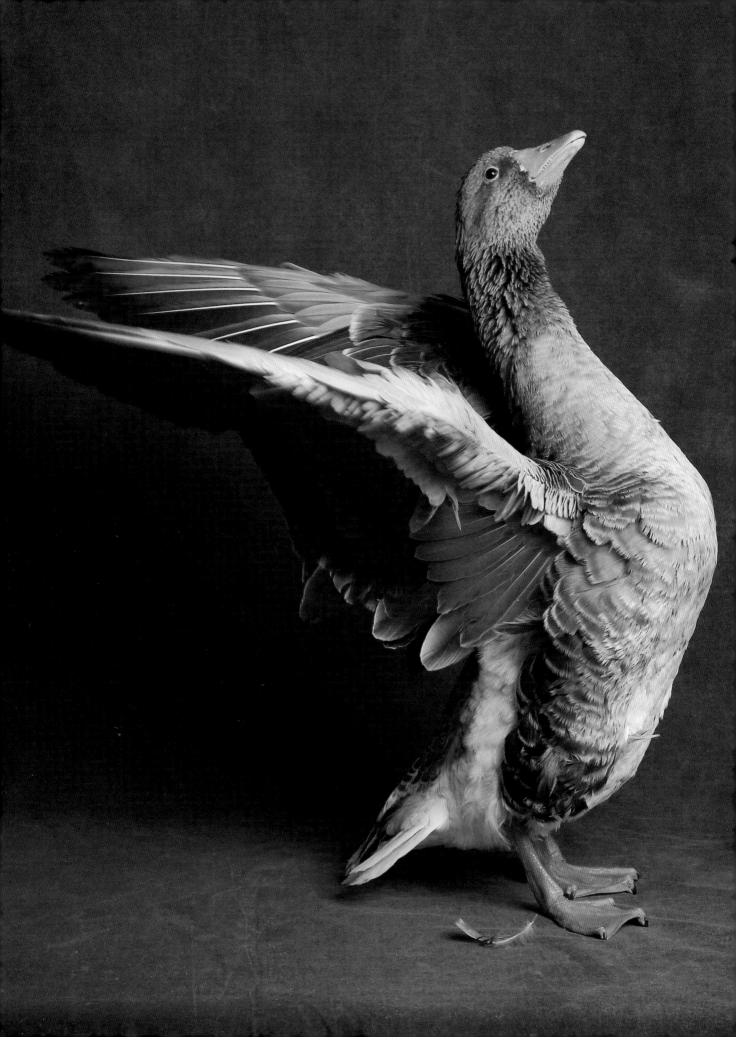

Waterfowl

..

Be kind to your web-footed friends,

for a duck may be somebody's mother.

Be kind to your friends in the swamp,

where the weather is always damp.

—Parody lyrics set to Sousa's "Stars & Stripes Forever," writer unknown

DUCKS, GEESE, AND SWANS are all fairly closely related. In fact, biologists often struggle with classifying birds among the categories. The birds tend to be broken down by size, with smaller birds classified as ducks, medium as geese, and large as swans, which are written about in the Other Birds of Interest chapter (page 239). They are all widely distributed across the globe and in the wild tend to migrate over long distances.

There are well over one hundred species of wild ducks, yet all domestic ducks are thought to be descended from just two of these: the Mallard and the Muscovy. The wild Mallard is the progenitor of most of our domesticated ducks. They were probably first domesticated about five thousand years ago for meat and eggs, with separate domestications occurring at about the same time in Asia and the Middle East. The wild Mus-covy, a species native to Central and South America, was first domesticated in pre-Inca Peru as a pet — ultimately giving us the domestic Muscovy.

MALLARDS

The Mallards belong to a large group of ducks called dabbling ducks, so named for their distinc-

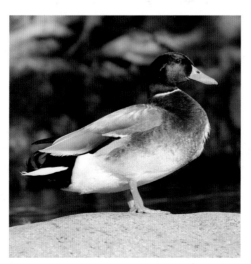

Above: Most domestic ducks have been developed from the wild Mallard. Left: A Gray goose.

tive style of feeding. These ducks feed by dabbling their bill at the surface of water, which in essence pumps water through the bill, filtering out food particles as the water passes through. They also graze on grasses along the shoreline.

Some people may be surprised to find out that dabbling ducks are omnivores, consuming a fair quantity of insects, worms, fish, mollusks and crustaceans (such as snails, clams, shrimp, crabs), toads and frogs, snakes, and even some small mammals. In general, dabblers are social birds that tend to hang out in shallow waters and wetland areas and nest on the ground.

It is not surprising that the mallards have played an important role in the development of domesticated ducks, because they are the most ubiquitous waterfowl. Found in all areas of the Northern Hemisphere

except the high Arctic tundra, as well as in many areas of the Southern Hemisphere, they adapt to a wide variety of ecosystems and tolerate human disturbance and activity with nary a problem.

MUSCOVIES AND GEESE

Muscovies belong to a group called perching ducks, which was at one time considered a stand-alone type of duck but now is considered a subtype within the dabbling ducks. Members of the perching species make their homes in well-wooded areas near rivers and lakes and tend to roost in trees, often making nests in them.

Muscovies are funny-looking ducks with distinctive pebbly red skin around the face. They are particularly carnivorous and are often kept on small farms for their ability to control flies and other nuisance insects.

Geese were also domesticated about five thousand years ago in southeastern Europe, northern Africa, and Asia. Three species (the Greylag, the Egyptian, and the Asian "Swan goose") are the ancestors of all domestic geese.

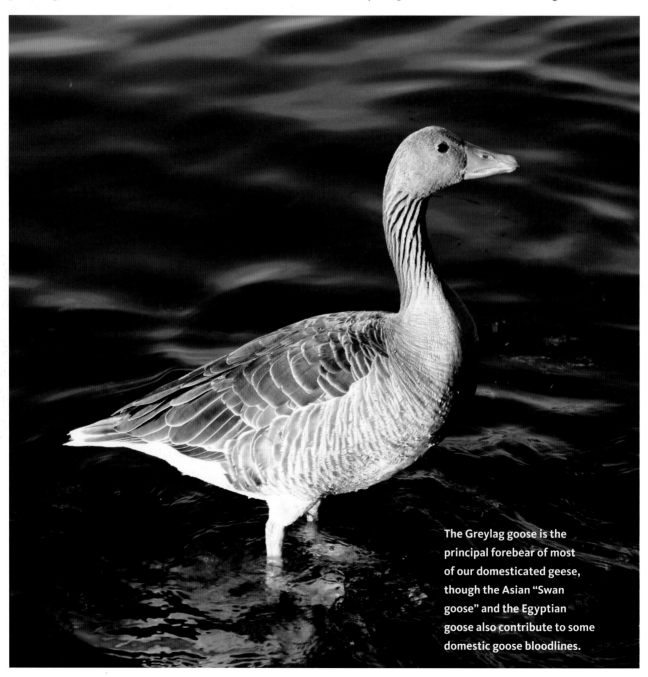

The Greylag goose is the principal forebear of most of our domesticated geese, though the Asian "Swan goose" and the Egyptian goose also contribute to some domestic goose bloodlines.

Raising Waterfowl

ALTHOUGH DUCKS AND GEESE are less common in North American backyards and barnyards than chickens, they have been kept for meat, often considered a luxury item, for feathers, and for egg production for over several centuries. Ducks and geese are also kept as pets (including as house pets, when "diapered"), for ornamental purposes, to control insects and weeds, and, in the case of geese, as guardian animals and doorbells.

In a backyard or small-scale barnyard operation, ducks and geese will usually go broody and raise their own young if allowed. Drakes (male ducks) generally don't participate in child rearing, but ganders (male geese) are full partners in caring for the brood.

Commercial waterfowl operations usually incubate eggs and raise the young indoors with supplemental heat for at least the first six weeks of life. Larger commercial operations often have the ducks continue their lives indoors to protect them from predators, though geese usually go out on pasture until they are ready for processing. Wisconsin and Indiana lead the country in commercial duck production; California and South Dakota are the main goose-producing states.

A FEW PRECAUTIONS

Domestic ducks are about the most predator-vulnerable critters we ever raised in a barnyard setting. In the wild, a duck's main defense is its ability to take flight quickly or slip into a body of water when threatened, but many domestic breeds no longer fly well and are often kept where they don't have access to sheltering bodies of water. The larger breeds, such as the Aylesbury, Pekins, and Rouens, also tend to be slow, ploddish birds, and not the most astute at perceiving danger in the neighborhood.

If you plan to raise ducks, you must take precautions — such as keeping them in fenced yards or running them in a mixed flock with geese — to protect them from dogs, foxes, coyotes, and other predators. Our ducks would wander out into the pastures to graze during the day, and if we didn't shoo them home well before dusk, we would inevitably lose some.

Geese are less prone to predation, but some can be nasty. During

Ducks (like this pair of Magpies) are fun and relatively easy to raise, making them a good choice for a family project.

Geese, such as this Toulouse, are gregarious and entertaining, but they can be somewhat destructive.

Male Plumage in Eclipse

For many breeds of ducks, the male's breeding plumage (known as nuptial plumage) is distinctly different from the female's. However, during the molt (also known as the eclipse period) the drake will resemble the female, only in a somewhat darker shade. For most breeds of geese (Pilgrim and Shetland geese are the exceptions), the adult male and the adult female are the same color.

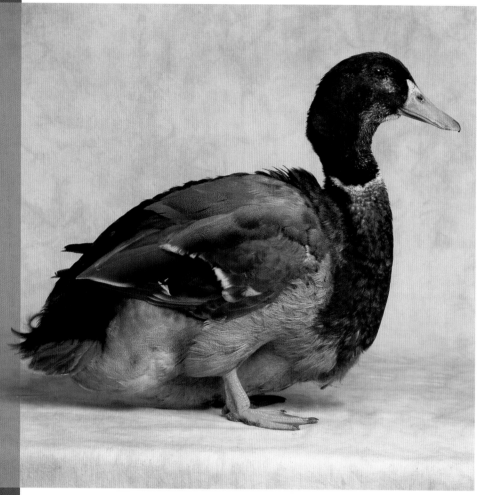

the breeding season, when they are fighting for dominance or protecting their females, some ganders are especially mean. Generally speaking, all geese breeds have the potential for some aggressiveness, but individual temperaments run the gamut from docile and sweet to hostile. Geese can also be somewhat destructive. I remember our flock of geese eating all of the wires underneath the truck one day. Another time they ate dozens of young seedlings that I had raised over the previous eight weeks in the house and just transplanted to the garden (they are grazers after all, and young tender plants are a grazer's delight). In spite of these traits, I have always liked geese and was particularly fond of some Embdens with sweet dispositions that we had for a time. They came running to visit — necks craned forward, and honking all the way — whenever I walked out of the house.

Ducks, especially the large, slow-moving breeds (such as this Rouen), are more vulnerable to predation than other types of birds, so you need to take into account how you will protect your flock.

Breeds in Trouble

The American Livestock Breeds Conservancy (ALBC) completed a waterfowl census in 2001, and the results were troubling. Six breeds of ducks (Ancona [shown below], Aylesbury, Magpie, Saxony, Silver Appleyard, and Welsh Harlequin) and four breeds of geese (American Buff, Pomeranian, Pilgrim, and Roman) are critically endangered, and thirteen breeds fall into the Rare, Watch, and Study categories. That's almost three-quarters of the waterfowl breeds recognized in North America!

This situation is really a shame, because ducks and geese are beautiful, versatile birds that are generally easy to raise. They are hardy, active, and have good resistance to most diseases.

Classifications

DUCKS AND GEESE are classified in the APA *Standard of Perfection* according to general weight categories. For ducks, the classes are Bantam, Light Weight, Medium, and Heavy; for geese they are Light, Medium, and Heavy. In the following pages, each breed's weight class is given below the breed description. For easy reference and comparision, the tables to the right give the average weight for each class and the breeds (those described on the following pages) included in that class.

For consistency, I characterized breeds that have not been accepted into the APA *Standard of Perfection* (Ancona, Australian Spotted, Dutch Hookbill, and Golden Cascade ducks and Gray, Shetland, and Tufted Buff geese) using the same weight classifications as the APA-recognized breeds.

APA Weight Classifications for Ducks

CLASS	WEIGHT OF ADULT MALE	BREEDS INCLUDED
Bantam	40 oz. (1.1 kg) or less	Australian Spotted, Call, East Indies, Mallard
Light	4–5 lb. (1.8–2.25 kg)	Campbell, Dutch Hookbill, Magpie, Runner, Welsh Harlequin
Medium	7–8 lb. (3.2–3.6 kg)	Ancona, Buff, Cayuga, Crested, Golden Cascade, Swedish
Heavy	9 lb. (4 kg) or more	Appleyard, Aylesbury, Muscovy, Pekin, Rouen, Saxony

APA Weight Classifications for Geese

CLASS	WEIGHT OF ADULT MALE	BREEDS INCLUDED
Light	5.5–14 lb. (2.5–6.4 kg)	Canada, Chinese, Egyptian, Roman, Shetland
Medium	14–21 lb. (6.4–9.5 kg)	American Buff, Gray, Pilgrim, Pomeranian, Sebastopol, Tufted Buff
Heavy	22 lb. (10 kg) or more	African, Embden, Toulouse

The Australian Spotted duck is a bantam breed.

Ancona

THIS IS A RELATIVELY NEW breed, developed in the early years of the twentieth century in England. It is similar to the **Magpie** (page 190) and was probably bred up from the same parent stock: **Runners** (page 195) and an old Belgian breed called the Huttegem. It is larger than the Magpie, however, and falls in the medium size class.

Anconas are best known for their spots (think patches of coloring like a Holstein cow). There are a number of color combinations, including black and white, blue and white, chocolate and white, lavender and white, and tricolored, and breeders are continuing to experiment with new colors. The APA has not recognized the Ancona breed, but a few breeders are working to obtain recognition of the breed, so it may show up in a future edition of the APA *Standard of Perfection.*

The Anconas lay white, cream, tan, blue, green, or spotted eggs, and they are good layers with a long productive season. Known as excellent foragers, they are hardy and produce a nice carcass that is a little less fatty than birds of some of the other breeds. They're also supposed to be less vulnerable to predation than some other ducks because they tend to be homebodies, not wandering far from their nighttime accommodations.

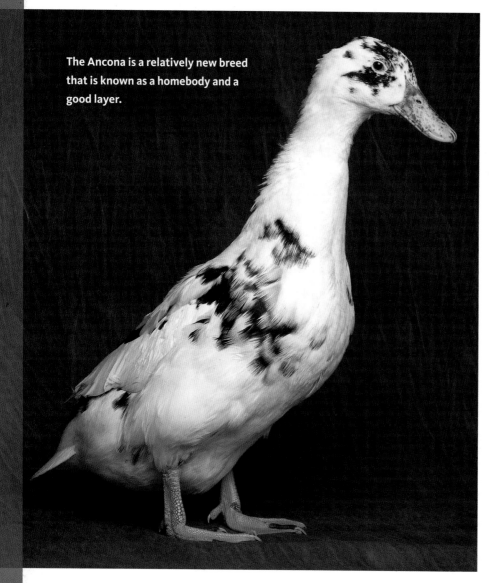

The Ancona is a relatively new breed that is known as a homebody and a good layer.

The Ancona's spots are more asymmetrical patches than true spots.

ANACONA FACTS

SIZE CLASS Medium

COLOR White with patches of color, such as black, blue, or chocolate.

CONSERVATION STATUS Critical

Appleyard

DEVELOPED IN THE 1930S by English waterfowl enthusiast Reginald Appleyard, the Appleyard is an excellent bird for the production of meat and eggs. It is also an excellent ornamental, with color similar to that of a **Mallard** (page 190), but with a lighter silvery gray tint in drakes and a light silvery brown tint in hens.

Appleyards, which are sometimes referred to as Silver Appleyards, were first brought to the United States in the 1960s and were just recognized by the APA at a qualifying meet in 1998. This recognition may help bring the breed back from the brink of extinction.

Reginald Appleyard did a good job producing a bird that has excellent carcass traits, fast growth, good production of white eggs, and excellent foraging ability. The meat is flavorful but not too fatty. The Appleyards are known for having a calm temperament, making them a nice choice for small-flock owners.

The Appleyard was first admitted to the APA in 1998.

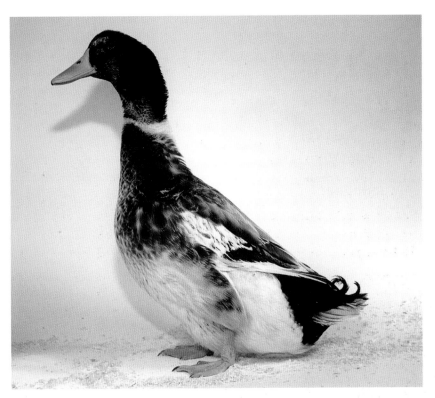

The Appleyard drake shows coloring similar to the Mallard, but with a silvery gray tint.

APPLEYARD FACTS

SIZE CLASS Heavy

COLOR Similar to that of Mallards but shaded slightly lighter. Drakes have silvery gray feathers flecked with fawn under throat.

CONSERVATION STATUS
Critical

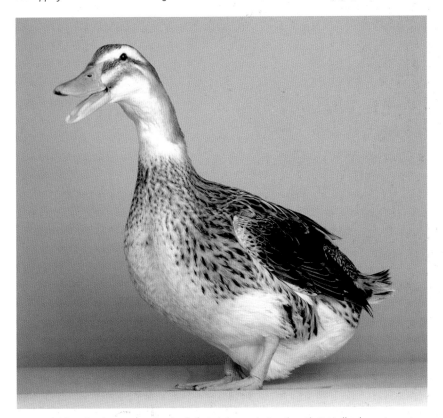

Appleyard females show more silver and silvery brown coloring than their Mallard counterparts.

Australian Spotted

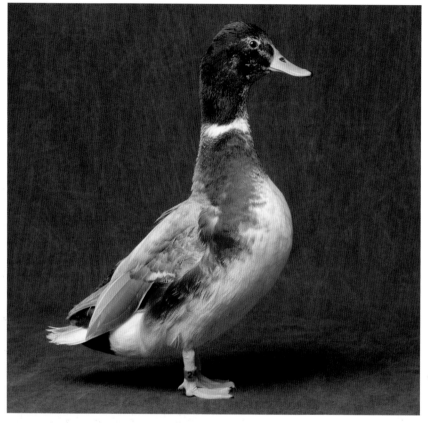

An Australian Spotted Bluehead drake.

ANOTHER BREED whose name belies its beginnings, the Australian Spotted duck is an American original. A true bantam duck, the Australian Spotted was reportedly developed in the 1920s from a mixture of **Mallard** (page 190), **Call** (page 180), Northern Pintail, and an unidentified Australian wild duck.

According to Dave Holderread, one of the leading experts on waterfowl in the United States, the "Spots," as they are often called, are long-lived, personable ducks that are exceptionally hardy, have outstanding foraging abilities, and are the best layers of the bantam breeds. They have a voracious appetite for insects and are often kept as a pest-control squad.

Australian Spotted ducks are known for having a racy, teardrop-shaped body. They weigh around 2 pounds (900 g). Thanks to their small size, they still fly well, so in backyard situations they need a high fence with a covered top or they should have 8 to 10 of their primary flight feathers clipped annually.

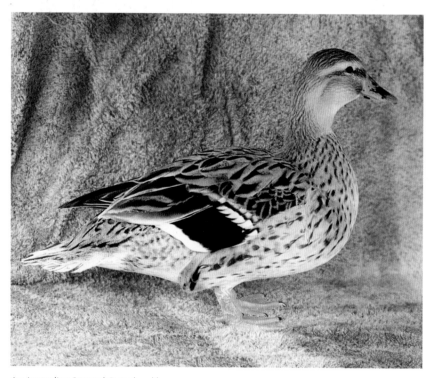

An Australian Spotted Greenhead hen.

Australian Spotted ducks are small, friendly birds.

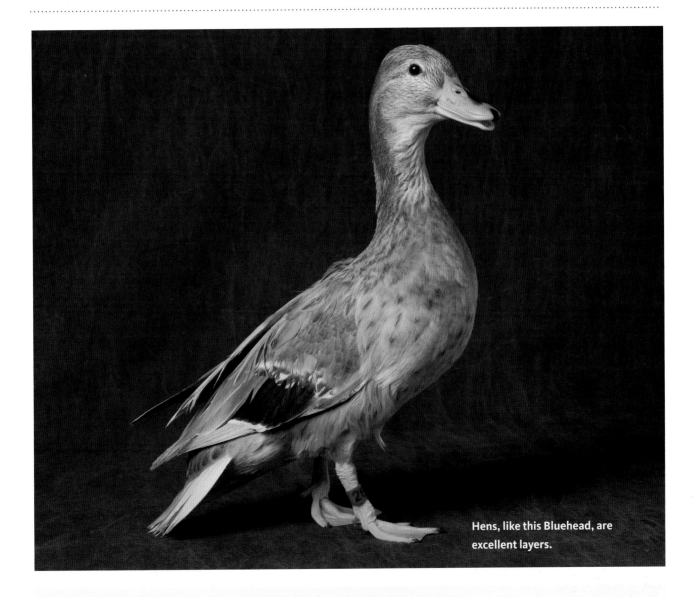

Hens, like this Bluehead, are excellent layers.

AUSTRALIAN SPOTTED FACTS

SIZE CLASS Bantam

COLOR The color resembles a Mallard's but has a slightly washed-out effect created by a light white frosting on the feathers; the hen has distinct spots all year; the drake is heavily spotted only when in eclipse plumage. The Greenhead is the foundation variety for the breed; the Bluehead and Silverhead are variants that were developed from the Greenhead.

Bluehead. Same as Greenhead, except all black, gray, and dark brown areas of plumage are diluted with bluish gray.

Greenhead. Eyes are dark brown; shanks and feet are orange with some gray shading. *Drake*: Bill is yellowish green. Head and neck are iridescent green with a white band encircling the neck. Sides of body and breast are reddish brown; center of breast and extending under body are light gray shading to white; the back and undertail cushion are greenish black; the wings are in various shades of gray with brilliant blue, white, and black highlights. *Hen*: Bill is orange with dark gray or brown shading. Upper body is fawn frosted with white, with most feathers being center marked with dark brown; underbody shading to white; wings highlighted in brilliant blue, white, and black.

Silverhead. Same as Greenhead, except all black, gray, and dark brown areas of plumage are diluted with silver.

CONSERVATION STATUS Study

Aylesbury

NAMED FOR THE TOWN of Aylesbury in England (about 40 miles [65 km] north of London), this large white duck has long been a favorite in Britain, where it's believed to have been developed during the early years of the nineteenth century. It was displayed at the first-ever London poultry show in 1845. Thought to be the first recognized duck breed to be imported to the United States, it made its first formal appearance on this side of the Atlantic in a show in Boston in 1849.

The Aylesbury was traditionally raised as a market bird for the London table trade and as such was bred to have a distinctive body type: both drakes and hens have a deep, prominent, rounded breast; a blocky body; and a long, prominent keel that runs parallel to, and almost touching, the ground.

In the late eighteenth and early nineteenth centuries the ducks were walked to market, and inns along the road to London had specially designed pens where duck drovers could safely keep their birds overnight. In the morning the birds were driven through a cold tarry solution in a shallow ditch, followed by a layer of sawdust, to protect their feet. By 1839 they were being transported to London by train, on cars that carried thousands of ducks at a time. Their solid white plumage was valued for use in quilts.

The Aylesbury was first admitted to the APA in 1874.

Aylesbury ducks are very heavy meat birds, with a prominent keel that almost drags on the ground.

AYLESBURY FACTS

SIZE CLASS Heavy

COLOR Pinkish white bill (though birds on a ration that is high in yellow pigment such as corn, or fresh, light, leafy greens, may have distinct yellow shading in their bills). Orange shanks and feet. White skin (unlike most other domestic ducks, which have yellow skin) and pure white plumage.

CONSERVATION STATUS Critical

Buff

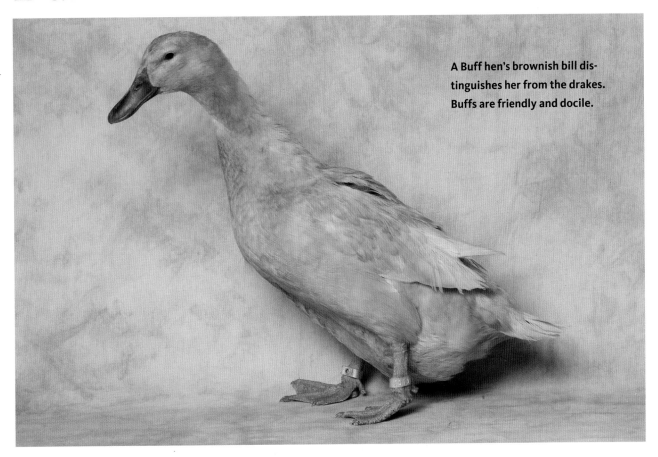

A Buff hen's brownish bill distinguishes her from the drakes. Buffs are friendly and docile.

WILLIAM COOK of Orpington, England (also the breeder of the Orpington chicken) developed the Buff, or Buff Orpington, in the beginning of the twentieth century and showed the breed at the 1908 Madison Square Garden show. Cook used **Cayuga** (page 184), **Runner** (page 195), and **Aylesbury** (page 178) ducks in breeding the Buff.

Initially Cook's main goal was to obtain a buff-colored duck, though later he introduced other colors. The Buff is the only color recognized by the APA, and in an unusual step for the organization, it accepted the breed by its color-only name, making it the only breed of this distinction ever admitted to the *Standard of Perfection*.

The Buff is a friendly and fairly docile bird that forages well. Raised frequently by fanciers for show purposes, the breed shouldn't be discounted as a practical backyard or barnyard bird; Cook's secondary goal was to produce a respectable dual-purpose production bird, and he succeeded. Buffs yield a fine medium-size roaster that cleans up nicely thanks to the light-colored pinfeathers. Hens are good layers of medium-size white or lightly tinted eggs.

The Buff was first admitted to the APA in 1914.

BUFF FACTS

SIZE CLASS Medium

COLOR *Drake*: Bill is yellow; shanks and feet are orangey yellow. Head and upper neck are rich fawn buff to seal brown. Body is ideally an even shade of rich fawn brown. *Hen*: Bill is brownish orange with dark bean. Shanks and feet are orangey yellow. All plumage is an even shade of rich fawn brown.

CONSERVATION STATUS Threatened

Call

WITH AN ALMOST stuffed-animal appearance of a kid's toy, Calls are the cutest of all ducks. They have a tiny beak, fairly large eyes for their size, and a rounded head and stubby neck set atop a squat, rounded body.

Most poultry historians think they were developed in northern Europe in the seventeenth century as a "decoy duck," though some think that the Europeans may have brought initial breeding stock from Japan or China. When tethered out in areas where hunters wanted to draw in wild ducks, they would "call" in unsuspecting flocks with their chatty, loud voices.

Calls are raised primarily as show birds. They make excellent pet ducks, having an extra-friendly disposition. Around the backyard or barnyard they are quite active, making them constantly entertaining. However, for all the Call's good points, Dave Holderread shares one drawback to the breed: They are among the noisiest of all ducks. He says if you have close neighbors it's a particularly important point to be aware of, citing cases where the Calls have caused serious disputes with non-bird-raising neighbors.

The Call was first admitted to the APA in 1874.

Call ducks are tiny, toylike birds, and are as cute as can be. They are very friendly, but also quite noisy. The hen (top left) has a slightly shorter and more feminine beak than the male (bottom left).

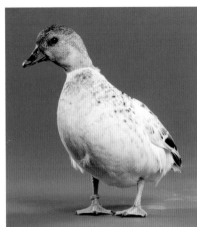

There are six colors currently recognized by the APA — Blue, Buff, Gray, Pastel, Snowy, and White. To the far left is a Gray drake and to the near left is a Snowy hen.

CALL FACTS

SIZE CLASS Bantam

COLOR

Breeders are working on a number of additional colors, but these are the colors currently recognized by the APA.

Blue. Bill is greenish blue to bluish slate. Shanks and feet are reddish brown shaded with irregular markings of grayish black. Eyes are dark brown. Plumage is bluish slate with some darker lacing and highlights. Breast has a pure white heart-shaped patch on front. Wings are colored like the body, except ideally the outer two or three flight feathers are white.

Buff. Shanks and feet are orangey yellow. Eyes are brown. *Drake*: Bill is yellow. Head and upper neck are rich fawn buff to seal brown. Body is ideally an even shade of rich fawn brown. *Hen*: Bill is brownish orange with dark bean. All plumage is an even shade of rich fawn brown.

Gray. Mallard-type coloring. Eyes are dark brown. *Drake*: Bill is greenish yellow; shanks and feet are orange with brownish tinge. Head and neck are lustrous green with distinct white collar at base of neck. Breast is rich purplish brown (claret). Upper body is steel-colored; lower body is light ashy gray. Tail is ashy brown shaded with white; coverts are black with green and rich purple highlights. Wings are gray highlighted with blue, black, and white. *Hen*: Bill is brownish orange. Shanks and feet are orange shaded with dark brown. Body is in shades of brown striping or penciling. Back, tail, and wings are light brown highlighted with green, bluish green, black, and white.

Pastel. Eyes are brown. *Drake*: Bill is apple green with dark bean. Head and neck are soft powdery blue with distinct white collar at base of neck. Plumage is in shades of blue overlaid with buff and gold with a rose or mauve sheen. Breast is purplish brown shading to rose or lilac. *Hen*: Bill is brown with dark saddle and bean. Plumage is in shades of blue overlaid on shades of golden brown shading to rose. Wings and tail are highlighted with shades of silver and bluish buff.

Snowy. Eyes are brown. Shanks and feet are orange with brownish tinge. *Drake*: Bill is greenish yellow with dark bean. Head and neck are iridescent green; distinct white color at base of neck. Breast, shoulders, and legs are claret laced in white, shading more to white toward stern. Back is stippled gray with some white lacing. Underbody is white. Stern and tail are black with some white lacing. Wings are gray and white with black and violet highlighting. *Hen*: Bill is brownish orange with dark blotch midway and dark bean. Head and neck are fawn lightly stippled with brown. Breast and body are light fawn shading to white. Tail is brownish gray with white lacing. Wings are gray and white with brownish black and violet highlights.

White. Bill is bright yellow; eyes are blue; shanks and feet are bright orange. Plumage is pure white.

CONSERVATION STATUS Not applicable

Campbell

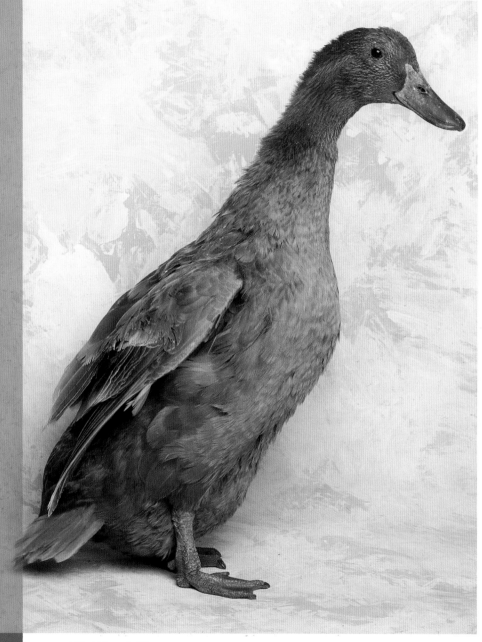

A Khaki Campbell hen.
Campbell hens lay as many
as 340 eggs per year.

THE CAMPBELL WAS developed in the late 1800s in England by Mrs. Adele Campbell, who later told people that she had bred the bird to take care of "the great appetite on the part of my husband and son for roast duckling!" Adele had a single British Fawn and White (called Penciled in North America) **Runner** (page 195) that was a prolific layer. She bred it first to a **Rouen** (page 194) to increase its size. Later she used a **Mallard** (page 190) drake to increase hardiness and foraging ability.

Adele succeeded in increasing the size for carcass production while maintaining reasonably good laying ability. Later breeders worked on increasing egg production, and by the 1920s the Campbell became recognized as the most abundant layer in duckdom, pumping out as many as 340 medium-size eggs per year.

Mrs. Campbell's first Campbells were colored somewhat like Mallards. Because buff-colored poultry was all the rage at the time, Adele experimented with breeding back Campbells to Penciled Runner ducks. The cross didn't yield buff, but it did produce a color that reminded her of the British military uniforms of the time, so she dubbed these birds Khaki Campbells.

A few other color varieties were later developed, though they have not been recognized by the APA. Both the White and Dark varieties are commercially available in North America.

The Campbell was first admitted to the APA in 1941.

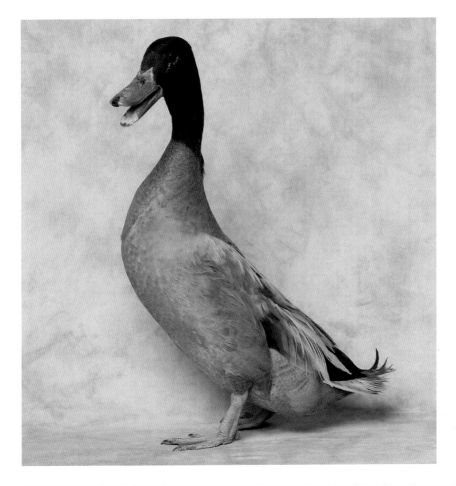

A Khaki Campbell drake. White and Dark varieties are commercially available though not recognized by the APA.

CAMPBELL FACTS

SIZE CLASS Light

COLOR

Dark. Eyes are dark brown. *Drake*: Bill is bluish green with black bean at tip. Shanks and feet are orange with brown shading. Head, neck, and rump are beetle green. Body is medium to dark grayish brown. Wings have white highlights, and often a purplish speculum. Tail is in various shades of grayish brown. *Hen*: Bill is greenish black. Shanks and feet are dark brown at maturity. Head and neck are dark cocoa brown with light brown ticking. Plumage is primarily dark brown distinctly penciled with khaki; may be lighter over the shoulders. Speculum has less iridescence than the drake's but is similarly colored.

Khaki. Eyes are dark brown. Shanks and feet are orange with brown shading (ranging from light to heavy). *Drake*: Head, neck, and rump are brownish bronze with a bit of green sheen. Body is dark tan in a shade reminiscent of khaki cloth; it fades with exposure to sunlight to very light tan. Wings have some dark brown highlights with a hint of green iridescence. Tail is tan. *Hen*: Head and neck are medium dark brown. Body is dark tan, but also can fade when exposed to sunlight. Wings have dark brown highlights, though lighter than the drake's.

White. Eyes are blue. Bill color ranges from bright orange to pale pink. Shanks and feet are orange. As hens approach laying age, their bill, shanks, and feet often develop gray or green spotting. Plumage is white.

CONSERVATION STATUS Watch

Cayuga

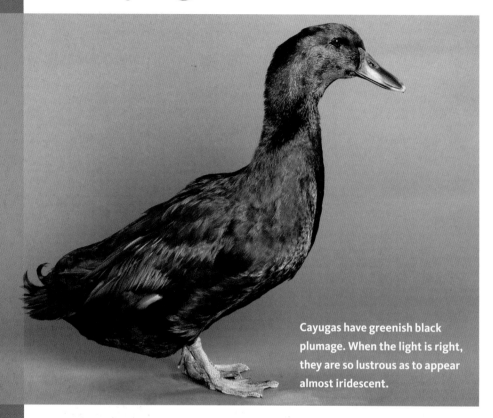

Cayugas have greenish black plumage. When the light is right, they are so lustrous as to appear almost iridescent.

Older Cayugas lose some of the luster in their plumage with age and can "go gray," with some birds turning predominantly grayish white.

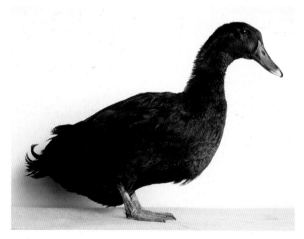

THIS BREED IS NAMED after Cayuga Lake (which is named after an American tribe that inhabited the Northeast) in the Finger Lakes region of New York, where it was developed in the early 1800s. By 1863 it was recognized by the Cayuga name.

Its ancestry is uncertain. Some people speculate that it was bred from a wild black duck, though the color does show up as a mutation in breeds derived from the **Mallard** (page 190), and the breed shows a number of characteristics that are consistent with a Mallard-based breed.

The Cayuga breed is really quite stunning: both the drake and the hen are a shiny beetle green–black that is remarkably iridescent when seen in the sunlight. Cayugas (especially hens) often "go gray," with feathers showing a grayish white tinge. The graying can show up sometime between 4 and 18 months, and some individuals eventually turn predominantly white.

Although they started out as commercial roasting ducks, they lost popularity in the commercial duck market when Pekins, with their slightly larger size and lack of dark pinfeathers, took over that sector in the late 1800s. Cayugas are still raised by hobbyists and small farmers for both their aesthetic and practical qualities as ornamental birds and roasters. They have a quiet, docile disposition, and they are a particularly hardy breed, making them good pet ducks for the backyard or barnyard.

The Cayuga was first admitted to the APA in 1874.

CAYUGA FACTS

SIZE CLASS Medium

COLOR Bill is ideally black, though olive black at the outer tip is acceptable. Eyes are dark brown. Shanks and feet are black to dusky black (orange shading is acceptable in older drakes). Plumage throughout is extremely lustrous greenish black.

CONSERVATION STATUS Threatened

Crested

Crested ducks sport a pouf of feathers on top of their head that reminds me of ladies' pillbox hats from the 1950s and 1960s (I can almost envision Jackie O. decked out in one).

The crest is a mutation that spontaneously occurs from time to time in **Mallards** (page 190) and their descendants, as well as in some other species of wild ducks. The trait has been selected in the Crested over many centuries. Unfortunately, this mutation is accompanied by a lethal allele combination, so in purebred breedings, about 25 percent of the embryos die in the egg. The combination also sometimes results in health problems, including a deformed neck and poor balance.

Crested ducks are reasonably good layers but are maintained primarily as pets and ornamental birds. They are quite hardy. A number of color varieties are known around the world, but the APA recognizes only the Black and the White.

The Crested was first admitted to the APA in 1874.

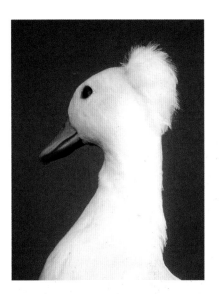

CRESTED FACTS

SIZE CLASS Medium

COLOR

Black. Bill is ideally black, though olive black at the tip is acceptable. Eyes are dark brown. Shanks and feet are black to dusky black (orange shading is acceptable in old drakes). Lustrous greenish black plumage throughout.

White. Yellow bill. Blue eyes. Light orange shanks and feet. Pure white plumage.

CONSERVATION STATUS

Not applicable

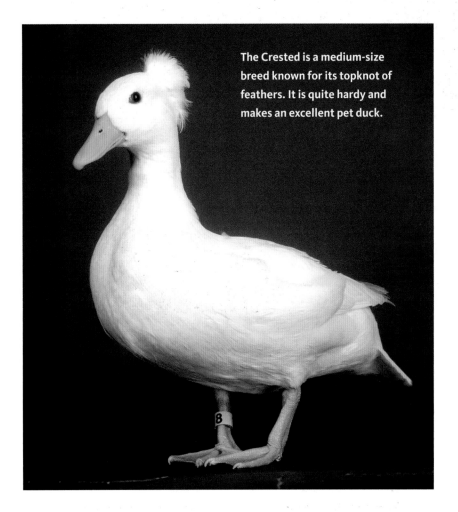

The Crested is a medium-size breed known for its topknot of feathers. It is quite hardy and makes an excellent pet duck.

Dutch Hookbill

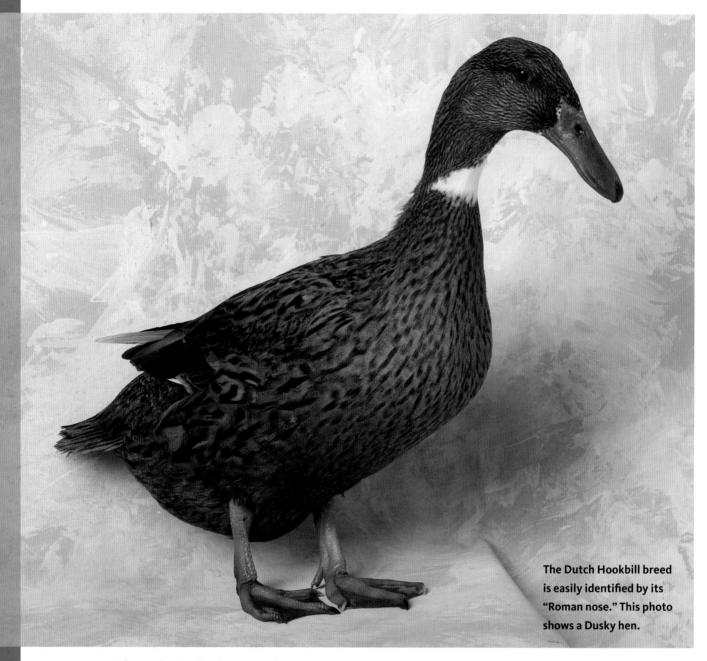

The Dutch Hookbill breed is easily identified by its "Roman nose." This photo shows a Dusky hen.

THE DUTCH HOOKBILL is an old breed that has been documented in the Netherlands (where they are known as Kromsnaveleend) and Germany since the seventeenth century, though they were only imported to North America in early 2000 by Dave Holderread. They are named for their hooked bill that curves from the forehead, and reminds me of a "Roman nose" in horses. They are quite rare, though several breed conservationists are now raising them. They have yet to be recognized by the APA in the *Standard of Perfection*.

About the size and stature of a large **Mallard** (page 190), Dutch Hookbills are very active birds. Hens lay lots of blue eggs, but breeders report that the eggs can do poorly when artificially incubated if the incubation environment (temperature and humidity) isn't just right. Broody hens do better.

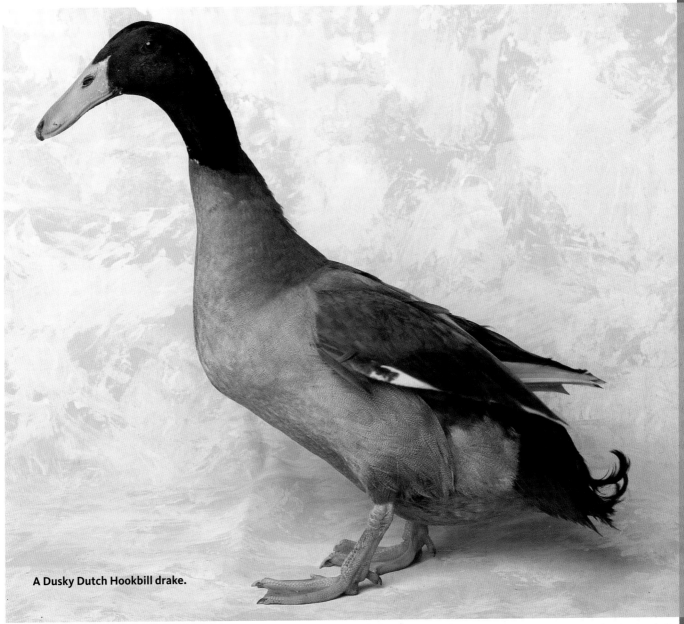

A Dusky Dutch Hookbill drake.

DUTCH HOOKBILL FACTS

SIZE CLASS Light

COLOR

Dusky. Eyes are dark brown. Shanks and feet are dark orange. *Drake*: Bill is distinctive grayish blue, often shaded with green if diet includes yellow-pigmented ingredients. Head, neck, lower back, and tail coverts are greenish black. Body in shades of gray. *Hen*: Bill is usually pinkish orange with dark brownish black saddle, though occasionally bill is solid dark slate. Head and neck are dark cocoa brown with light brown ticking. Body is dark brown penciled with light brown.

White. Bill is pink, though hens may develop dark gray spotting. Eyes are blue. Shanks and feet are orange. White plumage.

White-Bibbed Dusky. Colored like the Dusky, but with a large, white, pear-shaped bib covering the chest and front of neck and three to ten white primaries on each wing.

CONSERVATION STATUS Not applicable

East Indies

ALTHOUGH THE NAME would indicate that the East Indies duck originated in southeastern Asia, the breed as we know it now was developed in North America in the nineteenth century. The breed is thought to have been developed from a strain of ducks kept by native peoples in South America, which Charles Darwin described in his writings of his trip on the HMS *Beagle*.

In the late 1800s the East Indies weighed around 3 pounds (1.4 kg), but continued selection for size has resulted in a smaller bird that weighs between 1 and 2 pounds (450–900 g). Though small like a **Call** (page 180), it has a body shape similar to that of the **Mallard** (page 190), with coloring like that of the **Cayuga** (page 184).

These birds are generally shyer and quieter than Calls, making them good pets, and they are popular with fanciers for showing. They are very good fliers, so in a backyard setting pens with a top are a must, unless you want to clip eight to ten primary wing feathers once a year.

The East Indies was first admitted to the APA in 1874.

EAST INDIES FACTS

SIZE CLASS Bantam

COLOR Bill is ideally black, though olive black at the outer tip is acceptable. Eyes are dark brown. Shanks and feet are black to dusky black (orange shading is acceptable in old drakes). Lustrous greenish black plumage throughout.

CONSERVATION STATUS Not applicable

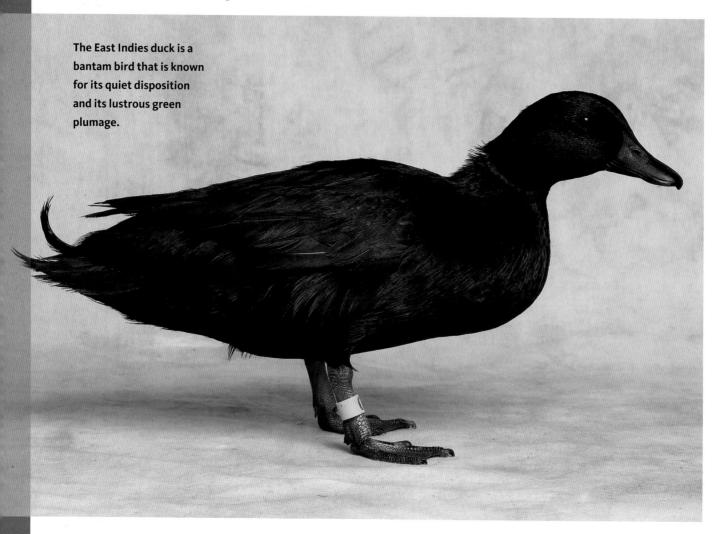

The East Indies duck is a bantam bird that is known for its quiet disposition and its lustrous green plumage.

Golden Cascade

The Golden Cascade is a fairly new breed that is good for both meat and egg production. Photo at left shows a hen; the one below shows a drake.

THE GOLDEN CASCADE is a fairly new breed developed in 1979 by Dave Holderread. Holderread's goal was to have a fast-growing, good-size, active foraging bird with excellent laying ability, and that produced autosexing characteristics from crosses of the drake with females of any breed. He used **Khaki Campbell** (page 182), "French Clair" **Rouen** (page 194), **Pekins** (page 193), and **Crested** (page 185) ducks as parent stock for the breed. "They were named by my wife, Millie," he says, "for the golden day-old color, and for the dominant mountain range of the Northwest — the Cascades."

Numbers of breeding birds are still fairly low for the Golden Cascade, and they are not yet accepted in the APA *Standard of Perfection*. However, more breeders are showing interest in them, and several hatcheries are now carrying them.

Known as a dual-purpose breed for both meat and eggs, the Golden Cascade is also a lovely bird for ornamental purposes. The hens are super layers that have a particularly long productive season.

GOLDEN CASCADE FACTS

SIZE CLASS Medium

COLOR Eyes are dark brown. Shanks and feet are orange. *Drake*: Bill is orange to greenish orange. Head, neck, lower back, undertail covert, and wing speculum are greenish bronze. Neck has white collar. Breast is reddish brown; body is pale cream. *Hen*: Bill is orange with brownish shading. Plumage is primarily rich fawn-buff color with creamy white shading on underbody, throat, and front of neck. Hens also have a creamy white facial stripe passing over the eyes.

CONSERVATION STATUS Not applicable

Magpie

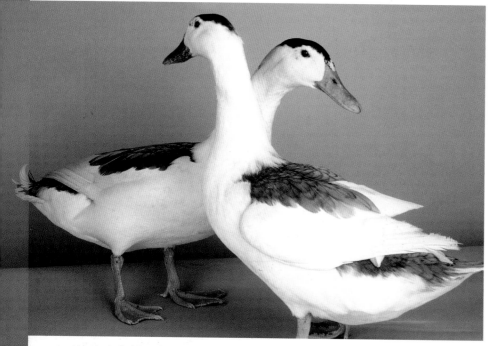

Magpie ducks have plumage that is white with colored splotches (black is the most common). The hens are excellent layers.

DIFFERENT SOURCES speculate on slightly different parentage for these snappy-looking ducks, but most agree that a **Runner** (page 195) of some type contributed to their size and conformation. An old Belgian breed, the Huttegem, has been suggested as part of the mix, as has the **Cayuga** (page 184).

One thing everyone seems to agree upon is that the Magpie was developed in Wales during the early years of the twentieth century. The first documented import to the United States came in 1963.

For a small bird, the Magpie has a reasonably good carcass, with high-quality meat, and the white feathers on its breast make it easy to clean. But Magpies are better known for egg production than for meat, with ducks producing as many as 290 eggs per year.

They are active birds, foraging enthusiastically and consuming lots of insects, slugs, snails, and other pests. Though not the best of fliers, like other lightweight breeds, they can easily top a 3-foot-tall (91 cm) fence if spooked.

The Magpie was first admitted to the APA in 1977.

MAGPIE FACTS

SIZE CLASS Light

COLOR Bill is yellow or orange spotted with green (solid green is permissible in old birds), with black bean. Eyes are dark gray or dark brown. Shanks and feet are orangey red spotted with grayish black; the shade darkens with age. Plumage is white with large patches of color on head, back, wings, and tail. Black is the most common color, but blue is also recognized by the APA and breeders have also developed chocolate and silver varieties.

CONSERVATION STATUS Critical

Mallard

THE MALLARD is the most common wild duck in North America and ancestor to most of our domestic ducks. The APA recognizes it in the bantam class, and some game bird enthusiasts do keep semidomesticated flocks of Mallards for show purposes.

To breed wild Mallards in captivity, breeders must obtain a permit from federal and/or state agencies, and it is illegal to now obtain Mallards from the wild. To learn more, contact your state's wildlife agency (or provincial agencies in Canada).

The Mallard was first admitted to the APA in 1961.

MALLARD FACTS

SIZE CLASS Bantam

COLOR

Gray. Eyes are brown. Shanks and feet are reddish orange. *Drake*: Bill is yellowish green with dark bean. Head and neck are lustrous green with white collar at base of neck. Breast is rich purplish brown. Body is in shades of gray with some black penciling. Tail is ashy brown with white lacing. Wings are gray and brown with black, iridescent blue, and white highlights. *Hen*: Primarily shades of brown. Wings are brown highlighted with black, iridescent blue, and white.

Snowy. Eyes are brown. Shanks and feet are orange with brownish tinge. *Drake*: Bill is greenish yellow with dark bean. Head and neck are iridescent green with distinct white collar at base of neck. Breast, shoulders, and legs are purplish red (claret) laced in white, shading more to white toward stern. Back is stippled gray with some white lacing. Underbody is white. Stern and tail are black with some white lacing. Wings are gray and white with black and violet highlighting. *Hen*: Bill is brownish orange with dark blotch midway and dark bean. Head and neck are fawn lightly stippled with brown. Breast and body are light fawn shading to white. Tail is brownish gray with white lacing. Wings are gray and white with brownish black and violet highlights.

CONSERVATION STATUS Not applicable

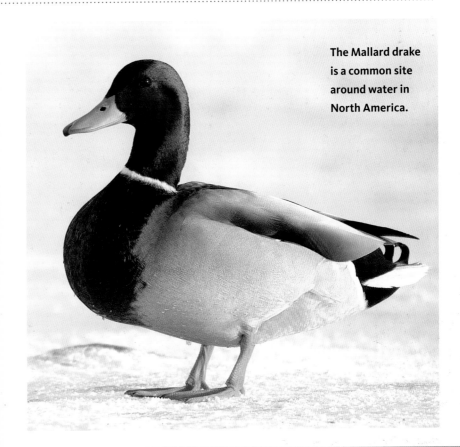

The Mallard drake is a common site around water in North America.

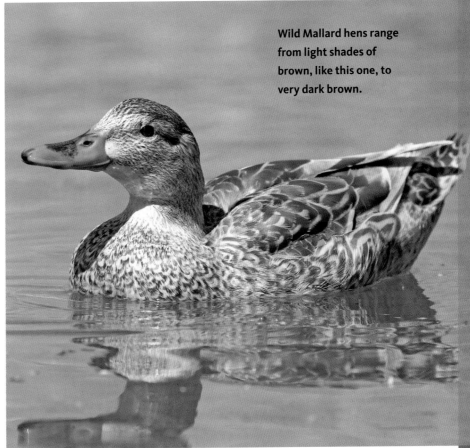

Wild Mallard hens range from light shades of brown, like this one, to very dark brown.

Muscovy

As domestic ducks go, the Muscovy is an odd duck. It is descended from the wild Muscovy, a native duck of South and Central America that does not migrate and uses sharp toenails to nest in trees.

Native tribes were already keeping domesticated Muscovies when Europeans first reached the Americas. Muscovies made their way to the United States and Canada from stocks that were sent to Europe by Columbus and the conquistadors and then came back across the Atlantic. Although the White Muscovy was admitted to the first APA *Standard of Perfection* in 1874, the breed was actually fairly rare in North America until the later years of the twentieth century, when poultry raisers began to appreciate its many unique traits.

The domestic Muscovy is a very large bird raised for meat, which is less greasy than the meat of some breeds derived from the **Mallard** (page 190). The duck can brood three clutches per year.

The bird is a voracious omnivore and excellent forager, making it great for pest patrol. We kept Muscovies on our dairy farm in Minnesota to help control flies, ticks, and other nuisance insects with good results. Muscovies are also known to sometimes eat mice, rats, and other rodents. The Muscovy is a quiet and personable duck, though old drakes sometimes become extremely aggressive toward other fowl, animals, and even humans. It is a flier and often chooses to roost in trees, but it usually sticks around home.

The Muscovy was first admitted to the APA in 1874.

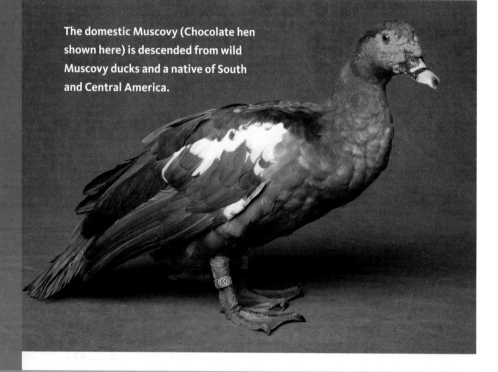

The domestic Muscovy (Chocolate hen shown here) is descended from wild Muscovy ducks and a native of South and Central America.

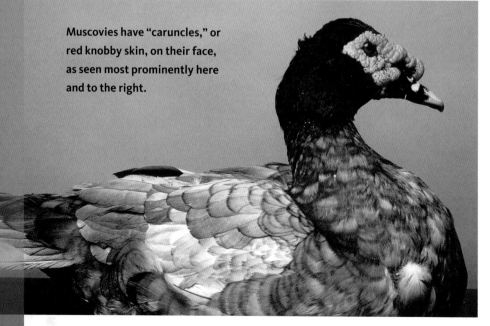

Muscovies have "caruncles," or red knobby skin, on their face, as seen most prominently here and to the right.

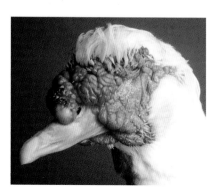

SIZE CLASS Heavy

COLOR Mature birds have lumpy red skin about the face called caruncles. These knobby protrusions are more dominant on the drake than the hen.

Black. Bill is pink shaded with horn; eyes are brown; shanks and feet are black to dusky yellow. Plumage is lustrous black, except for white forewings on mature birds.

Blue. Bill is pinkish horn marked with dark horn or black; eyes are brown; shanks and feet are dusky yellow. Plumage is blue all over, except for white forewings on mature birds.

Chocolate. Bill is pinkish horn marked with dark horn or black; eyes are brown; shanks and feet are brownish yellow. Plumage is an even milk chocolate all over, except for white forewings on mature birds.

White. Bill is pinkish tan; eyes are blue; shanks and feet are pale orange. Plumage is pure white on mature birds; immature birds may have black in their head plumage.

CONSERVATION STATUS Not applicable

Pekin

ALTHOUGH THE COMMERCIAL duck sector is little more than an anthill in the overall North American poultry industry, the Pekin is to ducks what the Cornish-Rock cross is to chickens. Pekins are raised almost exclusively for market thanks to fast growth, good feed conversion, and an easily cleaned, white-feathered carcass. The breed was developed in China and was first imported to the United States in the early 1870s.

Pekins are gregarious and talkative ducks that do well as pets. The ducks are good layers (upwards of 150 eggs per year isn't uncommon), but they rarely go broody, so if you want to hatch your own, you will need to use an incubator. The Pekin's feathers are looser and fluffier than those of other ducks, so its plumage quality goes downhill in wet and muddy pens.

The Pekin was first admitted to the APA in 1874.

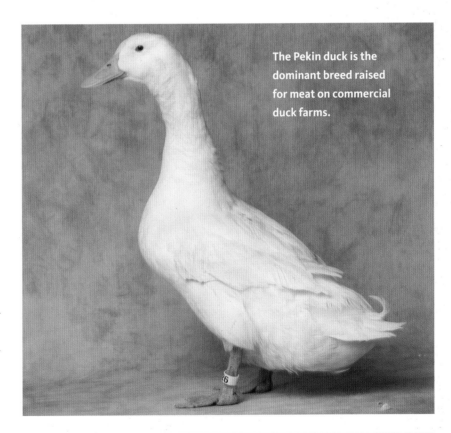

The Pekin duck is the dominant breed raised for meat on commercial duck farms.

PEKIN FACTS

SIZE CLASS Heavy

COLOR Yellow bill. Light orange shanks and feet. Pure, creamy white plumage.

CONSERVATION STATUS Not applicable

Rouen

THE ROUEN, a very large Mallard-colored bird, was developed in France hundreds of years ago. In the early 1800s the English greatly influenced the Rouen we know today by increasing its weight, changing its shape, and improving its colors.

The breed first made its way to North America in the mid-1800s. Although it was initially developed in France as a table bird, it is now a popular bird for fanciers who work to perfect its colors.

The Rouen started as a general-purpose bird, and the production-type Rouen is still a reasonably good utility bird. The type that has been bred to meet the requirements of the APA *Standard of Perfection* is considerably heavier than the production type, and like the **Ayles-**bury (page 178), it has a deeper keel. In fact, the keel is often so deep as to drag on the ground. Standard-bred males may have fertility problems. Both types mature slowly and produce excellent-quality meat.

The production-type Rouens are good foragers, with a calm and gentle disposition. They are unlikely to fly, but they can wander great distances, which can make them easy prey for foxes, dogs, and large hawks or eagles. Though they aren't prolific layers, the ducks are often good mothers. On the other hand, the standard-bred Rouens don't tend to forage as actively, nor wander far from their food and water supply.

The Rouen was first admitted to the APA in 1874.

ROUEN FACTS

SIZE CLASS Heavy

COLOR Eyes are brown. Shanks and feet are reddish orange. *Drake*: Bill is yellowish green with black bean. Head and neck are lustrous green with white collar at base of neck. Breast is rich purplish brown. Lower back and undertail coverts are lustrous greenish black. Tail is ashy brown with white lacing. Wings are gray and brown with black, iridescent blue, and white highlights. Rest of body is shades of gray penciled with black. *Hen*: Bill is orange with brown shading and dark bean. Plumage is primarily a medium shade of rich brown; most feathers are penciled with dark brown. Wings are brown highlighted with black, iridescent blue, and white.

CONSERVATION STATUS Watch

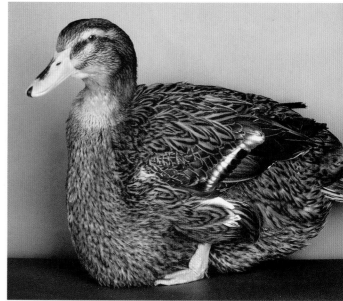

The Rouen breed is colored much like its Mallard forebears (male on left; female on right).

Runner

RUNNER DUCKS, which are sometimes referred to as Indian Runner ducks, are comical-looking birds. They have a tall, thin, upright stature that at one time garnered them the name "penguin ducks."

Indonesian rice farmers, who would walk the ducks out to the paddies for the day and then home again at night, developed the breed for laying purposes and to control pests in the paddies. They were imported to Europe by ship captains in the sixteenth century.

Thanks to their rice-paddy heritage, Runners are remarkably efficient foragers and will cover large areas each day. They are among the most energetic members of duckdom, constantly on the move. The ducks are prolific layers, outperforming many chickens. They make great pets and are excellent exhibition birds.

The Runner was first admitted to the APA in 1898.

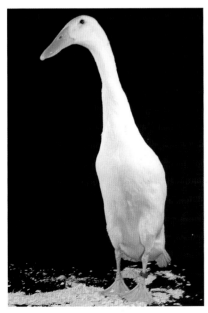

A common White Runner.

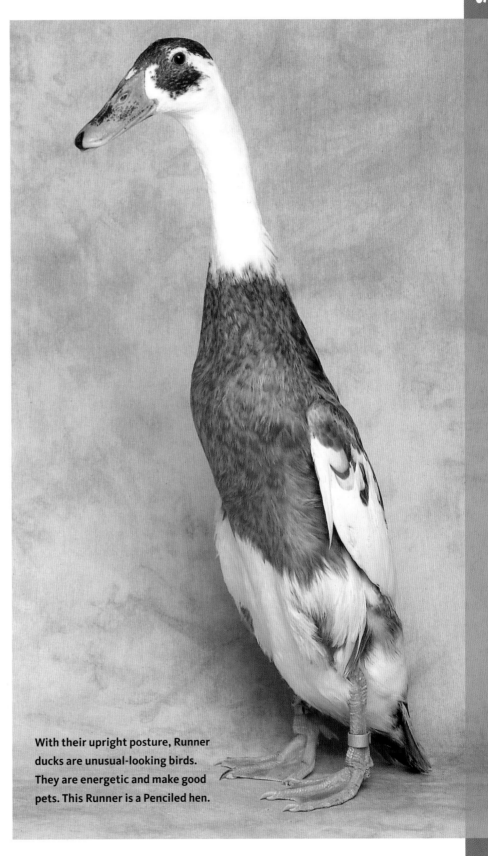

With their upright posture, Runner ducks are unusual-looking birds. They are energetic and make good pets. This Runner is a Penciled hen.

RUNNER FACTS

SIZE CLASS Light

COLOR Breeders have developed many color varieties, some of which are not recognized in the APA *Standard of Perfection,* as well as these recognized colors:

Black. Bill is black (olive tip is permissible); eyes are brown; shanks and feet are black, shading to orange in old drakes. Plumage is lustrous greenish black.

Buff. *Drake*: Bill is yellow; shanks and feet are orangey yellow. Head and upper neck are rich fawn buff to seal brown. Body is ideally an even shade of rich fawn brown. *Hen*: Bill is brownish orange with dark bean. Shanks and feet are orangey yellow. All plumage is an even shade of rich fawn brown.

Chocolate. Bill is blackish brown (olive tip is permissible); eyes are brown; shanks and feet are dark brown, shading to orange in old drakes. Plumage is an even chocolate brown.

Cumberland Blue. Bill is greenish blue in drake and bluish gray in hen. Eyes are brown. Shanks and feet are smokey orange to gray. Plumage is bluish slate throughout (drakes are often darker than hens).

Fawn and White. Bill is yellow to greenish yellow in drake and yellow spotted with green to dull green in hen; both sexes have black bean. Eyes are blue or bluish brown. Shanks and feet are orangey red. Fawn and white plumage is distinctly patterned in sections: Head is fawn with white highlights giving way to white upper neck. Lower neck, upper breast, and upper body, including wings, are fawn. Lower body is white. Tail is fawn.

Gray. Eyes are brown. Shanks and feet are reddish orange. *Drake*: Bill is yellowish green with dark bean. Head and neck are lustrous green with white collar at base of neck. Breast is rich purplish brown. Lower back and undertail coverts are lustrous greenish black. Rest of body is shades of gray that is penciled with very narrow wavy lines of black. Tail is ashy brown with white lacing. Wings are gray and brown with black, iridescent blue, and white highlights. *Hen*: Plumage is primarily a medium shade of rich brown; most feathers are penciled with dark brown. Wings are brown highlighted with black, iridescent blue, and white.

Penciled. Eyes are blue or bluish brown. Shanks and feet are orangey red. *Drake*: Bill is yellow to greenish yellow with black bean. Head is greenish bronze with white highlights. Upper neck is white. Lower neck, upper back, upper breast, shoulders, and upper wings are fawn. Lower breast, lower back, lower body, lower wings, and legs are white. Tail is dull greenish bronze. *Hen*: Bill is orangey yellow spotted with green when young, going to dull green when mature, with black bean. Plumage is similar to that of male, but more distinct penciling shows up in fawn-colored feathers.

White. Bill is yellow; eyes are leaden blue; shanks and feet are orange. Plumage is pure white.

CONSERVATION STATUS Watch

Saxony

THE SAXONY was developed in Germany in the first half of the twentieth century, but few specimens survived World War II, so the breeder, Albert Franz, started his breeding program again. His persistence paid off, and the breed was recognized in Germany in 1957.

In 1984 Dave Holderread, a leading waterfowl expert in the United States, imported some Saxony birds to his Oregon farm and helped build support for the breed on this side of the Atlantic. His efforts resulted in APA acceptance of the Saxony breed in 2000.

The Saxony is a good all-purpose breed. Ducks are excellent layers, with typical production at two hundred or more large white eggs per year. They will brood and raise their own clutch. As meat birds they produce a good carcass; the meat is flavorful yet not very greasy. They are active foragers and hardy birds, adapting well to various environments.

The Saxony was first admitted to the APA in 2000.

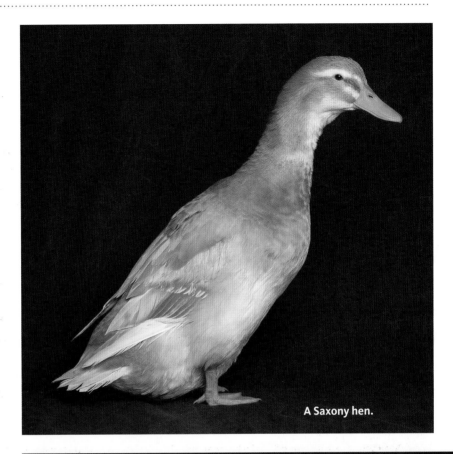

SAXONY FACTS

SIZE CLASS Heavy

COLOR Eyes are brown; shanks and feet are orange. *Drake*: Bill is yellow to greenish yellow; dark bean is permissible in mature birds. Head and neck are powder blue with white collar at base of neck. Breast is claret frosted with white. Upper back is silver darkening to bluish gray over rump. Body is oatmeal shading to creamy white. Tail is in shades of blue-gray, oatmeal, and creamy white. Wings are oatmeal highlighted with claret, blue-gray, silver, and white. *Hen*: Bill is yellowish to brownish orange; dark bean is permissible in mature birds. Head and neck are fawn-buff highlighted with bold creamy white stripes above the eyes and creamy white highlights on throat and front of neck. Body is fawn-buff with some blue shading. Wings are oatmeal highlighted with blue-gray, silver, and creamy white.

CONSERVATION STATUS Critical

A Saxony hen.

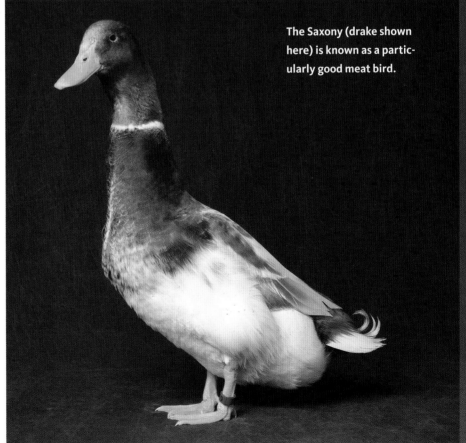

The Saxony (drake shown here) is known as a particularly good meat bird.

Swedish

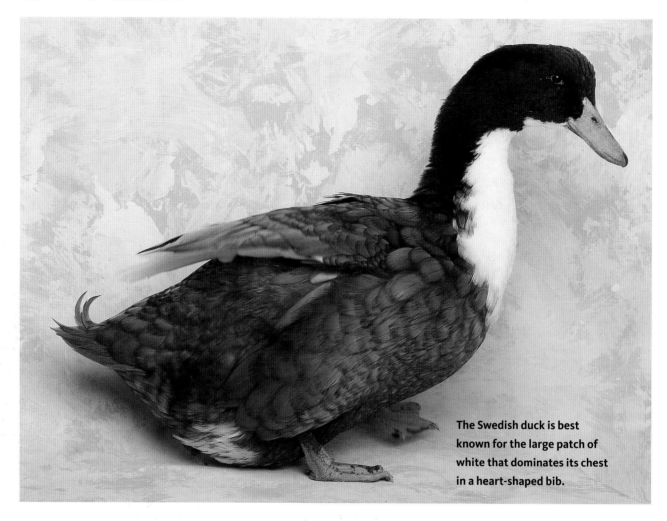

The Swedish duck is best known for the large patch of white that dominates its chest in a heart-shaped bib.

BLUE DUCKS HAVE BEEN bred for centuries in northern Europe, in an area ranging from northern Germany and Poland through Sweden, Denmark, and Norway. The Swedish breed has been documented at least since 1835 and was first imported to North America in 1884.

The Blue Swedish, as it is also known, is slow to mature but is a good meat-type duck and a reasonable layer. Obviously, coming from such northern latitudes, the breed is also quite hardy.

Like other blue domestic fowl, it doesn't breed true 100 percent of the time: about 25 percent of the offspring will be black; 25 percent will be white, silver, or splashed; and about 50 percent will be blue. Only the blue variety is recognized in the APA *Standard of Perfection* and may be shown, though a few breeders have also been working with the black variety.

The Blue Swedish was first admitted to the APA in 1904.

SWEDISH FACTS

SIZE CLASS Medium

COLOR Bill is greenish blue in males and bluish slate in females. Eyes are dark brown. Shanks and feet are reddish brown shaded with grayish black markings. Plumage is primarily uniform bluish slate, with white, heart-shaped bib on breast and two or three white flight feathers in wings. Drake's head is darker slate blue to almost black.

CONSERVATION STATUS Watch

Welsh Harlequin

LESLIE BONNET, a Welsh farmer, found an unusual color mutation in his flock of **Khaki Campbells** (page 182) in 1949 and began breeding for it. In 1968 hatching eggs were imported to the United States, followed by adult birds in 1981.

In spite of their light weight, Welsh Harlequins are fine utility birds, producing lean meat on an easy-to-clean carcass. They are active foragers, though some people who have kept them on pasture report that they are more vulnerable to predation due to their light-colored plumage than other darker-colored breeds. Like the Campbells, from which they originated, the ducks are abundant layers. They will go broody and are excellent mothers.

The Welsh Harlequin was first admitted to the APA in 2001.

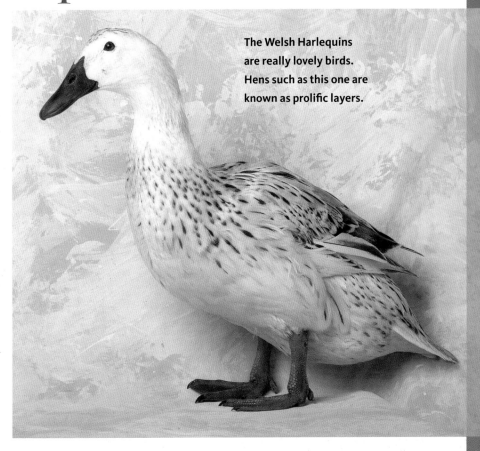

The Welsh Harlequins are really lovely birds. Hens such as this one are known as prolific layers.

WELSH HARLEQUIN FACTS

SIZE CLASS Light

COLOR *Drake*: Bill is green to yellowish green. Head and neck are greenish black with white collar at base of neck; breast, shoulders, and sides of body are reddish chestnut frosted with white; upper back is mottled in gray and chestnut with frosted white highlights; lower back and undertail coverts are greenish black. Wings are shades of gray frosted with white, with a broad blue or green speculum. Tail is black with main feathers edged in white. *Hen*: Bill is greenish black. Head and neck are shaded fawn and creamy white with brown stippling most prominent on the crown. Most feathers of shoulders, breast, sides of body, and tail are center-marked with dark brown surrounded by fawn and frosted or laced with white. Underbody is mostly creamy white. Wings are grayish brown frosted with white, with greenish bronze or blue speculums.

CONSERVATION STATUS Critical

A Welsh Harlequin drake.

African

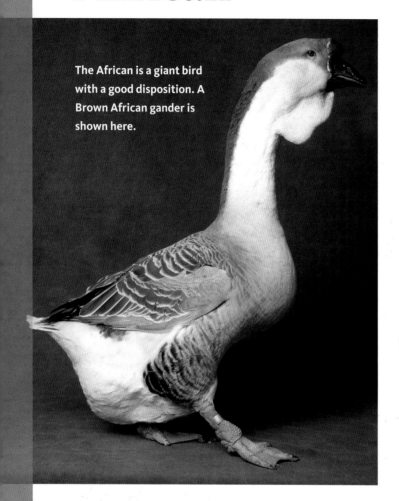

The African is a giant bird with a good disposition. A Brown African gander is shown here.

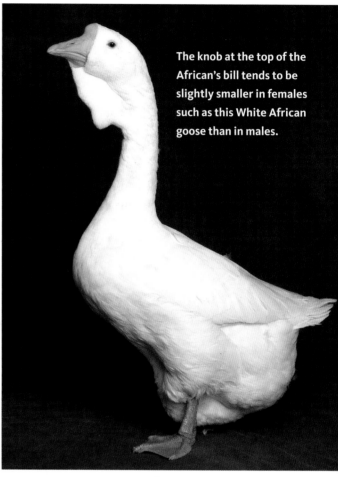

The knob at the top of the African's bill tends to be slightly smaller in females such as this White African goose than in males.

THE NAME "AFRICAN GOOSE" is misleading. In fact, historically the breed seems to have been known by different names at different times and in different places. It arrived in the United States in the middle of the nineteenth century.

The African goose, like the **Chinese** (page 203), derives from the Swan goose of Southeast Asia. Some waterfowl enthusiasts speculate that it is a cross between the Chinese and the **Toulouse** (page 213). Dave Holderread, a leading waterfowl expert, thinks that it is a pure extract from the Swan goose, and that the physical differences between it and the Chinese,

such as weight differences and the appearance of a dewlap in the African, are strictly the result of selective breeding.

The African is considered by some people to be one of the gentlest breeds of domestic geese. It talks a lot, though it is not extremely loud, and it has an unusual sound that is more like a "doink" than a "honk." It is cold-hardy, though its knobs can be subject to frostbite in extremely cold climates. The African is also known for producing a good carcass with tasty, lean meat.

The African was first admitted to the APA in 1874.

AFRICAN FACTS

SIZE CLASS Heavy

COLOR Recognized in two varieties:

Brown. Black bill and knob; orange shanks and feet. Plumage is in shades of brown that vary from very light (almost white) to a dark slaty brown.

White. Bill, knob, and feet are all orange. Solid white plumage.

CONSERVATION STATUS Watch

American Buff

THE HISTORY OF the American Buff is unclear. It is generally thought to have been developed from common barnyard geese in the United States during the nineteenth century, though some poultry historians speculate that it is the result of crosses of **Buff Pomeranians** (page 209) with **Embdens** (page 205). Whatever its early origins, the breed was perfected in the 1930s and 1940s by Oscar Grow of Missouri, a renowned waterfowl enthusiast and author of *Modern Waterfowl Management*.

American Buffs are quite docile and make excellent parents. The goose goes broody easily; both mom and dad dote on their goslings once they pop from the shell.

They are the largest of the medium-size geese, making fine roasting birds that are easily prepared thanks to light-colored pinfeathers that allow them to dress out as cleanly as white geese. The Slow Food USA's Ark of Taste (see page 7 for more information on this program) has adopted the American Buff in an effort to increase its numbers.

The American Buff was first admitted to the APA in 1947.

AMERICAN BUFF FACTS

SIZE CLASS Medium

COLOR Orange beak, shanks, and feet. Plumage is primarily light yellowish buff (sometimes referred to as apricot-fawn) laced with white, except for the pure white underbelly.

CONSERVATION STATUS Critical

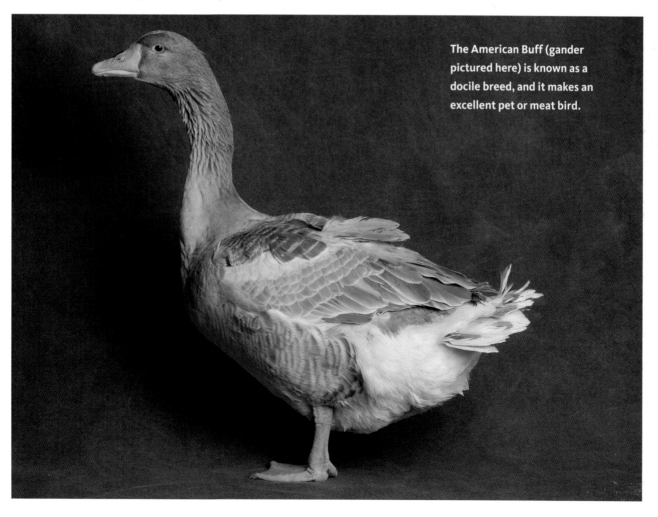

The American Buff (gander pictured here) is known as a docile breed, and it makes an excellent pet or meat bird.

Canada

CANADA GEESE ARE THE familiar, and endemic, wild geese of North America that are regularly seen near ponds and waterways, at golf courses, and in parks and pastures around much of the United States.

There are several subspecies; the APA *Standard of Perfection* describes the Eastern type. To keep Canada geese in captivity today, breeders must obtain a permit from federal and/or state agencies.

To learn more, contact your state's wildlife agency.

The Canada was first admitted to the APA in 1874.

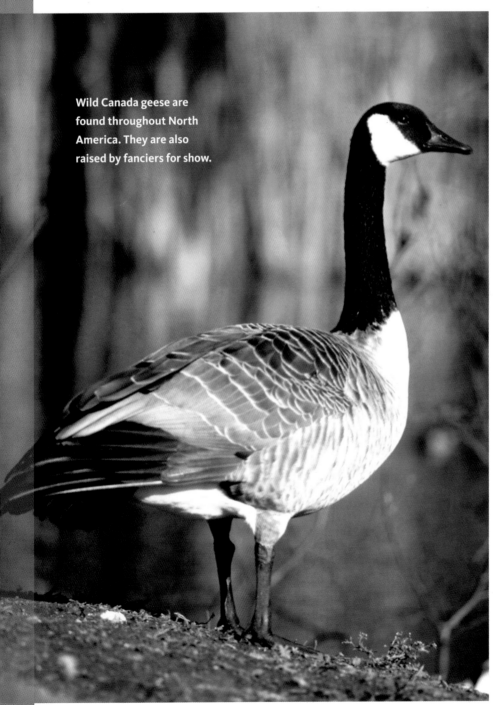

Wild Canada geese are found throughout North America. They are also raised by fanciers for show.

CANADA FACTS

SIZE CLASS Light

COLOR Bill, eyes, shanks, and feet are all black. Head and neck are black with light gray to white markings on side of face and under throat. Body is primarily gray on top and very light gray to white underneath. Tail is glossy black.

CONSERVATION STATUS Not applicable

Chinese

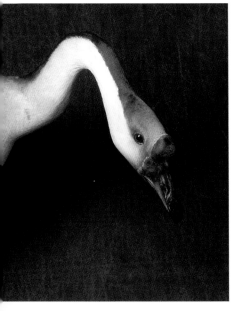

LIKE THE **AFRICAN** (page 200), the Chinese goose is descended from the Asian Swan goose. No one is quite sure how or when it arrived in North America, but it did make it here quite early: George Washington kept the breed at his Mount Vernon farm.

Chinese geese share some traits with their "cousins" the Africans, including similar coloring and a knob on the top of the bill, though the Chinese are considerably smaller. In spite of their lighter weight, Chinese are tall, lithe, and graceful birds. Due to their smaller carcass, they have never been an important commercial meat bird in North America, though they have been raised in huge numbers in China for meat, and make an excellent meat bird for smaller families. They also are among the most prolific layers of any geese, averaging around 50 to 60 eggs per year.

They are quite talkative and are active foragers. They have served admirably as "weeder" geese, cleaning field crops and established gardens, and as guard geese. In fact, in Dumbarton, Scotland, a flock of more than one hundred Chinese geese guarded the famous Ballantine distillery's 25 million gallons of aging whiskey until the distillery was decommissioned in 2002.

Chinese geese that meet the specifications of the APA *Standard of Perfection* are difficult to find. Anyone interested in Chinese geese for show purposes should seek out private breeders who have show-quality birds. The show birds will have an arched and exceedingly slender neck.

The Chinese was first admitted to the APA in 1874.

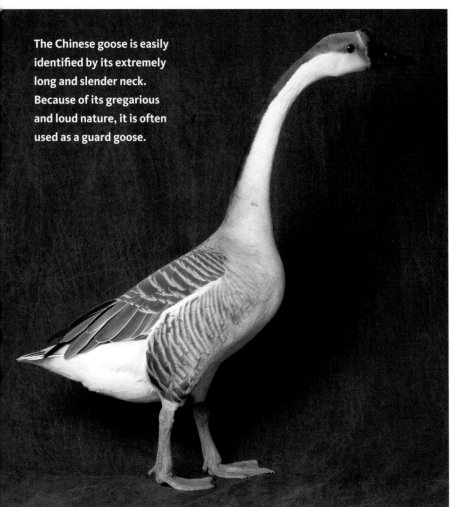

The Chinese goose is easily identified by its extremely long and slender neck. Because of its gregarious and loud nature, it is often used as a guard goose.

CHINESE FACTS

SIZE CLASS Light

COLOR Recognized varieties:

Brown. Black bill and knob. Orange shanks and feet. Plumage is in shades of brown varying from very light (almost white) to a dark slaty brown.

White. Bill, knob, and feet are all orange. Solid white plumage.

CONSERVATION STATUS Watch

Egyptian

DOMESTIC EGYPTIAN geese are direct descendants of wild Egyptian geese — birds that are more closely related to the sheldrakes (in the family Tadorninae) than to other geese (members of the Anserinae family).

Wild Egyptian geese live throughout large areas of Africa and were first domesticated by the ancient Egyptians and kept as guard animals. Their eggs, which are rounder than most bird eggs, held religious significance; the Egyptians associated them with the sun god Ra. Although the Egyptian strains were lost when Persians invaded Egypt in 525 BC, tribes in other parts of Africa maintained their own semidomesticated flocks.

Although fanciers keep Egyptians today, they are still at best semidomesticated birds that should be left to serious fanciers. Egyptians are among the most aggressive and bad-tempered of all breeds during the breeding season (in fact, in Oregon, and possibly other states and provinces as well, it is illegal to own Egyptians due to their invasive and aggressive nature). Pairs create strong bonds and are good parents, but they will attack other birds (even of their own kind) and destroy eggs from other birds' nests. Because of this, under most circumstances they must be kept separated from other geese and ducks when they are breeding. They are also excellent fliers, so clipping flight feathers is a common chore among those who raise them.

In spite of the challenge this breed presents, fanciers who wish to keep only a few birds often enjoy the Egyptians because of their unique appearance: they are the smallest domestic geese and also the most colorful, with reddish patches around the eyes that give them a bespectacled look, and iridescent reddish highlights.

The Egyptian was first admitted to the APA in 1874.

EGYPTIAN FACTS

SIZE CLASS Light

COLOR Bill is reddish purple; eyes are orange; shanks and feet are reddish yellow. Head and neck are black and gray with reddish brown patches around eyes. Back is gray and black with a reddish cast. Breast is grayish brown with a reddish brown patch that appears like a bloodied area around a stab wound. Upper body is gray and black; lower body is yellowish buff with black penciled lines. Wings are white and black. Tail is glossy black.

CONSERVATION STATUS Not applicable

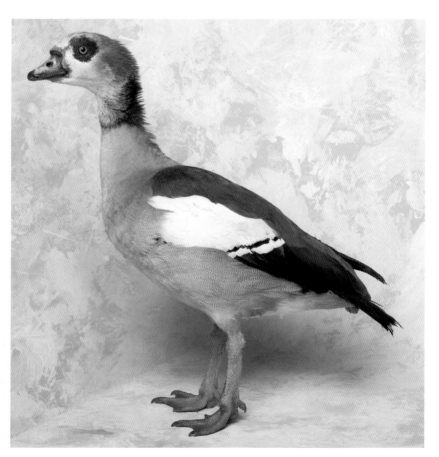

Egyptian geese are semidomesticated and are the most aggressive breed maintained by fanciers. They are not a good choice for novices.

Embden

THE EMBDEN is a very old breed of goose. Some poultry historians believe it was developed in Germany, around the Ems River, though others believe it was developed further north, in Denmark. It was first imported to the United States in 1820 from Germany, followed by imports from England.

Embdens are the tallest geese, and thanks to their heavy weight and all-white plumage, they have always been a popular market fowl for meat production. Males and females are similar in appearance, but goslings can be sexed (distinguished by gender) up until about three weeks of age based on the color of their downy feathers, which are lighter gray in the males than in the females.

Although some Embden ganders can be quite aggressive, particularly during breeding season, overall the breed is fairly gentle. They are quite well adapted to barnyard settings.

The Embden was first admitted to the APA in 1874.

EMBDEN FACTS

SIZE CLASS Heavy

COLOR Bill, shanks, and feet are orange. Eyes are blue. Plumage is white.

CONSERVATION STATUS Not applicable

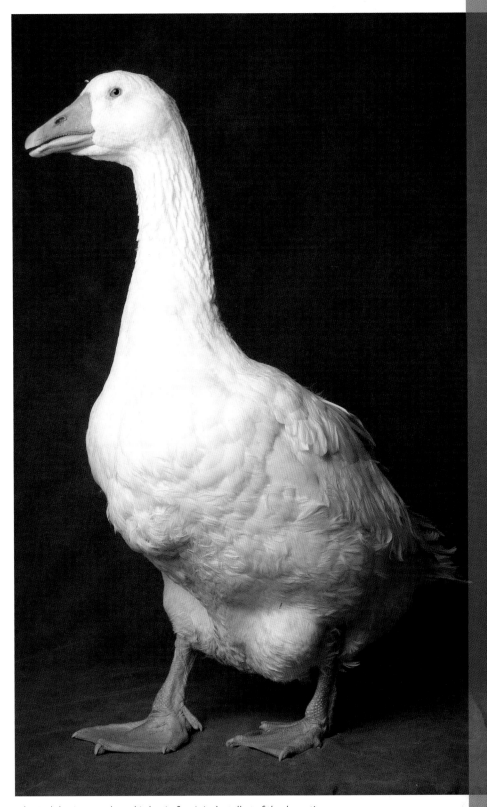

The Embden is a very large bird — in fact it is the tallest of the domestic geese. It is popular for meat production and is generally gentle.

Gray

The Gray is an old farmyard-type breed and though rare today, it still makes an excellent utility bird. A male is shown here.

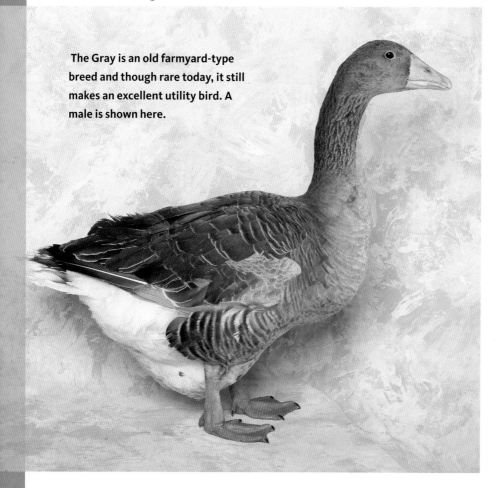

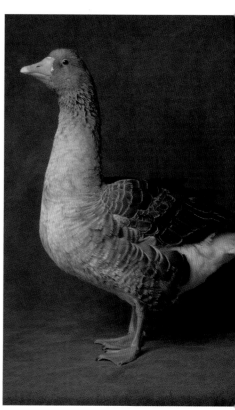

The goose is a very good layer and mother.

ALTHOUGH THE GRAY is not recognized by the APA, it is a traditional barnyard bird that until the 1960s was the predominant goose throughout the United States and Canada. The Gray closely resembles its forebear, the English Gray, which is a direct descendant of the Western Greylag.

Craig Russell, one of the foremost poultry historians today, suggests that the Gray has been around as a distinct breed for at least four hundred years in England. Russell and other members of the Society for the Preservation of Poultry Antiquities are advocating for recognition of the breed by the APA to help conserve the remaining population of farmyard Grays, and the ALBC is studying the breed's genetics and numbers to better understand its situation.

As an old production-type breed that was kept as a utility bird by small farms, the Gray has excellent natural reproduction capabilities. A Gray goose can lay 60 or more eggs per year, with high fertility the norm, and she is a good, broody mother. In fact, some of the old strains of the Gray brooded two clutches per year.

GRAY FACTS

SIZE CLASS Medium

COLOR Bill, shanks, and feet are orange. Eyes are gray. Plumage on upper body is gray with some white lacing, shading to white on lower body.

CONSERVATION STATUS Study

Pilgrim

WHEN PEOPLE HEAR the name, they assume that the Pilgrim came over with early American colonists, but in fact it was developed hundreds of years later. Its name is generally credited to Oscar Grow, a renowned waterfowl breeder and author from the early twentieth century, and his wife. Mrs. Grow purportedly came up with the name in

PILGRIM FACTS

SIZE CLASS Medium

COLOR Bill, shanks, and feet are all orange. *Gander:* Eyes are bluish gray. Plumage is white with traces of gray in body, wings, and tail. *Goose:* Eyes are hazel brown. Head is light gray with a predominating white area. Neck is light gray with some white. Upper body is shades of gray with lacing of white to light gray. Lower body is very light gray, approaching white.

CONSERVATION STATUS Critical

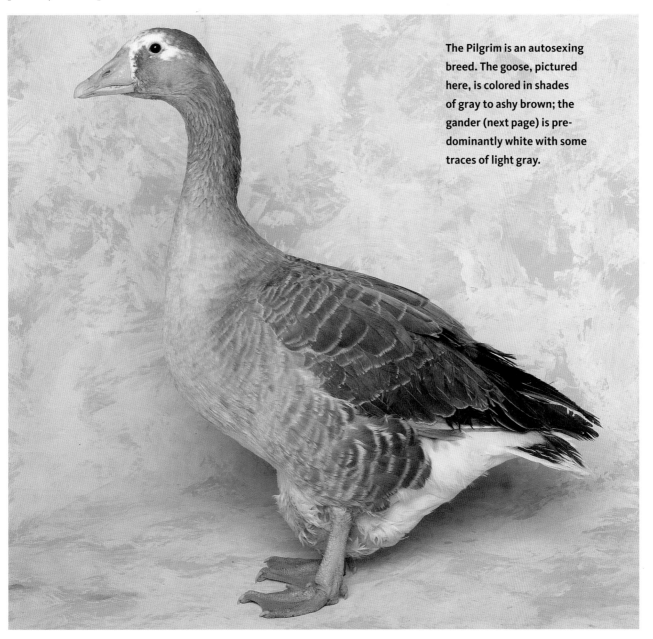

The Pilgrim is an autosexing breed. The goose, pictured here, is colored in shades of gray to ashy brown; the gander (next page) is predominantly white with some traces of light gray.

Pilgrim *continued*

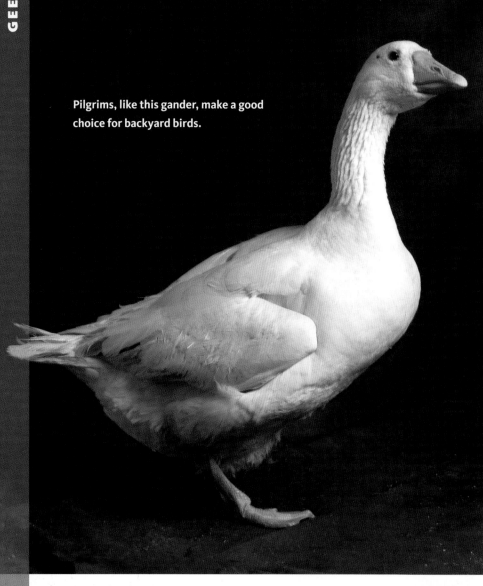

Pilgrims, like this gander, make a good choice for backyard birds.

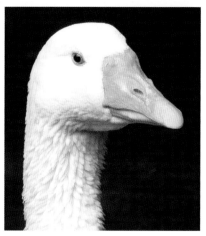

memory of her family's personal pilgrimage to Missouri during the Great Depression.

The Pilgrim is the only APA-recognized goose to show auto-sexing color in adult birds. Males are primarily white with a small amount of gray on the rump, flanks, and wings. The females are pale gray with some white on the face, neck, and rump; the amount of white increases with age.

Experts suggest that the Pilgrim may have descended from the West of England breed or the French Normandy breed, both of which likely came to North America with early settlers (there are written references to autosexing geese in the colonies). Grow's efforts established the breed more widely and gained it recognition in the APA *Standard of Perfection.*

Pilgrims are excellent backyard and barnyard birds. While hardy, active foragers, they are also about the most easygoing of all goose breeds, with a quiet disposition. They are excellent parents. They produce a good roasting bird and have been accepted to Slow Food USA's Ark of Taste.

The Pilgrim was first admitted to the APA in 1939.

Pomeranian

Most North American domestic geese of European origin are descended from the Western Greylag, but some experts suspect that the Pomeranians, developed in Germany, are descended from the Eastern Greylag, a subspecies with a little more pink shading in its bill and legs than the Western subspecies.

Pomeranians were brought to North America centuries ago with early German settlers and were common in areas where farmers of German extraction settled. However, the breed was not accepted by the APA until the 1970s, and then only the saddleback varieties were recognized, though historically the solid color varieties, including buff, gray, and white, were important to farmers.

The Pomeranian is a practical breed for both meat and egg production. Individual temperaments run from docile and sweet to fairly aggressive. They tend to be boisterous and talkative, so they make good guard animals on a farm, but they may not be the best backyard birds if neighbors are close by.

The Saddleback Pomeranian was first admitted to the APA in 1977.

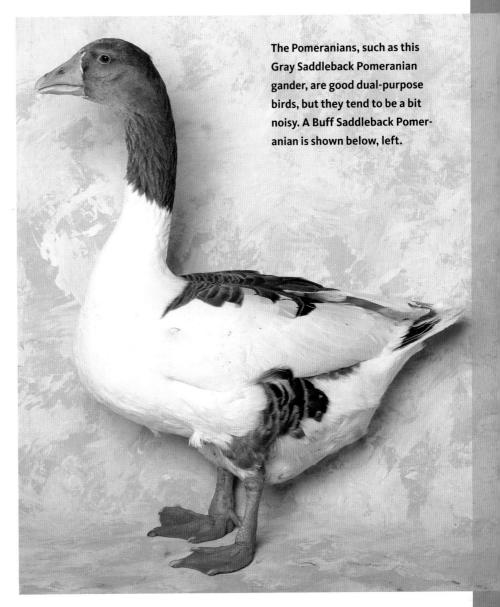

The Pomeranians, such as this Gray Saddleback Pomeranian gander, are good dual-purpose birds, but they tend to be a bit noisy. A Buff Saddleback Pomeranian is shown below, left.

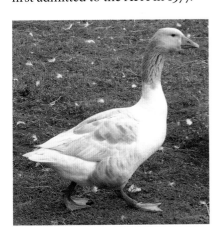

POMERANIAN FACTS

SIZE CLASS Medium

COLOR Bill is reddish pink to deep tan color. Eyes are blue. Shanks and feet are orangey red.

Buff Saddleback. Head is buff, usually with a white border at the junction of the bill and head, although the ideal in exhibition is a solid-colored head. Upper neck is buff; lower neck is white. Back and scapulars are buff edged with pale buff to white. Body, tail, and wings are white highlighted with some buff.

Gray Saddleback. Same pattern as buff, but in ashy brown edged in grayish white.

CONSERVATION STATUS Critical

Roman

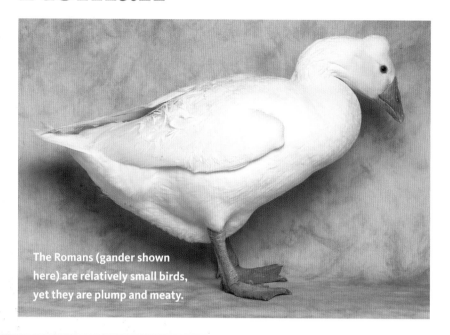

The Romans (gander shown here) are relatively small birds, yet they are plump and meaty.

DEVELOPED IN ROME over two thousand years ago, the Roman goose comes in two types. The common type in North America is tufted, with a small pouf of feathers on top of its head; there is also a clean-headed type that doesn't show the tuft, though it is seldom seen in North America.

To the ancient Romans, the goose was a revered animal associated with Juno, the goddess of light, marriage, and childbirth. Roman literature tells the story of how these sacred geese saved the city with their warning cries when the Gauls were about to attack.

The Roman is a small but plump goose with a good meat-to-bone ratio, making it an ideal roaster for family-size meals. The breed is known for a charming and friendly disposition. Females are fairly good layers and good mothers. This combination of traits makes the Roman a good choice for backyard geese.

The Tufted Roman was first admitted to the APA in 1977.

ROMAN FACTS

SIZE CLASS Light

COLOR Bill is pinkish with white bean. Eyes are blue. Shanks and feet are orange to pinkish orange. Plumage is pure white, though young birds may show traces of gray.

CONSERVATION STATUS Critical

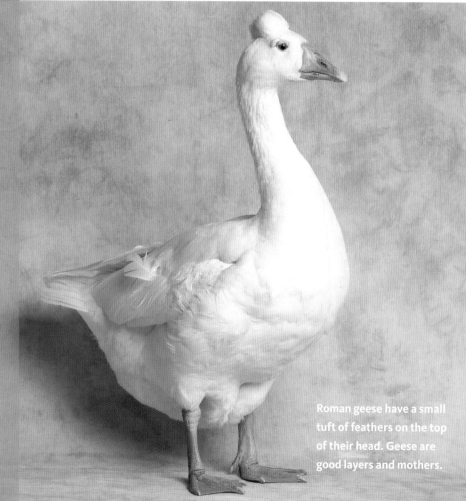

Roman geese have a small tuft of feathers on the top of their head. Geese are good layers and mothers.

Sebastopol

SEBASTOPOLS LOOK LIKE they just got a curly perm at a hairdressing salon. The effect is caused in part by the length of their feathers, which are elongated up to four times the length of the feathers found in other breeds. They originated in southeastern Europe and are named for a Black Sea port city in Russia.

In North America, Sebastopols are kept primarily as ornamental birds and pets, though they are kept as utility birds in other countries; they do produce a good carcass and tasty meat. Dave Holderread, who has raised a large flock of prize-winning Sebastopols for over twenty years, says they have very good personalities, and that they are fairly hardy.

The Sebastopol was first admitted to the APA in 1939.

SEBASTOPOL FACTS

SIZE CLASS Medium

COLOR Bill is orange; eyes are blue; shanks and feet are deep orange. Plumage is pure white, though young birds may show traces of gray.

CONSERVATION STATUS Threatened

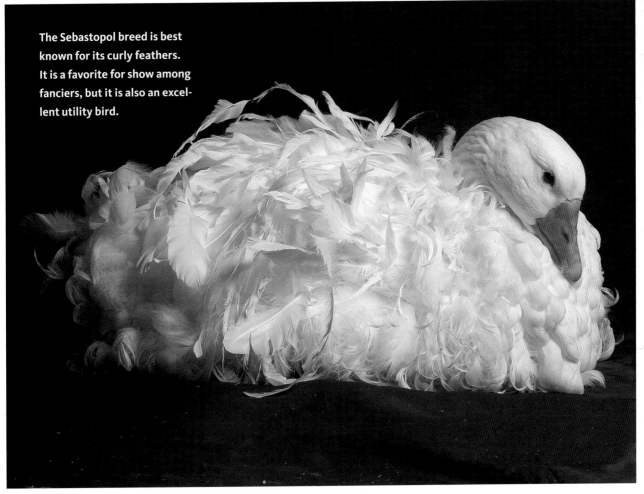

The Sebastopol breed is best known for its curly feathers. It is a favorite for show among fanciers, but it is also an excellent utility bird.

Shetland

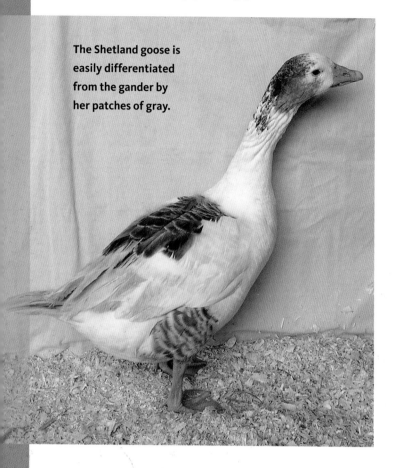

The Shetland goose is easily differentiated from the gander by her patches of gray.

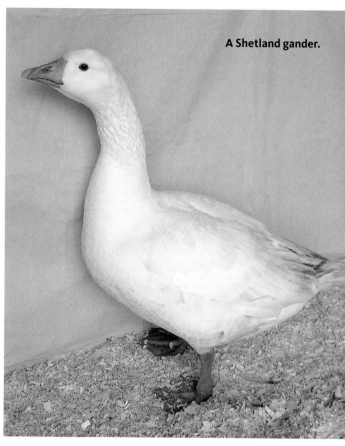

A Shetland gander.

THE SHETLAND ISLANDS are a small archipelago off the northern coast of Scotland. Islands are often home to unique breeds that evolve over time with little influence from outside, and the Shetland Islands are well-known for their localized breed populations. The Shetland ponies and Shetland sheep may be the most famous critters to hail from the islands, but Shetland goose, an autosexing bird, also developed there.

As a relatively new import to the United States, having arrived in 1997 when Nancy Kohlberg of Cabbage Hill Farm in New York imported them, Shetland geese are not yet recognized in the APA *Standard of Perfection*.

The Shetland Islands are at a far northern latitude, about the same as that of Anchorage, Alaska, and are bounded by the North Atlantic and the North Sea, with few trees and only rough, salt-tolerant grasses. Because the environment is so challenging, the breeds that have evolved on the islands are small, hardy, and quite scrappy. Shetland geese are exceptional foragers, and where grass is good, they can almost fully sustain themselves by grazing. Pairs generally mate for life and are very good parents.

SHETLAND FACTS

SIZE CLASS Light

COLOR Bill is pink with some yellow shading toward the nostrils. Shanks and feet are pink to pinkish orange. *Gander:* Eyes are blue; plumage is white. *Goose:* Eyes are brown or bluish brown. Head and neck are a mixture of white with some gray. Upper body, scapulars, tail, and wings are primarily gray with some white highlights; lower body is primarily white.

CONSERVATION STATUS Critical

Toulouse

THE TOULOUSE BREED is very old, having originated directly from the Western Greylag in southern France as a farmyard bird and has been selected for foie gras (liver pâté) production.

The Toulouse was first imported to England during the late years of the eighteenth century. The original French production-type birds were moderately large geese with no dewlap (a fold of skin under the beak at the chin). They went through major changes as they were developed to produce exhibition-type birds, which are extraordinarily large and have pendulous dewlaps.

The exhibition type was imported to North America around the middle of the nineteenth century, and later imports brought production-type birds as well.

Today, the ALBC recognizes three Toulouse types: Production, Standard Dewlap, and Exhibition. The Production Toulouse, a utility bird that is still able to breed naturally and has a fairly typical goose shape, is still fairly numerous. The Standard Dewlap Toulouse is more heavily boned and bred to gain weight rapidly for foie gras production. The Exhibition Toulouse has an exaggerated dewlap and keel.

Both the Standard Dewlap and Exhibition types can have trouble breeding.

The Production type is still a very good forager, but the Standard Dewlap and Exhibition types are often kept in confinement, where they tend to chow down on provided feed until they become fat. Dave Holderread says his big Exhibition birds still breed well specifically because he keeps them on pasture, where they are vigorous grazers and get plenty of exercise.

All three types have loose, fluffy feathers on their rump and lower body, making them more subject

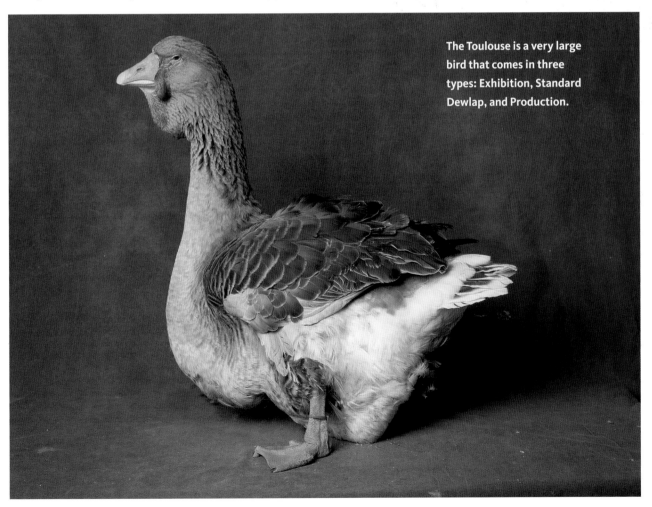

The Toulouse is a very large bird that comes in three types: Exhibition, Standard Dewlap, and Production.

to fly strike (maggot infestations in cuts and wounds) than other breeds. The breed is known for a rather docile temperament.

The Toulouse was first admitted to the APA in 1874.

TOULOUSE FACTS

SIZE CLASS Heavy

COLOR The gray is the original, and most common color; the buff is a recently developed color in the Standard and Exhibition types.

Buff. Bill is light orange; eyes are dark hazel; shanks and feet are orange. Head, neck, and upper body are in shades of buff, growing lighter to almost white on the lower body. Tail is buff and white.

Gray. Bill is orange with light horn bean; eyes are dark brown or hazel; shanks and feet are deep reddish orange. Head, neck, and upper body are in shades of gray, growing lighter to almost white on the lower body. Tail is gray and white.

CONSERVATION STATUS Watch

Tufted Buff

Tufted Buff geese have a small topknot of feathers, similar to the Roman. The breed was developed from crossing Tufted Romans and the American Buff.

THIS IS A RELATIVELY NEW breed developed in the early 1990s by Ruth Book of Missouri. Book was an enthusiastic goose keeper who kept hundreds of geese for pleasure. She also got into breeding and decided she wanted to create a buff-colored **Tufted Roman** (page 210). She crossed a small **American Buff** (page 201) gander from Dave Holderread's flock with her Tufted Roman geese. After a number of years of crossing and back-crossing, she standardized the traits, yielding the Tufted Buff breed.

The Tufted Buff sports a little bonnet of feathers on top of its head, thanks to its Roman fore-bears, and shows the apricot coloring and size of its American Buff predecessors. Some people also refer to them as Roman Tufted geese.

Tufted Buffs are active birds, but people who keep them report that they are fairly quiet and very friendly geese. The geese are prolific layers, and the eggs they lay tend toward high fertility, but hatchability can be a problem: they need very good humidity control when artificially incubated.

TUFTED BUFF FACTS

SIZE CLASS Medium

COLOR Orange beak, shanks, and feet. Plumage is primarily light yellowish buff (sometimes referred to as apricot-fawn) laced with white, except for the pure white underbelly.

CONSERVATION STATUS Not applicable

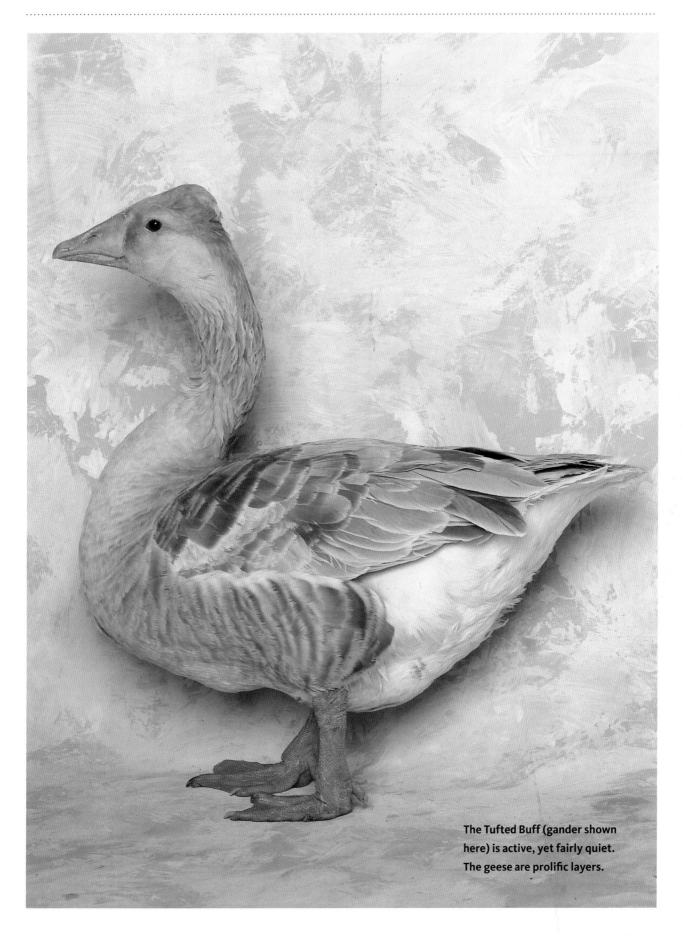

The Tufted Buff (gander shown here) is active, yet fairly quiet. The geese are prolific layers.

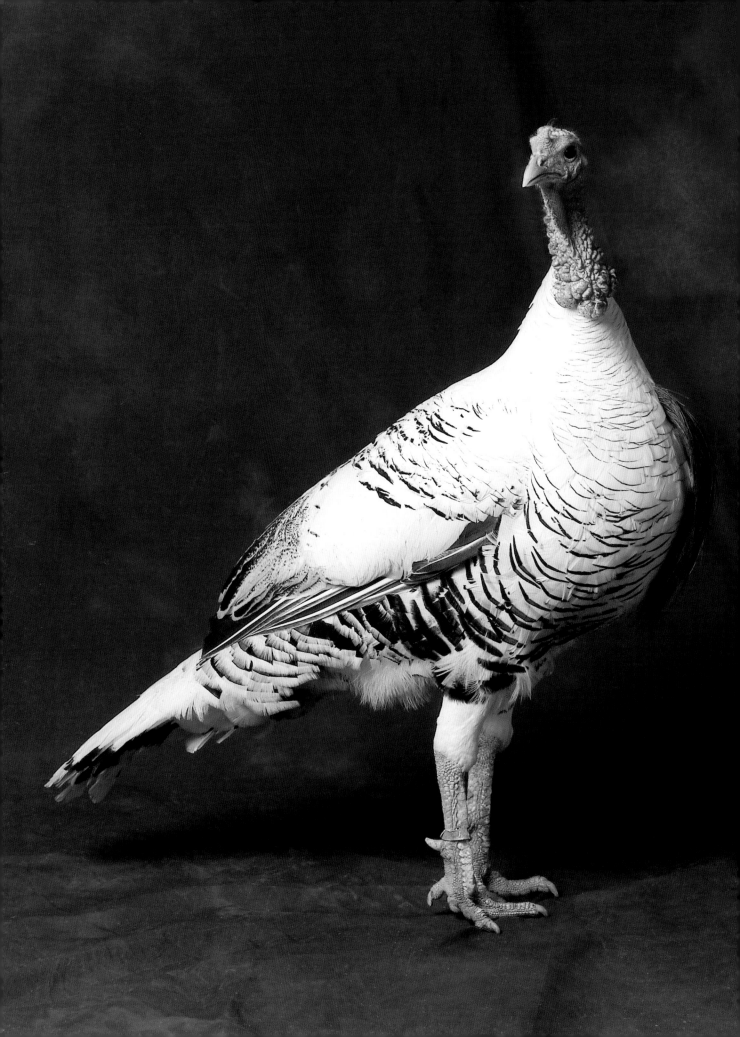

Turkeys

..

The boys came trooping home with appetites

that would have made the big turkey tremble,

if it had not been past all fear.

—Louisa May Alcott, *Little Men*

THE FOSSIL RECORD PROVIDES clear evidence that several species of turkey roamed North and Central America over 10 million years ago. The common wild turkey *(Meleagris gallopavo)* is the bird most associated with North America. Its six subspecies (Eastern, Florida or Osceola, Gould's, Merriam's, Mexican, and Rio Grande) adapted to distinct geographic areas and once numbered in the millions, roaming the continent from southern Canada to northern Mexico.

Another species, the Ocellated turkey *(Meleagris ocellata),* roamed over large areas of Central America. (A handful of biologists consider the Ocellated turkey to be another subspecies of the common wild turkey, not a separate species in its own right.) Remains found in the La Brea tar pits of California prove that still another kind of turkey, *Parapavo californicus* (now extinct), once

lived along the West Coast of the United States.

The first domestication of turkeys probably happened during the heights of the Aztec empire, around 200 BC, with the Occelated turkey, and initially it had more to do with religious ceremony than dinner. A second,

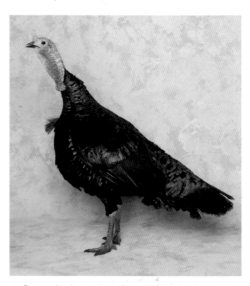

Left: Royal Palm turkey. Above: This turkey is a critically endangered Black turkey.

apparently independent, domestication took place in the American Southwest around AD 200 in the Mogollon culture of New Mexico. By the time the Spanish arrived, turkey was widely available throughout Central America. In fact, ambassadors for Montezuma, the famous Aztec ruler, presented Cortés with six golden turkey statuaries.

We think of the bird gracing the holiday dinner table as an American original, yet in an odd twist, the birds that the Pilgrims feasted on at Thanksgiving were actually brought from Europe. Spanish explorers returning from the New World in the late 1400s and early 1500s brought turkeys back with them. In fact, by 1511 Spain's King Ferdinand ordered that every ship returning to Spain should bring back ten turkeys (five toms and five

Turkey Colors

Most wild turkeys show bronze coloring, but from time to time recessive colors and patterns appear in wild flocks. From early on in the turkey's domestication, breeders selected for these recessive colors, and their efforts have yielded the color varieties we see today.

hens). These turkeys were domesticated and spread throughout the continent surprisingly quickly. Later, as colonists crossed the Atlantic in the other direction, the domestic turkey returned with them and recrossed with Eastern wild turkeys.

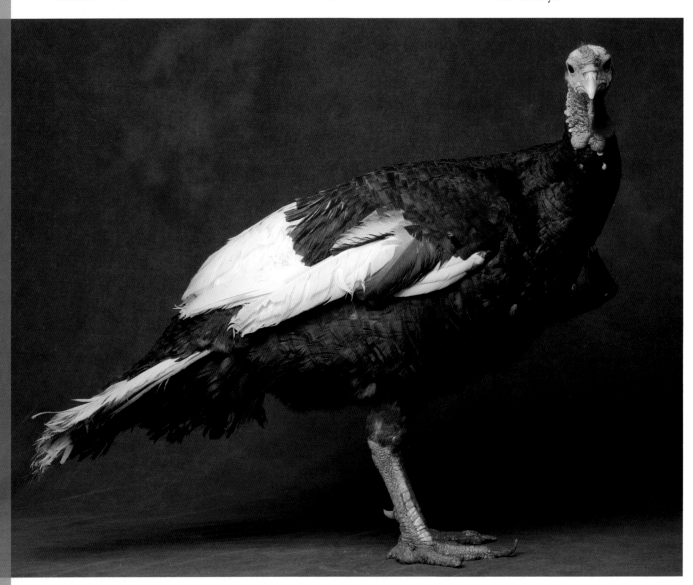

The Bourbon Red turkey is one of the varieties breeders developed by selecting for naturally occurring recessive colors.

Turkeys did not fare well in the years after Europeans came to the Americas because they could be lured to piles of corn and other feed placed in fields, making them easy pickings for hunters. Their numbers declined until the 1930s and '40s, when, scientists estimate, there were only about thirty thousand left in the wild in the United States and none in Canada.

Hunters and wildlife agencies banded together to restore turkey habitat and limit baited hunting sites, and now there are again millions of turkeys throughout most of their traditional range. Today the nonprofit National Wild Turkey Federation (see Resources, page 26) actively works to improve habitat and increase numbers of these birds in the wild.

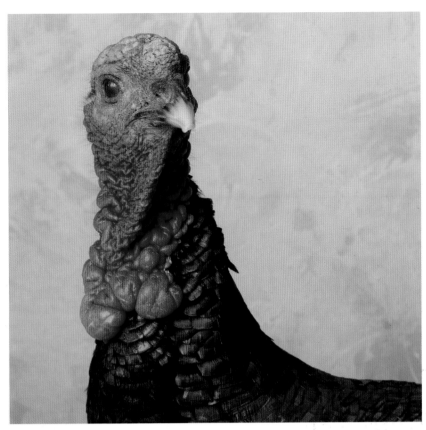

Turkeys have distinct pebbly skin, known as carunculated skin, on their faces and necks. It can change color depending on their mood.

Ben Franklin and Our National Symbol

In 1774 founding father Ben Franklin wrote a letter to his daughter in which he offered his thoughts on the eagle as national symbol and why he felt the turkey would have made a far superior choice:

For my own part I wish the Bald Eagle had not been chosen the Representative of our Country. He is a Bird of bad moral Character. He does not get his Living honestly. You may have seen him perched on some dead Tree near the River, where, too lazy to fish for himself, he watches the Labour of the Fishing Hawk; and when that diligent Bird has at length taken a Fish, and is bearing it to his Nest for the Support of his Mate and young Ones, the Bald Eagle pursues him and takes it from him.

For the Truth the Turkey is in Comparison a much more respectable Bird, and withal a true original Native of America. . . . He is besides, though a little vain & silly, a Bird of Courage, and would not hesitate to attack a Grenadier of the British Guards who should presume to invade his Farm Yard with a red Coat on.

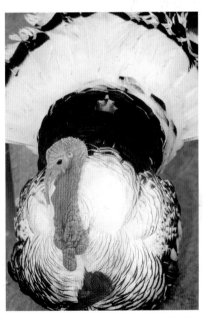

Turkeys also have a "snood," or piece of fleshy skin above the beak. On males, the snood can contract to a short stub or stretch out to hang well below the beak, as seen on this Royal Palm tom. On females, it is always just a small piece of skin.

Industrialization and Its Effects

WITH A GOBBLE-GOBBLE here and a gobble-gobble there, the turkey has pecked its way across the United States for hundreds of years to become an American icon. Traditionally, small farmers raised turkeys both for meat production and for pest control (gobblers are avid eaters of insects like the tobacco hookworm and the tomato hornworm). By 1970, the production of turkeys had dramatically changed from small-scale farm production to large-scale confinement production on an industrial-type farm (see box on Heritage Turkeys versus Commercial Turkeys at right for an explanation of this shift).

Today industrial farms produce almost all of the 280 million turkeys required in the United States and Canada to meet the demand for holiday birds and turkey products ranging from turkey bacon to soup. Over 99 percent of the breeding stock, which is essentially held by just three multinational companies, is tied to merely a few strains of Broad Breasted White turkeys that can no longer breed naturally.

This movement toward industrial turkey production has left many of the old heritage turkeys, such as the Standard Bronze, the Bourbon Red, and the Royal Palm, in trouble. In 1997 the American Livestock Breeds Conservancy (ALBC) considered turkeys to be among the most critically endangered domestic animals and the most vulnerable to extinction.

The good news is that the birds are making a comeback that, according to ALBC's technical program manager, Marjorie Bender, "is nothing short of amazing." Thanks to the efforts of the ALBC, Slow Food, and some dedicated turkey breeders, small farmers are rediscovering the virtue of naturally breeding heritage turkeys for a farm enterprise. They are also finding a ready market with consumers who appreciate the taste of turkeys produced the old-fashioned way.

Though these old varieties are still not out of the woods, the change is, indeed, remarkable. In a 1997 census, the ALBC found only 1,335 breeding birds among the eight standard varieties of turkeys recognized by the American Poultry Association (APA). There were so few of some varieties, such as the Narragansett, with only 6 breeding birds, that the ALBC staff thought they were as good as lost.

When the staff conducted another census in 2003, however, populations had increased by 220 percent, though all but the Royal Palm and Bourbon Red remained critically endangered, with breeding populations of fewer than 500. During the winter of 2005, the ALBC contacted a number of hatcheries as the first stage in a census to track population trends. They found another 25 percent increase since 2003 in the total population of breeding birds. Even the Narragansett was rebounding, with 686 breeding birds.

Most turkeys raised for market today are the Broad Breasted Whites, as shown here on a large-scale turkey farm.

Heritage Turkeys versus Commercial Turkeys

Text courtesy of the American Livestock Breeds Conservancy and a number of its partners.

A heritage turkey is defined by the historical, range-based production system in which it is raised. A turkey must meet all of the following criteria to qualify as a heritage turkey.

Naturally mating: The heritage turkey must be reproduced and genetically maintained through natural mating, with expected fertility rates of 70 to 80 percent.

Long productive life span: The heritage turkey must have a long productive life span. Breeding hens are commonly productive for five to seven years and breeding toms for three to five years.

Slow growth rate: The heritage turkey must have a slow to moderate rate of growth. Today's heritage turkeys reach a marketable weight in 26 to 28 weeks, giving the birds time to develop a strong skeletal structure and healthy organs prior to building muscle mass. This growth rate is identical to that of the commercial varieties of the first half of the twentieth century.

Beginning in the mid-1920s and extending into the 1950s, turkeys were selected for larger size and greater breast width, which resulted in the development of the Broad Breasted Bronze. In the 1950s, poultry processors began to seek broad-breasted turkeys with less visible pinfeathers, as the dark pinfeathers, which remained in the dressed bird, were considered unattractive. By the 1960s the Large or Broad Breasted White had been developed and soon surpassed the Broad Breasted Bronze in the marketplace.

Today's commercial turkey is selected to efficiently produce meat at the lowest possible cost. It is an excellent converter of feed to breast meat, but the result of this improvement is a loss of the bird's ability to successfully mate and produce fertile eggs without human intervention. Both the Broad Breasted White and the Broad Breasted Bronze turkeys require artificial insemination to produce fertile eggs. These turkeys also have a less robust immune

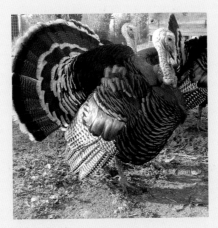

A Standard (heritage) Bronze.

system and are prone to cardiac, respiratory, and joint problems.

The turkey known as the Broad Breasted Bronze in the early 1930s through the late 1950s is nearly identical to today's heritage Bronze. Both are naturally mating, productive, and long-lived, and both require 26 to 28 weeks to reach market weight.

This early Broad Breasted Bronze is very different from the modern turkey of the same name. The Broad Breasted Bronze turkey of today has traits that fit modern, genetically controlled, intensively managed, efficiency-driven farming.

While superb at their job, modern Broad Breasted Bronze and Broad Breasted White turkeys are not heritage turkeys. Only naturally mating turkeys meeting all of the above criteria are heritage turkeys.

The APA lists eight varieties of turkeys in its *Standard of Perfection*. Most were accepted into the standard in the last half of the nineteenth century, with a few more recent additions. They are the Black, Bronze, Narragansett, White Holland, Slate, Bourbon Red, Beltsville Small White, and Royal Palm. The ALBC also recognizes other naturally mating color varieties that have not been accepted into the APA *Standard of Perfection*, such as the Jersey Buff, White Midget, and others. All of these varieties are heritage turkeys.

Definition prepared by Frank Reese, owner and breeder, Good Shepherd Farm; Marjorie Bender, research and technical program manager, American Livestock Breeds Conservancy; Dr. Scott Beyer, department chair, poultry science, Kansas State University; Dr. Cal Larson, professor emeritus, poultry science, Virginia Tech; Jeff May, regional manager and feed specialist, Dawes Laboratories; Danny Williamson, farmer and turkey breeder, Windmill Farm; and Paula Johnson, turkey breeder, and Steve Pope, promotion and chef, Good Shepherd Farm.

Breed versus Variety

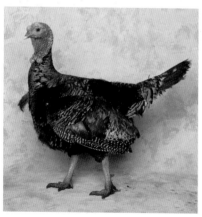

The American Poultry Association considers all turkeys to be one breed with various color varieties, such as the Buff and Bronze, seen here.

YOU MIGHT RECALL THE definition of a breed from chapter 1. A breed is a group of animals that exhibits definable and identifiable characteristics (visual and performance) that allow it to be distinguished from other groups within the same species. Within breeds there may be more than one variety based on differences in color or other physical traits. The APA is the official arbiter for defining breeds and varieties in the United States, and it has always classified all turkeys as one breed, with eight recognized varieties.

Some growers and poultry conservationists are advocating that some varieties be recognized as individual breeds. Andy Lee and Patricia Foreman, the authors of *Day Range Poultry,* are among those campaigning for the change. The following comes from the Good Earth Publications Web site (see page 261 for address):

"We strongly feel the use of 'varieties' does turkeys a great disservice, and that to use 'breeds' is technically correct. When mated together, members of a breed consistently reproduce the same traits. The Black Spanish, Narragansett, Royal Palm, Bronze, Slate, Buff, White Holland, and Sweetgrass turkeys are all groups of animals within the same species that consistently reproduce certain traits.

If that's good enough for chickens, pigs, goats, cows, and sheep, then surely it's good enough for turkeys. They are turkey breeds. To us, it seems much more compelling for folks to act and save a vanishing breed rather than a variety. 'Variety' seems more like something you would pick up at the corner discount dollar store — something not valuable."

DIFFERENT TRAITS

The phenotypic differences between some turkeys also seem to make a compelling argument for redefining at least some of the varieties as separate breeds. For example, the differences between the Broad Breasted Bronze and the Standard Bronze extend beyond minor external traits: the Broad Breasted can no longer mate naturally, though the Standard can; the Broad Breasted has a larger breast and appreciably shorter legs; and Standard toms weigh around 36 pounds (16.3 kg) at maturity, while Broad Breasted toms weigh 50 pounds (22.7 kg).

There are also some recognizable and reproducible differences in performance traits among the varieties, such as levels of disease resistance, growth rate, temperament, and other traits that are not just based on color. The ALBC and Virginia Polytechnic Institute and State University in Blacksburg, Virginia, are conducting a DNA analysis of the varieties to help determine relationships between them, and to help better understand which ones may best be identified as breeds instead of varieties.

SHARED TRAITS

Turkeys do have some traits that are shared equally between the varieties. To begin, they are all relatively large birds, with the smallest varieties (such as the White Midget and the

Beltsville Small White) sized slightly larger than the biggest chickens and the larger varieties standing 3 feet (91 cm) tall.

The head, which is bare of feathers and has a wrinkled, pebbly texture (known as carunculated skin), is red but can change color to shades of grayish blue, bluish white, or bright blue. The turkey's wattles can change from red to very bright red to almost white. The color changes are sort of an emotional barometer: colors change when turkeys are excited and when they are mating.

Turkeys have a snood (also known as a front caruncle). The snood is a piece of fleshy skin located just above the beak. The hen's snood is always just a small piece of skin, more like a large wart. The male's snood is a long flap that either tightens up to an inch-long (2.5 cm) stubby protrusion or lengthens so that it's hanging well over the beak. A long snood is helpful when trying to impress the girls or make the other guys think you are the toughest dude around.

All toms, and occasionally some hens, have a beard, or a group of bristly "feathers" (they look more like very coarse hair fibers) protruding from the upper breast a few inches below the bottom of the neck. As a group the beard feathers on a mature tom can be almost 1 inch (2.5 cm) around and reach lengths of 8 to 12 inches (20–30 cm). Females with a beard (10 to 50 percent, depending on the variety) will tend to have just a few feathers, each about 6 inches (15 cm) long.

Gobble is the word we use for turkey sounds, but actually only toms gobble. They also have a bunch of other signature sounds ranging

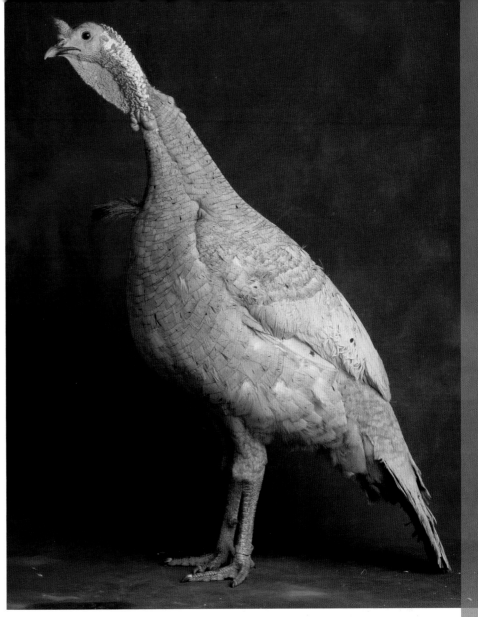

Some varieties that have not been bred for industrial production, such as this Slate tom, are still able to mate naturally.

Other Naturally Breeding Varieties

There are a number of naturally breeding varieties that have never been admitted to the *Standard of Perfection* by the APA but that the ALBC, the Society for the Preservation of Poultry Antiquities (SPPA), and turkey enthusiasts are interested in maintaining.

Most take their names from their colors and patterns, such as the Calico, the Chocolate, the Lilac, and the Red, though some take their names from the place where they originated, such as the Nebraskan, the Nittany (developed at Penn State and named for Mount Nittany, which overlooks the campus), and the Sweetgrass, a calico-colored variety that was a sport out of a Bronze flock owned by Sweetgrass Farms in Big Timber, Montana.

A strutting Bourbon Red tom is trying to impress a flock of Standard Bronze hens in a backyard flock. When on display like this, the tom will emit a base-drum thump sound and a series of ticking noises.

from base-drum thumps to ticking noises. Strutting males emit a non-vocal sound that comes from deep in the breast and has a two-part resonance of *chump* and *hummm*. Hens also have a variety of sounds, such as yelps (which sound like a high-pitched *dupe*) and purring sounds. Both sexes have a staccato-type of call they use as an alarm when they sense a predator in the area.

For the most part turkeys have a good disposition, but toms are rather bulky, so they can be dangerous when aroused or provoked. They are inquisitive and entertain-ing. Some of our toms became like big dogs, gobbling excitedly when we came out of the house and following us around. One in particular would stand guard at the milking parlor door every day as we milked the cows and would reprimand any cow that walked toward the door.

Turkeys are active foragers and will make a circuit of their world each day, partaking in grass and bugs. If given the chance when young, they will take to roosting in trees, though if you raise Broad-Breasted birds they get far too large to continue the practice.

Auburn

ALSO KNOWN AS THE Light Brown, the Auburn is a variety that has not been recognized by the APA but has been referred to in literature since at least the eighteenth century. It is similar to the **Bronze** (page 230). The hen is colored like a typical Bronze, but the tom's coloring is reddish brown, making it an autosexing variety.

There is also a very similar subvariety of the Auburn known as the Silver Auburn. The Silver's coloring is a faded-out shade of the reddish brown with some silvery gray highlights. The two Auburn varieties are among the most rare according to the ALBC and SPPA.

AUBURN FACTS

SIZE **Old Tom:** 36 lb. (16.3 kg) | **Old Hen:** 20 lb. (9 kg)

CONSERVATION STATUS Study

An Auburn tom showing off his reddish brown color in full display.

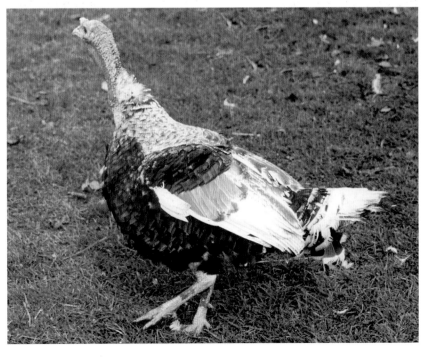

A close-up of a Silver Auburn tom's coloring. His color is more subdued than the Auburn tom's coloring above.

Beltsville Small White

RESEARCHERS DEVELOPED this turkey at the U.S. Department of Agriculture Research Center in Beltsville, Maryland, during the 1930s and 1940s, with the goal of producing a small, white-feathered turkey for home and small-scale production that would provide a turkey for market year-round. They used **White Holland** (page 237), White Austrian, **Bronze** (page 230), **Black** (page 227), a strain of **Broad Breasted White** from Cornell (page 229), and Eastern wild turkey stock in the breeding program.

For a short time the Beltsville enjoyed extraordinary success. In the 1950s it accounted for over a quarter of all turkey sales. Millions of birds were produced annually, and consumers at the supermarket recognized its name. Unfortunately, in spite of its brief heyday, it was one of the first casualties of the industrialization of turkey production, and by 1974 it was nearly extinct.

At one time, poultry enthusiasts feared that the Beltsville might actually be extinct. Since then, two closed research flocks have been discovered in Canada, and another at Iowa State University. A few individual breeders are also keeping small populations. The Beltsville

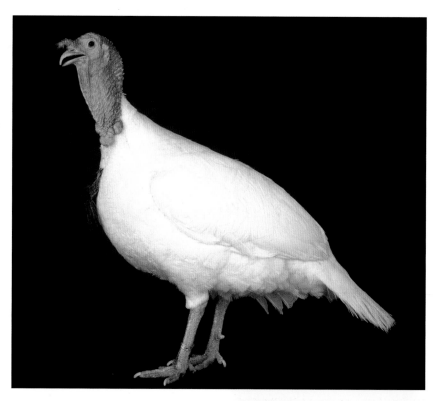

Small White may again enjoy popularity as farmers discover the value of a smaller turkey that consumers can enjoy throughout the year.

The Beltsville Small White was first admitted to the APA in 1951.

BELTSVILLE SMALL WHITE FACTS

SIZE **Old Tom:** 23 lb. (10.5 kg) | **Old Hen:** 13 lb. (5.9 kg)

CONSERVATION STATUS Critical

The Beltsville Small White was developed as a perfect bird for year-round consumption. At one time it was extremely popular and well-known by consumers, but today it is critically endangered.

Black

THE BLACK WAS DEVELOPED IN Europe from the first turkeys brought there by Columbus and other early New World explorers. These explorers reported on the occasional black turkey among New World flocks, but the color, which is a metallic black throughout, enjoyed greater favor among Europeans, who selected for the trait. Several black types are found in Spain, England, Italy, and France.

The Black was among the turkeys that returned to North America with early settlers. It was crossbred with wild turkeys to help develop the **Bronze** (page 230), the **Narragansett** (page 234), and the **Slate** (page 236) varieties. Thanks to its European development, the Black is sometimes referred to as the Black Spanish or the Norfolk Black.

The Black was first admitted to the APA in 1874.

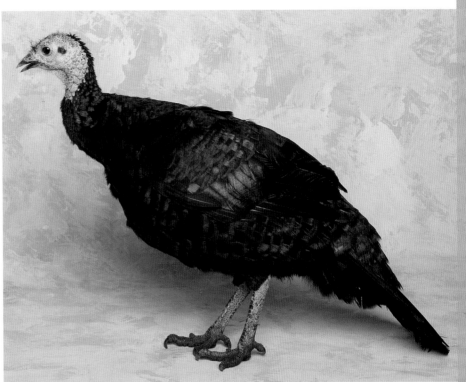

BLACK FACTS

SIZE **Old Tom:** 33 lb. (15 kg) |
Old Hen: 18 lb. (8.2 kg)
CONSERVATION STATUS
Critical

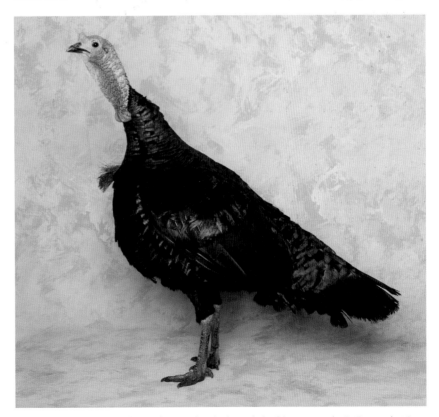

The Black turkey (female shown above and male shown below) is very popular in Europe, but in North America it is critically endangered.

Bourbon Red

THE BOURBON RED is an older American variety developed in Pennsylvania and Kentucky from crosses of **Buff** (page 232), **Bronze** (page 230), and **White Holland** (page 237) turkeys in the late 1800s. It is a large bird with primarily rich chestnut-red plumage laced in black and highlighted by some white on the wings and tails.

The Bourbon Red has remained popular with small producers thanks to excellent utility traits, such as good foraging capability, a relatively heavy breast, light-colored pinfeathers for a clean carcass, and richly flavored meat. In fact, the Bourbon has the most breeding birds of any nonindustrial heritage breed, with over fifteen hundred documented in the 2003 ALBC census — about double the number from the 1997 census.

Part of the Bourbon's rebounding success can be attributed to Slow Food USA, which has placed the Bourbon, as well as the Buff, Standard Bronze, and **Narragansett** (page 234) varieties, in its Ark of Taste program (see page 7).

The Bourbon Red was first admitted to the APA in 1909.

The Bourbon Red is a beautifully colored, majestic bird that has enjoyed rebounding numbers thanks to its placement on Slow Food USA's Ark of Taste.

BOURBON RED FACTS

SIZE **Old Tom:** 33 lb. (15 kg) |
Old Hen: 18 lb. (8.2 kg)
CONSERVATION STATUS Watch

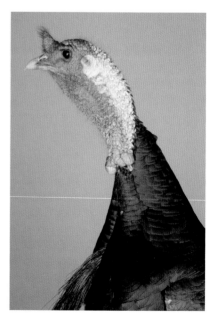

Broad Breasted White

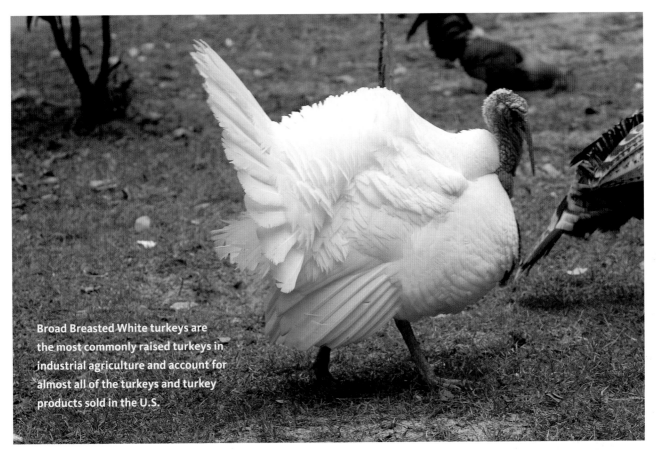

Broad Breasted White turkeys are the most commonly raised turkeys in industrial agriculture and account for almost all of the turkeys and turkey products sold in the U.S.

ALSO CALLED THE Large White, this variety has been developed over the past half century specifically for intensive, industrial production. Unfortunately, it is sometimes shown under the name White Holland, though the **White Holland** (page 237) is a heritage bird that can still breed naturally.

Broad Breasted Whites were developed from the White Holland and some white sports of the **Broad Breasted Bronze** (page 230). They have been selected for decades for efficiently producing the most meat at the least cost, and they are quite remarkable in that ability. The result, however, is a loss of the birds' capacity to mate naturally, so artificial insemination is required to produce fertile eggs.

Broad Breasted Whites generally are not kept beyond one year of age because they have leg problems and are prone to suffering from heart problems such as plaque buildup. Most birds are butchered as soon as they reach marketable weight, between 14 and 18 weeks of age. The one exception is small groups of breeding toms that are milked for sperm used in artificial insemination.

BROAD BREASTED WHITE FACTS

SIZE **Old Tom:** 50 lb. (22.7 kg) | **Old Hen:** 36 lb. (16.3 kg)

CONSERVATION STATUS Not applicable

Bronze

THE STANDARD (or unimproved, or heritage) Bronze was developed in the United States in the 1700s. As colonists began establishing settlements along the eastern seaboard, the turkeys they brought with them from England crossbred with the Eastern wild turkey, yielding a cross that was larger and healthier than the birds from Europe.

The color of the cross was close to that of its wild forebears (an iridescent reddish brown with flecks of green that glints coppery in the sun), but the moniker Bronze wasn't applied until the 1830s, when a strain developed in the Point Judith area of Rhode Island was dubbed the Point Judith Bronze.

During the late eighteenth and early nineteenth centuries, breed-

ers began selecting for a larger breast and legs, ultimately ending up with the Broad Breasted Bronze. The Broad Breasted quickly dominated the marketplace, and by the 1940s the Standard Bronze was losing its position of prominence in the turkey world.

The Broad Breasted Bronze was the first variety to be bred up to a point where its large breast

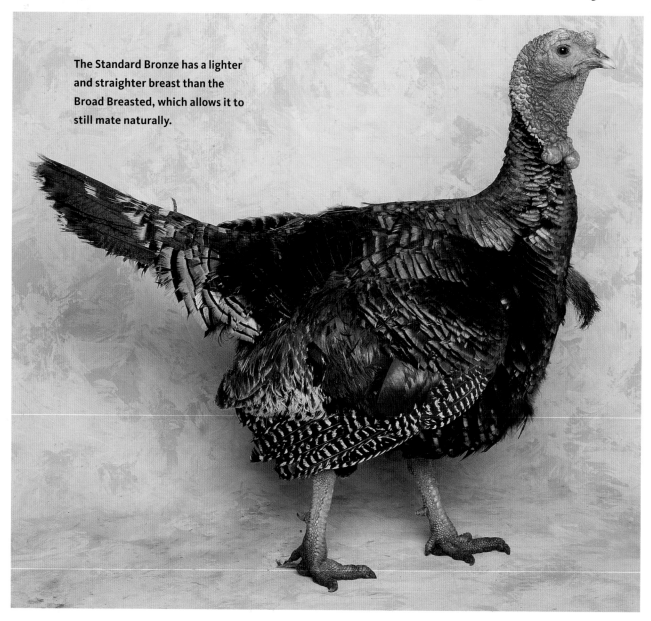

The Standard Bronze has a lighter and straighter breast than the Broad Breasted, which allows it to still mate naturally.

and small legs precluded it from mating naturally, thus requiring human intervention. All Broad Breasted Bronze turkeys are the result of artificial insemination.

The Broad Breasted Bronze had a short stint (twenty years or so) as the main commercial turkey in North America, only to be replaced by the **Broad Breasted White** (page 229). However, the Bronze maintained some popularity with barnyard and backyard producers.

Unfortunately, over the ensuing years the Standard Bronze, which was capable of mating naturally, almost disappeared. Today it is making a comeback. Like the **Bourbon Red** (page 228), it has been adopted by Slow Food USA's Ark of Taste program (see page 7).

The Broad Breasted fared better than the Standard Bronze, though its known breeding population has been reduced to the point that the ALBC has added it to its conservation priority list. The ALBC is trying to secure a clearer understanding of the Broad Breasted population and threats to it.

The APA *Standard of Perfection* seems to have mixed information about the two, thus creating problems for both types. It lists only the Bronze, which, it states, is "sometimes referred to in modern commercial terminology as Broad Breasted." It lists a weight that is higher than that of the Standard Bronze and lower than that of the Broad Breasted Bronze. And the color that is listed is closer to that of the Standard Bronze than that of the Broad Breasted, which is slightly darker than the Stan-

dard. Breeders are advocating for a correction in the *Standard of Perfection* so future issues may clear this up.

The Bronze was first admitted to the APA in 1874.

BRONZE FACTS

SIZE **APA Old Tom:** 36 lb. (16.3 kg) | **Old Hen:** 20 lb. (9.1 kg)
Standard Old Tom: 34 lb. (15.4 kg) | **Old Hen:** 19 lb. (8.6 kg)
Broad Breasted Old Tom: 45 lb. (20.4 kg) | **Old Hen:** 32 lb. (14.5 kg)
CONSERVATION STATUS **Standard** Critical. **Broad Breasted** Study.

The Broad Breasted Bronze's breast is larger than the Standard and protrudes in front, precluding natural mating.

When seen in the light, bronze feathers have high iridescence in shades of copper and blue.

Buff

THE BUFF'S ORIGINS are unclear, though it was popular in the mid-Atlantic states of New Jersey, Delaware, and Pennsylvania in the nineteenth century thanks to its light-colored pinfeathers, which made the carcass easy to clean. It was used in developing the **Bourbon Red** (page 228), which quickly ascended in popularity, leaving the Buff to languish.

By 1915 the Buff's popularity had declined to the point that it was dropped from the APA *Standard of Perfection*. This was done in part because it was hard to breed the birds to fit the color standard, which called for "even buff color throughout with light flight feathers [wings and tails]."

The original Buff was probably extinct within a few years of being dropped from the *Standard of Perfection*. Then in the 1940s and 1950s, the New Jersey Agricultural Experiment Station undertook a project to re-create Buffs as part of a program to improve the market qualities of small and medium-size birds.

Thanks to the station's work, the Buff (also called the Jersey Buff) enjoyed a brief recovery, but in the end it slid toward extinction again, with only 42 breeding birds identified in the ALBC's 2003 census. But the future is now looking brighter for the Buff, as it has been adopted by Slow Food USA's Ark of Taste program (see page 7).

The Buff was first admitted to the APA in 1874 but dropped in 1915. The Jersey Buff has not been recognized by the APA.

BUFF FACTS

SIZE **Old Tom:** 25 lb. (11.4 kg) | **Old Hen:** 14 lb. (6.4 kg)
CONSERVATION STATUS
Critical

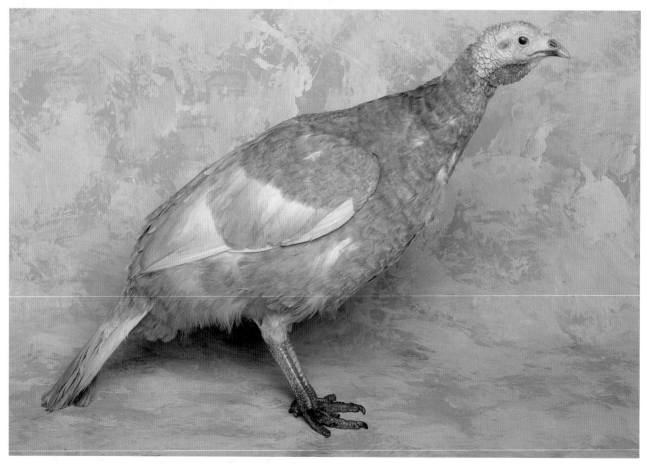

As described in the APA Standard of Perfection, *the Buff color is hard to breed for, a point that some breeders think helped to fuel its slide toward extinction.*

Midget White

THE MIDGET WHITE is similar to the **Beltsville Small White** (page 226) and is sometimes shown in poultry shows under that classification. The Midget White is a fairly new breed. It was developed by Bob Smyth at the University of Massachusetts during the late 1950s and the early 1960s.

Like the staff at Beltsville, Smyth was seeking a smaller bird for barnyard production. He used as a foundation stock **Royal Palms** (page 235) and commercial Whites, which at the time could have been **Broad Breasted Whites** (page 229), **White Hollands** (page 237), or a cross of the two.

MIDGET WHITE FACTS

SIZE **Old Tom:** 20 lb. (9.1 kg) | **Old Hen:** 12 lb. (5.5 kg)

CONSERVATION STATUS
Critical

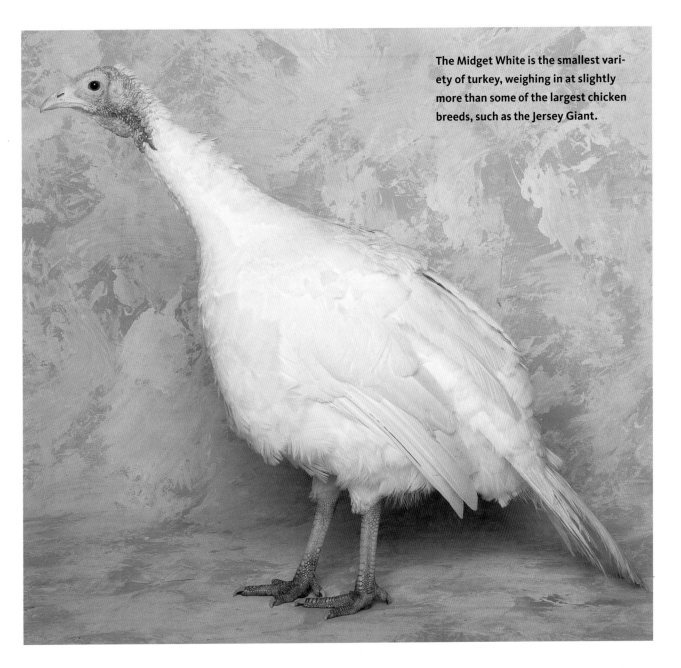

The Midget White is the smallest variety of turkey, weighing in at slightly more than some of the largest chicken breeds, such as the Jersey Giant.

Narragansett

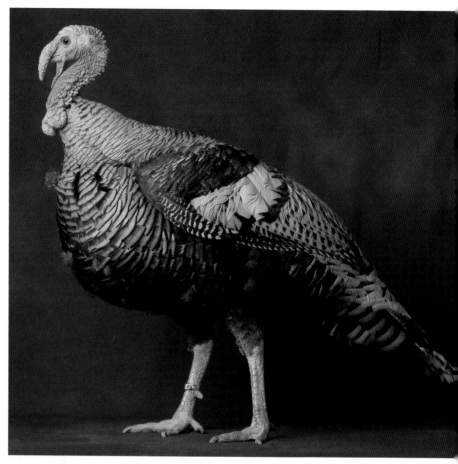

LIKE THE **BRONZE** (page 230), the Narragansett, named for Narragansett Bay in Rhode Island, developed in the 1700s from crosses of domestic turkeys brought from Europe with Eastern wild turkeys. (In fact, some speculate that it may have been an intermediate between wild turkeys and the Bronze.) Its coloring is similar to that of the Bronze in pattern, but where the Bronze has a coppery tinge on the exposed portion of its feathers, the Narragansett has a steely gray color.

The Narragansett breed was especially popular in New England during the nineteenth and early twentieth centuries, and it also commanded respect in the mid-Atlantic states and the Midwest. But by the early 1950s its numbers had plummeted, in spite of the fact that it was known for good meat quality, broodiness, and calm disposition.

In fact, when the ALBC completed its 1997 census, the organization had found only 6 breeding birds. By 2003 the Narragansett, with the help of its position in Slow Food USA's Ark of Taste program (see page 7), had rebounded to 368 breeding birds — the most impressive increase in breeding numbers for any birds checked in the six-year census.

The Narragansett was first admitted to the APA in 1874.

The Narragansett is a very old variety that originated in North America. It is colored somewhat like a Bronze, but where the Bronze has coppery coloring the Narragansett has steely gray coloring.

NARRAGANSETT FACTS

SIZE **Old Tom:** 33 lb. (15 kg) | **Old Hen:** 18 lb. (8.2 kg)

CONSERVATION STATUS
Critical

Royal Palm

THE ROYAL PALM is a lovely bird of medium stature that was developed primarily as an ornamental variety. Its distinctly offset black-and-white pattern occurs occasionally in mixed-variety flocks, and in the 1920s Enoch Carson, a Florida breeder, began breeding to stabilize the color.

Although the Royal Palm was developed primarily for exhibition (when the tail is displayed its banded markings are breathtaking), it is a great choice for a backyard or barnyard. Royal Palms are excellent foragers and produce a nice size carcass for a small family meal.

There are two subvarieties of the Royal Palm that are not recognized by the APA: the Blue Palm and the Golden Palm. The Blue Palm's coloring is bluish brown in areas that are black on the Royal Palm. The Golden Palm has a creamy golden tint in areas of the body that are white on the Royal.

The Royal Palm was first admitted to the APA in 1977.

ROYAL PALM FACTS

SIZE **Old Tom:** 22 lb. (10 kg) | **Old Hen:** 12 lb. (5.5 kg)
CONSERVATION STATUS Rare

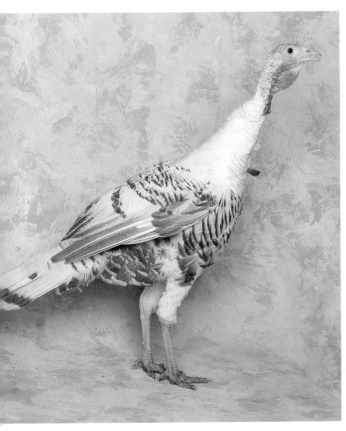

This male Blue Palm's coloring is slightly lighter than the Royal Palm's.

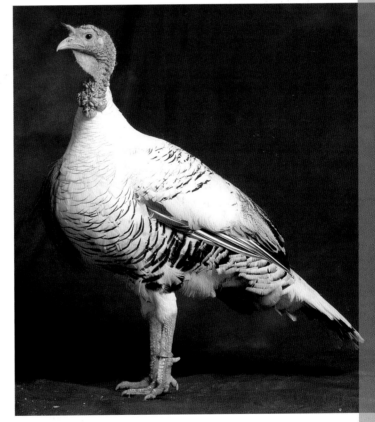

Royal Palms are beautiful birds, with a distinct band of color on their tail when in full display.

Slate

THE SLATE HAS A pattern similar to Splash (page 29), with bluish black to black spots spattered against a slate blue base color. However, due to the gene combination that produces the slate color, offspring may be black, blue, or slate. Birds that show the slate coloring range from light lavender to dark, ashy slate blue. Sometimes the lighter types are referred to as "Lavender Turkeys."

Because of the unusual gene combination that yields the slate color, breeding for show-quality color (which is listed as slaty or ashy blue in the APA *Standard of Perfection*) is a challenge. One other challenge of raising Slate turkeys is that some old birds (particularly hens) that have been bred from an early Penn State strain may develop an unusual form of cataracts that can lead to blindness, but it is very easy to select against the trait and remove it from your breeding population.

The Slate was first admitted to the APA in 1874.

SLATE FACTS

SIZE **Old Tom** 33 lb. (15 kg) | **Old Hen** 18 lb. (8.2 kg)
CONSERVATION STATUS Critical

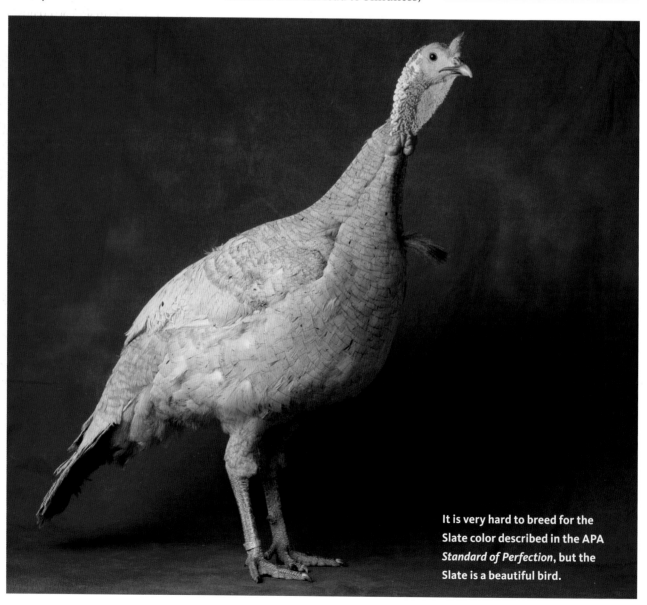

It is very hard to breed for the Slate color described in the APA *Standard of Perfection*, but the Slate is a beautiful bird.

White Holland

THE WHITE HOLLAND originated in Europe (probably in Holland or Austria, where the populace showed an early preference for white-colored birds). The breed, which has been documented in England since the early 1800s, was imported to the United States and accepted into the first APA *Standard of Perfection* in 1874. The White Holland quickly became popular for commercial production thanks to its white pinfeathers, but it dwindled quickly after the 1950s, when the **Broad Breasted White** (page 229) became the bird of choice for commercial production.

The entry for White Hollands in the APA *Standard of Perfection* includes a note that says they "may be referred to in commercial terminology as Broad Whites or Large Whites." This reference has probably contributed to confusion about the variety and to the reduction in the White Holland population, as Broad Breasted Whites are sometimes substituted for them in poultry shows.

The true White Hollands are still naturally breeding, have the same conformation and body type as other standard varieties, and don't have the shortened and enlarged breast of the Broad Breasted White.

The White Holland was first admitted to the APA in 1874.

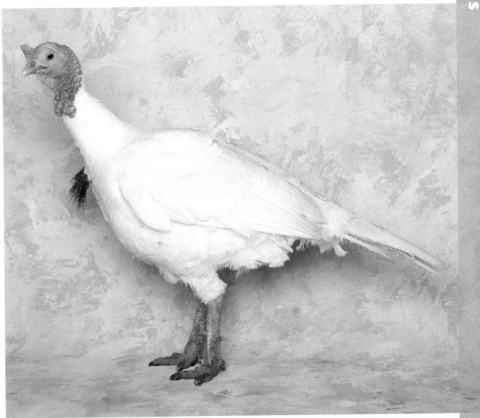

White Hollands are critically endangered, in part because breeders were allowed to show Broad Breasted Whites under the same classification. Breeders interested in saving the variety are seeking clarification of the standard.

WHITE HOLLAND FACTS

SIZE **Old Tom:** 33 lb. (15 kg) | **Old Hen:** 18 lb. (8.2 kg)

CONSERVATION STATUS Critical

Other Birds of Interest

Birds of a feather will gather together.

—Robert Barton, *The Anatomy of a Melancholy*, 1621

AROUND THE WORLD, people have historically kept birds beyond common barnyard fowl, including upland game birds for meat and hunting; ratites (such as emus and ostriches) for meat, eggs, feathers, and oil; and small birds (such as pigeons and doves) for food or fancy. Although far less familiar than the birds presented in previous chapters, they have plenty of enthusiastic fans in North America.

Most of these other birds tend to be captive-reared, semidomesticated birds that share genetic and behavioral traits with their wild relatives. They have not been reared in captivity long enough to become domesticated to the same extent as the chickens and turkeys — in other words, they can go feral quite easily.

A number of these other birds, including the guinea fowl, pheasants, peafowl, partridges, and quail are among the 263 species found in the order Galliformes, so they are related to chickens and turkeys and share a number of traits. With the exception of quails and swans, the birds described in this chapter have stout, short wings, so they are not particularly good long-distance fliers and don't migrate over vast

Above: Swans are the largest waterfowl, and though not common as barnyard birds, they are kept as estate birds by some fanciers. Left: A blue Indian peacock.

areas, but they are strong runners. They are at least slightly omnivorous, eating insects, small rodents, and small reptiles, and using their short, thick bills to forage. Within most species, the females are the primary incubators and caregivers for the young.

The largest birds in the world are the ostriches and emus, which are members of the ratite clan, a group that also includes rheas, kiwis, and three species of Australian cassowaries. The ratites are ancient birds, having come on the scene about 150 million years ago, when the world was broken into two supercontinents: Gondwana, which includes Africa, Antarctica, Arabia, Australia, India, and South America, and Pangea, which encompassed most of the land areas that now make up the Northern Hemisphere.

One Big Bird

Ostriches can weigh up to 400 pounds (182 kg) and stand up to nine feet (2.75 m) tall, but while they are the largest birds today, they aren't the largest of all time. The elephant bird of Madagascar — a member of the ratite clan driven to extinction in the sixteenth century — weighed over a thousand pounds (454 kg) and stood over 10 feet (3 m) tall, making ostriches appear rather small!

Ratites have wings that are relatively short for the size of their bodies, and rather flat breastbones, making them incapable of flight. However, they do tend to use their wings with great drama and flair in breeding displays, and as a means to lure prey away from their young with a movement that suggests they are injured. What they lack in flying ability, they make up in running capability, thanks to their phenomenally powerful legs. In fact, an ostrich — which is the fastest biped creature on the planet — can outrun a horse (and kill a human with a single kick). The ratites are also among a small group of birds that share a distinctive palate (jaw and roof of mouth), from which they receive their scientific class name, Palaeognathae, which translates as "old jaw."

Swans are fairly closely related to ducks and geese. There are eight species of swans in the world, and though none are truly domesticated, several are kept as semidomestic, ornamental birds on farms, on estates, and in parks. Adult swans are rarely victims of predators. They are big, strong birds that can easily defend themselves unless they are injured or sick. But predators (particularly turtles, birds of prey, foxes, and dogs) can take cygnets (baby swans), especially from young parents.

Regulations

If you are interested in raising upland game birds or ratites, you should know that some states have regulations regarding the keeping of these birds. Check with your state's division of wildlife or your county extension office to learn if there are applicable rules, or license or permit requirements.

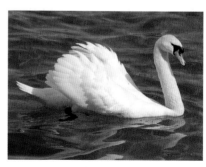

Swans make a beautiful addition to a pond.

Emu

THE EMUS (*Dromaius novaehollandiae*) originated in Australia approximately 80 million years ago. They were imported to North America from the 1930s through 1950s, primarily as zoo stock. Because of an export ban in Australia beginning in 1960, the birds in North America today are mainly from domestically bred lines, though some eggs have been imported in recent years.

Emus became popular as a barnyard bird in the early 1980s. Growers then became more interested in emu production as a niche market. Investments in breeding stock increased dramatically but demand did not, and many growers incurred major financial losses. The market is stable now but the up-front investment is still hefty, with birds selling for thousands — or even tens of thousands — of dollars for pairs.

Emus have unusual plumage, in that their feathers have two shafts, with widely spaced barbs that create a loose, soft, almost hairlike effect. Their tail hangs low behind their body, and is loose and floppy, giving these birds the appearance of a mini-haystack on legs.

The female emu tends to be dominant, selecting her mate and choosing and defending a territory for the nest. Emus live for 30 to 40 years. The female generally produces 10 to 15 dark-green eggs annually (mainly in winter) that weigh over a pound and a half (680 g) apiece, remaining productive for 16 years or more. Interestingly, the male sits on the nest during the entire 55-day incubation period, living off the fat on his back — literally.

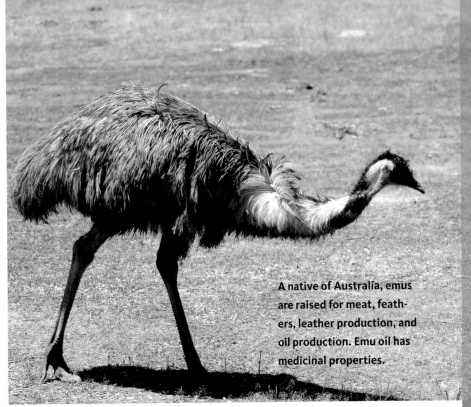

A native of Australia, emus are raised for meat, feathers, leather production, and oil production. Emu oil has medicinal properties.

Known as very good foragers, emus also consume abundant insects. They not only run at up to 40 miles (65 km) per hour for short bursts, but also they are excellent swimmers. Their calls, which consist of booming, grunting, and drumming sounds, are quite loud. They produce red meat that tastes similar to beef but contains much less fat and is lower in calories than chicken and turkey. Their skin can be made into a fine, light leather, and they produce oil (from a large fatty strip along their back) that has been found to have anti-aging and anti-inflammatory properties.

EMU FACTS

SIZE 110–140 lb. (50–63.5 kg) (female is generally slightly larger than male); up to 6 feet (1.8 m) tall.

COLOR Plumage is predominantly in shades of tan and brown, possibly with some black mixed in, though in young birds, or immediately after molting, the feathers will be so dark as to appear almost black overall. Head and neck are lightly feathered or feather free, except on females prior to egg laying. Feathers that occur on head and neck are black; skin on head and neck is in shades from bluish gray to bluish black.

PLACE OF ORIGIN Australia

SPECIAL QUALITIES Produce meat, eggs, leather, and oil, which is said to have medicinal properties.

Guinea Fowl

GUINEAS ARE AMONG the noisiest birds, warning of intruders with a shrill staccato cry and chattering boisterously throughout the day. The guinea hens have a two-note call that sounds like they are calling out *buck-wheat, buck-wheat*. They are gregarious and flighty birds with comical dispositions; however, their crazy antics and clamoring demeanor may not endear them to close neighbors.

There are six species of guinea fowl in the wild, three of which are raised in captivity in North America. By far the most common is the helmeted guinea *(Numida meleagris)*, and the color descriptions (next page) apply to this order. The helmeted gets its name from the bony protrusion atop its head. Vulturine guineas *(Acryllium vulturinum)* and crested guineas *(Guttera pucherani)* are also kept by a handful of fanciers. The vulturine guineas are fantastic-looking birds, with wildly iridescent blue plumage highlighted with stripes and dots. They are also slightly larger than other guineas, and slightly calmer. They do well in captivity, becoming quite tame. Crested guineas are growing in popularity because they can adapt to being kept in a confined area. They can be recognized by a topknot of curly black feathers on their head.

Guinea fowl are all highly omnivorous, eating insects, rodents, snakes, and small frogs and reptiles, as well as forage and grain. In fact, in Lyme-disease areas, they are used quite effectively to reduce tick infestations. The hens are fairly prolific layers of small dark eggs

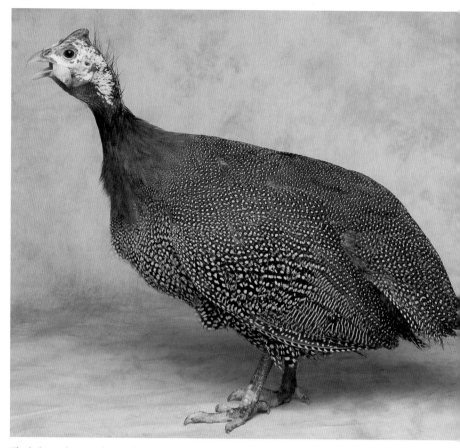

The helmeted guinea (a Pearl Gray shown here) is the most common of guinea fowl. Guineas are known for their voracious appetite for insects, reducing tick populations where they live.

from late spring through early fall, but they hide their nests in fields and woods, or around haystacks and brush piles, making it hard to retrieve all of their eggs.

Guinea hens are great mothers and have been known to hatch and brood as many as 50 keets (or young guineas) at a time. Those that are hatched naturally are susceptible to dying from dampness or cold during the first week or so of life, but any that survive that initial period are quite hardy. Guineas are occasionally crossed with other poultry, yielding a sterile hybrid.

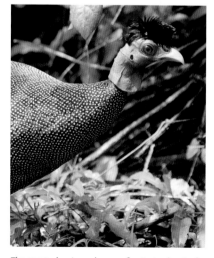

The crested guinea, known for its topknot of feathers that give it a Little Richard look, can adapt to confined areas better than other guinea fowl.

GUINEA FOWL FACTS

SIZE **Cock:** 4 lb. (1.8 kg) |
Hen: 3.5 lb. (1.6 kg)

COLOR

Bronze. Dark black plumage with a cast of bronze over shoulders, back, neck, and chest. Primary wing feathers have a reddish color.

Brown. Dark brown plumage with white dots. Hens are darker than cocks.

Buff. Soft tan plumage without dots. Hens are darker than cocks.

Buff Dundotte. Soft tan plumage with white dots throughout. Hens are darker than cocks.

Chocolate. Chocolatey dark brown color. Not dotted overall, but may have a few dots and bars in the flank area.

Coral Blue. Medium blue with a darker coral blue on the neck, breast, and back. Not dotted overall, but may have a few dots and bars in the flank area.

Lavender. Light blue plumage with white dots.

Lite Lavender. Lighter version of the Lavender.

Opaline. Icy whitish blue plumage. Hens are darker than the cocks.

Pearl Gray. Dark gray plumage with white dots. They are close to the wild color.

Pewter. Pewter gray plumage, sometimes a little streaky in appearance.

Pied. Pied can be of various colors (purple, pearl, chocolate, buff) with white on the front of neck, breast, lower body, wing, and sometimes the back, and the color on back of neck, back and upper body, tail, and flank.

Porcelain. Very pale pastel blue with white dots. Hens are darker than cocks.

Powder Blue. Uniform light blue color. No dots or barring.

Royal Purple. Dark black plumage with purplish sheen. Do not have regular dotting, but may have some dotting and barring in the flank area.

Sky Blue. Medium blue with a darker coral blue on the neck, breast, and back, with a hint of blue on blue lacing.

Slate. Steel blue plumage with slight cream-color cast over shoulders and back. Also have a collar of iridescent purplish blue around neck.

Violet. Dusty black with purple sheen; no dots or barring. These look very purple on a cloudy day or in the shade, unlike the Royal Purple, which show their purple best in the sun.

White. Pure white plumage with a few black hairs on the back of the neck. The whites have lighter colored skin, and the meat is a lighter color also.

PLACE OF ORIGIN Africa

SPECIAL QUALITIES Delicately-flavored meat and eggs. Excellent "watchdogs" and insect controllers.

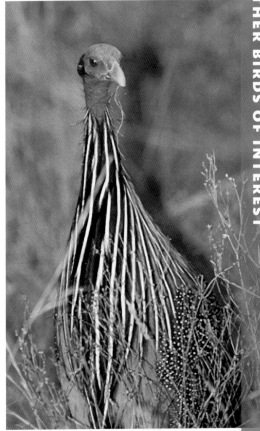

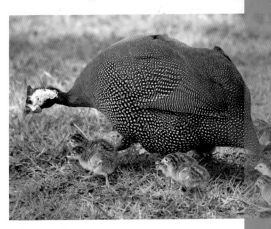

Vulturine guineas (top photo) are calmer than other guinea fowl. Helmeted guinea fowl (bottom photo) come in many color varieties, and breeders are continuing to breed for new colors.

Ostrich

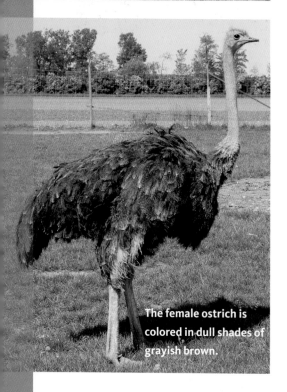

Ostriches are the largest birds in the world, and they can outrun a horse.

The female ostrich is colored in dull shades of grayish brown.

THE OSTRICHES (*Struthio camelus*) are the largest living birds in the world. In the wild, they weigh up to about 175 pounds (80 kg) and stand up to 9 feet (2.75 m) tall; domestic strains reach about the same height, but a big male can weigh as much as 400 pounds (182 kg). They developed in Africa, where they live on the grasslands and desserts that transect the continent. They have been recognized as a species for over 40 million years, and the proto-ostrich (the immediate forebears of the current species) were around at least 80 million years ago.

In the 1830s, the first ostrich farms were set up in South Africa, and within a decade farms appeared in Florida and California. They were farmed not only for meat and eggs, but also for their feathers, coveted by the millinery industry and used for decorating ladies' hats. Wild ostriches were also killed for feathers, and the wild populations plummeted.

After the end of World War I, ostrich feathers went out of style, and wild populations began to rebound at the same time as many of the farms started to close down. The handful of people who kept raising ostriches in the United States after the crash in the feather market did so largely as a tourist attraction.

As with the emus, the 1980s saw renewed interest, and a subsequent crash, in ostrich farming. Today the market seems to have stabilized, and ostrich farmers have banded together to strengthen their markets, which are driven by low-fat, low-cholesterol red meat and fine leather. The meat is similar to beef, but a little sweeter.

Ostriches are very long living birds and can reach 75 years of age. They begin breeding between 2 and 3 years old and stay productive into their 20s, laying up to 30 eggs per year that weigh around 3 pounds (1.4 kg) each. The creamy white shell is so strong that a person could stand on it and not break it.

OSTRICH FACTS

SIZE 150–400 lb. (68–182 kg); up to 9 feet (2.75 m) tall.

COLOR Males are black with white plumes on the ends of the wings and tail. Females are dull grayish brown with dull white plumes on the ends of wings. Skin on legs and neck is bluish tan to grayish pink depending on which wild strain the birds originated from; skin color is brighter and more vivid during breeding season.

PLACE OF ORIGIN Africa

SPECIAL QUALITIES Fine leather, low-fat red meat. The only bird with two toes, they can maintain running speeds of 50 mph (80.5 kmph) over long distances.

Partridge

PARTRIDGES ARE MEMBERS of the pheasant family. Worldwide there are 106 species of partridge, though none are native to the Americas. Two of these — the chukar *(Alectoris chukar)* and the Hungarian or Gray *(Perdix perdix)* — are raised in North America.

The chukar partridge originated in eastern Europe and western Asia, from the Balkans through Turkey, Tibet, and Mongolia. First released in California in 1932 for hunting purposes, they have developed self-supporting wild populations throughout the Great Basin, west of the Rocky Mountains. Chukars thrive on overgrazed rangelands in the west, feeding on annual and perennial grasses and forbs.

Chukars are small birds that are considered one of the best species for beginners interested in raising game birds. Chukar hens begin laying eggs in early spring and continue into late summer. They lay 40 or more eggs per season, but rarely go broody in captivity. Broody bantam chickens (the smaller the hen the better, as the eggs are fragile) are often used to incubate chukar eggs and rear the young, or they can be incubated and reared artificially.

The Hungarians were first imported in the early years of the nineteenth century, and like the chukar, were released for hunting purposes. They have established self-sustaining populations in the northern Great Basin, the northern plains (including fairly far north into the Canadian prairie), and parts of the Midwest into

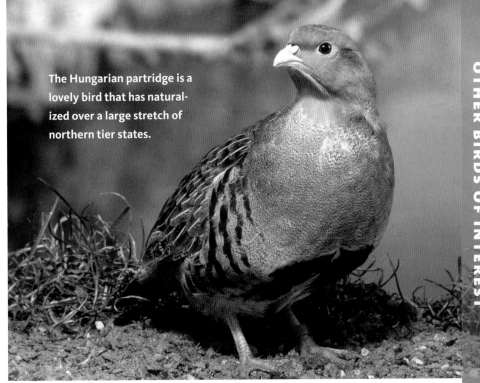

The Hungarian partridge is a lovely bird that has naturalized over a large stretch of northern tier states.

Iowa, Minnesota, and Wisconsin, preferring farmed fields with adjacent woods or hedgerows. They eat mainly seeds and forage but also consume some insects.

The Hungarian hens are prolific breeders and will brood large clutches; however, breeding pairs can't be kept in large groups due to fighting. The birds form their pair bonds in late winter and early spring, and remain committed as a pair through the rearing of chicks. They are a little more challenging to raise in captivity than chukars, so the price tends to be higher, and you may only be able to find mature birds or hatching eggs.

Distinguished by its Zorro mask, the chukar partridge is one of the most commonly kept game birds in North America.

PARTRIDGE FACTS

SIZE 1–2 lb. (500–900 g)

COLOR *Chukar*: grayish blue with white belly, and black and white banding on face, neck, and wings. It can be identified by the black mask that runs across its eyes, Zorro style. *Hungarian*: gray and brownish gray on front of neck and back, white with a dark patch on belly, brownish red around face.

PLACE OF ORIGIN Eurasia

SPECIAL QUALITIES Small, attractive birds for release as a hunting bird, or for show.

Peafowl

WHO HAS NEVER SEEN a peacock and not stood in sheer awe of its beauty? This bird has captured our imaginations through the millennia, as evidenced by its place in mythology, art, and early literature (including a mention in the Bible). The species is known as peafowl; males are peacocks, hens are peahens, and — you guessed it — young are peachicks.

In the wild there are three species: the Indian (*Pavo cristatus*), Green (*Pavo muticus*), and Congo (*Afropavo congensis*). There are also more than a dozen subspecies (which are actually part of the pheasant clan). The Indian and the Green are the most vibrant, and the two species that have captured man's fancy; the Congo is a smaller and duller version of peafowl that hasn't garnered the same affections as its showier cousins, and has never really been domesticated.

The Indian and the Green are both from Asia. The Indian is found in parts of India (where it is recognized as the national bird), Pakistan, Sri Lanka, and up into the Himalayas; the Green throughout a wide swath of Southeast Asia, from Bangladesh and Burma east into Thailand and China. In the Hindu communities of India and Pakistan, the Indian is considered sacred; because humans do not harass it, it has acclimated to living right in populated areas and is quite tame.

The Green is a little more standoffish, flighty, and aggressive. When kept in captivity together, the species will cross.

Peafowl are long-living birds, with many birds making it into their 50s. Indian peafowl are quite hardy, but the Greens do not tolerate cold climates well. The peafowl, like chickens, have complex color genetics, so by applying selective breeding, there are now 185 recognized color varieties for domesticated peafowl.

PEAFOWL FACTS

SIZE 6–9 lb. (2.7–4.1 kg)

COLOR The United Peafowl Association recognizes 185 varieties based on color. The best information on these color varieties is available online (see page 259 for Web site).

PLACE OF ORIGIN Asia

SPECIAL QUALITIES The most gorgeous of birds, kept for ornamental purposes in parks, at zoos, and on private estates.

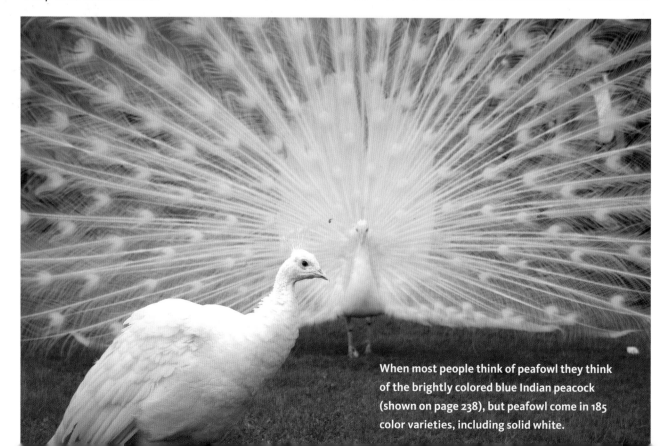

When most people think of peafowl they think of the brightly colored blue Indian peacock (shown on page 238), but peafowl come in 185 color varieties, including solid white.

Pheasant

THERE ARE ACTUALLY hundreds of species within the biological family of pheasants, or Phasianadae, including the jungle fowl and chickens, turkeys, Old World quail, and partridge, as well as the true pheasants. But most often, when North Americans use the term *pheasant*, they are referring to the ringneck, or common pheasant *(Phasianus colchicus)*.

The ringneck is a native of Asia, ranging from the eastern shore of the Black Sea east through the northern slopes of the Himalayas, into Manchuria and Korea, and

south to Vietnam. The earliest fossil records of pheasants indicate that they originated in China about 2 to 2.5 million years ago. They were imported to the Americas in the 1880s and have done phenomenally well over large areas of North America, establishing self-sustaining breeding populations in dozens of states and some provinces in Canada.

Breeders involved in the production of birds for release for hunting primarily concentrate on raising the ringneck pheasants, but fanciers also raise a number of the more

exotic species, and some conservationists are getting involved with breeding threatened and endangered species to help maintain their populations. The ringnecks are relatively easy to raise in captivity. One cock is suitable for five to seven hens. The breeding season begins in late winter or early spring and goes through midsummer. Hens are solely responsible for incubation and care of the clutch, laying about 40 eggs in a typical season. In the wild, they build their nests right on the ground in tall vegetation consisting of grasses, weeds, or shrubs.

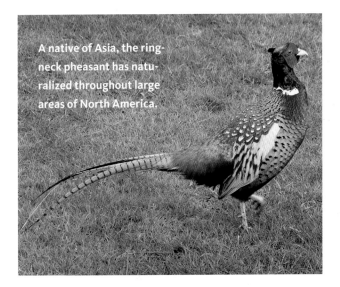

A native of Asia, the ringneck pheasant has naturalized throughout large areas of North America.

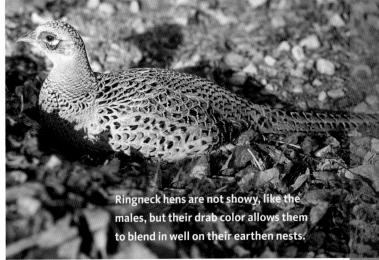

Ringneck hens are not showy, like the males, but their drab color allows them to blend in well on their earthen nests.

PHEASANT FACTS

SIZE 2–4.5 lb. (.9–2 kg)

COLOR *Male*: Lustrous copper to brown with dark lacing on breast, back, and lower body, shading to grayish brown and gray on back. Tail is grayish brown barred with darker brown. Lustrous black head, with red highlight on face, and white ring around neck.

Female: Light brown with dark brown and black highlights (barring and stripes) on some feathers. White highlights around face.

PLACE OF ORIGIN Asia

SPECIAL QUALITIES Generally raised for release as game birds. Delectable meat.

Pigeon and Dove

PIGEONS AND DOVES usually do not inspire fondness: people complain that the birds, which have become feral throughout most of North America, are dirty, noisy, or underfoot beggars looking for a handout. But there are also thousands of fanciers around the country who absolutely love the pigeons and doves they raise for show, for recreation (racing and homing), and for meat. Pigeons have also served the important role of message carrier for the military, from the days of the Roman Empire through World War II, when three thousand American soldiers managed over fifty thousand birds.

Biologists don't really recognize a difference between pigeons and doves (for the sake of brevity, I will use the term pigeon for both), but most people think of the pigeons as being the larger specimens, and the doves being the smaller species. They all belong to an order called the Columbiformes, and there are over

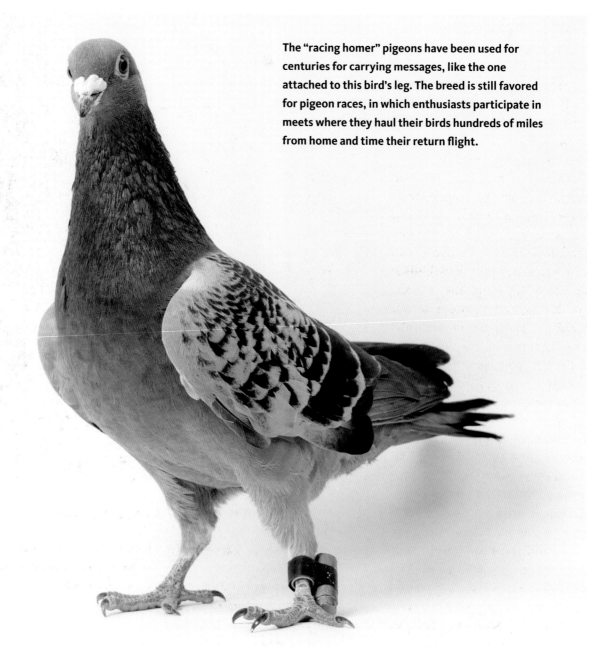

The "racing homer" pigeons have been used for centuries for carrying messages, like the one attached to this bird's leg. The breed is still favored for pigeon races, in which enthusiasts participate in meets where they haul their birds hundreds of miles from home and time their return flight.

three hundred species in the clan.

The wild species have world-wide distribution (the mourning dove probably being the most familiar of the American species). The domestic pigeons and doves, including the feral "street" pigeons that are common in cities, are domesticated birds that were developed beginning five thousand years ago from rock doves that were native to Africa, Europe, and Asia. French colonists first imported pigeons to Canada as early as 1607, and immigrants from around the world continued to bring them to North America over the ensuing centuries.

There are over eight hundred recognized breeds, ranging from showy birds with wild colors and exotic feather patterns to rather plain-looking birds in solid shades of gray, and from very large birds to extremely tiny birds. They are reasonably easy to raise, though anyone wishing to participate in racing and homing events will need to spend a good deal of time on training. Most are quite hardy and can live in simple buildings called lofts.

As a rule of thumb, pigeons (particularly the common breeds, like the Ringnecks) will brood and nurture their own young, known as squabs. The hen is usually a dutiful mother, and will raise a small clutch of two squabs. The cock can become aggressive with other birds (including his own hen) during the breeding season, so breeders often keep separate small lofts for breeding birds to have some degree of privacy.

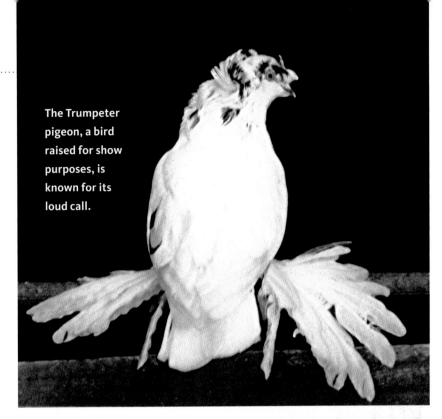

The Trumpeter pigeon, a bird raised for show purposes, is known for its loud call.

Doves are the smaller members of the pigeon clan.

PIGEON AND DOVE FACTS

SIZE 0.25–3.5 lb. (.1–1.6 kg), depending on the breed.

COLOR Hundreds of varieties.

PLACE OF ORIGIN Europe, Asia, Africa.

SPECIAL QUALITIES Easy to keep, even in cities. Beautiful and entertaining.

Quail

Several distinct groups of birds bear the name *quail*. The button quails are Old World upland/shore birds that are in the family Turnicidae, and are closer to our native plovers than to the quail that are native to North America. These tiny birds — about the size of a golf ball —are raised as pets and generally kept in indoor aviaries.

Old World and New World species are relatively small, plump-bodied upland game birds. The main physical differences between the two are that the mandible, or lower jaw, is serrated on the New World quail, and the Old World quail has a spur on the lower leg that its New World counterpart lacks. Though they share some appearance traits, they are from biologically unique families. There are 32 species of New World quail that are members of the Odontophoridae family, including the North American natives: California, Gambel's, Montezuma, mountain, and scaled quail. The Old World quails are members of the pheasant, or Phasianidae, family.

The bobwhite and Japanese, or coturnix, are the most common quail species raised in captivity for release as game, for meat, or for eggs, though some breeders also raise the California, Gambel's, and scaled species. The Japanese is an Old World species; the others are New World species.

In the wild, quail live in groups called coveys ranging in size from half a dozen birds to hundreds of birds. Quails also don't like to be overcrowded, however, so provide adequate room and some cover (pine boughs or brush piles work well) in the pen.

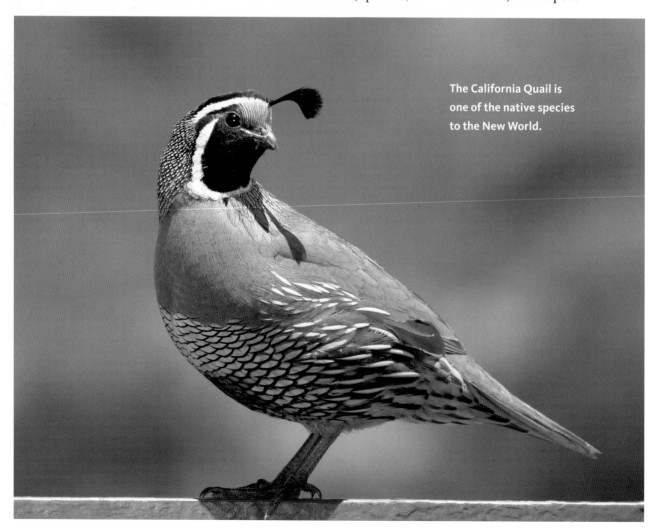

The California Quail is one of the native species to the New World.

Quail are quiet, pleasant birds to keep. Due to their small size and fine bone structure, quail are somewhat fragile, so calm movement and easy handling is essential. Once grown, though, they are quite hardy.

Breeding season begins in early spring and runs into late summer, with the hens laying up to one hundred eggs per season. Some producers who are primarily marketing eggs use lights to keep up year-round production, and in this situation a single hen can lay over two hundred eggs.

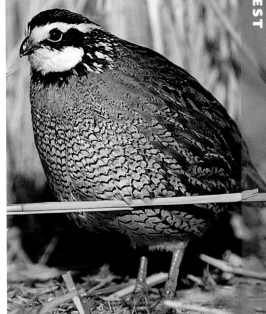

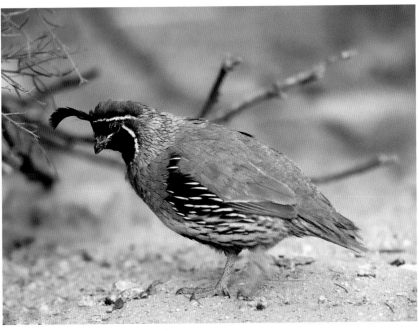

The Gambel's quail (male shown here) is a native of the southwestern United States and Mexico. Some breeders raise these handsome birds in captivity.

QUAIL FACTS

SIZE 4–12 oz. (113–340 g)

COLOR Plumage is in earthen shades of tan, brown, gray, off-white, and black, depending on species. Many species have a face mask or other attractive highlights; some are distinguished by a small plume of topknot feathers.

PLACE OF ORIGIN Global distribution, depending on species.

SPECIAL QUALITIES Prolific layers for game species, excellent meat quality. Often released for hunting.

The Bobwhite quail (top) is one of the more common quail raised in captivity. The Japanese, or coturnix (bottom), is also a common quail in captivity.

Swan

A MALE SWAN is called a *cob*, a female is a *pen*, and a baby is a *cygnet*. Swans typically mate for life, though if a mate dies, the remaining bird will eventually accept a new mate. Since they have not been overly bred up under domestication, swans still maintain much of their wild character and make excellent parents, often carrying their young on their backs while swimming.

Though swans can become fairly petlike, cobs can be dangerously aggressive when protecting their young, or their mate if she is setting on the nest. Whereas ducks and geese can be kept in an area with no access to water, swans seem to need a small pond that is at least 3 feet (91 cm) deep and has a fairly sizeable yard area around it for rest and foraging. Because they are not fully domesticated, swans could be prone to leaving of their own volition, so typically owners clip flight feathers or pinion a wing on at least one bird to keep a flock around.

The Mute swan (*Cygnus olor*) is the most common species kept by waterfowl enthusiasts. It is of Eurasian origins and was first brought to North America in the mid-1800s. Over the ensuing years, some Mutes have escaped captivity, and there are now wild populations living in parts of the United States and Canada. In fact, in some areas of the Northeast they are now considered a nuisance.

In spite of the name, the Mute swan isn't truly mute, but it is

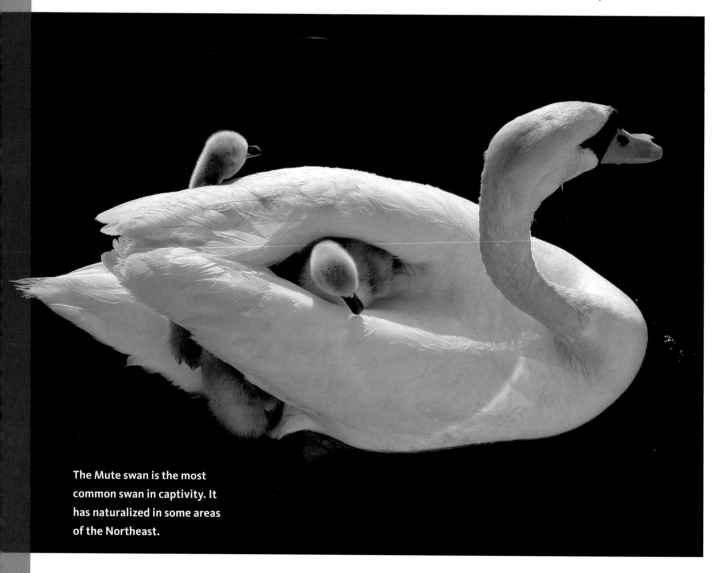

The Mute swan is the most common swan in captivity. It has naturalized in some areas of the Northeast.

generally much quieter than other swan species. Mute swans are the largest waterfowl and the heaviest of all flying birds, weighing up to 50 pounds (22.7 kg).

The Black swan (*Cygnus atratus*) is from Australia and is the second most common swan kept in captivity. It was discovered "down under" by Dutch explorers in 1697, and when they brought back word of its existence to Europe, people were incredulous and didn't believe it could possibly exist. Black swans are particularly unique among swans in one interesting way: the cob will aid the pen with incubation duties.

Some breeders keep other species, but they are far less common than Mute and Black swans. Federal and state wildlife regulations apply to those keeping Trumpeter (*Cygnus buccinator*), Tundra (*Cygnus columbianus*), and now Mute swans, so check with your state's wildlife agency if you would like to add any of these birds to your collection.

SWAN FACTS

SIZE **Black Male:** 20 lb. (9.1 kg) |
Female: 20 lb. (9.1 kg) |
Mute Male: 20 lb. (9.1 kg) |
Female: 14 lb. (6.4 kg)

COLOR

Black. Bill is orange with white bean. Eyes are orangey red. Shanks and feet are gray. Plumage is grayish black to black, with white primary and secondary flight feathers.

Mute. Bill is orange, with black bean and black splash at nostril. Eyes are dark brown. Shanks and feet are grayish black. Plumage is pure white. Cygnets are brownish gray.

PLACE OF ORIGIN

Black. Australia **Mute.** Eurasia, from the British Islands to Mongolia

SPECIAL QUALITIES

Beautiful birds, kept for their elegance.

The Black swan (above) is a native of Australia. It is often kept in captivity. Young swans (left) are called cygnets, and often hitch a ride on their parents' back while mom or dad is paddling around the pond.

Glossary

American Standard of Perfection. A book published by the American Poultry Association describing each breed recognized by that organization.

Artificial Insemination (AI). The placement of semen in the uterus or oviduct of a female by means that aren't natural (without sexual contact between the male and the female).

Autosexing. The trait whereby males and females are different colors, either when they "pop" from their shell or as adults, depending on the breed.

Bantam. A miniature chicken or duck, about one-fourth the size of a regular-size chicken. Some bantams are distinct breeds; others are a miniature version of a large breed. Bantams are kept largely as ornamental birds, though some have good production characteristics for meat and eggs.

Bantam Standard. A book published by the American Bantam Association describing each of the bantam breeds recognized by that organization.

Banty. Affectionate word for bantam.

Barring. Alternate transverse markings of two distinct colors on a feather.

Beak. The hard, protruding portion of a bird's mouth, consisting of an upper beak and a lower beak.

Beard. The feathers (always found in association with a muff) bunched under the beaks of such breeds as Antwerp Belgian, Faverolle, and Houdan. Also, the small tuft of coarse black hair-like feathers protruding from the breast of a turkey, particularly adult males.

Biddy. Affectionate word for a hen.

Bill. The upper and lower mandibles of waterfowl.

Biodiversity. A broad range of types of plants and animals in an environment.

Biosecurity. Disease-prevention management.

Blade. The lower unserrated portion of a single comb, or the portion to the rear of the last point on the male.

Bleaching. The fading of color from the beak, shanks, and vent of a yellow-skinned laying hen.

Bloom. The moist, protective coatings on a freshly laid egg that dries so fast you rarely see it; also, peak condition in an exhibition bird.

Bluish slate. A bluish gray color.

Body. The trunk of the bird, excluding head, neck, wings, tail, thighs, shanks, and toes. When used in color descriptions the breast and back are reported separately.

Booted. Having feathers on the shanks and toes and having vulture hocks.

Bows. See "wing bow."

Breed. A group of birds that are like each other and different from other birds; also, pairing a male and a female for the purpose of obtaining fertile eggs.

Breeders. Mature birds from which fertile eggs are collected; also, a person who manages such birds.

Breed true. The characteristic of purebred offspring whereby they resemble both parents.

Broiler. A young, tender meat chicken; also called a "fryer."

Brooder. A mechanical device used to imitate the warmth and protection a mother bird gives her offspring.

Broody. A hen that covers eggs to warm and hatch them.

Buttercup comb. Consists of a single blade arising at the juncture of the beak and the head giving way to a cup-shaped crown set at the center of the head; the edges of the cup are serrated with evenly spaced points.

Cape. The short feathers between a bird's neck and back.

Caruncles. The fleshy bulges on the naked portions of the head and neck of turkeys and some ducks.

Chestnut. A dark red-brown color.

Chronic. Description of a disease having long duration measured in days, months, or even years and being somewhat resistant to treatment.

Class. A group of birds competing against each other at a show.

Classification. The grouping of purebred birds according to their place of origin or unique and common characteristics, such as "American," "Asiatic," or "Single Comb, Clean Legged."

Clean legged. Having no feathers growing down the shanks.

Close feathered. Feathers are held tightly against the body.

Clutch. A batch of eggs that are hatched together, either in a nest or in an incubator (from the Old Norse word *klekja*, meaning to hatch), also called a "setting"; also, all the eggs laid by a hen on consecutive days, before she skips a day and starts a new laying cycle.

Cock. A male fowl more than 12 months of age; the male chicken may also be called a "rooster."

Cockerel. A male chicken under one year old.

Comb. The fleshy bulge on top of the head.

Condition. The state and quality of a bird with regard to general health, cleanliness, and "brightness" of plumage.

Conformation. A bird's body structure.

Coop. The house or cage in which a type of poultry lives.

Coverts. Feathers that cover the bottoms of the quills on a bird's wings and tail.

Creamy white. A pale shade of yellowish white.

Crest. A puff of feathers on the heads of breeds such as Houdan, Silkie, or Polish; also called a "topknot."

Crop. A pouch at the base of a chicken's neck that bulges after the bird has eaten; also, to trim a bird's wattles.

Crossbreed. The offspring of a hen and a rooster of two different breeds.

Cuckoo. A term applied to a coarse and irregular type of barring.

Cushion. A group of feathers over the base and back of the tail that give the bird a rounded appearance.

Cushion comb. A small, low comb that is quite smooth.

Cull. To eliminate a non-productive or inferior bird from a flock; also, the non-productive or inferior bird itself.

Cygnet. A young swan.

Debeak. To remove a portion of a bird's top beak to prevent cannibalism.

Defect. Any characteristic that makes a bird less than perfect.

Dewlap. A pendulous growth of skin under the beak or bill at the chin.

Disqualification. A defect or deformity serious enough to bar a bird from a show.

Domesticated species. A species that has been brought into a codependent and relatively "tame" relationship with humans that has resulted in unique biological changes within the species.

Dominecker/Dominicker. Colloquialism for Dominique, often erroneously applied to barred Plymouth Rocks.

Down. The soft, furlike fluff covering a newly hatched chick; also, the fluffy part near the bottom of any feather.

Drake. A male duck.

Dual-purpose bird. A type of bird raised for both meat and eggs.

Dub. To trim the comb.

Duckling. A young duck.

Dusky. Blackish shading over yellow skin.

Dust. The habit chickens have of thrashing around in soft soil to clean their feathers and discourage body parasites.

Ear tuft. A group of feathers on each side of the neck, protruding out from the area just below the ear.

Eclipse period. The molt for ducks, during which the male resembles the female.

Embryo. A fertilized egg at any stage of development prior to hatching.

Fancier. A person who breeds a particular type of animal.

Fawn. A light brownish tan color.

Feather legged. Having feathers growing down the shanks.

Fertile. Capable of producing a baby bird.

Fertilized. An egg that has accepted sperm to produce an embryo.

Finish. The amount of fat beneath the skin of a meat bird; also, a term applied to a bird that has completed growing.

Flight feathers. The large primary feathers of the wings and tail that allow a bird to gain altitude.

Flock. A group of birds living together.

Forager. A bird that searches for food in its natural environment.

Fowl. Domesticated birds raised for food; also, a stewing hen.

Free range. To allow poultry to roam pasture at will.

Frizzle. Feathers that curl rather than lie flat.

Fronts. See "wing fronts."

Fryer. A tender young meat chicken; also called a "broiler."

Game bird. Within the chicken species, it designates a breed of bird that was originally developed and used for cockfighting. It also pertains to upland species of nondomesticated and semidomesticated birds, such as quail, that were commonly hunted.

Gander. A male goose.

Genotype. The complete genetic makeup of an individual as described by the arrangement of its genes.

Goose. A large waterfowl with a long neck; also a female goose.

Gosling. A young goose.

Grade. To sort eggs according to their interior and exterior qualities.

Gypsy. A grayish to almost dark plum color seen on some combs, wattles, and earlobes.

Hackle. Plumage on the side and rear of the neck of fowl; typically differs significantly between males and females, except in "hen-feathered" breeds.

Hard feather. The term used to describe the narrow, short, and tough feathers of game breeds.

Hardiness. The ability to withstand harsh environmental conditions, such as extreme cold or extreme heat.

Hatchability. Percentage of fertilized eggs that hatch under incubation.

Hen. A female fowl more than 12 months of age.

Hen feathered. The characteristic of a rooster having rounded rather than pointed sex feathers.

Heritage breed. A livestock breed with unique genetic traits that was traditionally raised by farmers in the past, before industrial agriculture. A heritage breed was developed to be particularly well adapted to its environment.

Horn. A type of beak color. This term covers a wide variety of

beaks that aren't true white, black, or yellow but are muted or semi-translucent shades of gray to grayish brown to yellowish gray.

Host. A bird (or other animal) on or in which a parasite or an infectious agent lives.

Hybrid. The offspring of a hen and rooster of different breeds, each of which might themselves be crossbred; often erroneously applied to the offspring of a hen and rooster of different strains within a breed.

Immunity. Ability to resist infection.

Incubate. To maintain favorable conditions for hatching fertile eggs.

Incubation period. The time it takes for a bird's egg to hatch; also, the time it takes from exposure to a disease-causing agent until the first symptom appears.

Incubator. A mechanical device for hatching fertile eggs.

Infertility. Temporary or permanent inability to reproduce.

Intensity of lay. The number of eggs a female bird lays during a given time.

Keel. The breastbone, which resembles the keel of a boat.

Khaki. Light brown or tannish color.

Knob. A tough bulge on the head at the junction between the head and the bill in some breeds.

Lacing. The bordering of a contrasting color around the entire edge of a feather.

Leader. The round tapering spike at the rear of a rose comb.

Luster. The brilliant, glossy and light-reflective characteristic of plumage seen in some breeds.

Mite. A tiny jointed-legged body parasite.

Molt. The annual shedding and renewing of a bird's feathers.

Morbidity. Percentage affected by a disease.

Mortality. Percentage killed by a disease.

Mottling. A varying percentage of colored feathers tipped with white; also, plumage in which the surface is spotted with colors that are different from the base color of the feather.

Muff. The feathers (always found in association with a beard) sticking out from both sides of the face of such breeds as Antwerp Belgian, Faverolle, and Houdan; also called "whiskers."

Nest. A place where a female bird feels she may safely leave her eggs; also, the act of brooding.

Nuptial plumage. A male duck's plumage when it is not in molt.

Ornamental chicken. Chicken kept and shown for its beauty rather than its ability to lay eggs or produce meat.

Oviduct. The tube inside a female bird through which an egg travels when it is ready to be laid.

Parasite. An organism that lives on or inside a host animal and derives food or protection from the host without giving anything in return.

Pasting. Loose droppings sticking to vent area.

Pea comb. Medium-length comb that grows low and close to the head and is marked with lengthwise ridges or round serrations.

Pecking order. The social rank of poultry.

Pen. A group of chickens entered into a show and judged together; also, a group of chickens housed together for breeding purposes; also, a female swan.

Penciling. Crosswise bars on feathers. Also narrow concentric markings inside edge of feathers, as well as fine markings on feathers in Rouen and Gray Call ducks.

Perch. The place where poultry sleep at night; the act of resting on a perch; also called "roost."

Persistency of lay. The ability of a female bird to lay steadily over a long period of time.

Phenotype. The physical characteristics or behaviors of an animal that can be observed or tested for, such as feather color, aggressiveness, or blood type.

Pigmentation. The color of a bird's skin, eyes, beak, shanks, etc.; pigmentation is affected by the quantity and type of pigment granules in the cells of body tissue.

Pinbones. Pubic bones.

Pinfeathers. The tips of newly emerging feathers.

Pinion. The outer segment of the wing.

Plumage. The total set of feathers covering a bird.

Poult. A young turkey.

Poultry. Chickens and other domesticated birds raised for food.

Predator. One animal that hunts another for food.

Primaries. The long, stiff flight feathers at the outer tip of the wing.

Processor. A person or firm that kills, cleans, and packages meat birds.

Producer. A person or firm that raises meat birds or layers.

Pubic bones. Two sharp, slender bones that end in front of the vent; also called "pinbones."

Pullet. A female chicken under one year old.

Purebred. The offspring of a hen and rooster of the same breed.

Ratite. A group of ancient birds that includes ostriches, emus, rheas, kiwis, and three species of Australian cassowaries.

Resistance. Immunity to infection.

Roaster. A cockerel or pullet, usually weighing 4 to 6 pounds, suitable for cooking whole in the oven.

Roost. The place where chickens spend the night; the act of resting on a roost; also called "perch."

Rooster. A male chicken; also called a "cock."

Rose comb. A large comb that's broad in front and lies flat on top and terminates in a spike in the rear, which may turn upward or lie nearly horizontal.

Saddle. The part of a bird's back just before the tail.

Salmon. A shade of medium reddish ochre.

Scales. The small, hard, overlapping plates covering a fowl's shanks and toes.

Scapular. A feather at the base of a bird's wing.

Secondaries. The large wing feathers adjacent to the body, visible when the wing is folded or extended.

Self color. A single and uniform color through all plumage.

Semidomesticated bird. A bird whose feeding and breeding schedules are controlled by humans but that still shows wild tendencies; not yet fully domesticated.

Set. To keep eggs warm so they will hatch; also called "brood."

Sexed. Newly hatched offspring that have been sorted into male and female groups.

Sex-linked. Any inherited factor linked to the sex chromosomes of either parent. A plumage color difference between the male and female progeny of some crosses is an example of sex-linkage. Useful in sexing day-old chicks.

Sex feather. A hackle, saddle, or tail feather that is rounded in a hen but usually pointed in a rooster (except in breeds that are hen feathered).

Shank. The part of a bird's leg between the claw and the first joint.

Sickles. The long, curved tail feathers of some roosters.

Silkie. Soft and fluffy feathers that have a narrow shaft; also a breed of chickens with silkie feathers.

Single comb. A comb that has five or six distinct serrations along the upper edge. It is always erect and larger in the male.

Slaty blue. A dark grayish blue color in the feathers.

Smut. Black feathers that are uncharacteristic for the breed, such as black body feathers in a Rhode Island Red.

Snood. A piece of fleshy skin located just above the beak of a turkey; also known as a front caruncle.

Spangling. A distinct marking of contrasting color at the end of a feather, in shapes that vary from a well-defined "V" to a half-moon.

Species. A group of organisms that are genetically similar and have evolved from the same genetic line.

Spent. No longer laying well.

Sport. Genetic mutation that occurs naturally or is induced (for example, by radiation); also, cockfighting.

Spurs. The sharp, pointed protrusions on a male bird's shanks.

Stag. A cockerel on the brink of sexual maturity, when his comb and spurs begin to develop.

Standard. The description of an ideal specimen for its breed; also, a chicken that conforms to the description of its breed in the *American Standard of Perfection*, sometimes erroneously used when referring to large as opposed to bantam breeds.

Sterile. Permanent inability to reproduce.

Sternum. Breastbone or keel.

Straightbred. Purebred.

Straight run. Newly hatched offspring that have not been sexed; also called "unsexed" or "as hatched."

Strain. A flock of related birds selectively bred by one person or organization for so long that the offspring have become uniform in appearance or production.

Stress. Any physical or mental tension that reduces resistance.

Stub. Down on the shank or toe of a clean-legged chicken.

Tom. A male turkey.

Trio. A cock and two hens or a cockerel and two pullets of the same breed and variety.

Tuft. A small pouf of feathers on a bird's head.

Type. The size and shape of a bird that tells you what breed it is.

Undercolor. The lower portion of the feather — the fluff that is usually hidden from view.

Vaccine. Product made from disease-causing organisms and used to produce immunity.

Variety. Subdivision of a breed according to color, comb style, beard, or leg feathering.

Vent. An outside opening through which a chicken emits eggs and droppings from separate channels.

Vulture hocks. Stiff and long feathers growing from the lower part of the thigh.

Walnut comb. A broad and solid comb that shows some grooves like a walnut half.

Waterfowl. Swimming game birds.

Wattles. The thin pendant appendages at either side of the base of the beak and upper throat, usually much larger in males than in females.

Whiskers. Muffs.

Wing bow. The surface part of the wing below the shoulder and located between the wing front and covert.

Wing coverts. Two rows of feathers that cover the lower portion of the wing's secondary feathers.

Wing fronts. The front portion of the wing where it joins the shoulder; sometimes referred to as the "wing-butt".

Willow. A yellowish green to green color in the shanks and toes.

Zoning. Laws regulating or restricting the use of land for a particular purpose, such as raising poultry.

Resources

Breed Clubs

If you are interested in a particular breed, get in touch with the breed club, and join them if you do acquire birds of that breed. Most clubs have very modest dues, but they really help support and maintain their respective breeds.

AMERAUCAUNA
Ameraucana Breeders Club
Birch Run, Michigan
www.ameraucana.org

AMERICAN GAME BANTAM
American Game Bantam Club
http://groups.msn.com/agbc

ARAUCANA
Araucana Club of America
Frankton, Indiana
www.araucanaclubofamerica.org

ASEEL (ASIL)
Oriental Game Breeders Association
Creston, California
805-237-1010

AUSTRALORP
Australorp Club of Australia Inc.
www.australorps.com
(open to breeders worldwide)

BEARDED D'ANVER
Belgian Bearded d'Anver Club
Okeana, Ohio
www.danverclub.com

BOOTED BANTAM AND BEARDED D'UCCLE
Belgian d'Uccle and Booted Bantam Club
Maple Park, Illinois
www.belgianduccle.org

BRAHMA
American Brahma Club
Richmond, Kentucky
http://groups.msn.com/AmericanBrahmaClub

COCHIN
Cochins International
Bloomfield, Indiana
http://cochinsinternational.cochinsrule.com

CORNISH
International Cornish Breeders Association
Leonard, Texas
903-587-2950

CUBALAYA
Cubalaya Breeders Club
http://groups.yahoo.com/group/CubalayaBreedersClub

DOMINIQUE
Dominique Club of America
Scarborough, Maine
www.dominiquechickens.org

DORKING
Dorking Club of North America
Chapin, Illinois
217-243-9229

DUCKS
International Heavy Duck Breeders Association
Palatine Bridge, New York
518-673-5668
www.geocities.com/kyleyac/HeavyDuckClub.html

DUTCH BANTAM
American Dutch Bantam Society
Brighton, Michigan
www.dutchbantamsocietyamerica.com

EMU

American Emu Association
541-332-0675
www.aea-emu.org

FAVEROLLE

Faverolles Fanciers of America
www.faverollesfanciers.org

GUINEA FOWL

Guinea Fowl Breeders Association
www.gfba.org

HAMBURG

North American Hamburg Society
Atascadera, California
www.geocities.com/northamericanhamburgsociety

JAPANESE

Japanese Bantam Breeders Association
Dunnellon, Florida
352-795-9836
http://home.columbus.rr.com/jbba/JBBA.html

JERSEY GIANT

National Jersey Giant Club
Pequot Lakes, Minnesota
218-562-4067

LANGSHAN

American Langshan Club
Claremore, Oklahoma
http://groups.yahoo.com/group/Langshans

LEGHORN

American Brown Leghorn Club
Stanwood, Washington
www.the-coop.org/leghorn/ablc1.html

MARAN

American Marans Club
Newnan, Georgia
770-304-9842
www.americanmaransclub.com

NAKED NECK

American Naked Neck Club
Harrod, Ohio
419-648-9282
www.crohio.com/nn

OLD ENGLISH GAME

Old English Game Bantam Club
www.bantychicken.com/cgi-bin/OEGBCA/index.cgi

ORLOFF

Russian Orloff Club of America
Silver Lake, Indiana
574-566-2426

ORPINGTON

United Orpington Club
Brownsdale, Minnesota
507-567-2009
www.geocities.com/srp18407/UOC.html

OSTRICH

American Ostrich Association
www.ostriches.org

PEAFOWL

United Peafowl Association
Greens Fork, Indiana
www.peafowl.org

PHOENIX

Oriental Game Breeders Association
(see listing under **Aseel**)

PIGEON

American Dove Association
www.doveline.com

International Federation/American Homing Pigeon
Fanciers
www.ifpigeon.com

National Pigeon Association
www.npausa.com

Other pigeon organizations
www.pigeonclubsusa.com

PLYMOUTH ROCK
Plymouth Rock Fanciers of America
Burgettstown, Pennsylvania
www.crohio.com/rockclub

POLISH
Polish Breeders Club
Cridersville, Ohio
http://groups.msn.com/PolishChickens

RHODE ISLAND RED
Rhode Island Red Club of America
Chino Valley, Arizona
www.crohio.com/reds

ROSECOMB
Rosecomb Bantam Federation
Thomaston, Maine
www.rosecomb.com/federation

SEBRIGHT
Sebright Club of America
Ila, Georgia
706-789-2869

SERAMA
Serama Council of North America
Vacherie, Louisiana
www.seramacouncilofnorthamerica.com

SHAMO
Oriental Game Breeders Association
(see listing under **Aseel**)

SICILIAN BUTTERCUP
American Buttercup Club
Cadillac, Michigan
231-862-3671
www.geocities.com/americanbuttercupclub

SILKIE
American Silkie Bantam Club
Palm Springs, California
www.americansilkiebantamclub.org

SUMATRA
American Sumatra Association
Boonville, North Carolina

WYANDOTTE
Wyandotte Breeders of America
Cassville, Wisconsin
608-725-2179
www.crohio.com/wyan

YOKOHAMA
Oriental Game Breeders Association
(see listing under **Aseel**)

Other Organizations

AMERICAN BANTAM ASSOCIATION
Augusta, New Jersey
973-383-8633
www.bantamclub.com

AMERICAN LIVESTOCK BREEDS CONSERVANCY
Pittsboro, North Carolina
919-542-5704
www.albc-usa.org

AMERICAN PASTURED POULTRY PRODUCERS' ASSOCIATION
Blodgett, Oregon
541-453-4557; *www.apppa.org*

AMERICAN PHEASANT AND WATERFOWL SOCIETY
www.apws.org

AMERICAN POULTRY ASSOCIATION
Burgettstown, Pennsylvania
724-729-3459
www.amerpoultryassn.com

HERITAGE TURKEY FOUNDATION
Capitola, California
831-476-1271
www.heritageturkeyfoundation.org

NATIONAL WILD TURKEY FEDERATION
Edgefield, South Carolina
800-843-6983
www.nwtf.org

NORTH AMERICAN GAME BIRD ASSOCIATION
www.naga.org

PET DUCK AND GOOSE ASSOCIATION
www.geocities.com/petduckassociation

SLOW FOOD ARK OF TASTE
Brooklyn, New York
718-260-8000
www.slowfoodusa.org/ark

SOCIETY FOR THE PRESERVATION OF POULTRY ANTIQUITIES
(A Division of the National Poultry Museum & Heritage Center)
Bonners Springs, Kansas
570-837-3157
http://groups.msn.com/SPPA

STANDARD TURKEY PRESERVATION ASSOCIATION
Ponoka, Alberta, Canada

Valuable Information Sources

WEB SITES

www.ansci.umn.edu/poultry/index.html is the Web address for the University of Minnesota's poultry pages. Many land-grant universities have poultry programs (check with your county extension agent for more information), but Minnesota's has an especially valuable poultry site, with many excellent publications for small-flock owners, such as *Farm Flock Poultry*, *Game Birds*, *Raising Ducks*, and *The Small Flock for Poultry Meat*.

www.attra.org is truly one of my favorite Web resources for those interested in any aspect of sustainable farming. The acronym stands for Alternative Technology Transfer for Rural America, and the staff at ATTRA provides hundreds of detailed online reports and documents addressing production and marketing for farm products.

www.backyardchickens.com is an online community of chicken enthusiasts, with message boards and educational information (including a page on coops that are perfect for backyard chicken operations). And the community is big (in 2003 the site traffic topped a million unique visitors) and getting bigger. This is a great resource for both new and experienced chickenphiles!

www.eggbid.com is a great resource for finding hatching eggs and birds in an eBay-type auction. You can also find farm-type items for auction.

www.feathersite.com is the personal mission of Barry Koffler, a dedicated poultryphile from New York State who keeps lots of fancy birds. Barry has loaded the pages with tons of valuable information that can keep any bird junkie busy for hours. This Web site has had well over 2 million visitors since its inception.

www.gbwf.org is an Internet resource for enthusiasts of Galliformes, the order of birds that includes pheasants, partridges, quail, grouse, turkeys, guinea fowl, and cracids (more commonly referred to as game birds). It covers conservation, aviculture, and other topics and has an active forum.

www.goodearthpublications.com is an online resource for information and publications that promote sustainable practices.

www.poultryyouth.com provides a place for young poultry enthusiasts to join a virtual community. It also has wonderful articles on poultry raising useful no matter how old you are — and a good list of individual breeders, broken down by state (you can add your listing for free if you are into breeding birds for sale).

BOOKS

American Bantam Association. ***Bantam Standard***. 2005.

American Poultry Association. ***American Standard of Perfection***. 2001.

Christman, Carolyn J., and Robert O. Hawes. ***Birds of a Feather: Saving Rare Turkeys from Extinction***. Pittsboro, NC: American Livestock Breeds Conservancy, 1999.
Anyone who is contemplating raising heritage turkeys should consider this small book from the good folks at the ALBC. It covers turkey genetics and conservation strategies in excellent detail.

Damerow, Gail. ***The Chicken Health Handbook.*** North Adams, MA: Storey Publishing, 1994.
This is an excellent resource for small-flock owners with detailed information on health care, disease treatment and prevention, and dealing with parasites.

Damerow, Gail. ***Storey's Guide to Raising Chickens***. North Adams, MA: Storey Publishing, 1995.
Gail's book is really a pillar among books on caring for chickens. Everything you need to know, whether you are getting your first birds or have years behind you, is covered well in this book.

Dohner, Janet Vorwald. ***The Encyclopedia of Historic and Endangered Livestock and Poultry Breeds***. New Haven: Yale University Press, 2001.
Janet did extensive research on heritage breeds, making this one of the best books on the topic. It is a hefty treatise on the history and value of hundreds of breeds.

Holderread, Dave. ***Storey's Guide to Raising Ducks***. North Adams, MA: Storey Publishing, 2001.
Dave is truly renowned in the waterfowl world and provides a remarkably informative book for those interested in raising ducks (and most of the information is also applicable to geese).

Kilarski, Barbara. ***Keep Chickens! Tending Small Flocks in Cities, Suburbs, and Other Small Places.*** North Adams, MA: Storey Publishing, 2003.
I love this book: a fun, firsthand account of Barbara's own dive into chickendom, with plenty of valuable how-to information, it is a must-have for the aspiring or neophyte backyard poultry keeper.

Lee, Andy, and Patricia Foreman. ***Day Range Poultry***. Buena Vista, VA: Good Earth Publications, 1999.
This is an excellent resource for those interested in pastured poultry production, and it has good detail on raising turkeys on pasture.

Minnaar, Maria. ***The Emu Farmer's Handbook.*** Blaine, WA: Hancock House Publishers, 1998.
The is the most comprehensive how-to book for anyone considering getting into emu or ostrich production.

Pangman, Judy. ***Chicken Coops.*** North Adams, MA: Storey Publishing, 2006.
This book has 45 unique coops (including turkey roosts and brooder houses) with informative drawings and lively stories to inspire your creativity.

Sponenberg, Phillip, and Carolyn J. Christman. ***A Conservation Breeding Handbook***. Pittsboro, NC: American Livestock Breeds Conservancy, 2004.
This is a valuable resource for those interested in breeding endangered birds (or other critical populations of farm animals).

Stromberg, Loyl. ***Poultry of the World***. Ontario, Canada: Silvio Mattacchione & Co., 1996.
Loyl Stromberg of Stromberg's Hatchery is a well-known poultryman who has an abiding love for birds. This title is one of many books he's written on fowl and provides entertaining yet valuable information on birds from around the globe.

Vriends, Matthew, and Tommy Erskine. ***Pigeons: A Complete Pet Owners Manual.*** Hauppauge, NY: Barrons Educational Books, 2005.
This is a top-notch introduction for aspiring pigeon-keepers of all ages.

MAGAZINES

Backyard Poultry, and/or Countryside & Small Stock Journal
Medford, Wisconsin
http://backyardpoultrymag.com,
www.countrysidemag.com
Backyard Poultry is a fairly new title from Dave and Anne Marie Belanger, a brother-and-sister team who grew up in the publishing/homesteading business. Their dad, Jerry, started publishing *Countryside* in 1969. *Countryside* is an all-around homesteading title. *Backyard Poultry* is a great addition for anyone who loves chickens and other feathered creatures.

Feather Fancier
Ontario, Canada
www.featherfancier.on.ca
A newspaper for Canada's fancier community that is published 11 times per year. It covers the Canadian show world and includes how-to articles and an extensive section of advertisements for breeders.

Game Bird and Conservationist's Gazette
Salt Lake City, Utah
www.gamebird.com
Although this gazette doesn't cover chickens, it is the essential-information source for people who are interested in other birds, ranging from doves and ducks to geese, guineas, quail, pheasants, and swans. The magazine always has a large section of classified ads.

Hobby Farms
Lexington, Kentucky
www.hobblyfarmsmagazine.com
I'm a contributing editor to *Hobby Farms*, which covers a wide range of topics on rural living, including poultry.

Mother Earth News
Topeka, Kansas
www.motherearthnews.com
Mother Earth has been around for decades, covering a broad array of homesteading topics.

Poultry Press
Connersville, Indiana
www.poultrypress.com
Poultry Press is a monthly newspaper that has been around for over ninety years and serves the "standard-bred poultry community." It is a must-read publication for those who actively participate in poultry shows and events around the country. There is information on all the large shows and most of the smaller shows, as well as informative articles about birds and their care and tons of ads for breeders and suppliers.

Commercial Hatcheries

Abendroth's Waterfowl Hatchery
Waterloo, Wisconsin
920-478-2053
chickens, turkeys, ducks, geese

Ashley Valley Game Birds
Vernal, Utah
435-781-2923
www.mcbeeweb.com/irishmyst
chickens, pheasants

B&D Game
Harrah, Oklahoma
405-964-5235
www.bdfarm.com
quail, pheasants, chukars, guineas, jungle fowl

Bear Bayou Quail Farm
Channelview, Texas
281-452-5407
www.bearbayouquail.homestead.com
quail

BELT HATCHERY
Fresno, California
559-264-2090
www.belthatchery.com
chickens (maintains its own breeding flocks for a variety of standard, heavy, and specialty breeds)

BERG'S HATCHERY
Russell, Manitoba
204-773-2562
www.bergshatchery.com
chickens, turkeys, ducks, geese

BIG SKY GAME BIRDS
Victor, Montana
chickens, quail

BOBWHITE QUAIL FARM OF HATCHBEND
Newberry, Florida
352-472-6556
www.bobwhitequailfarmofhatchbend.com
quail, pheasants

CACKLE HATCHERY
Lebanon, Missouri
417-532-4581
www.cacklehatchery.com
chickens, turkeys, ducks, geese, guineas

CALICO WOODS FARM
Grove Spring, Missouri
www.calicowoods.com
chickens, turkeys, ducks, geese, guineas, peafowl

CEDAR GROVE FARMS
Edgewood, New Mexico
505-281-1013
http://members.aol.com/CGFARMS/index.html
pheasants, quail, partridges, wild waterfowl, peafowl

CENTRAL HATCHERY
Madison, Nebraska
800-272-2449
www.centralhatchery.com
chickens

CHICK HATCHERY
Birch Run, Michigan
www.chickhatchery.com
chickens (specializes in Ameraucanas and Vorwerks)

CHUKAR CREEK HATCHERY
Kittanning, Pennsylvania
724-868-2596
www.chukarhatchery.com
quail, partridges

CLEARVIEW STOCK FARM AND HATCHERY
Gratz, Pennsylvania
717-365-3234
chickens

CM GAME BIRDS
Eidson, Tennessee
615-216-8069
http://ebiz.netopia.com/quailfarms
chickens, pheasants, quail, partridges

DARK EGGS
Pearblossom, California
877-572-8266
www.darkeggs.com
chickens (specializes in brown layers)

DECORAH HATCHERY
Decorah, Iowa
563-382-4103
www.decorahhatchery.com
chickens, turkeys, ducks, geese, guineas, pheasants, quail

DIRT WILLY
Ardrossan, Alberta
780-922-6080
www.dirtwilly.com
pheasants, partridges, wild turkeys

DOGWOOD ACRES
Adamsville, Tennessee
731-632-5080
www.angelfire.com/country/DOGWOOD
ducks, geese, wild waterfowl

DOUBLE-R DISCOUNT SUPPLY
West Melbourne, Florida
866-325-7779
www.dblrsupply.com
chickens, turkeys, ducks, geese, guineas, peafowl

DOUBLE T FARM
Glenwood, Iowa
712-366-3526
www.doubletfarm.com
chickens, wild waterfowl, swans

DUNLAP HATCHERY
Caldwell, Idaho
208-459-9088
www.dunlaphatchery.webyp.net
chickens, turkeys, ducks, guineas, partridges, pheasants

EAGLE NEST POULTRY
Oceola, Ohio
419-562-1993
chickens, turkeys, ducks, geese

C. M. ESTES HATCHERY
Springfield, Missouri
800-345-1420
www.esteshatchery.com
chickens, turkeys, ducks, geese, guineas, pheasants

FAIRVIEW HATCHERY
Remington, Indiana
800-440-1530
www.fairviewhatchery.info/index
chickens, turkeys, ducks, geese, guineas, pheasants, peafowl

THE FEATHER BARN
Elwood, Illinois
chickens, ducks, geese, peafowl

FEATHERHEAD'S GAMEBIRDS & GUINEAS
Elgin, Texas
512-281-2330
http://featherheadso.tripod.com
chickens, ducks, quail, partridges, guineas

FEATHER MOUNTAIN HATCHERY
(A Division of the C&C Family Farm)
Chino Valley, Arizona
928-636-3701
http://njsparks.com/FeatherMountainHatchery/Home.htm
chickens, turkeys, geese

GUINEA FARM
New Vienna, Iowa 52065
563-853-4195
www.guineafarm.com

GULF COAST HATCHERY
McDavid, Florida
850-327-6364
chickens

HALL BROTHERS HATCHERY
Norwich, Connecticut
860-886-2421
chickens, turkeys, ducks, geese, guineas

HARPER'S GAME FARM
Booker, Texas
806-435-3495
www.harpersgamefarm.com
chickens, turkeys, ducks, geese, guineas, peafowl, wild turkeys

HEARTLAND HATCHERY
Amsterdam, Missouri
660-267-3679
www.heartlandhatchery.com
chickens, turkeys, ducks, geese, guineas

HOFFMAN HATCHERY, INC.
Gratz, Pennsylvania
717-365-3694
www.hoffmanhatchery.com
chickens, turkeys, ducks, geese, guineas, swans, peafowl, quail, pheasants, partridges, wild turkeys

HOLDERREADS' WATERFOWL FARM
Corvallis, Oregon
541-929-5338
ducks, geese

HOOVER'S HATCHERY
Rudd, Iowa
800-247-7014
www.hoovershatchery.com
chickens, turkeys, ducks, geese, wild turkeys, pheasants, peafowl, guineas

HOWELL'S EXOTIC WATERFOWL
Muldrow, Oklahoma
918-427-4813
www.howellsswans.com
ducks, geese, swans

IDEAL POULTRY BREEDING FARMS
Cameron, Texas
254-697-6677
www.ideal-poultry.com
chickens, turkeys, ducks, geese, guineas, partridges, quail

JOHNSON'S WATERFOWL
Middle River, Minnesota
218-222-3556
ducks

KAIBIC'S HATCHERY
Sanford, North Carolina
919-777-9399
chickens, turkeys, ducks, geese, guineas

LAKE CUMBERLAND GAME BIRD FARM
Monticello, Kentucky
606-348-6370
www.lakecumberlandgamebirds.com
quail, pheasants, chukars

LARRY'S POULTRY
Fort Morgan, Colorado
800-676-1096
www.larryspoultry.com
chickens, turkeys, ducks, geese, guineas, partridges, pheasants, quail, pigeons

LAZY 54 FARM
Hubbard, Oregon
503-981-7801
http://lazy54farm.com/
chickens, turkeys, guineas, pheasants, partridges

MARTI POULTRY FARM
Windsor, Missouri
660-647-3999
www.martipoultry.com
chickens, ducks, guineas

MASON HATCHERY
Walters, Oklahoma
580-875-3503
www.masonhatchery.com
guineas

MATHEWS POULTRY
http://poultry2.tripod.com/index.html
chickens, ducks, geese, quail, turkeys

McFARLANE PHEASANTS
Janesville, Wisconsin
800-345-8348
www.pheasant.com
pheasants, partridges

METZER FARMS
Gonzales, California
800-424-7755
www.metzerfarms.com
turkeys, ducks, geese, guineas

MEYER HATCHERY
Polk, Ohio
888-568-9755
www.meyerhatchery.com
chickens, turkeys, ducks, geese, guineas, pheasants

MICHENER PHEASANT PHARM
Nebraska City, Nebraska
pheasants, wild turkeys

MOUNT HEALTHY HATCHERIES
Mt. Healthy, Ohio
800-451-5603
www.mthealthy.com
chickens, turkeys, ducks, pheasants, guineas, quail,
partridges

MOYER'S CHICKS, INC.
Quakertown, Pennsylvania
215-536-3155
www.moyerschicks.com
chickens

MURRAY MCMURRAY HATCHERY
Webster City, Iowa
800-456-3280
www.mcmurrayhatchery.com
chickens, turkeys, ducks, geese, guineas, pheasants,
peafowl, quail

MYERS POULTRY FARM
South Fork, Pennsylvania
814-539-7026
chickens, turkeys, ducks, geese, quail, partridges

NOLL'S POULTRY FARM
Kleinfeltersville, Pennsylvania
717-949-3560
chickens

NORTH RIVER GAMEBIRDS
Newburgh, New York
914-464-1702
www.noriv.com/birds
pheasants, quail, partridges

NORTHWEST GAMEBIRDS
Kennewick, Washington
509-586-0150
www.nwgamebirds.com
quail

OAKWOOD GAME BIRDS
Princeton, Minnesota
800-328-6647
www.oakwoodgamefarm.com
pheasants, partridges

ORLOPP HATCHERY
Orosi, California
559-528-4856
turkeys

PEA RIDGE GAMEBIRD HATCHERY
Hartville, Missouri
417-741-7737
http://pheasantfarm65667.tripod.com
wild waterfowl, pheasants, quail

PERFORMANCE POULTRY
Carrying Place, Ontario
613-968-2508
www.performancepoultry.com
chickens, turkeys, ducks, geese, quail, guineas,
pheasants, partridges

PHINNEY HATCHERY, INC.
Walla Walla, Washington
509-525-2602
chickens, turkeys, ducks, geese, guineas, pheasants,
partridges

PINEWOOD POULTRY FARM
Sam Rayburn, Texas
409-698-2472
www.pinewood.cjb.net
chickens, turkeys, ducks, geese, guineas

PRICKEREE PINES GAMEBIRD FARM
Lowell, Michigan
616-897-1080
www.prickereepines.homestead.com
ducks, wild waterfowl, peafowl

PRIVETT HATCHERY
Portales, New Mexico
800-774-8388
www.privetthatchery.com
chickens, turkeys, ducks, geese

REICH POULTRY FARMS
Marietta, Pennsylvania
717-426-3411
chickens, turkeys, ducks

RICE'S POULTRY FARM
Wickliffe, Kentucky
chickens

RIDGWAY HATCHERIES, INC.
Larue, Ohio
800-323-3825
www.ridgwayhatchery.com
chickens, turkeys, ducks, geese, guineas

ROBERTS WATERFOWL
Fulton, Kentucky
270-468-5419
www.rarebird.com/robertswaterfowl/index.htm
swans, wild waterfowl

ROCHESTER HATCHERY
Westlock, Alberta
780-307-3622
www.rochesterhatchery.com
chickens, turkeys, pheasants

ROCKING T RANCH & POULTRY FARM
Kempner, Texas
512-556-2746
www.poultryhelp.com
chickens, quail, guineas

ROCK-N-CEDAR
Mulgrow, Oklahoma
918-427-3510
www.boxess.com/chome.htm
peafowl

ROCKY MOUNTAIN HATCHERY AND GAME BIRDS
Victor, Montana
406-642-3253
http://members.aol.com/Birdman40/pheasant.html
pheasants

SAND HILL PRESERVATION CENTER
Calamus, Iowa
563-246-2299
www.sandhillpreservation.com
chickens, turkeys, ducks, geese, guineas (a small commercial farming operation dedicated to preserving agricultural biodiversity in plants as well as fowl; it has an excellent selection of preservation species as identified by the American Livestock Breeds Conservancy and the Society for the Preservation of Poultry Antiquities)

SCHLECHT HATCHERY
Miles, Iowa
563-682-7865
www.schlechthatchery.com
chickens, ducks, geese

SEVEN OAKS GAME FARM
Wilmington, North Carolina
910-791-5352
www.poultrystuff.com
chickens, ducks, quail

SHADY LANE POULTRY FARM
Winchester, Kentucky
859-737-2636
www.shadylanepoultry.com
chickens (the only hatchery to my knowledge that is selecting and hatching birds based on their suitability for pastured poultry production, carrying both commercial and heritage breeds that have been bred to perform well on grass)

SHOOK POULTRY
Claremont, North Carolina
828-459-0571
www.geocities.com/shookpoultry
chickens

SHULTE WATERFOWL
Marshall, Minnesota
507-532-2893
ducks, geese

SQUAW CREEK FARM
Osceola, Iowa
641-342-6469
http://stanritar.tripod.com/main.html
quail, wild waterfowl

STROMBERG'S CHICKS AND GAMEBIRDS
Pine River, Minnesota
800-720-1134
www.strombergschickens.com
chickens, turkeys, ducks, geese, guineas, partridges, peafowl, swans

SUNNYSIDE INC. OF BEAVER DAM
Beaver Dam, Wisconsin
920-887-2122
chickens, turkeys, ducks, geese

SUN RAY CHICKS HATCHERY
Hazleton, Iowa
319-636-2244
www.sunrayhatchery.com
chickens, turkeys, ducks, geese, guineas

TOWNLINE HATCHERY
Zeeland, Michigan
616-772-6514
www.townlinehatchery.com
chickens, turkeys, ducks, geese, guineas, pheasants

URCH/TURNLAND POULTRY
Owatonna, Minnesota
507-451-6782
chickens, ducks, geese, turkeys, peafowl, guineas

UTGAARD'S HATCHERY
Star Prairie, Wisconsin
715-248-3200
chickens, ducks, geese, guineas, pheasants

VALENTINE HATCHERY
Old Town, Florida
www.vhatchery.com
chickens, turkeys

WALTERS HATCHERY
Stilwell, Oklahoma
918-778-3535
www.historicalturkeys.com
turkeys (specializes in heritage breeds of turkeys)

WELP, INC.
Bancroft, Iowa
800-458-4473
www.welphatchery.com
chickens, turkeys, ducks, geese, guineas

WITT FARMS
Cassatt, South Carolina
803-432-1067
ducks, geese

WHO'S YUR HATCHERY
Kokomo, Indiana
765-566-3562
www.wyhatchery.net
chickens

X-TREME GAME BIRDS & POULTRY
Elgin, Texas
512-281-4182
www.xtremegamebirds.com
chickens, ducks, geese, turkeys, quail, pheasants

YACHATS VALLEY HATCHERY
Yachats, Oregon
541-547-3213
chickens, turkeys, ducks, geese

Bibliography

Allen, Durward, L. *Pheasants in North America.* Harrisburg, PA: StackPole, 1956.

American Bantam Association. *Bantam Standard.* 2005.

American Poultry Association. *American Standard of Perfection.* 2001.

Anderson, Virginia DeJohn. "Animals into the Wilderness: The Development of Livestock Husbandry, in the Seventeenth-Century Chesapeake," *The William and Mary Quarterly,* 3rd Series, Volume LIX, April 2002: 377-408.

Batty, Joseph. *Old and Rare Breeds of Poultry.* West Sussex, England: Beech Publishing House, 2006.

Blackburn, Harvey D., Terry Stewart, Don Bixby, Paul Siegal, and Eric Bradford. *United States of America Country Report for FAO's State of the World's Animal Genetic Resources* (USDA Agricultural Research Service, December, 2003).

Christman, Carolyn J., and Robert O. Hawes. *Birds of a Feather: Saving Rare Turkeys from Extinction.* Pittsboro, NC: American Livestock Breeds Conservancy, 1999.

Damerow, Gail. *Storey's Guide to Raising Chickens.* North Adams, MA: Storey Publishing, 1995.

Dohner, Janet Vorwald. *The Encyclopedia of Historic and Endangered Livestock and Poultry Breeds.* New Haven: Yale University Press, 2001.

Holderread, Dave. *Storey's Guide to Raising Ducks.* North Adams, MA: Storey Publishing, 2001.

Hutt, F.B. *Genetics of the Fowl* (Reprint of 1949 McGraw-Hill title). Blodgett, OR: Norton Creek Press, 2003.

Jull, Morley A. "Fowls of Forest and Stream Tamed by Man," *The National Geographic Magazine,* Volume LVII, No. 3, March 1930: 327-371.

Jull, Morley A. "The Races of Domestic Fowl," *The National Geographic Magazine,* Volume LI, No. 4, March 1927: 379-452.

Kemp, Rick. *Pure Breed Poultry Raising.* Kangaroo Press, Australia, 1985.

Lamon, Harry M., and Rob R. Slocum. *The Mating and Breeding of Poultry* (Reprint of 1920 Orange Judd Company title). Guilford, CT: The Lyons Press, 2003.

Lewis, Harry R. "America's Debt to the Hen," *The National Geographic Magazine,* Volume LI, No. 4, March 1927: 353-367.

McGrew, T. F. *The Book of Poultry.* New York: T. Nelson & Sons, 1926.

Minnaar, Maria. *The Emu Farmer's Handbook.* Blaine, WA: Hancock House Publishers, 1998.

Poultry - Production and Value: 2005 Summary. USDA National Agricultural Statistics Services, April, 2006.

Sibley, Charles. *Phylogeny and Classification of Birds: A Study in Molecular Evolution.* New Haven: Yale University Press, 1990.

Sponenberg, D. Phillip, and Carolyn Christman. *A Conservation Breeding Handbook.* Pittsboro, NC: American Livestock Breeds Conservancy, 2004.

Stromberg, Loyl. *Poultry of the World.* Ontario, Canada: Silvio Mattacchione, 1996.

Todd, Frank S. *Natural History of Waterfowl.* Vista, CA: Ibis Publishing, 1996.

Vriends, Matthew, and Tommy Erskine. *Pigeons: A Complete Pet Owners Manual.* Hauppauge, NY: Barron's Educational Series, 2005.

Wayre, Philip. *A Guide to Pheasants of the World.* London: Country Life Books, 1969.

Woodard, Allen, Ralph Earnest, Pran Vohra, Lewis Nelson, and Fred C. Price. *Raising Game Birds* (Leaflet 21046, Division of Agricultural Sciences, University of California, September, 1978).

Credits

Breeders

We would like to acknowledge the breeders whose birds were photographed for this book.

CHICKENS

Ameraucana: Mark Campbell 36 bottom center & bottom right, 39 top left & right; Kathy Gratsch 6 middle, 38; Camille Lewandowski 39 bottom left

American Game Bantam: Larry Bruffee 106 bottom; Jeremy Miller 106 top

Ancona: SPPA member Glenn Drowns 40

Andalusian: Dalton Birden 14; SPPA member Glenn Drowns 30 bottom right, 42

Appenzeller: SPPA member Glenn Drowns 108

Araucana: Jay Yodst 4, 15, 33 top left & top right, 43

Aseel: SPPA member Dr. Charles Everett 74

Australorp: Benjamin Hildebrandt 44 right; John Orlowski: 44 left

Barnvelder: SPPA member Glenn Drowns 45, 46

Bearded d'Anvers: Johanna Jewell 34 bottom right, 109, 110

Blue Hen of Delaware: Dr. H. Wesley Towers 75, 76

Booted Bantam & Bearded d'Uccle: Brandon Burke 34 right 2nd from top; Beth Collier 35 middle left, 112; Camille Lewandowski 34 middle left, 111; Jeremy Preston 112 left

Brahma: Jackie Koedatich 77 bottom, 78 right; Dale & Mary Siegenthaler 32 top right, 78 bottom left; Garrett Spence 32 top row center, 77 top

Buckeye: John Brown 79, 80 top right & bottom; Kimber Woodford 80 top left

California Gray: Daniel Flyger 47

Campine: SPPA member Glenn Drowns 48, 49

Catalana: SPPA member Glenn Drowns 50

Chantecler: Tom Kane x, 34 bottom left & bottom center, 51, 52

Cochin: Elizabeth Clapp 113 bottom; Judy Gantt 34 right 2nd from bottom, 113 top; Mark Guy 114 bottom; Bill Serene 114 top

Cornish: Sarah Leininger 81 top; Andrew Sawkulech 36 right, 82; J. Sybertz 81 bottom

Crevecoeur: SPPA member Glenn Drowns 116

Cubalaya: SPPA member Glenn Drowns 117, 118

Delaware: SPPA member Glenn Drowns 83, 84

Dominique: Lily Branga 53 left; Cindy Jackson 25 right; Jeff Shaske 30 top left, 53 right

Dorking: SPPA member Glenn Drowns 85

Dutch Bantam: Laura Haggerty 119, 120 top; Matt Rogers 119 bottom

Faverolle: Dick Boulanger top left & bottom left; SPPA member Glenn Drowns viii; Camille Lewandowski 87 right

Fayoumi: SPPA member Glenn Drowns 54

Frizzle: Jay Birden 24; Margaret Schnall ii, 35 top left

Hamburg: SPPA member Phil Bartz 56 top left; James Cadigan 36 right 2nd from top, 56 bottom left; Jay Horn 36 top right; Donald Krahe 33 left 2nd & 3rd down, 55, 56 right; Mark Longerman 33 middle center & right

Holland: SPPA member Glenn Drowns 88, 89

Houdan: SPPA member Glenn Drowns 121, 122 top

Iowa Blue: SPPA member Glenn Drowns 90, 91

Japanese Bantam: Paul Kroll 122 bottom; Tim Temple ix, 18, 33 bottom left & center, 123, 124

Java: SPPA member Glenn Drowns 92, 93

Jersey Giant: SPPA member Glenn Drowns 95 top; John Pierce 6 top, 94, 95 bottom

Kraienkoppe: SPPA member Glenn Drowns 35 middle right, 125

La Fleche: SPPA member Glenn Drowns 126 left & bottom right; Forrest Beauford 126 top right, 127

Lakenvelder: SPPA member Glenn Drowns 57, 58 top

Langshan: Rebecca Buffington 128; Forrest Beauford 129

Leghorn: Dave Anderson 60 right; Gay Biordi & Richard Holmes 32 middle left & center, 59 bottom, 60 left; Ken Manville 37 top left, 58; Hudson Reynolds 19; Michael Schlumpohm 23 middle, 59 top

Malay: William Bender 96 right; Ronald Profitt 96 left

Manx Rumpy: SPPA member Glenn Drowns 130

Maran: SPPA member Glenn Drowns 32 top left, 61; Mallory Seely 62

Minorca: SPPA member Glenn Drowns 63, 64

Modern Game: Cheryl Barnaba 30 right 1st and 2nd from top, 132 top left; Eva Christiansen 132 top right; Tom Kane 35 top right; William Pfeil 35 top center, 132 bottom; Andrew Sawkulech 29 right, 36 bottom left; Nathaniel Trojanowski 131; Cliss Troxline 31 middle left

Naked Neck: Todd Cosart 135 bottom; Ellen Kennedy 134; Patrick Sheehy 135 top

Nankin: SPPA member Monte Bowen 136

New Hampshire: SPPA member Glenn Drowns 98 top; Jackie Koedatich 97

Norwegian Jaerhone: SPPA member Nancy Ellison 65

Old English Game: David Hager 13, 140 top left; Rick Harman 141 bottom; Kathleen Mai 35 left 2nd from bottom; Steven Roets 29 left; Jacob Seely 21, 33 bottom right, 34 top left, 35 bottom right, 137 top, 140 bottom right, 141 top; Juel Sheridan 137 bottom, 140 top right; Thomas Family Bantams: 31 top left, 31 top center, 32 middle left, 32 left 2nd from bottom

Illustrations

Courtesy of the National Human Genome Research Institute 12
Maurice Wilson, © Natural History Museum, London 240

Photography

Interior Photographs © Adam Mastoon, except for the following:

Courtesy of the American Livestock Breeds Conservancy: 28, Dr. Phillip Sponenberg 225
© Willis Anderson/World of Stock 229
© Dennis Avon/ardea.com 245 top
© Cheryl Barnaba 23 top, 25 left, 30 2nd from top right, bottom left & center, 31 middle left, 32 bottom right, 37 top left, 44 left, 58 bottom, 60 right, 69 top right & bottom left, 78 right, 81 bottom, 87 left top & bottom, 113 bottom, 114 top, 119 bottom, 122 bottom, 137 bottom, 140 top right, 149 bottom, 175 top, 178, 195 left
© William G. Bender, Jr. 96 right, 166
© John Daniels/ardea.com 248
© Kevin Fleming 75, 76
© Daniel Flyger 47
© Steffen Foerster/World of Stock 242 bottom
© Stephen Green-Armytage 171 top, 175 botttom, 184 bottom, 185, 190, 192 bottom left & right, 194 right, 211 top, 219 bottom, 226, 228 right
© Jennifer Huesby 221, 231 top
© iStockphoto: Stacey Bates 253 right, Donald Blais 191, Geoff Delderfield 253 left, Ernesto Ghigna 246, Markus Gregory 244 bottom, Cay-Uwe Kulzer 251 left, Nature's Display 169 & 250, Peter Llewellyn 191, Wojtek Piotrowski 252, 220, Tristan Poyser 220, Snowshill 247 left, Gary Unwin 241, Kouptsova-Vasic 240, Iva Villi 239, Karl-Ove Vindenes 170, Geoff Whiting 244 top, Jamie Wilson 243 bottom
© Greg Kelm 65
© Marc King 167
© Barry Koffler 66 top
© www.MyPetChicken.com 98, 135 top, 181, 184
© Curtis Oakes 212
© Painet, Inc.: Ken Archer 251 top right, Paul Browne 202, 247 right, Francis Caldwell 245 bottom, Rob and Ann Simpson 243 top, Harald Jahn Viennaslide 238
Diana Reed, courtesy of feathersite.com 249 top
Joel Schroeder 35 middle right, 46, 125, 130
© Gary Spray 176 bottom, 209 left
© Jackie Stoddard 249 bottom
© Dennis Thomas 31 top center
© M. Watson/ardea.com 251 bottom
© Doug Wechsler/VIREO 22
© Ken Woodard Photography 224

Index

Other Storey Titles You Will Enjoy

Barnyard in Your Backyard, edited by Gail Damerow.
Expert advice on raising healthy, happy, productive farm animals.
416 pages. Paper. ISBN-13: 978-1-58017-456-5.

Chicken Coops, by Judy Pangman.
A collection of hen hideaways to spark your imagination and inspire you to begin building.
180 pages. Paper. ISBN-13: 978-1-58017-627-9. Hardcover. ISBN-13: 978-1-58017-631-6.

The Chicken Health Handbook, by Gail Damerow.
A must-have reference to help the small flock owner identify, treat, and prevent diseases common to chickens of all ages and sizes.
352 pages. Paper. ISBN-13: 978-0-88266-611-2.

How to Build Animal Housing, by Carol Ekarius.
An all-inclusive guide to building shelters that meet animals' individual needs: barns, windbreaks, and shade structures, plus watering systems, feeders, chutes, stanchions, and more.
272 pages. Paper. ISBN-13: 978-1-58017-527-2.

Keep Chickens!, by Barbara Kilarski.
Everything you need to know to raise healthy chickens in small (urban or suburban) environments.
160 pages. Paper. ISBN-13: 978-1-58017-491-6.

Small-Scale Livestock Farming, by Carol Ekarius.
A natural, organic approach to livestock management to produce healthier animals, reduce feed and health care costs, and maximize profit.
224 pages. Paper. ISBN-13: 978-1-58017-162-5.

Storey's Guide to Raising Series.
Everything you need to know to keep your livestock and your profits healthy. Titles in the series include: *Rabbits, Ducks, Turkeys, Poultry, Chickens, Dairy Goats, Llamas, Pigs, Sheep,* and *Beef Cattle.*
Paper. Learn more about each title by visiting *www.storey.com.*

These and other books from Storey Publishing are available
wherever quality books are sold or by calling 1-800-441-5700.
Visit us at *www.storey.com.*